MAGICK CITY:
TRAVELLERS TO ROME
FROM THE MIDDLE AGES
TO 1900

VOLUME I:
THE MIDDLE AGES TO THE
SEVENTEENTH CENTURY

ABOUT THE AUTHOR

Inaugural Teaching Fellow in Ancient History, University of Sydney (1962-4), Lecturer in History, University of Melbourne (1965-2005), retiring from a Personal Chair. MA (Syd.), DLitt (Melb.), Hon.DLitt (Macquarie), Fellow of Society of Antiquaries, Royal Historical Society, Australian Academy of the Humanities, and Corresponding fellow of Pontifical Roman Academy of Archæology. Awarded the Premio Daria Borghese 2019 for his *Prince of Antiquarians: Francesco de Ficoroni.*

BY THE SAME AUTHOR

Pharaonic Egypt in Victorian Libraries
University of Melbourne, 1970

The Unification of Egypt
Refulgence Press, 1973

Zosimus: New History, translated with commentary
Australian Society for Byzantine Studies, 1982

Gibbon's Complement: Louis de Beaufort
Istituto Veneto, 1986

The History of Rome: A Documented Analysis
Bretschneider, 1987

The Historical Observations of Jacob Perizonius
Accademia Nazionale dei Lincei, 1991

The Eagle and the Spade: The Archæology of Rome During the Napoleonic Era
Cambridge University Press, 1992

Jessie Webb, A Memoir
University of Melbourne, 1994

Melbourne's Monuments
University of Melbourne, 1997

*Napoleon's Proconsul: The Life and Times
of Bernardino Drovetti (1776-1852)*
Rubicon Press, 1998

The Infancy of Historiography
University of Melbourne, 1998

The Pope's Archæologist: The Life and Times of Carlo Fea
Quasar, 2000

(ed.) Raymond Priestley, *The Diary of a Vice-Chancellor:
University of Melbourne 1935-1938*
University of Melbourne, 2002

*The Emperor's Retrospect: Augustus' Res Gestæ in
Epigraphy, Historiography and Commentary*
Peeters, 2003

What an Historian Knows
University of Melbourne, 2008

The Prince as Poisoner: The Trial of Prince Sigismondo Chigi (1790)
(with Dino Bressan), Tipografia Vaticana, 2015

(ed.) *Fifty Treasures: Classical Antiquities in Australian
and New Zealand Universities*
Australasian Society of Classical Studies, 2016

Rome, Twenty-nine Centuries: A Chronological Guide
Gangemi, 2017

The Prince of Antiquarians: Francesco de Ficoroni
Quasar, 2017

Akhenaten: An Historian's View
American University (Cairo), 2018

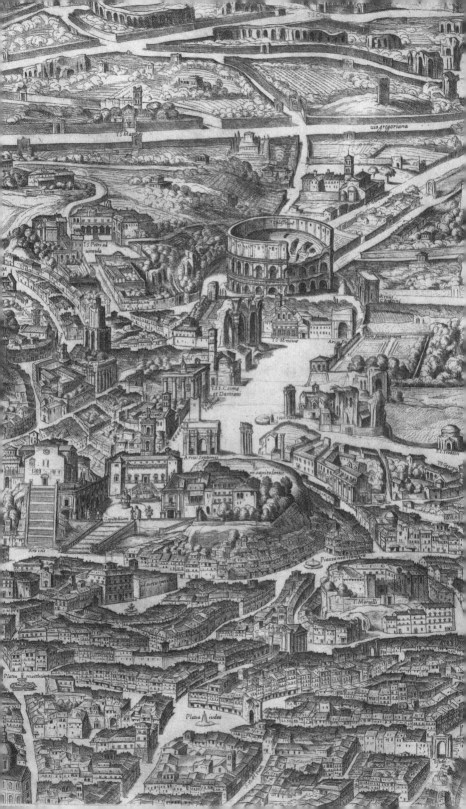

MAGICK CITY

TRAVELLERS TO ROME
FROM THE MIDDLE AGES
TO 1900

VOLUME I:

THE MIDDLE AGES TO THE
SEVENTEENTH CENTURY

BY RONALD T. RIDLEY

PALLAS ATHENE

CONTENTS

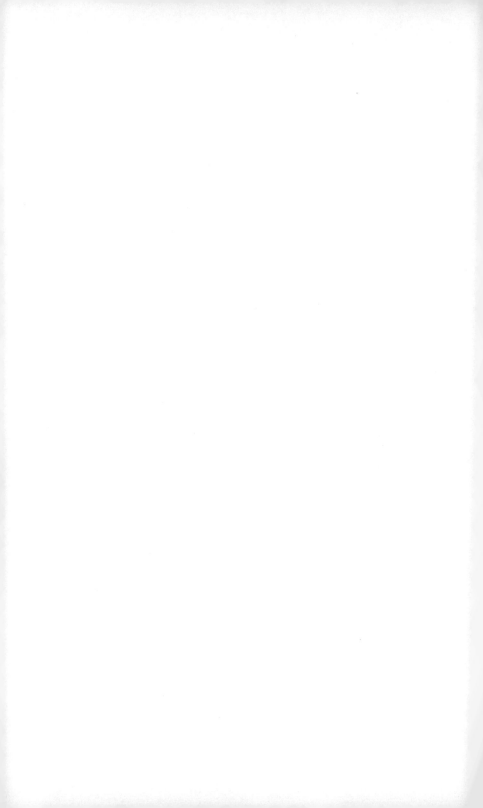

INTRODUCTION

By any rational account, Rome is the most extraordinary city in the world. It has had a continuous and pre-eminently influential history now for almost three millennia, thus dwarfing the other great cities which others may care to name: London, Paris, Beijing, New York, even Jerusalem (destroyed in 586 BC and AD 70, and which never exercised Rome's temporal power). It has had two primary roles, first as the head of the most influential political organisation the world has ever seen, second as the centre of one of the world's most powerful religions. In the former role, after unifying Italy in the fifth and fourth centuries BC, Rome went on to conquer first the Mediterranean, then the 'Successor' kingdoms which had divided the empire of Alexander (the Antigonids, Seleucids and Ptolemies) and finally ruled from Britain to the Euphrates, and from the Rhine and Danube to the Sahara. In the control of that empire Rome – and to the end that city remained the political centre, being called, starkly and without further epithet, simply Urbs, *the* City – laid down rules for political behaviour and government which, despite all the times that she did not live up to her ideals, have been an inspiration ever since. And the provinces which she ruled became the nations of the modern Europe.

On the spiritual side, by about the fourth century, Rome came to be accepted as the seat of the primate of the Christian Church. That bishop went on to become a leading political figure in his own right – successor in some senses to the emperor, as the forged Donation of Constantine tried to claim, and surely the most extraordinary monarchy the world has ever devised – but exercising a far more potent spiritual sway over most of the crowned heads of Europe until the Reformation in the sixteenth century stripped away half of these subjects. In one of the most ironic reversals in history, that realm was finally reduced to its original spiritual power in 1870, when Italy was at last reunited.

And culturally, as the centre of the Church, Rome throughout the centuries has been the subject of the attention of the greatest artists, architects, musicians and other creative geniuses of the western world. It is in this capacity that Rome has exercised an appeal beyond the members of her own community, an appeal to the whole civilised world, and has been a magnet to anyone wishing to be considered a member of it. It has thus over the centuries, beginning with the Middle Ages, but especially since the Renaissance, been a mecca for travellers from all parts of the world. They have come to visit the capital of Catholic Christianity – whether to worship or to criticise – they have come as students of classical antiquity, they have come seeking creative inspiration, they have come as admirers of beauty, and they have come out of awareness that something would be missing in their lives if they had not set foot in the 'Eternal City' – and they have found a lifetime inadequate to satisfy all their needs.

This book had its genesis in my *Eagle and the spade* (Cambridge 1992), a study of the French occupation of Rome 1808-1814. Accounts by contemporary visitors were a major source. They were more extensively consulted for my biography of Carlo Fea (*The pope's archæologist*, Rome 2000), which required knowledge of Rome from 1770. I had in the meantime been gathering travellers' accounts beginning from the Middle Ages, having realised their value. It became clear that a book based on a judicious selection from them should be both interesting and useful. A major source on Rome had been neglected, with one exception.

We certainly do not need another book on the Grand Tour, based on a small selection of the best known writers. Equally certain: there will be many more such. Rome deserves better.

For this volume I have read and indexed more than two hundred travellers from some fifteen countries, beginning with Sigeric in the tenth century and ending with George Trevelyan at the end of the nineteenth. The travellers of the nineteenth century and many of the eighteenth are readily available, many, in fact, in excellent modern editions. The older, and in some cases very rare, accounts have been found especially in some of my favourite libraries, notably the Biblioteca Vaticana in Rome and the British Library in London.

Some things have been deliberately omitted. All the sources are published ones. To begin searching through archives, where I have spent much time in my life, would have been a recipe for ensuring that the work could never be finished. The published sources are probably the most important: that is how they found a publisher. Second, guidebooks are not quoted among the travellers, but only fitfully alluded to in introductory sections. What this book presents is, as far as possible, authentic responses by real visitors.

The more than two hundred accounts which have been used provide an amazingly detailed and revealing account of the city through the centuries, mainly the sixteenth to the nineteenth. They have been chosen to favour those travellers who bring acute observation to bear, those whose business was observation, such as artists and writers. The outstanding representatives in each century seem easy to identify: Michel de Montaigne in the sixteenth century, John Evelyn in the seventeenth, Johann Wolfgang von Goethe in the eighteenth, and perhaps a shared prize in the nineteenth: Charles Dickens and Florence Nightingale.

There are very clear themes in the chapter devoted to each century: how did the travellers arrive in Rome? Where did they stay? Did they employ guides? What were their expenses? What did they see of churches, palaces, villas and antiquities? What did they like or dislike of what they saw? What did they think of Rome in all its contemporary facets? What events did they witness? What portraits do they provide of people in Rome at the time of their visit?

This book thus constitutes not only a record of Rome through these centuries as seen through the eyes of those who came from elsewhere to view and study it, but also a history of taste. Reactions to even outstanding figures such as Raphael, Michelangelo and Bernini have oscillated dramatically over the centuries, the last being particularly maligned. On the other hand, the reputation of some artists has remained remarkable constant; Guido Reni is an example, as the following pages will amply demonstrate. The travellers also provide invaluable commentary on many matters not easily found in the standard histories of Rome: the great Renaissance collections of antiquities which began to be dispersed at the end of the eighteenth

century, the rich musical and theatrical life of the city, its libraries, and not least its accommodation for travellers. Not to be overlooked also are the comments on government and society, usually of a more critical tenor than those to be found in the standard histories, but valuable as the views of contemporary observers.

It should be stressed that the many illustrations have been chosen with great care: not the usual decorations, but, as far as possible, contemporary with the descriptions which they accompany.

The travellers of some nations have previously been the subject of serious scholarship. Most notable in this regard are the British. No other nationality has been as well served, for example, by Pine-Coffin's bibliography and the stunning biographical dictionary of the eighteenth century travellers by Ingamells. German travellers, however, also have their bibliography by Tresoli, and a splendid general volume by Noack. What is extraordinary, however, is that so much which appears here has not found its way into the standard reference works: the librarians recorded by Mabillon, the musicians so graphically recorded by Burney, and the many antiquarians and archæologists found throughout. And for anyone who wishes to identify members of leading Roman aristocratic houses, the various reference works on such families are worse than useless. They often do not even provide family trees.

It is quite easy to find what one wants in this book. Each chapter is set out in uniform fashion, with main topics and names highlighted. After the mediæval background, which is in chronological order, the introduction to each chapter treats arrival, lodgings, expenses, guides and general reactions; the churches are discussed in order of the major basilicas, then the other churches in alphabetical order, ecclesiastical festivals in calendrical order, then the catacombs; the palaces and villas are generally in alphabetical order, sometimes by order of attention; antiquities are grouped in much the same way as they would have been visited; contemporary Rome progresses from topographical introduction to government, economy, social classes, religion, education, hospitals, libraries, music, theatre, cafes etc; events are in chronological order; portraits finally treat first the popes in their order, then other people alphabetically. If one wishes to know whether any

traveller has been consulted (and the exact dates of his or her time in Rome), one turns to the list at the front of each chapter. If then one wishes to know where they are quoted, running one's eye down the footnotes will find the instances.

I might be allowed to note that reading, sorting, analyzing and making sense of anything said by some two hundred travellers across so many centuries has not been the labour of a moment, but undertaking it has given me immense enjoyment.

As always Ingrid Barker has transformed a very complicated typescript into impeccable text on disk. Without her my work would not be possible.

On a sunny Saturday afternoon in late January 1971 Thérèse and I first set foot in the Eternal City. We arrived very unusually, as none of the travellers in this book did, after a month long sea voyage by 'express service' from the other end of the earth, across the Indian Ocean and up the Atlantic, disembarking in Naples and reaching Rome by train. Since then we have usually spent most of each fourth year in Rome, exploring, toiling, absorbing and delighting. She has been an incomparable companion and guide.

NOTE ON MODERN WORKS OF ART

Travellers often mention modern paintings in various collections. Every effort has been made to trace these; they have often been moved. Where a new location is known it is indicated; where nothing of any such work can be found in modern catalogues of the artist in question – and the attributions are often fanciful – nothing more is said; where the work is still in the same collection, it is asterisked.

CURRENCY

One other thing is indispensable for understanding the many references to prices: the CURRENCY system. For most of the time the following is valid:

10 *bajocchi* (copper) = 1 *paolo* (silver) = 6d Eng.
100 *bajocchi* = 1 *scudo* (silver) = 5 *livres* / francs
2 *scudi* = 1 sequin (gold) = 10/- stg = 1 ducat
4 *scudi* (4.5 by 1780s) = £1 stg.

THE MEDIÆVAL AND EARLY
RENAISSANCE BACKGROUND

Rome in the Middle Ages is a far cry from the second century described by Gibbon in his history of the Roman Empire as 'the period in the history of the world during which the condition of the human race was most happy and prosperous'. Christianity, spasmodically persecuted by the government, became the dominant religion by the end of the fourth century. The political transformation, on the other hand, was slower. The Ostrogoths took over the rule of Italy at the end of the fifth century, and after a Byzantine interlude they were succeeded by the Lombards in the mid sixth. Rome itself was subject to capture by various barbarian peoples: the Visigoths in 410, the Vandals in 455, but the bishop of Rome slowly consolidated and extended his power. Fear of attack resulted in Leo IV (847-55) walling the Vatican. The bishop looked for protection to the Franks in the north: Charlemagne, first Holy Roman Emperor, was crowned in Rome in 800. The alliance often descended into rivalry over investiture, the local aristocracy also vied for power, the Normans were added to the equation, sacking Rome in 1084, and by the twelfth century there was also a Republican movement. The zenith of papal power was reached with Innocent III (1198-1216), but by 1308 a seventy years' exile in Avignon began. The return was followed by the Great Schism (1378-1417).

The city at this time was an intriguing mixture of classical and Christian. Many of the former monuments and buildings were in ruins, but many had been converted to Christian use, the first being the Pantheon in 609. The city soon became a haunt for pilgrims from all over Europe, with the primacy within the Church of the Roman bishop being established by Gregory I (590-604) and especially with Boniface's institution of the Jubilee in 1300. It thus became customary

for religious and secular leaders to come to Rome on appointment for ratification, or to try to resolve the endless theological disputes racking the local churches.

The most influential text on the mediæval city, especially a guide for visitors, was the *Mirabilia Urbis Romæ* ('Marvels of the City of Rome'), now thought to have been written by Benedict, a Roman deacon *c.* 1140. It is divided into three parts: statistics under headings, such as gates, arches, hills, baths, palaces, bridges, cemeteries and places of martyrdom; secondly, legends; and thirdly, the classical monuments. The first of the legends, for example, was the prophecy by the Tiburtine Sibyl to Augustus of the coming of Christ; another that the Colosseum was the temple of Apollo, from whose gigantic statue came the head and hand then in the Lateran (in fact this tradition was a combination of the colossal statue of Nero by the amphitheatre from which it derives its popular name, with the fragments of the gigantic Constantinian statue, now in the Capitoline). The third section, the perambulation of the ruins, continues the legends. The Vatican obelisk (see ill. p. 84) was called Cæsar's Needle, and his ashes were reputedly in the golden ball on its summit. The golden pine-cone then in the atrium of St Peter's (see ill. p. 27) was thought to have stood originally on top of the Pantheon. The author did know, however, that near the Hill of the Silversmiths (the *clivus argentarius*) were the temples of Concord and Saturn in the Forum. On the other hand, a dragon was said to crouch beneath the temple of Vesta (his authority was the life of St Silvester!), and the temple of Venus and Rome was dubbed that of Concord and Piety; Titus' arch was known as that of the Seven Lamps, from its decoration. The *Mirabilia* went through many editions and had enormous influence, as we shall see.

Although there were such guidebooks, it is unlikely that the mass of pilgrims used them. They would have fallen into the hands of the local guides, who would have misled them, as they continue to do, for their own profit.

Few of the visitors to be discussed divulged, strange to say, where they lodged. The mass of pilgrims undoubtedly found refuge with the famous hostels (*ospedali*) maintained by each of the main European

nations. And it goes without saying that Rome was already beginning to rely for a generous part of its income on such visitors. The journey across Europe, in truth, was far from easy. As Hildebert of Lavardin put it *c.* 1100:

> If I was in Rome with you, I suffered the injuries of the snows, I survived the mountains, either slippery with ice or harsh with rocks.
>
> I survived unharmed the traps laid for me returning from Rome, I escaped uninjured the threatening huge storms at sea, and I did not fall in with Barbary pirates.[1]

Or as a traveller from York summed up:

> So many dangers block the way, so many ambushes, so many thieves, so many persecutors of the Holy Church, that because of them no one can arrive at Rome unless he doffs his religious habit, and lyingly states that he is a lay person, denying that he is a priest or a monk.[2]

One of the earliest mediæval visitors was SIGERIC, archbishop of Canterbury (990-994), who arrived in 990.[3] He visited twenty-three churches out of a possible approximately hundred and twenty. He had come down through France and then across the Great St Bernard pass, and almost certainly stayed at the 'Schola Saxonum', the English hospice by St Peter's. In Rome, Sigeric lists only the churches which he visited over two days, but his is 'the only extant list of Roman churches between the eighth and the twelfth centuries'. He naturally first went to St Peter's, then S Maria in the Schola Anglorum, San Lorenzo in Lucina, S Valentino (by the first milestone on the via Flaminia), S Agnese fuori le mura ('outside the walls'), San Lorenzo fuori le mura, San Sebastiano, SS Vincenzo ed Anastasio (Tre Fontane), S Paolo fuori le mura, SS Alessio e Bonifazio and S Sabina (on the Aventine), Santa Maria in Cosmedin, Santa Cecilia (Trastevere), S Crisogono, Santa Maria in Trastevere and S Pancrazio (via Aurelia). After this extremely energetic day, Sigeric and companions returned to their lodging. The next day they visited the Pantheon, Santi

9

Giovanni Ambrogio Brambilla, Pilgrim's map of Rome, 1560s, showing the main basilicas and churches to be visited. St Peter's is most prominent centre bottom, so the 'map' looks from the west. In the Middle Ages, the seven main visits to be made were, in order, St Paul's, St Sebastian's, St Lawrence, St John in Lateran, Holy Cross in Jerusalem, St Mary the Greater, and finally St Peter's

Apostoli, and the Lateran, where Sigeric had lunch with the pope, John XV (985-996), and presumably received the *pallium* of his office. He completed his tour with S Croce in Gerusalemme, S Maria Maggiore, S Pietro in Vincoli and S Lorenzo in Panisperna.

After a gap of a century, an interesting group of visitors is found in the twelfth century. One of the most famous relics of such a visit was the poem on the ruins of Rome by HILDEBERT OF LAVARDUN (*c.* 1056-1133), bishop of Tours. This is preserved for us in William of Malmesbury's *History of the English kings* (4.351):

> Nothing equals you, Rome, although you are totally ruined;
> How great you were when whole you show, now overthrown.

The passage of time has destroyed your pride, and the palace
Of Cæsar and the temples of the gods lie in a swamp.
That work, that work is ruined which dreadful Araxes
Both feared while it stood and mourned when it had fallen;
Which the swords of kings, which the wise laws of the
 senate,
Which the gods had established as lord of the world;
Which Cæsar wished to have for himself alone by a crime
Rather than as a sharing and loyal father-in-law;
Which grew by three Means: by force she conquered, by laws
She tamed, by gold she bought enemies, crimes and friends;
Which, while it lasted, the care of earlier generations
 watched over,
Aided by the wealth and loyalty of strangers and its location
 by the sea.
Both ends of the earth sent material and craftsmen;
The location provided its own walls,
Kings spent their treasure, fortune lavished its favour,
Artists their skill, the whole earth its wealth.
The city has fallen, of which if I strived to say something
 worthy,
I could say this: 'Rome once was.'
Neither the sequence of years, however, nor fire or sword
Has been able entirely to destroy this glory.
Human effort was able to create a Rome so great
That the efforts of the gods could not destroy it.
Bring riches, marble, the renewed favour of the gods,
Let the hands of craftsmen labour sleeplessly on new deeds,
Your structures cannot equal the walls still standing,
Or even restore the ruins.
The gods themselves wonder at the statues of the gods,
Seeking only to equal their images.
Not even Nature could create gods with this appearance,
As man created marvellous statues of the gods.
These gods have such an aspect that they are rather
The product of artists' skill than their divinity.

Happy would Rome be if either she were free of tyrants,
Or such tyrants thought it shameful to break their oath!

Hildebert was in Rome *c.* 1100, and this is a remarkable tribute to
the city's pagan past. The pope at the time may have been Pascal II,
who conducted long and bitter struggles over investiture with emper-
ors and kings. Hildebert's enthusiasm and nostalgia are the Renaissance
avant le mot.

Another ecclesiastical visitor was ABBOT SUGER of Saint-Denis (1081-
1151), who arrived in 1123 under Calixtus II (1119-1124), in order to
attend the First Lateran Council.

> During the year following our ordination, we lost no time in
> visiting Rome to prevent being charged with ingratitude, for
> the holy Roman church had welcomed us cordially at Rome
> and elsewhere in many different councils before our promo-
> tion when we were acting on behalf of our own church and
> others. It had also joyfully given ear to our pleadings and dealt
> with our affairs more favourably than we deserved. We were
> again welcomed with great honor by the lord pope Calixtus
> and the whole curia; and for six months we stayed there with
> him, attending a great council of 300 or more bishops at the
> Lateran; it had been called to bring the quarrel of investitures
> to a peaceful conclusion.

By a strange slip of memory he states that he was to return to Rome
'some years later' when the pope was to raise him to a higher position,
but that the death of the pope made Suger turn back at Lucca, 'to
avoid a fresh encounter with that old avarice of the Romans'.[4] Calix-
tus had, however, died the very next year, 1124.

The English ecclesiastic JOHN OF SALISBURY (*c.* 1115-1180) served, in
fact, in the papal curia 1149-1153 under Eugenius III (1145-1153). He
provides a very lively picture of that pontiff in relation to a divorce
case, that of Hugh of Apulia in *c.* 1150. Eugenius dismissed the
witnesses as unreliable, and then did something remarkable:

> [B]ursting into tears, he hastened down from his seat in the

sight of all, great as he was, and prostrated himself before the count so utterly that his mitre, slipping from his head and rolling in the dust, was found after the bishops and cardinals had raised him under the feet of the dumbfounded count. And he begged and entreated him, as far as a father's affection, an orator's eloquence and the venerable dignity of the Roman pontiff in the church could prevail, to put aside all ill-will and take back his wife affectionately, not merely in enforced obedience to the law, but with all the trust and love of a husband. 'And my dearest son,' he added, 'to persuade you to do as I ask more fully and freely, behold I, the successor of Peter and vicar of Christ, to whom (unworthy though I am) the keys of the kingdom of heaven are given, will grant if you consent that this my daughter, your wife, may bring and confer on you a priceless dowry, namely the forgiveness of your sins, for all the sins you have yet committed shall be laid on me in the judgment day, if henceforth you remain loyal to her.' All present wept with him, and the count himself, bathed in tears, promised to obey with reverence and joy.[5]

John also provides a precious portrait of Hadrian IV, Nicholas Breakspeare, the only English pope (1154-9). Although the meeting was at Benevento, it is obviously relevant to contemporary Rome. Hadrian asked what men thought about him and the Church. John did not hold back:

Scribes and Pharisees sit within Rome, placing upon the shoulders of men insupportable burdens with which they themselves do not dirty their own fingers. They are lords over the clergy...

They weaken the Church, inflame quarrels, bring into conflict the clergy and the people, have no compassion whatsoever for those afflicted by labours and miseries, delight in the plunder of churches and calculate all profits as piety. They deliver justice not for the sake of truth but for a price...

But even the Roman pontiff himself is burdensome and almost intolerable to everyone, since all assert that, despite the ruins and rubble of churches (which were constructed by the

devotion of the Fathers) and also the neglect of altars, he erects palaces and parades himself about not only in purple vestments but in gilded clothes.

John revealed that he was not alone in voicing these criticisms. Guido Dens, cardinal deacon of S Pudenziana, asserted that within the Church there existed 'a root of duplicity and a nourishment of avarice which is the beginning and root of all evils'. John admitted that there were honest clerics but he obviously found it hard to name them, offering Bernard of Redon, cardinal deacon of SS Cosmas and Damian, and the bishop of Præneste. He then proceeded with an attack on Hadrian himself:

> Why is it, father, that you discuss the lives of others and investigate into yourself so little? All applaud you, you are called Father and Lord of everyone, and upon your head is poured all the oil of the sinner. If you are father, therefore, why do you accept presents and payments from your children? If you are lord, why do you not arouse fear in your Romans and why do you not recall them to the faith, suppressing their recklessness? Yet perhaps you wish to maintain the city for the Church by means of your presents. Did Pope Sylvester acquire it by means of such presents? You are off the path, father, and not on the path. The city is to be maintained out of the same presents by which it was acquired. What is freely given is freely accepted. Justice is the queen of the virtues and is embarrassed to be exchanged for any amount of price. If justice is to be gracious, she is to be free from charge. She who cannot be seduced may by no means be prostituted for a price; she is entirely and forever pure. In so far as you oppress others, you will be oppressed by even greater burdens.

And what was Hadrian's response? He 'laughed and congratulated such great candour', and then told the story of the stomach and the other parts of the body, which plotted against the former because they did all the work and the stomach gained all the benefit. When they attempted to starve the stomach, however, the only result was that

they enfeebled themselves. The stomach in the body and the prince in the state (or the pope in the Church) are the same office, declared Hadrian.[6]

Of Rome itself John records only one monument (the Arch of Constantine: see ill. Vol. II): 'It is only because of the inscription on a triumphal arch that the onlooker recognises that Constantine (who was of British stock) is proclaimed liberator of the country and founder of peace.'[7]

Of another English visitor to Rome in this time, however, John's records tell something of great interest. Henry of Winchester (and brother of King Stephen) had been suspended by Theobald, archbishop of Canterbury (1138-1161); he therefore travelled to Rome to regain favour. That he managed, but all attempts to become archbishop of western England were repulsed by Eugenius. 'When the bishop realised that he could hope for nothing more than absolution, he obtained permission before leaving to buy old statues at Rome, and had them taken back to Winchester.'[8] This is one of the earliest records of the export of Roman antiquities, but nothing seems known of their present whereabouts.

One of the most distant visitors to Rome at this time came from Iceland. ABBOT NIKOLAS of Munkathvera (d. 1159), the first abbot of that Benedictine monastery, arrived in 1154, the year before he became abbot. His description begins with the five bishops' thrones: in S Giovanni in Laterano, S Maria Maggiore, S Lorenzo fuori le mura (which he calls SS Stefano e Lorenzo) and here he loses interest in the thrones. Special mention is given also to S Agnese fuori le mura ('the most splendid in the whole city'), 'All Saints' (i.e. the Pantheon, 'a large and splendid church, and it is open above'), and, of course, St Peter's: 'noble... very large and splendid; there is to be had full absolution from the perplexities of men the wide world over'. Embedded within his list of churches are mentions of secular monuments: 'the hall that King Diocletian owned' (presumably his baths), 'Crescentius' citadel... very handsome' (Castel Sant'Angelo), and (to the east of St Peter's, but to be moved to the piazza by Domenico Fontana in 1586) St Peter's obelisk (see ill. p. 84).[9]

A visitor of a totally different stamp appeared in June 1155, none

other than FREDERICK BARBAROSSA (1123-1190, Holy Roman Emperor from 1152), who came to receive his crown from the hands of Hadrian IV.

> Presently the prince, coming to the steps of the church of the blessed Peter, was received with all honour by the supreme pontiff and led to the tomb ('*ad confessionem*') of the blessed Peter. Then after the solemnities of the Mass had been celebrated by the pope himself, the king attended by his knights under arms, received the crown of the empire with the appropriate blessing. This was in the fourth year of his reign in the month of June, on the fourteenth day before the Kalends of July [18 June, 1155]. All who were present acclaimed him with great joy, and glorified God for so glorious a deed.

While this was transpiring, however, the people had gathered at the symbol of their authority, the Capitol. They were furious that the emperor had been crowned without their assent. The Romans then advanced on St Peter's and killed some German sergeants. Battle was thus joined near Castel Sant'Angelo, from which rocks and javelins were hurled. The frenzy of the Romans, urged on by their womenfolk, was such that it was a long time before they were compelled to retreat by the German professionals. The chronicler asserts that one thousand were killed or drowned in the Tiber, and six hundred taken captive. The next day Frederick withdrew towards Tivoli. It was summer and the noxious air of Rome was notorious.

What lay behind these amazing events was the teaching of Arnold of Brescia (1100-1155), a student of Abelard. He was expelled from Rome in 1155, and executed the same year. He preached against the temporal power, in favour of sacerdotal poverty and republicanism. 'Nothing in the administration of the City was the concern of the Roman pontiff.' Inspired by such doctrines, the Roman people had sent an embassy to Fredereck near Sutri. The envoys announced that they were sent by the senate and people of Rome, offered him the crown, and proposed cooperation to restore Rome's power over the world. They asked a large sum of money for their expenses. Frederick's

reply was to deliver a long history lesson, on how the Romans had handed over their power to the Franks, and how it had now passed by valour to the German Emperors.[10] Hence the confrontation in Rome. The visit to Rome of RABBI BENJAMIN OF TUDELA in Spain (d. 1173) occurred in *c.* 1160. He is known as an intrepid traveller: Turkey, Egypt, Persia and China. With him there is a return to the mentality of the *Mirabilia*. Let him speak for himself, because it is hard to imagine that anyone who in fact had seen Rome at this time could present this account.

> Rome is divided into two parts by the River Tiber. In the one part is the great church which they call St Peter's of Rome. The great Palace of Julius Cæsar was also in Rome [presumably referring to the Palatine]. There are many wonderful structures in the city, different from any others in the world. Including both its inhabited and ruined parts, Rome is about twenty-four miles in circumference. In the midst thereof there are eighty palaces belonging to eighty kings who lived there, each called Imperator, commencing from King Tarquinius down to Nero and Tiberius, who lived at the time of Jesus the Nazarene, ending with Pepin, who freed the land of Sepharad from Islam, and was father of Charlemagne.
>
> There is a palace outside Rome (said to be of Titus). The Consul and his 300 Senators treated him with disfavour, because he failed to take Jerusalem till after three years, though they had bidden him to capture it within two.
>
> In Rome is also the palace of Vespasianus, a great and very strong building; also the Colosseum, in which edifice there are 365 sections, according to the days of the solar year; and the circumference of these palaces is three miles. There were battles fought here in olden times, and in the palace more than 100,000 men were slain, and there their bones remain piled up to the present day [catacombs?]. The king caused to be engraved a representation of the battle and of the forces on either side facing one another, but warriors and horses, all in marble [a sarcophagus ?], to exhibit to the world of war the days of old.

In Rome there is a cave which runs underground, and cata-
combs of King Tarmal Galsin and his royal consort who are
to be found there, seated upon their thrones, and with them
about a hundred royal personages. They are all embalmed and
preserved to this day. In the church of St John in the Lateran
there are two bronze columns taken from the Temple, the
handiwork of King Solomon, each column being engraved
'Solomon the son of David'. The Jews of Rome told me that
every year upon the 9th of Ab they found the columns exuding
moisture like water. There also is the cave where Titus the son
of Vespasianus stored the Temple vessels which he brought
from Jerusalem. There is also a cave in a hill on one bank of
the River Tiber where are the graves of the ten martyrs. In
front of St John in the Lateran there are statues of Samson in
marble, with a spear in his hand, and of Absalom the son of
King David, and another of Constantinus the Great, who built
Constantinople and after whom it was called. The last-named
statue is of bronze, the horse being overlaid with gold [the
statue of Marcus Aurelius]. Many other edifices are there, and
remarkable sights beyond enumeration.[11]

Benjamin should be forgiven for this fantasy: Capgrave is telling the
same stories three centuries later.

We enter the thirteenth century with the tragic GERALD OF WALES
(Giraldus Cambrensis, c. 1145-1223), the tumultuous priest, who went
to Rome no fewer than three times (November 1199-Lent 1200,
March-June 1201, and January-June 1203); all these visits were to do
with ecclesiastical disputes: his own election as bishop of St David's
in Wales and the status of the Welsh church, for which he advocated
a third archbishop, alongside those of Canterbury and York. In all
this his most bitter enemy was Hubert, archbishop of Canterbury
(1193-1205). Various perjuring envoys were sent to Rome by Hubert
to oppose Gerald, and his election as bishop was never confirmed,
thanks to unconscionable bribery ('a bow that never misses its mark
in the court of Rome'),[12] although Innocent III (1198-1216) had orig-
inally greeted him as archbishop.

His lodging he mentions only on the occasion of his third visit: he stayed in the Lateran. Of Rome at the time in the many pages describing his three visits, Gerald records only that in 1200 'many pilgrims from Wales were at this time flocking to Rome in diverse companies'. He also recorded the papal custom of leaving the city to avoid the midsummer heat, retreating to places such as Segni or Ferentino. There is one episode, however, which is linked to a place and to Innocent, and which may serve as an example of the arguments which so occupied Gerald and the papal court. Gerald was 'harassed almost every day by pleading in the morning before the pope in the consistory and in the evening before the chamberlain'. Gerald refers to himself as the archdeacon, and to Hubert's agents as ribalds and gadabouts:

> when one evening the parties were brought before the Chamberlain and the host of ribalds were coming forward to give evidence for the gadabout, a certain person, instructed therein by the archdeacon, addressed the chamberlain as follows: 'It is strange that a man, than whom there lives none more worthless in all the world nor one more given to gadding about, a man who has deserted virtue no less than his order, should be allowed in this court to lift up his voice to trouble a good and honourable man. For that horse, which was taken from him in Wales and which he falsely asserts to be this horse, was a gelding, whereas this horse is entire.' And at once the gadabout leapt forth into the midst and, being both hasty and shameless and itching to affirm or deny anything whatsoever, if thus he might be the gainer, turned to the speaker and said 'You lie without a doubt and I will prove it. For my horse had everything that a good horse ought to have, and has them still, as my lord the chamberlain may perceive and, if it so please him, may cause to be seen and proved without delay.' This said, the archdeacon and his friends at once demanded that this evidence should be taken down word for word; and so it was done, as is the custom in those parts... And the chamberlain at once sent certain of his servants together with ours to inspect the horse in the stable, and the gadabout went also that he might show them

the more surely how things stood. But in a short time they returned, and one of the chamberlain's servants said: 'My Lord, we have done what you commanded of us, and could find no such thing there; and the monk himself who came with us, although he inspected the horse more carefully than we did, making a careful examination both with eyes and hands, could not find anything there except a useless rod and an empty bag.' This jest was hailed with universal laughter, and the chamberlain postponed the case to the following afternoon. And when that same night he repeated the matter to the Lord Pope, the Holy Father was dissolved in laughter and ordered that the horse should be restored to the archdeacon and the gadabout bidden to hold his peace. And on the morrow this was done to the great confusion of the opposing party and the huge joy and exultation of the whole court when they heard of it.

Gerald also describes the habits of Innocent:

Now it happened that at this time the pope went to the Maidens' Fountain (*Fons Virginum*), whither he delighted oft to go to walk, when occasion offered. Now this was a most beautiful fountain not far from the south side of the Lateran, pouring forth cold clear water and enclosed by man's art in Parian marble, whence it sent forth a pleasant and ample stream to water the fields.[13]

One of the best known travellers to Rome in the Middle Ages also came from Britain. Almost nothing is known about GREGORY except that he was English, had the title *magister*, and lived after Hildebert (*c.* 1100), whom he quoted. He is usually dated *c.* 1200, but also as late as the 1230s. He may have been an envoy to Rome, and may have been the Gregory known as chancellor to Otto of Tonengo, papal envoy to England. Gregory's *Marvels of Rome* ('Narraccio de Mirabilibus Urbis Romæ') indeed recalls the *Mirabilia* and is arranged in categories. There are four main classes of antiquities: statues, palaces (and some temples), arches and columns. The famous equestrian statue at the Lateran (Marcus Aurelius, which was moved to the

Capitol in 1538 by Michelangelo) was then the subject of an amazing range of foolish identifications: Theodoric (said pilgrims), Constantine (said the Romans), Marcus Quirinus (said the men of greatest learning), defender of Rome against the dwarf king of the Miseni (because of the small figure under the horse's hoofs) or Q. Quirinus, who leaped into a chasm to save Rome from a plague (according to the cardinals). The fragments of the colossal statue of a fourth century emperor now on the Capitol (see ill. overleaf) were thought to come from a statue near the Colosseum which always rotated to face the sun (i.e. Nero in the guise of Apollo) and which had been destroyed by Gregory the Great. The famous boy removing a thorn from his foot, the Spinario (Capitoline: see ill. p. 209), was then identified as Priapus. This was because, according to Gregory, 'if you lean forward and look up to see what he is doing, you discover genitals of extraordinary size'! There was a tradition that Rome had once had a hall of statues representing the provinces of the empire, each of which had a silver bell around its neck which rang if that province was plotting rebellion; the hall had reputedly fallen in ruin on the birth of Christ. Gregory does not

The statue of Marcus Aurelius in its old position (pre-1538) between the Lateran basilica and palace (together with the fragments of a colossal statue, later removed to the Capitoline Museum (fourteenth century MS)

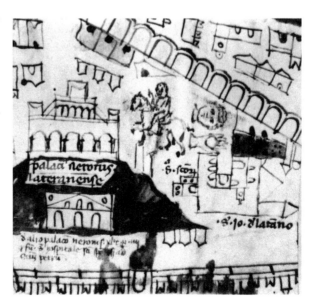

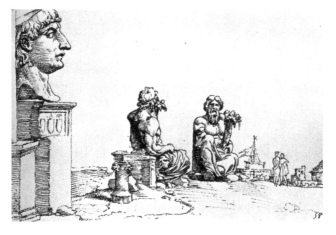

Martin van Heemskerck, The colossal bronze head and the rivers Tiber and Nile on the Capitol, *1530s*

locate this hall, but the *Mirabilia* placed it on the Capitol. This seems to be a misunderstanding of the *Porticus ad Nationes*, but the building which was notorious for falling was the Basilica of Maxentius. The Quirinal Horsetamers were thought to be mathematicians (see ill. Vol. II), and the statues of the Nile and Tigris on the Quirinal (moved to the Capitol in 1517, when the Tigris became the Tiber) were then called Solon and Liber. The most interesting statue, however, was a Venus in the Stazi gardens (now the Capitoline Venus), which Gregory went to see no fewer than three times!

Of palaces Gregory mentions that of the Cornuti, which seems to have been the temple of Serapis on the Quirinal; that of Diocletian, obviously the baths of that emperor; that of Augustus: the Basilica of Maxentius; and that of the 'sixty emperors', probably the Palatine. Only two temples are named: that of Pallas, unidentified, and the Pantheon.

Three arches are described: that of Augustus near the Pantheon, apparently the Arcus Pietatis, demolished at the end of the Middle Ages; an arch of Pompey, unidentified; and the arch of Scipio – in reality that of Constantine. There is also much confusion about pyramids and obelisks. The 'pyramid of Romulus' was in the Borgo, and was demolished by Alexander VI in the 1490s. What Gregory calls the pyramid of Augustus near the porta Latina is presumably that of

Cestius (see ill. p. 80). The 'pyramid of Cæsar' is, of course, the Vatican obelisk. It is remarkable, finally, that Gregory pays no attention to the Colosseum.

The fifteenth century provides a rich harvest of travellers to Rome. That extraordinary woman, the earliest English autobiographer, MARGERY KEMPE (1373-1440), from a well-off Norfolk family, came to Rome in 1414-5, in the reign of Gregory VII. This was a pilgrimage after she had been married for twenty years and had borne fourteen children. She came to Rome on her way back from the Holy Land, arriving in Italy in Venice, and reaching Rome after August 1414. She stayed first at the English hospice, the Hospital of St Thomas of Canterbury in via Monserrato. From here she was ejected on account of her 'great weeping, violent sobbing and loud crying', but was later invited by the master and brothers to return. Her time was spent in religious devotions. She mentions only churches, such as S Giovanni in Laterano, where she heard Mass said by a German priest who held 'one of the greatest offices of any priest in Rome'. It was with him that she conversed in English, and he in German – or Latin – without an interpreter. She was at Santi Apostoli in November 1414, and at S Marcello she prayed for assistance after giving away all her money. She also visited S Brigida in piazza Farnese and the chapel of St Jerome in S Maria Maggiore.

There is one note on Rome at this time: the weather. At the end of 1414

> there were such great storms of thunder and lightning, heavy rain and stormy weather, that very old men living in Rome at that time said they had never seen anything like it before; the flashes of lightning were so frequent and shone so brightly inside their houses that they truly believed that their houses would be burnt with the contents.

Margery left Rome after Easter 1415, but there is no note on her route home, save that she went via Middelburg.[14]

PERO TAFUR (*c.* 1410-*c.* 1484) was a Spanish nobleman from Córdoba, who spent Lent 1436 at Rome. He combined an interest in both the

churches and the antiquities, but also provides notes on topography. The walls he calculated at twenty-four miles in circumference, 'so built, and of such height, that they appear to be fresh from the hand of the master builder'. The Tiber he claimed had a bed of lead; he also commented on the many mills on the river. The city was sparsely populated, but was healthy where that population was concentrated: Campo de' Fiori, the Capitol, and the site of the future Ghetto. Tafur described some churches. St Peter's 'is a notable church, the entrance is very magnificent, and one ascends to it by very high steps. The roof is richly worked in mosaic. Inside the church is large, but very poor and in bad condition and dirty, and in many places in ruins.' Its reconstruction would begin in fifty years' time. Within the church he drew attention to 'two large columns encased in wood, where they put those who are possessed by spirits'. The pope was said incredibly to have his dwelling adjoining the church 'on the slopes of the Aventine Hill'(!), but it was 'a mediocre place and when I was there it was ill-kept'. At S Giovanni in Laterano Tafur spent most time describing the 'Tarpeian Gate', which he seems to imagine to have been the door originally to the Roman treasury, but was now the door at the basilica opened only in Jubilee years. 'The church is large, but not rich nor well built, nor clean, nor richly adorned.' Nearby was the Sancta Sanctorum, a chapel containing a painting of Christ by St Luke.

> It is the most revered object, and the greatest relic in Rome. Four men armed with iron maces guard it continually hour by hour, and on one day in the year, the feast of the Virgin, in the middle of August, they take out the relic, and protected by men-at-arms, and amidst much rejoicing, they carry it in procession and take it to the church of S Maria Maggiore, where it rests that day and night, and the following day they return it to its place.

S Croce in Gerusalemme he imagined to be entirely built from earth brought from that city as ballast in ships. Beneath S Maria in Aracœli was a large vaulted chamber where the Romans held councils, and where he claimed that Cæsar was murdered.

Of antiquities Tafur devoted most space to 'Cæsar's Needle', the Vatican obelisk (see ill. p. 84): 'a high tower made of one piece of stone, like a three cornered diamond raised on three brazen feet; and many taking it for a holy thing, creep between the ground and the base of that tower'. At the Lateran still was the statue of Marcus Aurelius (see ill. p. 21). To all of Gregory's amazing list of identifications, Tafur could now add another: Mucius Scævola, who burnt his right hand when he failed to kill king Porsenna! He also provides a variant on the hall of imperial statues, generally placed on the Capitol, but sometimes in the Pantheon. Now it is in the Colosseum; the colossal statue, the head of which supposedly reached the roof, was surrounded 'by figures of all the kings and princes in the world, each having a chain around the neck fastened to the feet of that great statue, and when it was known that any king or prince was rising against Rome, they threw down his image and issued decrees commanding war to be made upon him'. The fantastic element of each statue having a bell which rang has been abandoned. The 'palace of Augustus' was the Basilica of Maxentius, where 'it is said that even now every year, on the day of the birth of Our Lord, some portion falls'. This was the result of the prophecy of the Sibyl to Augustus. The Pantheon, finally, was where the Roman people held their council. We are not surprised, then, when Tafur complains:

> I found no one in Rome who could give me any account of those ancient things concerning which I enquired, but they could, without doubt, have informed me fully as to the taverns and places of ill-fame.

In short, Rome, 'which used to be the head of the world is now the tail'.[15]

One of the most famous fifteenth century visitors and one who has left us one of the most extensive accounts is JOHN CAPGRAVE (1393-1464), prior of King's Lynn in Norfolk, and provincial of the Augustinians. He came to Rome with Sir Thomas Tudenham, who was to be executed for treason in 1461. Capgrave mentions the death of Henry Beaufort (April 1447) and that John Kemp was archbishop

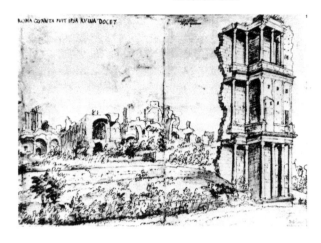

*Martin van
Heemskerck,
The Septizonium,
1530s*

of York (true until July 1452). He may well therefore have been in
Rome for the Jubilee Year of 1450. Capgrave adopted the *Mirabilia's*
cataloguing: gates, walls, towers, bridges, hills, palaces, arches and
catacombs, and retold many of its legends. Castel Sant'Angelo was
Hadrian's palace; that of Cæsar was 'fast by the great stone on which
his bones lie'; and that of Titus and Vespasian was 'without Rome as
we go on to the catacombs'. The golden ball on top of the 'needle of
St Peter's' of course contained Cæsar's ashes. To the *Mirabilia's* story
of the temple on the Capitol containing the statues of the provinces,
Capgrave added that it was made by Virgil (an example of Virgil the
magician in the Middle Ages). He repeated the *Mirabilia's* fancy that
the Quirinal Horsetamers were the philosophers Pratellus and Sibia
(Praxiteles and Phidias!) and the explanation of the 'Lateran rider' as
the hero who saved Rome by capturing an enemy king 'as he went to
a tree to avoid the burden of his womb' (i.e voided the burden of his
belly!). The Colosseum was declared to have been dedicated to the
Sun and the Moon (the *Mirabilia* declared that it contained statues
of the Sun and Moon in their chariots). The Pantheon celebrated
Agrippa's victory over the Persians. The Romans thought that the
Septizonium, the monumental facade at the south-eastern end of the
Palatine, was the dwelling of the Seven Sages. Pshaw! cried Capgrave.
They never came to Rome. It was connected with the welcome to

Rome of Augustus after all his conquests, or St Gregory's establishment of the seven sciences (it was, in fact, built by Septimius Severus in 203 and demolished by Sixtus V in the 1580s). The Circus Maximus passed for the Arch of Tarquinius Priscus (a garbled version of the tradition that Priscus built the Circus Maximus). And Testaccio, the pottery dump of ancient Rome, was called Omnis Terra, because it was thought that it was formed by all Rome's subjects having to bring pots full of earth as tribute! The twenty-five chapters of Capgrave's first book thus constitute a very comprehensive picture of the mediæval fantasies about the classical monuments as late as the fifteenth century, showing that there had been little, if any, advance in understanding since Benedict's *Mirabilia* three centuries earlier.

The second book is devoted to the churches. The account of the main basilicas will suffice. Capgrave gives us one of the last views of old St Peter's:

> The length is 22 pillars; betwixt every pillar is 12' of space, and every pillar containeth 4' of thickness, so there are of those spaces of 12' 23, beside other pillars which came out of Solomon's temple, of which 4 stand on the one side and 4 on the other and 4 athwart before the altar.

Twenty-nine steps fifty-seven feet broad (the same as the church) led up to it, and seven years' indulgence was granted for every step

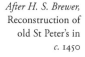

After H. S. Brewer,
Reconstruction of
old St Peter's in
c. 1450

climbed. The church contained eighty-eight altars and the bodies of eight Apostles.

S Paolo was owned by the Benedictines. Cognoscenti entered by the west (front) door, because there Paul's head had once been hidden, and one thus gained twenty-eight years' indulgence. Capgrave mentioned the proving chair in the cloister, 'where the pope is assayed in whether he be man or woman', and the statue of Joan, which was to be seen on the way to this basilica.

At S Croce Capgrave was fascinated with the legend of Silvester II, who made a pact with the devil, and was told that he would die in Jerusalem, where he had no intention of going. He said Mass in this church, only to find that he was 'in Jerusalem', whereupon he ordered the people to dismember his body and throw it to the crows, but his heart was declared to be still hanging in the roof. Near the basilica were arches on which ran 'conduits of oil, water, and wine to the great palaces'. Not even the aqueducts were safe from fantasy.

About S Maria Maggiore Capgrave had to retell the story of the snow miracle: Pope Liberius (352-366) was commanded to build a church where snow fell on 5 August, in the middle of summer. The basilica's relics included the bodies of St Matthew, St Jerome, Popes Honorius, Eugenius, Gregory, Pelagius and Nicholas, the arms of St Luke and St Matthew, the head of St Vivian, an arm of St Thomas of Canterbury, the cradle of Jesus, the manger with hay, Joseph's stockings, Mary's milk, and 'much other thing'.[16]

One of the most interesting accounts of the fifteenth century is that of the Nuremburger NIKOLAUS MUFFEL (1410-1469), a noble who played a leading role in his city's politics and diplomatic service, and who accompanied Friedrich III, the first Hapsburg emperor, and the last to be crowned in Rome, to the city in March 1452, during the papacy of Nicholas V. On his return to Nuremburg, as a high financial official, however, he was found guilty of embezzlement and hanged. His work, on indulgences and sacred sites at Rome, marks a 'transition between the mediæval tradition and the first inklings of the renewal under Nicholas V' (1447-55). His Rome was not that of the humanists, but 'the centre of Christianity and the mecca of pilgrims'.[17] Muffel makes clear that he imagines others visiting the

sights of the city as he did: 'when one rides through the city…'. He first set out the seven major basilicas, then other churches, concentrating on relics and indulgences. He began as usual with the cathedral, S Giovanni. Its cross was made from the sword used to decapitate St Paul. Its relics included the altar of St John of Patmos, the Decalogue, the table of the Last Supper and the cloth with which Jesus wiped the Apostles' feet, part of the burning bush, the ashes of St John the Baptist, the heads of Zaccharia and Pancratius, the skeleton of Mary Magdalene, part of the shoulder of St Lawrence, Jesus' purple clothing, the knife used at his circumcision, his last loincloth, five loaves from the multiplication, St John's clothing, the cup from which he drank the poison, a large piece of the Cross, part of St John's chains, the hat of Joseph of Arimathea (many of these relics were said to have been brought back from Jerusalem by Titus and Vespasian!), the table on which Judas was paid, another on which the soldiers divided Jesus' clothing, three doors from Pilate's house, and four columns from the temple of Solomon which split at the time of Jesus' birth. That will suffice as a sample.

Muffel also mentioned three catacombs: at S Lorenzo, S Callisto and S Pancrazio. It was believed that they extended to the Tiber, and that the Christians had lived in them.

Although it was not his main intention, Muffel recorded a wealth of observation on the classical monuments, again a farrago of fantasy. At S Giovanni was one of the Twelve Tables, the oldest Roman law code (450 BC): this was in fact the law conferring power on the emperor Vespasian (AD 70), so less was understood about it now than by Cola di Rienzo a century earlier. Near the basilica the equestrian statue of Marcus Aurelius had become that of Septimosfero (Septimius Severus!). By porta San Paolo was the obelisk of the tomb of Romulus and Remus, or of Cæsar: this was the Pyramid of Cestius – which in fact bears an inscription making its owner perfectly clear. Then to the Forum and adjacent areas: the 'Tripolis arch', so named from the depicted capture of three cities, is the Arch of Severus. An obelisk on the Capitol (transferred to the villa Mattei in 1582) was said to contain the ashes of Octavian. That hill Muffel described as 'now desolate and abandoned, where is thrown all the rubbish of men and dead animals'.

In the ruins of its walls was the city's salt store (in the Tabularium: see p. 73).

On the other side of the Capitol at the beginning of the via Lata (now the Corso) was the tomb of C. Publius (C. Poplicius Bibulus). Back in the Forum was the 'fine portico' of the temple of Concord (i.e. Saturn). The temple of Mercury – 'still a noble building' – was now S Michele in the fish market (S Angelo in Pescheria). By S Maria Maggiore were the trophies 'in honour of the geese which saved Rome' (to be seen on the Capitol balustrade since 1589 and now known as the 'trophies of Marius': see ill. p. 195). The temple of Castor and Pollux in Muffel stood for Venus and Rome, the temple of Eternity for the Basilica of Maxentius, and S Adriano was the temple of Saturn. Most extraordinary, however, is the 'round Castle of Mirrors', but its identity is clear: it was the scene of the games, built in three super-imposed orders by Vespasian: the Colosseum, 'now much ruined and used as a quarry for lime'. The Arch of Constantine commemorated the conquest of the Adige, Corinthia, Austria and Carnia. Titus and Vespasian were buried on the Aventine (in two marble sarcophagi at S Saba). On the Quirinal were still the two enormous stone statues (the Nile and Tigris, moved to the Capitol in 1517). A wine cellar with nine vaults and doors could stable twelve hundred horses: this is the Sette Sale. Magnificent columns, hollow within, commemorated victories over the Trojans: if any sense can be made, this seems to be the Column of Trajan. The most extended description was devoted to the Pantheon, dedicated to Pantheon, 'god of the sea' (sic); the bronze pine cone, then at St Peter's, Muffel claimed, still following the *Mirabilia*, had once closed the oculus.

Muffel accompanied an emperor. The son of a king, DON FEDERIGO OF ARAGON, came to Rome forty years later, while the notorious Alexander VI Borgia was on the throne (1492-1503). That visit was recorded by the papal master of ceremonies, Johann Burchard. Federigo was the second son of Ferrante (Ferdinando) of Naples, a Spaniard, who wished to pay his compliments to the new pope, and thus insure himself against French plots against his throne. The visit took place in December 1492 and January 1493, and Burchard records the endless bickering over protocol: who should go to meet the prince, and how

soon he should be admitted to a papal audience, and where he should stand in relation to the cardinals. The account of the prince's entrance into Rome is of the greatest interest, being written by the official in charge of all formalities:

> At daybreak on Monday therefore I rode out towards Marino to meet Prince Federigo of Altamura as he approached Rome, in order to inform him of the arrangements for his entry into the city. At Marino I found Don Federigo and furnished him with full instructions on the details for his procession and reception, including all the functions which he himself would have to carry out. Next day in the middle of the morning, Cardinals [Oliviero] Caraffa and [Francesco, later Pius III] Piccolomini as the prince's close friends rode two miles and more out of Rome to greet him as he neared the city. Receiving him with all due honour, they then escorted him as far as the road leading through the porta Latina where they turned aside and parted company from the prince. With his retinue, he continued his journey to the porta Asinaria and only halted on reaching the main outer gate of the Lateran Church, partly because he wanted to escape from the mud, but partly also because the two cardinals who were then coming to meet him officially did not arrive as arranged outside the porta Asinaria. Meanwhile, the members of all the cardinals' households and those royal envoys who were in Rome came to welcome the prince, and with them were Don Giulio Orsini, the brother of Cardinal [Giovanni Battista] Orsini, and a number of other nobles, who dismounted from their horses and sought to pay honour to Don Federigo. He refused such obeisance and in the end they were compelled merely to remount their horses. The prince, still on horseback, continued to wait for about an hour for the two cardinals – Ascanio and Giovanni Borgia – who had been charged to meet him. They eventually arrived after two o'clock in the afternoon, and having saluted him with all due honour, they escorted him on his journey.

When the company entered the courtyard of the church of St John Lateran, where stood a bronze equestrian statue,

the palace priests and members of the papal household came forward to receive the prince. Although he only ranked fifth amongst the ecclesiastics present, it was Don Bartolomeo, the bishop of Segovia and master of the papal palace, who gave the welcome address. The prince was accompanied by seven other envoys, all lords of noble birth, who had been sent with him to swear homage to the pope, and these I placed in the leading positions behind Don Federigo in the procession. Our route ran through the city by way of the Colosseum straight to the church of Santa Maria Nova, adjoining the Ospedale della Consolazione, then across the front of the palazzo Savelli, and through the Pescheria, the piazza degli Ebrei and the Campo di Fiori to the Vatican Palace at St Peter's. The cardinals had been delayed, I believe, because the pope was trying to compel Don Federigo to ride straight to the palazzo dei Apostoli instead of visiting the Vatican on that day, and this despite the fact that earlier His Holiness had agreed to consider what the prince desired and had so decided with the cardinals.

In accordance with Don Federigo's wishes, the papal shield-bearers followed the lords, nobles and household members of his company, whilst our lords accompanied Rodrigo Borgia, the palace captain, and six pages rode in front of the sergeants-at-arms of the prince and the pope. The first of these pages was dressed in French fashion on a French horse and carried a silver gilt bow and quiver: the second, in Turkish garb, brandished a javelin and rode a wild horse like a Turk: the third appeared as a Spaniard, carrying a long lance and mounted on a light Spanish horse: the fourth wore a hooded cope like a priest: the fifth carried a crimson-coloured satchel: whilst the sixth bore a sword in a scabbard that was studded with pearls and precious stones worth six thousand ducats. Their horses were all magnificent beasts, adorned with golden brocaded trappings, very costly caps and jewelled collars. The prince was dressed in a suit of purple velvet with a collar of pearls and precious stones of six thousand ducats' value, and he wore a sword of similar worth. His horse's bridle was covered in

pearls and precious stones to the value of three thousand ducats, whilst all its trappings were gilt. Two hundred pack horses, all caparisoned in red, led the way in front of the company which was said to number between seven and eight hundred, although I was unable to estimate its total. Where the street was not wide enough, Cardinal Giovanni Borgia rode ahead and was followed by the prince and then Cardinal Ascanio: this was in contrast to what Cardinals Caraffa and Piccolomini had earlier done in similar circumstances, when both had more graciously followed the prince along the narrower lanes.

On reaching the Vatican, we climbed to the last of the new apartments adjoining the secretary's office, where the pope with five of the cardinals awaited the prince. The latter approached and kissed the pope's foot, hand and cheek, and then knelt on a cushion beside His Holiness whilst the seven other envoys and all the lords and nobles of his household in turn kissed the papal foot. Cardinal Ascanio had ordered that the prince should have a seat behind all the cardinals, but I took precautions to prevent this happening since I did not think it fitting for him to be seated thus, and I preferred that he should remain kneeling.

When these proceedings had been concluded, the prince was escorted by Cardinals Caraffa and Piccolomini to Cardinal [Girolamo or his brother Domenico] della Rovere's palazzo dei Apostoli, where he was to stay. The palace ecclesiastics, the envoys and the other prelates followed in the same order as they had ridden from the Lateran church to the Vatican.

The prince took part in ceremonies in St Peter's on Christmas Eve and Christmas Day and left Rome on 10 January 1493. 'He crossed through the city past the palazzo Massimo, the Campo de' Fiori and the piazza degli Ebrei, went out through the porta San Paolo, and embarked at the river there on a galley which was waiting.'[18]

Still in the reign of Alexander VI, finally, arrived the German ARNOLD VON HARFF (c. 1471-1505), who was in Rome March-April 1497. He was the son of a nobleman at the courts of the dukes of Julich and Gelders near Cologne. He undertook an extensive

pilgrimage through Italy to the East and the Holy Land. It seems, however, that he filled out his account with places which he did not visit (such as central Africa and India) and in Rome certainly he relied in part on a German pilgrim's guide of 1489; that tradition is not, of course, without interest. Of his lodging Harff tells only that the landlord's name was Andreas Barberer, clearly a fellow German: travellers often stayed at inns kept by countrymen. He tells nothing of the churches save their relics and indulgences: 'Within Rome there are seven chief churches which we visited four or five times, as great indulgence is thus to be obtained.' Even he, however, became alarmed at how many of them claimed to have the same bodies (such as St Matthew: in Santa Maria Maggiore, or in Padua, with his head perhaps in Trier!) 'But I will leave it to God to decide these errors of priests.' He described the Vatican palace as 'very richly built and extensive, with beautiful courts, pillars and rare apartments surrounded by beautiful pleasure gardens'. Nearby was the Vatican obelisk. When he asked about it, he was told a story about 'a Roman emperor' (presumably Cæsar). The other item of religious interest was the little chapel near S Clemente 'where stands a Pope with child carved in stone. This is Pope Jutta [sic: i.e. Joan] who died there.'

What Harff does record in detail are the Easter ceremonies of 1497, presided over by Alexander Borgia. This adds great piquancy to the account, not to mention the brawl on Good Friday in the Campo de' Fiori:

> On *Holy Thursday* I was taken by Dr (Johann) Payl etc. to St Peter's Minster where we saw the showing of Veronica [the annual exhibition of the veil supposed to show Christ's face]. Afterwards the pope was carried through the church to the square with all his cardinals. We were taken there secretly. The pope then pronounced the ban against all public usurers, upon those who committed crimes against the church, and against those who carried steel and iron to the heathen, and many other matters which are against the Christian faith. This took about an hour. When all the articles had been read he excommunicated them with candles and bells, consigning

them to eternal ban. When all this was finished the pope gave the benediction to the four corners of the world [*urbi et orbi*]. There were crowds down in St Peter's Square, on the steps, and all the streets were full of those who came to see and receive the benediction. About twelve at noon the following took place. The pope was taken to his palace into a very beautiful and rich apartment. There were twelve poor old men newly clad in white with hoods, caps and hose, all in white and very fine, who sat in a row on high chairs. Singing began, and two cardinals dressed the pope in a white alb, girt round with a cord. The cardinals then led the pope to the poor people. He fell on his knee before the first. There was one cardinal on the left who had a fine golden basin with sweet-smelling herbs, into which one of the poor men had to put his right foot. Thereupon the other cardinal on the right, who held a golden hand-jug full of water, poured it over the poor man's foot, and as he poured the pope washed the poor man's foot. Behind the pope stood a bishop who handed him a fine clean cloth, with which he dried the poor man's foot. When that was done the pope made the sign of the cross with his thumb on the poor man's foot and kissed it. Then they gave the pope a piece of ancient gold, which he wrapped in the same cloth with which he had dried the foot, and gave it to the poor man. Then the poor man kissed the pope's hands. When this was all finished, the two cardinals raised the pope from the ground and led him to the second poor man, before whom he again fell on his knee and did to him as to the first, and so on until the pope reached the last man, all which is indeed an act of great humility.

When this was all finished they led the pope back again and sat him in his chair. Then with the help of Doctor Payl and his friends I was led before him. I begged from his Holiness that he would give me leave to cross the sea to the Holy Land. The cardinals bade me kneel before him, and forthwith he gave me benediction, reading over me an absolution forgiving all my sins, both penalty and guilt. Then he stretched out his right foot on the shoe of which was embroidered a rich cross which

I had to kiss. He then ordered his attendants that I was to have the letter I desired as well as other matters. In this way Dr Payl obtained for me many privileges from the pope, since my old squire Van Moirse and the lord of Croy had sent a letter to him in which I was mentioned. This was sufficient for the time being and I took leave of him.

After midday on Holy Thursday, about Vesper time, we went into the pope's palace to his chapel, which is very rich and costly. The pope sat high up on a chair with the cardinals below in the centre of the chapel in their order, each according to his station, and after them many bishops, all very orderly. They then sang the Tenebræ Mass with the pope's singers in goodly descant. I was placed well forward so that I could see everything well. When the Tenebræ Mass was ended we went to St Peter's Minster where we saw exhibited the Veronica and a piece of Jesus' spear. There was an immense crowd and the people cried with a loud voice *Misericordia, Misericordia*.

On *Good Friday* before midday we saw the Passion Play in the Colosseum, as I have related above, and after midday we went to St Peter's Minster where we saw the Veronica twice displayed. We also went to the pope's chapel in his palace where they sang the Tenebræ Mass in such manner and order as I have described before. When this was ended we returned to our inn, our host being named Master *Andreas Barberer*. On the way, before we reached St Angelo's Castle, there was a great uproar in the street between the Romans and the Spaniards. There must have been 3,000 in the city belonging to the pope's party, who treated the citizens with much contempt and oppression. The Romans gathered themselves in the Campefloir [Campo de' Fiori], and the Spaniards captured St Angelo's Castle and made it their rallying point. However the uproar was suppressed by the great lords and cardinals who rode between them. The Romans were ready to kill the pope, so greatly was he hated with his friends the Spaniards, and before the Spaniards could muster themselves several were slain.

On Easter Eve we went early to St Peter's Minster and, with

assistance, were let in. The pope sat there with the cardinals, who sang and blessed the Easter candles and other wax candles which were thrown down from the minster among the people, who struggled and fought, since each one wanted to get a piece of candle. After this we went again into St Peter's and saw the showing of the Veronica.

On Holy *Easter Day* we went early to St Peter's Minster. The pope was in St Peter's chapel preparing for Mass, but with the help of good friends I was let into the chapel and was placed forward so that I could see everything well. They put first on the pope four kinds of albs made of white silk, each one shorter than the other, and on his head they placed a bishop's hat, and the cardinals carried him, sitting thus, from the altar quite twenty paces in a high chair ten steps high. The choir began to sing the *Officium*. Then two cardinals and seven bishops who served him at Mass carried the pope to the altar where he read the *Confiteor*. When that was finished he was carried, again sitting on his chair. When he was to sing *Gloria in Excelsis*, the two cardinals took off the bishop's hat and raised him, and thus he sang *Gloria in Excelsis*, after which he sat down again. Then the two cardinals held a book before him, from which he sang the collects. When he reached the Epistle two bishops presented themselves kneeling before him, upon whom he pronounced the benediction. They then stood up and the one sang the Epistle, first in Greek, then the other sang the same epistle in Latin. The same was done with the *Evangelium*. Item the pope then sang *Dominus Vobiscum* and commenced the *Credo*, sitting all the time, but the cardinals first removed his hat. They then led the pope up to the altar where he sang *Per Omnia Secula Seculorum*, and then continued with the *Prefacio* to the end as far as the *Sanctus*. So he read quietly on and consecrated the holy sacrament on the altar. When the *Pater Noster* had been sung he left the holy sacrament lying on the altar. Then the two cardinals led him again to his chair. When he was ready to communicate the two cardinals approached the altar. One took the holy sacrament and the other the cup and

carried them to the pope. He remained seated and broke the holy sacrament into three pieces, One piece he gave to the one cardinal on the right hand, who was kneeling before him, and the second piece he gave to the other cardinal kneeling on the left, both of whom had served him at Mass. The third piece he administered to himself. After this one of the cardinals held up the cup before him. He had a golden tube which he placed in the cup and sucked the sacrament of the Blood through the tube out of the cup. When this Mass was finished the two cardinals brought the other consecrated sacraments to the Pope. He then administered first with his hands to the cardinals, then to the bishops who had served him at Mass, then to his son who was a duke, then to many notable people of Rome who were all sumptuously clad. I was then also led forward and a bishop conducted me to the pope, where I knelt and received the holy sacrament from his hands, also the sacrament of the Blood, consecrated as he had received it himself. When all was completed and the pope had finished, they carried him sitting in a chair, having on his head the papal crown, through St Peter's Minster to the Veronica, which was then exhibited to him, and afterwards he was carried to his palace.[19]

Alexander's son, the duke of Gandia, was assassinated in June.

Our last glimpse of the world of the *Mirabilia* is accorded by Harff's notes on the classical monuments. Marcus Aurelius was 'a great metal man sitting on a metal horse'. The Pyramid of Cestius was 'two pointed towers in which lie buried Remus and Romulus' – which makes one very unsure whether Harff ever saw it. And nearby was Omnis Terra (the Testaccio). The ugly Roman drain cover now known as Bocca della Verità was at S Maria in Cosmedin (then called the Schola Græca): it was claimed that Virgil made it. Harff, like Muffel, called the Colosseum by the German name of the 'Castle of Mirrors' (*Spiegelborch*). It was here on Good Friday that Harff saw a Passion play: 'This was acted by living people, even the scourging, the Crucifixion, and how Judas hanged himself. They were all the children of wealthy people, and it was therefore done orderly and richly.' The

Arch of Titus was simply 'the triumphal arch of the great palace'. The Basilica of Maxentius was 'a palace of ruins', and Harff again told the story of its connection with the birth of Christ, to explain its dilapidated state. The church of Aracœli was the palace of Octavian. Let us end Harff's impressions, however, with his account of the tomb of Nero at Santa Maria del Popolo:

> where this monastery stood was formerly a nut-tree on which many devils lived who plagued all those who passed to & fro, and no one knew whence they came. It was shown to St Pascasius, the pope, in a dream that he should have the nut-tree cut down and cause a church to be built on the spot in honour of our blessed Lady. The pope made a great procession, which he accompanied, to the nut-tree, and struck the first blow himself, and the tree was at once rooted up. Beneath the tree, deep under the ground, they found a coffin in which lay Nero, the wicked tyrant, who slew St Peter and St Paul and many other martyrs. The pope caused it to be burnt to ashes with the nut-tree and thrown into the Tiber. The church was then built in honour of our blessed Lady. In this church is daily indulgence for 3,000 years.[20]

These accounts of nearly twenty visitors to Rome in the Middle Ages and early Renaissance from Britain, France, Germany, Spain and even Iceland are remarkable for their uniformity. The overwhelming focus is on relics and indulgences, for these visitors were essentially pilgrims. What is amazing, however, is the same visitors' account of the classical monuments – where they showed any interest – which reveals the incredible longevity of the mediæval guidebooks and the gullibility to which they pandered. A basic competence in Latin, confronted with the inscriptions on the arches and the Pyramid of Cestius, for example, would have brought the whole house of cards tumbling down. There are fleeting glimpses of some popes: Eugenius III, Hadrian IV, and Innocent III and very restrained accounts of Alexander VI. The violence of the city is shown in the battles of the Roman populace with Barbarossa's troops and Alexander VI's

Spaniards. One figure does not fit the mould: Hildebert of Lavardin was bordering on heresy in his adulation for the pagan past. The picture of Rome presented by the travellers of the sixteenth century will be almost unrecognisable. The individual with curiosity and personal reactions is suddenly before us.

SOURCE NOTES

1. Hildebert of Lavardin, Ep. 3.10 = PL 171.289; 3.7 = PL 171.287
2. Tractatus ebor. 3 = MGH de lite 3.658. These extracts are very usefully collected by Gerd Tellenbach, 703f.
3. His itinerary is BL Cotton Tiberius B, v, 23v-24r; on which see Ottenberg.
4. Suger, 125-6.
5. John of Salisbury, *Memoirs of the Papal Court*, 41.
6. John of Salisbury, *Policraticus*, 6.24.
7. Ibid., prologue.
8. John of Salisbury, *Memoirs*, 40.
9. F. Magoun, 'The Rome of two northern pilgrims'.
10. Otto of Friesing, 143-52.
11. Benjamin, 6-7.
12. Gerald of Wales, 292.
13. Ibid., 278-9
14. Kempe, chaps 31-42.
15. Tafur, 34-43.
16. Capgrave book 2, chap. 1 (St Peter's), 2 (S Paolo), 5 (Santa Croce), 7 (S Maria Maggiore).
17. Muffel, 19, 22.
18. Burchard, 42-5, 50.
19. Harff, 40-45. Dr Johann Payl defeats all German biographical dictionaries.
20. Harff, 35. The complete account of his stay occupies 15-46.

THE SIXTEENTH CENTURY

THE TRAVELLERS

Our sixteenth-century travellers come principally from France, Germany, England, with some from the Low Countries and Spain. Of the French, JACQUES LE SAGE (d. 1549) was a silk merchant from Douai, who was in Rome for the canonisation of S Francesco di Paolo (2 April 1519) and left on 4 May, on his way to the Holy Land. JEAN CAVE is a complete mystery, but he was an eye witness to the sack of Rome, and among the defenders of the city, returning to Paris shortly after. His *Bellum Romanum* was published only in 1896. It is here translated into English for the first time. FRANÇOIS RABELAIS (*c.* 1494-1553) is one of the most famous figures in French literature. The son of a lawyer, he had been ordained a Franciscan, but then transferred to the Benedictines until he studied medicine, graduating at Montpellier in 1530. He visited Rome no fewer than three times, accompanying the famous Cardinal Jean du Bellay, bishop of Paris, whom he served as physician. In his edition of Marliani's masterpiece on the topography of Rome (1534) he declared that 'the essential wish which I formulated, from the time I gained some knowledge of literature, was to travel all over Italy and so visit Rome, the capital of the world'. He knew long before he went what he desired to do: visit scholars, examine medicines unknown in France, and to make such a record that when he returned home he would have all that he needed. He in fact drew up a topography of the city with the help of two young Frenchmen, but then found that Marliani had anticipated him. This first visit (1534) was in fact an embassy of reconciliation by du Bellay to prevent schism with England – which failed. The second visit (1535-1536) was an attempt to call a council in Rome to discuss the crisis in the Church, which was again a failure. Rabelais, however, had a personal purpose which he achieved: by 'singular privilege' Paul III

approved Rabelais' transfer from the Franciscans to the Benedictines and his profession as a doctor. The third visit (1548-1549) was occasioned by the need to join the cardinal, who represented the irenists against the intransigents, between whom the French court was split.

Another DU BELLAY, cousin of the cardinal, was in Italy 1553-1557. This was Joachim du Bellay (1522-1560), one of the members of the classicising Pléiade. He also accompanied the cardinal, like Rabelais, acting as his accountant, but also finding time to fall in love with a married woman in Rome, and musing on the ruins in his sonnets *Les Antiquitez de Rome* (1558).

The greatest travel journal written by any visitor to Rome in this century, undoubtedly, was that by MICHEL EYQUEM DE MONTAIGNE (1533-1592) (see ill. opposite), which stands head and shoulders above the rest for its detail and humanity. He was in Rome 30 November 1580-19 April 1581. Although much occupied with his terrible sufferings from the stone, Montaigne was a keen observer of, even participant in, Roman life, most especially the Jewish community. He has, however, almost no notes on the antiquities. It is a fitting tribute to him that during his stay he was granted Roman citizenship.[1]

LOUIS DE MONTJOSIEU (Ludovicus Demontosius) (dates unknown), accompanied the duc de Joyeuse to Rome in 1583. He was obviously highly placed, having tutored a royal prince in mathematics. His book *Gallus Romae hospes* (1585) is supposedly the first guide book for foreigners, but in reality is five antiquarian essays (on pyramids, obelisks, Janus, chariots; the Pantheon; sculpture and gem-cutting; painting; and the Forum). He therefore provides no traveller's reactions. JACQUES DE VILLAMONT (no dates), of whom nothing is known despite his much quoted account, visited Rome 1588-1589, and was a great admirer of Sixtus V. HENRI, DUC DE ROHAN (1579-1638), spent 'eight uninterrupted days' in Rome in 1600. He travelled abroad because he was useless in France (at the age of 20, save the mark) now that peace had been made (the Edict of Nantes 1598).

Of Germans by far the most famous visitor – subsequently – was the Augustinian monk MARTIN LUTHER (1483-1535). He came as simply the travelling companion to an unnamed envoy – probably Anton Kresz – who was sent to resolve 'a grave disturbance'. Twenty-nine

Anon.,
Michel
Eyquem de
Montaigne,
*sixteenth
century*

German Augustinian houses (the Observantines) had reformed them-
selves, while twenty-five (the Conventuals) continued their old corrupt
ways. In order to force reform on the latter it had been decided to
form a union of all fifty-four communities, but the reformed houses
objected, arguing that they would be defiled. The embassy to Rome
was therefore an appeal against the order of union. Luther and Kresz
walked 1400 kms from Erfurt to Rome, a journey of some forty days,
November-December 1510/January 1511. On arrival, they stayed at the
Augustinian monastery of S Maria del Popolo.

There is unfortunately no contemporary record kept by Luther of
his visit. It can be reconstructed only from allusions usually twenty
years later in sermons, conversations and so on, subject to his later
theological development, then elaborated by his biographers and later
controversialists. Every item of his stay is thus contested: the date, its

purpose, and what he did and saw. As it happened, the pope, Julius II, most of the cardinals, the Swiss Guard, the chancellery, the papal families and foreign diplomats were all away in the Romagna for the war against France.

Some few things can be reconstructed. Luther made the pilgrimage to the seven great basilicas, traditionally in one day while fasting: S Paolo, S Sebastiano, S Lorenzo, S Giovanni Laterano, S Croce in Gerusalemme, S Maria Maggiore, and S Pietro.[2] He climbed the Santa Scala on his knees, praying for the soul of his grandfather; he regretted that his parents were still alive so that he could not perform the same service for them! He said many masses, and visited all churches and catacombs, especially S Sebastiano. The church which made the greatest impression on him was the German one, S Maria dell'Anima. Of antiquities he paid most attention naturally to the Pantheon and the Baths of Diocletian. He was not interestd in classical art, and we must remember that Raphael and Michelangelo were at the time engaged on their great paintings in the Vatican. The absence of the leading figures and very bad weather meant that no important festivals were held that January. He later declared Rome to be only 'the corpse of her earlier monuments', but even those were dangerous to visit, being the haunt of criminals.[3] In short, in Rome Luther 'neither saw, heard or did anything special'![4] And when the appeal against the union was rejected at the end of January 1511, Luther and Kresz departed to return to Germany.

JOHANN FICHARD (1512-1581) was a lawyer born in Frankfurt, who studied not only at Heidelberg and Freiberg but also Padua and Bologna; he was also a leading diplomat in the 1540s. He was in Rome at the death of Clement VII (Sept. 1534) and the death of the dauphin (August 1536). HANS GEORG ERNSTINGER (c. 1560-after 1611) visited Rome in 1595 with the Margrave Karl zu Burgau. He is unknown to standard German biographical dictionaries. PAUL HENTZNER (1558-1623) of Schlesia included Rome in October 1599 in his travels in Germany, France, England and Italy. He was a lawyer and this was the first published account of a European tour. HEINRICH SCHICKHART (1558-1634), an architect who worked for three dukes of Württemberg from the 1590s until his death, made study tours in Italy, 1598-1600, and later

in France. He came to Rome in 1599 with Duke Friedrich (1577-1608). It may be noted that it was already a feature of German travellers that they frequently accompanied young princes on educational tours. The British were already coming to Rome in large numbers, although the Reformation meant that most were Protestants. WILLIAM THOMAS (?–1554), 'constrained by misfortune' to travel abroad, was in Italy in 1545 and in Bologna wrote a defence of the recently deceased Henry VIII, but had returned to England by 1549. He was to become a clerk of the Privy Council and a member of the embassy to France to negotiate the marriage of their Princess Elisabeth with young Edward, to whom he was a tutor. Being dismissed on the accession of Mary, he took part in Sir Thomas Wyatt's conspiracy, for which he was arrested and hanged for treason. THOMAS HOBY (1530-1556), translator of Castiglione's *Courtier*, was in Rome November 1549-January 1550. THOMAS NASHE (1567-1601) was probably the best known British traveller to Rome this century. It is generally agreed that he made 'a hasty tour through France and Italy' after graduating from Cambridge. He settled in London in 1588, becoming a leading critic and satirist, an English Rabelais. His *Unfortunate Traveller* (1594) is the first picaresque novel in English and reflects his Italian experience. HENRY WOTTON (1568-1639) spent seven years in Europe, including Rome, March-April 1592. He later became an agent of Essex and therefore fell out of favour with Elizabeth, but was James I's ambassador to Venice for most of 1604-1624, and later Provost of Eton. FYNES MORYSON (1566-1630), Fellow of Peterhouse, travelled in Europe for four years, including Rome late 1593-Easter 1594. His account is invaluable to the social historian.

From the Low Countries came three visitors. The most important was Gerhard Gerhards, better known as ERASMUS (1466-1536), the leading Dutch scholar of the century, who was in Rome from April to mid-July 1509. He was, in fact, tutor to a natural son of James IV of Scotland, who was a student at Padua, and the visit is virtually unrecorded in his correspondence. *In Praise of Folly* was in preparation. Another leading scholar was STEPHAN PIGGE (1520-1604), philologist and antiquarian, born at Kempen in Holland, who accompanied Prince Karl von Kleve (1555-1575) to Rome December 1574-February 1575, where the prince suddenly died. Pigge's account is mostly

occupied with the reception of the prince by Gregory XIII, who was preoccupied with the Reformation.

ARNOLD VON BUCHELL (1565-1645) was born in Utrecht, and after study in Leyden he travelled in France 1584-1586, Germany 1587, and Italy 1587-1588, being in Rome 9 November 1587-7 February 1588. One of the most famous Spanish authors visited Rome in 1569: MIGUEL DE CERVANTES (1547-1616). A royal order had been issued for his arrest in September 1569 for wounding a man; his hand was to be cut off and he was to be exiled from Spain for ten years. No one in this century had a more particular and pressing motive for his visit. All we know about his time in Rome is that he served as chamberlain to Cardinal Giulio Acquaviva.[5]

INTRODUCTION

Let Erasmus set the scene. He visited Rome from April to July 1509, and three years later wrote from London to Cardinal Robert Guibé, who had shown him great kindness during his stay.

> I should have to look for a new river of Lethe if I wished to forget that city and be no more racked with longing for it; for I cannot without anguish recall the climate, the green places, the libraries, the colonnades, and the honeyed talks with scholars.[6]

The city to which visitors came in the sixteenth century was a very particular place, and some few travellers provide the essential details. Johann Fichard revealed that only one third of the space within the Aurelianic walls was occupied. The busiest street (via del Pellegrino) ran from the Vatican to Campo de' Fiori, but the 'straightest, longest and finest' was the via Giulia. This is confirmed by William Thomas (1549):

> Of the ground contained within the walls scarcely the third part is now inhabited, and that not where the beauty of Rome hath been but for the most part on the plain to the waterside (Campo Marzo) and in the Vatican, because that since the Bishops began

to reign every man hath coveted to build as near the court as might be. Nevertheless, those streets and buildings that are there at this time are so fair that I think no city doth excel it.

Montaigne also stressed that Rome was two-thirds empty, and 'if one counts the size by the number and density of houses and habitations, he thinks that Rome is not even one third the size of Paris. In number and grandeur of the public squares, and beauty of the streets, and beauty of the houses, Rome is, however, far superior.'[7]

One is now used to the many bridges allowing easy transit of the river. The situation in the sixteenth century was very different. Thomas stated flatly: 'Upon this river of Tiber in Rome be four bridges': ponte di Sant'Angelo from the city to the castle; ponte Sisto from the via Giulia to the Janiculum; ponte di San Bartolomeo (or ponte di Quattro Capi) across the island; and ponte di Santa Maria, where the Tiber leaves the city in the south (ponte Rotto, opposite Foro Boario, which collapsed in 1598, never to be restored). Hans Ernstinger (1595) counted five bridges, more correctly, by distinguishing the two bridges at the Tiber Island: ponte Quattro Capi (or the pons Fabricius) and ponte San Bartolomeo (or the pons Cestius).[8]

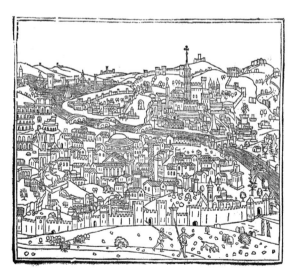

*The earliest known printed map of Rome (*Supplementum Chronicarum, *Venice 1490). The view is from the east. The five bridges can be clearly seen*

Foreigners remarked on the climate. For Montaigne 'the cold of winter closely approximated that of Gascony. There were strong frosts around Christmas, and unbearably cold winds. It is true that even then it thunders, hails and lightens.' Fynes Moryson noted the endemic flooding, and was astounded as any modern visitor who takes the trouble to study it at the flood gauge on the front of S Maria sopra Minerva. 'By reason of these floods, and for that the City is built upon the caves of old Rome (which makes the foundations to be laid with great charge) and also by reason of the vapours rising from the Baths, the aire of Rome is at this day unwholsome.'[9]

Most European travellers arrived from the north, across the Milvian Bridge and along the via Flaminia, entering by the porta del Popolo into the piazza of the same name. ACCOMMODATION was the first concern. It is a shame that more do not tell us where they stayed. Luther was in the Augustinian convent of S Maria del Popolo, Jacques le Sage at the Croce Bianca, in Macello dei Corvi at the foot of the Capitol (long demolished), Rabelais at the French embassy, Stefan Pigge in the Vatican, Montaigne at the most famous of the old inns, l'Orso, still to be found in the street named after it in the Campo Marzo, then rooms

Antonio Tempesta's map, first published in 1593, showing the Piazza del Popolo as it appeared at the end of the sixteenth century, with the obelisk erected in 1589

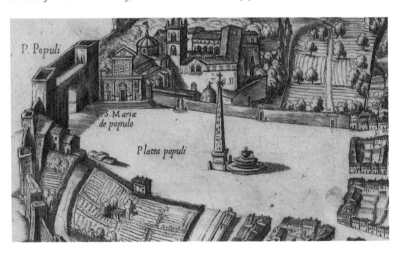

opposite S Lucia della Tinta, namely Hostaria del Monte di Brianzo nearby, Arnold von Buchell at the Gallo in Campo de' Fiori, and Moryson in the Borgo. A very amusing story is told by Moryson, who went to see Cardinal Allan to seek his protection while he visited the monuments, presumably at the English College. As he was departing, he met with various English priests, who promised to be his guides:

> I knew well that such guides would be very troublesome to me, for they (according to the manner) disputing of Religion, I must either seeme to consent by silence, or maintaining arguments full of danger in that place, besides that to gratifie them for their courtesie, I must needes have runne into extraordinary expences.

He told them his lodging, but then changed it to near the Vatican – where they would least think of looking for him.[10] The area around piazza di Spagna, later to be the centre for most travellers, was clearly not yet in fashion.

Another matter on which it would have been so useful to be informed is guides, CICERONI. Most travellers were shown around by someone, to make the best use of their often limited time. In contrast to later centuries, the travellers of the sixteenth century are extremely reticent about the identity of these people, to whom they must have resorted, and who were certainly available: we hear only of an unnamed Frenchman for Montaigne. Most of the guides would have been the ill-informed and sensationalist individuals who still ply the trade; although unnamed, we can catch their stories in the notes especially on antiquities (see p. 69).

The other matter about which we would like to know is EXPENSES. Again notes are sparse. Montaigne informs us that his rooms at the Hostaria del Monte di Brianzo cost 20 *scudi* per month. Rabelais fifty years earlier, on his second visit (July 1535-April 1536), accompanying Cardinal Jean du Bellay and staying as noted at the French embassy, wrote to his protector Bishop Geoffrey d'Estissac in February 1536 to say that the thirty *scudi* he had provided were almost all gone, despite the fact that he normally ate with the cardinal. 'But in little items of expense and the hiring of furniture and the maintenance

of clothing, a lot of money disappears, although I manage as sparingly as possible.' He then went on, however, to mention the 'thousand little wonders at a cheap price brought in from Cyprus, Candy [Crete] and Constantinople'. Moryson told of the costs of arriving in Rome. On crossing the Tiber near Castel Otricoli the *vetturino* claimed that his fees did not include ferries across rivers, so each traveller had to pay two *giulii* (⅕ *scudo*), and at the final town of Castel Nuovo, he insisted that he wanted to go straight on to Rome, and that if anyone wished to dine they could pay: another two and a half *paoli* (¼ *scudo*).[11]

The most concise epitome of what to see and what every traveller should take home is provided by Miguel de Cervantes' fictional note which must, for want of anything more direct, serve as the document on his own visit in 1569:

> He visited its temples, adored its relics, and marvelled at its grandeur. Just as from the claws of a lion one may judge the size and ferocity of the beast, so was his opinion of Rome formed from its marble ruins, the statuary whether whole or mutilated, its crumbling arches and baths, its magnificent porticos and huge amphitheatres, the renowned and sacred river that washes its banks to the brim and blesses them with countless relics from the bodies of martyrs that are buried there, its bridges which appear to be admiring one another, and its streets whose very names invest them with a dignity beyond those of all other cities in the world: the Via Appia, the Via Flaminia, the Via Giulia, and others of that sort. He was no less pleased by the manner in which the city was divided by its hills: the Cælian, the Quirinal, and the Vatican, along with the other four whose names show forth the greatness and majesty that is Rome. He likewise remarked the authority that is exerted by the College of Cardinals, as well as the majesty of the Supreme Pontiff and the great variety of peoples and nations that are gathered there. He saw and made note of everything in its proper place.[12]

It was, however, Thomas Nashe who gave us our best appraisal of the effects of travel in Italy at this time:

Italy, the paradise of the earth and the epicure's heaven, how doth it form our young master? It makes him to kiss his hand like an ape, cringe his neck like a starveling, and play at 'hey pass, repass come aloft', when he salutes a man. From thence he brings the art of atheism, the art of epicurizing, the art of whoring, the art of poisoning, the art of sodomitry. The only probable good thing they have to keep us from utterly condemning it is that it maketh a man an excellent courtier, a curious carpet knight; which is, by interpretation, a fine close lecher, a glorious hypocrite. It is now a privy note amongst the better sort of men, when they would set a singular mark or brand on a notorious villain, to say he hath been in Italy.[13]

BASILICAS, CHURCHES AND CATACOMBS

The prime concern of all pious visitors to Rome was, of course, the visit to the seven basilicas. Cervantes presumably recalled his time in Rome in 1569 in his *Journey to Parnassus*:

O powerful, grand, thrice-blessed, and passing fair
City of Rome! To thee I bend the knee,
Pilgrim new, a lowly devotee,
Whose wonder grows to see thy beauty rare!
The sight of thee, past fame, beyond compare,
Suspends the fancy, soaring though it be.
Of him who comes to see and worship thee,
With naked feet, and tender loving care.
The soil of this thy land which now I view.
Where blood of martyrs mingles with the clod,
Is the world's relic, prized of every land;
No part of thee but serves as pattern true
Of sanctity; as if the City of God
Had been in every line its model grand![14]

It is extraordinary that Jacques le Sage, who visited Rome in 1518,

and who went to hear a mass at ST PETER'S, was interested only in the
relics and an exorcism. He was shown the Veronica, the lance, the
bodies of Peter and Paul, the tunic worn by Jesus when he preached
in Jerusalem, and the rope with which Judas hanged himself. The
reconstruction of the most important church in the Christian world,
however, had been begun by Julius II della Rovere in 1506 and it was
not to be completed until 1626 under Urban VIII Barberini.

Johann Fichard in 1536 found the basilica 'more than half unroofed
and incomplete, so that you may graze [*sic*] in the middle of it'. The
monuments of Pius II and Pius III, however, were still in the chapel
of S Andrea (they would not be moved to Sant'Andrea della Valle
until 1614). And the famous bronze statue of St Peter (see ill. p. 132)
was on the left by the altar. We have here a very informal view of the
basilica in the middle of its rebuilding, which was to occupy the whole
century. Fichard visited it in the period between the death of the first
architect Donato Bramante in 1514 and the appointment of Antonio
da Sangallo the Younger in 1539; the sack of 1527 had also had a major
influence in halting work. Bramante ruthlessly destroyed the old
Constantinian basilica: Michelangelo was horrified at the way the
original columns were simply brought smashing down, although

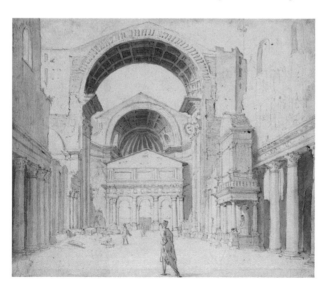

*Martin van
Heemskerck,*
Interior view
of St Peter's,
*showing both
the old basilica
and the new
one behind it,
1530s*

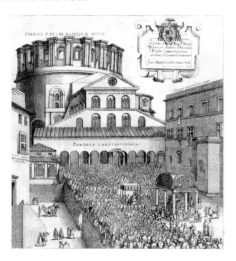

G. B. Cavalieri,
The opening of the
Porta Santa in the
Jubilee Year 1575.
The new St Peter's is
under construction:
Michelangelo's cupola
behind the surviving
portico of the Con-
stantinian basilica
and the Vatican palace
on the right

much of the old nave remained for the moment. By Bramante's death, the four arches of the dome were complete as well as the foundations of three arms of the crossing.

After the break, Sangallo the Younger, architect 1539-1546, seemed to have occupied himself in changing Bramante's plan into a much more grandiose scheme, in particular adding the enormous ambulatories and loggias. Michelangelo, appointed on his death, returned to Bramante's plan and devoted himself to the master feat, the construction of the dome, which was, in effect, the placing of the Pantheon on top of the basilica. It is strange that William Thomas in 1549 concentrates on the steps up to the porch (thirty steps, thirty paces long, 'the solemnest that I have seen'), and the porch, which then contained the Vatican pine-cone. 'The church within is nothing fair to the eye', but he mentions the tomb of Sixtus IV, the bronze statues of Peter and Paul, and 'a number of goodly pillars'. 'The new building, if it were finished, would be the goodliest thing of this world... Nevertheless, it hath been so many years a doing, and is yet so imperfect that most men stand in doubt whether ever it shall be finished or no.'

Towards the end of the century, Fynes Moryson was also taken with the pine-cone, and mentioned as the richest chapel that of Gregory XIII (half way down the right aisle, designed by Michelangelo, and

costing more than 80,000 *scudi*), and the fine statues of the 'stately sepulcher' of Paul III. Otherwise his account focussed on relics:

> Here they show the bodies of Saint Simeon, the Saint Jude the Apostle, and Saint John Chrysostome, and of Pope Saint Gregory the Great, and the head of Saint Andrew and of Saint Luke the Evangelist, and halfe the bodies of Saint Peter and Saint Paul, and Christ's face printed upon the handkercher of Veronica, and the head of the speare thrust into the side of Christ, and among many pillars brought from Hierusalem one upon which Christ leaned, when he did preach and cast out Divels, which yet hath power (as they say) to cast out Divels.

It is remarkable how similar are the notes of Hans Ernstinger the next year. By the visit of Heinrich Schickhart in 1599, work was proceeding on the gilding and painting of the dome.

There was one monument in the basilica which was to attract continuous attention, the already mentioned tomb of Paul III by Giacomo della Porta. Below the imposing figure of the pontiff were two female figures, one old and one young; the latter (see ill. opposite) was also exquisitely beautiful. Paul Hentzner is the first (in 1599) to tell the story that some Italians were so overcome by her beauty that she had since been covered in a metal garment. The story was to undergo innumerable embellishments in the future.[15]

Second only to St Peter's was s GIOVANNI IN LATERANO. This is the cathedral of Rome. Built originally by Constantine, its present form essentially goes back to Francesco Borromini (1650), except for the facade, the work of Alessandro Galilei (1735). Sixteenth century visitors, therefore, saw the old basilica. Moryson in 1594 gave some idea of the old church:

> sustained by four rows of brick pillars, and there hang certaine banners taken from the French, and neere the doore the Popes Sergius the fourth, and Silvester the second are buried in low monuments. In the church yard are old sepilchers, and little pillars of marble.

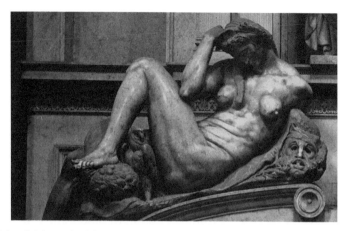

Michelangelo, The tomb of the Medici, 1519-33. Only very poor drawings survive of the della Porta's naked statue for Paul III's tomb. This Florentine tomb sculpture will suffice to give an idea of the sensual female figures that may have excited erotic fantasies

As for the contents, notably relics, Fichard noted the *lex regia*, the law conferring imperial powers on Vespasian (69-79) which had been uncovered here by Cola di Rienzo, two marble seats, which traditionally were used to test the newly elected pope's gender, following the scandal of Pope Joan, and a column from the temple of Solomon which had split when Jesus died. And outside, until it was moved by Michelangelo in 1538, stood the equestrian statue of Marcus Aurelius (see ill. p. 21). At Easter 1581 Montaigne paid a visit and was particularly fascinated by the heads of Peter and Paul:

> they still have their flesh, complexion and beard as if they were alive. St Peter has a white face, slightly elongated, a vermilion complexion, tending to sanguinary, a grey forked beard, and his head covered with a papal mitre. St Paul is dark-coloured, a broad and fatter face, a larger head, a thick grey beard. They are placed up high in a special place. The way they show them is by summoning the people by bells, and every so often they lower a curtain behind which are these heads, beside each other. They are exposed for the first time for the time it takes to say an Ave Maria, then immediately the curtain is raised again, then

they lower it again, three times. This showing is repeated four or five times a day.

The heads are still apparently preserved in silver reliquaries. Jacques de Villamont also paid special attention to the relics: the head of Zacharias, father of John the Baptist, of S Pancrazio, the chalice from which John the Evangelist drank poison at Domitian's command, the chains in which he was brought from Ephesus, the clothes of the Virgin, the shirt she made for Jesus, the cloth with which Jesus wiped the Apostles' feet, the purple robe given Jesus by Pilate, wood of the Cross, the Sudarium, relics of Mary Magdalen and St Lawrence, and at the end of the church a chapel with the altar used by John the Baptist in the desert, the rod of Aaron, the ark of the Covenant, part of the table of the Last Supper – all brought from Jerusalem by Titus! Ernstinger added two further relics in his account: a window from the house of Mary in Jerusalem by which Gabriel made the Annunciation, and a plaque indicating Jesus' height, which was said never to correspond to anyone else's. Not content with all that, Hentzner was also shown the pillar on which the cock crowed![16]

Within easy walking distance of S Giovanni is s croce in gerusalemme. Moryson was still able to record a fascinating old custom there: 'At the gate of this Church they shew a space where the whores keepe a feast upon the twenty of August, and there of old was the Temple of Venus.' This is yet another example of the longevity of paganism. The relics were, as now, famous, and Ernstinger listed a piece of the Cross, two thorns, the sponge, a nail, and one of the thirty pieces of silver.[17]

The same Ernstinger leaves us astounded in that visiting s pietro in montorio he said nothing of Raphael's *Transfiguration*, while at s pietro in vincoli, faced with the masterpiece of Michelangelo's tomb for Julius II, he could say only that it was worth seeing.[18]

s maria del popolo, Moryson alone informs us, in time of plague, replaced S Sebastiano as one of the seven basilicas, with all the indulgences which belonged to it. He whimsically added that 'the yard of this Church hath an Obeliske, almost as faire as that neere Saint John Lateran, which Pope Sixtus the fifth also erected'.[19] 'The yard of this church' is in fact the middle of the piazza del Popolo.

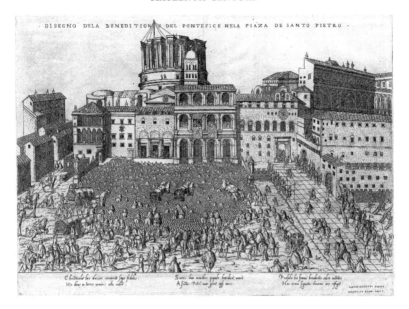

Antonio Lafreri, Papal Benediction at St Peter's, *1555*

EASTER was the central focus of the church calendar. Montaigne gave a fine description of what happened on Easter Thursday, 1581 (the reigning pope was Gregory XIII):

> In the morning the pope appears in his pontifical robes over the first portico of St Peter's, on the second level, attended by the cardinals, with a torch in his hand. On one side a canon of St Peter's reads in a loud voice a Latin bull, excommunicating an infinite number of people, including the Huguenots, mentioned by name, and all princes who retain some part of the Church's lands; at this item cardinals [Ferdinando] de Medici and [Antonio] Caraffa, who were next to the pope, laughed out loud. This reading lasts a good hour and a half; for at each item which the canon reads in Latin, on the other side of the pope cardinal [Gianvincenzo] Gonzaga, also without his hat, reads the same in Italian. Then the pope threw this lighted torch

down to the people, and for a joke or another reason, Cardinal Gonzaga threw down another, for he had three of them lit. It fell on the people, and down below there was an almighty to do in order to have a piece of this torch, and they fell to roughly with fists and sticks.[20]

At this time the Veronica was shown from a pulpit in the church, by priests wearing red gloves. 'Nothing was seen with greater reverence, the people prostrate on the ground, mostly weeping and crying out in pity.'

There were more than one hundred confraternities in Rome, and 'every man of quality' belonged to one. On Easter Thursday they all paraded in their colours, mostly with covered faces.

> As the night began, the city seemed all ablaze, with the companies marching towards St Peter's, each member carrying a torch, almost all of white wax. I think that there passed in front of me at least twelve thousand torches; for from eight o'clock until midnight, the street was always full of this procession, carried out with such order and judgement, although there were different troupes and parties from different places, there was never a break or an interruption. Each body had a great choir of music, always singing as they went along, and in the middle of the ranks, a row of penitents, whipping themselves; there were at least five hundred…[21]

And the first Sunday after Easter (Quasimodo Sunday) was the famous dowering of the poor girls:

> Besides his ordinary procession, the pope has twenty five horses which are led before him, adorned and draped in gold cloth, very richly fitted out, and ten or twelve mules, draped in crimson velvet, all led by his grooms on foot and his litter was covered with crimson velvet. Before him four horsemen carried four red hats at the end of staffs covered in red velvet and gilded at the handles and tops. He was on his mule. The cardinals who followed were also on their mules, adorned in

their pontifical clothes, the trains of their mantles attached by a pin to the bridles of their mules. The girls numbered one hundred and seven, each accompanied by an old relative. After the mass, they left the church in a long procession. On their return, one after another they went to the centre of the church of the Minerva, where this ceremony took place, and kissed the pope's feet. He blessed them, then gave to each from his own hand a purse of white damask, in which there was a *cedola* (money order). When they find a husband, they go to claim their alms, thirty-five *scudi* each, besides the white dress which they each have this day, which is worth five *scudi*. They have their face covered with a cloth, with only the eyes uncovered.[22]

Easter was certainly taken very seriously at Rome. Moryson alerts us to a sinister matter:

> Easter was now at hand, and the priests came to take our names in our lodging, and when we demanded the cause, they told us, that it was to no other end, but to know if any received not the Communion at that holy time, which when we heard, we needed no spurres to make haste from Rome into the state of Florence.[23]

The other great festival was CHRISTMAS. William Thomas gives a memorable account of 1547:

> on Christmas Day the year of our Lord 1547, Paul the Third being Bishop, I noted his coming to church because it was a principal feast celebrated *in pontificalibus*. Wherefore early in the morning I resorted to the palace and there waited the coming of the cardinals, that for the most part lie in the city and to come to St Peter's must pass ponte Sant'Angelo; where is an old order that whensoever any cardinal passeth the bridge there is a piece of ordnance shot off in the castle for an honour that the Bishop is bound to observe towards his brethren.
>
> I had not been long in the palace but I heard two pieces shot off at once, whereby I knew that two cardinals were coming,

and therefore resorted to the gate to see them and their train.

From Castel Sant'Angelo to St Peter's stairs there is an exceeding fair street, straight and level more than a quarter of a mile long, called *Borgo San Pietro*; in the further end whereof I saw these cardinals come, and therewith out of the bishop's palace came his guard of Switzers all in white harness and there alongst before the gate made a lane half on one side and half on the other, with their two drums and a fife before them. And as soon as the cardinals approached, the drums and fife began to play and so continued till the cardinals were well entered amongst the guard. Then the trumpets blew up another while till the cardinals were almost at the gate, and as they should enter, the shawms began to play and ceased not till they were alighted and mounted up the stairs to the bishop's lodging.

The like ceremonies were used unto all the cardinals that came, whether one came alone or many together. And there [I] tarried more than two hours, hearkening to this gunshot and merry piping, and reckoned above forty cardinals that came thus riding, sometime one alone and sometime three or four together.

There was no cardinal that came without a great train of gentlemen and prelates, well horsed and appointed – some had forty, some fifty, and some sixty or more – and next before every of them rode two henchmen, the one carrying a cushion and a rich cloth, and the other a pillar of silver; and the cardinals themselves, appareled in robes of crimson chamlet with red hats on their heads, rode on mules.

When they were all come to the palace and had waited awhile in the chamber of presence, the bishop himself, with the three-crowned mitre full of jewels, in a very rich cope, with shoes of crimson velvet set with precious stones, and in all his other pontifical apparel, came forth and at the chamber door sat him down in a chair of crimson velvet, through the which runneth two staves covered with the same. Thus being set, the prelates and clergy with the other officers passed on afore him; which are such a number as were able to make the muster of a

battle if they were well ordered in the field: dataries, treasurers, clerks of the chamber, penitentiaries, prebendaries, notaries, protonotaries, and a thousand more, each order of them in his divers device of parliament robes, all in scarlet and for the most part finely furred. Then came the double cross, the sword, and the imperial hat, and after that the cardinals by two and two, and between every two a great rout of gentlemen. Then came the ambassadors and next them the bishop himself, blessing all the way and carried in his chair by eight men, clothed in long robes of scarlet; and on either side of him went his guard, making room and crying, *Abbasso, Abbasso* (Down, down) for they that will not willingly kneel shall be made kneel by force. And I think verily the foremost of this order was distant from the hindermost more than a quarter of a mile.

Thus when he came into the midst of the church against the sacrament of the altar, he turned himself towards it and, bowing his head a little, seemed to make a certain familiar reverence. Then was he carried into the chapel, brought behind the altar (for the altar standeth in the midst, open every way), and there in a throne of wonderful majesty was set up as a god.

The cardinals then bestowed themselves after their ancienty in certain stalls, somewhat lower about the choir. Then sat the ambassadors and other prelates at their feet. And so when they were set, the chapel began the Offertory of the Mass and sang so sweetly that methought I never heard the like. At the communion of the Mass, the cardinal that celebrated brake the host in three pieces, whereof he eat one himself, and the other two he delivered upon the paten to a cardinal appointed that brought it to the Bishop, and in his presence (for fear of poisoning) took assay of the second piece and delivered him the third. When the Mass was finished, the bishop gave his benediction, with many years of pardon, and then returned to the palace in like order as he came.

As for the pomp he useth when he rideth abroad, I need not to speak of it, considering what I have said, saving that you shall understand how Corpus Domini is always carried in

a tabernacle before him on a white hackney that is taught to kneel both at the setting up and also at the taking down of it.[24]

As well as churches, the sixteenth century travellers also visited the CATACOMBS, almost always those at S Sebastiano. Moryson may be taken as representative:

> Here is a place called Catacombe, and there is a well, in which they say the bodies of Saint Paul and Saint Peter did lie unknowne a long time, and here is a way under earth to the Church yard of Calixtus, where they say the Christians lay hid, in times of persecution; and that there were found 174 thousand which had been made Martyres, and that eight of these were Bishops of Rome. Here on all sides with amazement I beheld the ruines of old buildings, and the sepulcher of the emperor Aurelius is not farre from this Church.[25]

His constant stress on 'they say' points to a source such as a guide, and there seems no indication that he descended into the catacombs. What he took to be Aurelius' tomb must have been along the via Appia (the mausoleum of Maxentius' son Romulus?).

It is striking how much attention was paid to RELICS by visitors both Catholic and Protestant. Thomas Nashe summed up:

> Should I memorise half the miracles which they there told me had been done about martyrs' tombs, or the operations of the earth of the sepulchre and other relics brought from Jerusalem, I should be accounted the most monstrous liar that ever came in print.[26]

Something else, finally, was witnessed by several travellers: EXORCISM (see ill. opposite). Le Sage in 1518 saw a woman being exorcised in St Peter's: the devils blew out a candle as they exited from her; there were four of them. A much longer description is given by Montaigne in 1581:

> I found in a chapel a priest intent on curing a *spiritato*, a melancholy, almost stupid man, held on his knees in front

of the altar, with some kind of cloth around his neck by which he was tied. The priest read in his presence many prayers and exorcisms from his breviary, ordering the devil to leave his body. Then he turned his attention to the patient, now speaking to him, now to the devil within him, reviling him, hitting him with heavy blows, and spitting in his face. The patient replied to his questions with little sense, for himself saying how he felt the movements of his illness, and for the devil how he feared god and

Francesco Guarini, St Benedict exorcises a monk, c. *1650*

how much these exorcisms worked against him. This went on for a long time, then the priest, as a last effort, retired to the altar and took in his left hand the monstrance containing the Corpus Domini, in the other holding a lit candle, turned upside down so that it melted and was consumed. Meanwhile he recited prayers, and finally menacing and severe words against the devil, in the loudest and most authoritative possible voice. When the first candle was about to extinguish near his fingers, he took another, then a second and a third. After this, he replaced his monstrance, that is the transparent vessel which held the Corpus Domini, and came back to the patient, speaking to him as to a man, had him released and restored to his people to be taken back home. He told us that this devil was of the worst type, obstinate, and that it would be very difficult to expel him. To ten or twelve gentlemen who were there he told several stories of this science and of the usual experiences which he had, especially that the day before he had rid a woman of a

large devil, which, as it came out, pushed out of the woman's mouth nails, pins and a tuft of hair. And because someone replied that she was not yet entirely restored, he said that this was another kind of spirit, lighter and less harmful, which had taken possession of her that morning, but that this kind (for he knew all their names, their categories and special distinctions) was easy to exorcise. I saw only this. My man only ground his teeth and twisted his mouth when the Corpus Domini was shown to him and sometimes mumbled 'If the fates so wish' (in Latin), for he was a notary and understood a little Latin.[27]

PALACES

The longest list is given by Paul Hentzner in 1599. He named eighteen main palaces: of the Conservatori, Porcari, Doria, Salviati over the Tiber, Lateran, S Giorgio in Damaso, Carpegna, de Rusticiis, Colonna, Colocci in Campo Marzo, Orsini below the Capitol, Farnese, Cancelleria, Quirinal, Caraffa, Capiteferro, Bufalo in Campo Marzo, Orsini in Campo de' Fiori, and S Marco. And when he went on to describe the 'houses of the citizens being rather beautiful, partly decorated with antique monuments, marbles and paintings, partly with gardens, fountains and nymphæa' he was obviously referring still to palaces.[28]

The one which attracted most notice from sixteenth century travellers was without doubt the FARNESE (see ill. opposite), built between 1514 and 1589; the architects were Antonio Sangallo, Michelangelo and Giacomo della Porta. William Thomas in 1549 declared that Paul III Farnese 'hath rooted out of the ruins of the antiquities such goodly marble pillars and other fine stone which he hath bestowed on that house that if he finish it as it is begun it will be the gallantest thing, old or new, that shall be found again in all Europe'. Jacques de Villamont declared that it took the prize for beauty in all Italy. Fynes Moryson scaled down his admiration: 'one of the fairest in Rome, which for the dignity of such a City, hath very few stately Palaces'. Of

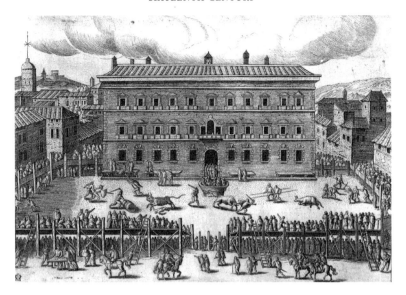

Hendrik van Cleef, Palazzo Farnese, *1560-80s*

its antiquities he mentioned only the Bull. It was Hentzner who gave some list of its treasures: paintings by many illustrious masters, porcelain vases from Portugal, silver tableware, ecclesiastical vestments, statues of Hercules, of a gladiator, of Commodus as gladiator, a Vestal in black marble with head, feet and hands in white, Hadrian, and the 'fierce Bull'.[29]

The second favourite was the VATICAN PALACE. Jacques le Sage in 1518 recorded visiting it on horseback, going up four abreast. There were two features of the Vatican palace which drew most attention, the Belvedere and the library.

The BELVEDERE collection (see ill. overleaf) was inaugurated by Julius II in 1503 and completed by Paul III in 1543. The first item was the Apollo from Julius' collection at S Pietro in Vincoli, to which were added the Laocoön (1506), Nile and Tiber and 'Cleopatra' (Ariadne) (1512), the Torso (1520s), and the Antinoüs (1543). Johann Fichard provided a list of its statuary in 1536, as did Hentzner (1599), but Thomas in 1549 gave more detail:

Henrik van Cleef, The Belvedere, before 1580. The statues of the two river gods can be seen in the court on the left

the Bishop's banqueting house, called Belvedere, one of the finest buildings that is to be seen, so rich, so pleasant, and of so goodly a prospect that it seemeth almost another paradise. The garden walled about is full of fair orange trees and hath in the midst a goodly fountain with perfect plots in mold of the river of Nile in Egypt and of Tiber that runneth through Rome, besides the images of fine marble of Romulus and Remus playing with a wolf's teats, of Apollo with his bow and arrows, of Laocoonte with his two children wrapped about with serpents, of Venus beholding little Cupido, of the sorrowful Cleopatra lying by the riverside, and of divers other too long to rehearse.

By 1594 Moryson reported: 'these are all locked up, and not to be seene without favour'. Hans Ernstinger declared the Laocoön the first sculpture in Rome.[30]

The Vatican LIBRARY was founded by Nicholas V (1447-1455) and

the new building to house it was created for Sixtus V (1585-1590) by Domenico Fontana, a structure which completely changed the Belvedere by dividing it in half. The earliest detailed description of a visit is by Montaigne in March 1581:

> It is in five or six rooms one after the other. There are many books attached [meaning chained] to several rows of shelves; others are in cupboards which were all opened for me. There are many manuscripts, notably a Seneca and the minor works of Plutarch. Of notable things I saw the statue of the good Aristides, with a beautiful bald head, a thick beard, wide forehead, and an expression full of kindness and dignity; his name is written on the very ancient base [in fact Aristides, the orator of Smyrna]. Also a Chinese book in strange characters, the pages of some material much softer and more transparent than our paper, and because it cannot stand the tincture of the ink, it is written on only one side, and the pages are all double and folded on the side where they are held; they say that it is the membrane of some tree. I also saw a fragment of ancient papyrus with unknown writing; it is the bark of a tree. I saw the breviary of St Gregory written by hand; it bears no evidence of date, but they say that it came down from him, hand to hand; it is a missal almost like ours and was taken to the last Council of Trent to serve as a witness to our ceremonies. I saw a book of St Thomas Aquinas, with corrections in hand by the author himself; he wrote badly, small writing worse than mine. Also a Bible printed on parchment, one of those Plantin recently did in four languages, which King Philippe sent to this Pope, as stated in the inscription on the binding. Also the original of the book which King Henry of England wrote against Luther, and which he sent about fifty years ago to Pope Leo X, inscribed in his own hand, with this beautiful Latin distich, also written by him:
> 'Henry king of England sends to Leo X this work, a testament of faith and friendship.'
> I read the prefaces, one to the pope, the other to the reader: he asked pardon for his military occupations and inadequacy; the Latin is good for a scholar.

My visit was without difficulty; everyone can see it in the same way and take out [i.e. look at] what they want. It is open almost every morning and I was taken everywhere and invited by a gentleman to use it whenever I wanted... [He mentions the librarian, Cardinal Charlet, viz. Gugliemo Sirleto, 1514-1585.] I also saw a Vergil manuscript, in incredibly large writing, in that tall narrow character which we see in imperial inscriptions, about the time of Constantine, somewhat gothic, having lost the square proportions of old Latin writing. The Vergil confirmed what I had always thought, that the first four lines in the *Æneid* are false: this book does not have them. [The verses connected the *Æneid* to Vergil's earlier works and are now omitted.] There is an Acts of the Apostles written in very beautiful gold Greek letters, as fresh as if they were written today. The script is massive and has a solid body, raised on the paper so that if you pass your hand across it [you imagine] you can feel the thickness.[31]

Here are listed many of the treasures which were in the future always to be shown to visitors, notably the manuscripts and the book of Henry VIII which won him the title of Fidei Defensor. Moryson, by contrast, gave only the dimensions of the three (*sic*) rooms, and said nothing of the books. Heinrich Schickhart more credulously thought that the manuscripts of Cicero, Virgil and Ovid were in their own hands.

Hentzner thoughtfully listed other libraries in Rome, at S Maria in Aracœli, S Maria del Popolo, S Maria sopra Minerva and S Agostino, not to omit S Pietro in Vincoli, Santi Apostoli, S Sabina, but these had been partly burned and partly plundered in 1527.[32]

As well as the Farnese and Vatican palaces, a few others caught the special attention of sixteenth century travellers. The QUIRINAL PALACE was begun by Gregory XIII in 1574 and completed under Clement XII in the 1730s. Clement VIII was the first pope to live there, from 1592. It thus made a strong impression on Moryson who visited just two years later:

Upon this said Mountaine of the Horses, the Pope hath a stately Pallace, which a Cardinall of Ferrara built, and he being dead,

Pope Gregorie the thirteenth seased upon it. The staires are very faire, each having his pillar, and the ascent is most easie. I think a fairer Gallerie can hardly be seene, being one hundred and twentie walking paces long. There is a Chamber wherin Pope Sixtus the fifth died. A second wherein Ambassadours are heard. A third in which Cardinals are chosen. The Popes study is very pleasant, and so is the Garden, having many Fountaines, Groves, Labyrinthes, a Rocke artificially distilling water, and many most sweet Arbours.

Hentzner noted various details: the pope's carrying chair 'very useful for the gouty', the spiral staircases, and the water organ which 'gives out a most sweet harmony'.[33]

The other palace which caught attention was the CHIGI, but not the famous one on piazza Colonna, begun only in 1578, for it is described by le Sage in 1518 as exquisite with beautiful gardens and stables for almost fifty horses. This was the villa Farnese, decorated by Raphael. What fascinated le Sage was that the Prince was not married but had had five or six children by a servant.[34] This was true: the Prince was Agostino (1465-1520), who married his mistress the year before he died.

ANTIQUITIES

We have been induced to think that musing on ruins is a particularly romantic pursuit. It is of the greatest interest that two sixteenth century travellers went out of their way to ponder the significance of the ruins of Rome. William Thomas in 1549 drew moral lessons:

When I came there and beheld the wonderful majesty of buildings that the only roots thereof do yet represent, the huge temples, the infinite great palaces, the unmeasurable pillars – most part of one piece, fine marble, and well wrought – the goodly arches of triumph, the bains, the conduits of water, the images as well of brass as of marble, the obelisks, and a number of other like things, not to be found again throughout a whole

world, imagining withal what majesty the city might be of
when all these things flourished, then did it grieve me to see
the only jewel, mirror, mistress, and beauty of this world, that
never had her like nor (as I think) never shall, lie so desolate
and disfigured that there is no lamentable case to be heard or
loathsome thing to be seen that may be compared to a small
part of it. Nevertheless, when I remembered again the occasions
whereof these glorious things have grown, what numbers of
wars the Romans have maintained with infinite bloodshedding,
destructions of whole countries, ravishments of chaste women,
sack, spoil, tributes, oppression of commonwealths, and a
thousand other tyrannies, without the which the Romans could
never have achieved the perfection of so many wonders as mine
eye did there behold, then perceived I how just the judgment
of God is that hath made those antiquities to remain as a foul
spoil of the Roman pride and for a witness to the world's end of
their tyranny. So that I wot not whether of these two is greater:
either the glory of that fame that the Romans purchased with
their wonderful conquests, or their present miserable state with
the deformity of their antiquities.[35]

The ruins also received very particular treatment in Joachim du
Bellay's *Antiquités de Rome* (1558). He sang of Rome's glory with a
'sacred horror'. Where others celebrated the seven wonders of the
ancient world, he would celebrate the seven hills of Rome, the 'seven
miracles of the world'. The visitor who searched for Rome, however,
could now find nothing of her:

New arrival, who seek Rome at Rome
And see nothing of Rome in Rome,
These old palaces, these old arches which you see
And these old walls, this is what is called Rome.

See that pride, that ruin, and how
The one who brings the world under her control,
To overcome everything, sometimes overcomes herself,
And becomes the victim of time, which destroys everything.

Rome is the only monument of Rome,
And only Rome has conquered Rome.
Only the Tiber, fleeing to the sea,

Remains of Rome. O inconstant world!
What is solid is destroyed by time,
And what is fleeting resists time.

(*Sonnet 3*)

Rome is no more: and if architecture
Recalls still some shadow of Rome,
It is like a body by magic
Called forth from the tomb by night.

(*Sonnet 5*)

It is only Rome's literature which keeps her alive.

Sacred sights and holy ruins,
Who alone retain the name of Rome,
Old monuments who still uphold
The honour of some many divine souls now dust,

Triumphal arches, 'points' rising to heaven,
Who astonish even the heavens to see you,
Alas, slowly you become ashes,
The people's fable and public plunder!

And though for a time the buildings resist
Time, time will finally
Raze works and names.

(*Sonnet 7*)

Time would also finally put an end to du Bellay's pain. Rome's sin was her pride (Sonnets 12-13) and the means of her ruin was civil war (Sonnets 10, 25, 31), and her own weight overwhelmed her (Sonnet 20). Once Rome gathered the treasures of the whole world to adorn her:

Oh profound marvel!
Rome living was the ornament of the world,
Dead she is the tomb of the world.
 (*Sonnet 29*)

She had, in fact, returned to her beginnings: just as she had once been
ruled by shepherds, so now once again she was ruled by one (Sonnet 18)!

For us the FORUM is the heart of classical Rome. It presented a very
different view in the sixteenth century as the renowned engravings of
Martin van Heemskerck attest (see ill. opposite). Johann Fichard
(perhaps drawing on Bartolomeo Marliani as well as his own obser-
vations) in 1536 noted the three columns of Caligula's bridge from
Palatine to Capitol (in fact, the temple of Castor and Pollux), the
temple of Faustina, the temple of Vesta (S Maria della Grazia), the
temple of Romulus (S Teodoro), the temple of Castor and Pollux (SS
Cosma e Damiano), the temple of Saturn (S Adriano), the temple of
Peace (the Basilica of Maxentius), and the Arch of Titus.

For Arnold von Buchell in 1587-1588 there were few monuments to
mention: the Arch of Severus, and the pedestal of an equestrian statue
of Constantine, but he was unusual in that he also listed some inscrip-
tions: Næratius Cerialis (*CIL* 6.1744) and Severianus (6.317). The
temple of Antoninus and Faustina he placed in the Forum of Cæsar!
The temple of Saturn was as usual S Adriano – where records of the
names of all citizens were kept. And the temple of the deified Vespa-
sian he identified as that of Capitoline Venus.

A few further notes were offered by Jacques de Villamont in 1588-89.
The BASILICA OF MAXENTIUS still had one column remaining (it was
removed to Santa Maria Maggiore in 1613-1614), and in bad weather
horsemen exercised their mounts under the vaults (see ill. p. 74).
Besides that, he listed the temples of Concord, Venus, Minerva and
Antoninus, and the Arch of Septimius Severus. Fynes Moryson in 1594
mentioned various buildings in the Forum: the temple of Romulus
(S Cosma), 'the temple and pallace of the Emperour Marcus Aurelius
and his Empresse Faustina' (i.e. the temple of Antoninus and Faustina)
and the temple of Vesta near S Maria Liberatrice (correct), the three
pillars of Caligula's 'Marble Gallerie' (either the temple of Castor or

Martin van Heemskerck, The Forum in the 1530s. On the left are the three columns of the temple of Castor and Pollux, then the eight columns of the temple of Saturn, the three of the deified Vespasian with the mediæval Capitol (Palace of the Senators, on the site of the ancient Tabularium) behind, the column of Phocas, and the Arch of Septimius Severus

of Vespasian), Lake Curtius, the Arch of Severus for his victories over the Parthians, the 'fairest Arch, next to that of Constantine', the Rostra (location unknown), the Milliare Aureum (Golden Milestone, from which all Roman distances were measured) at the foot of the Capitol, the treasury which he obviously equated with S Adriano without naming it ('a Church with a brasen dore'). Nearby, finally, used to be the statue called Marforio, Pasquino's correspondent, 'of late taken up by Pope Clement the eighth out of the valley, and placed upon this Mount' (the Capitol). It is obvious that the visible remains were all well known, but mostly wrongly identified. The correct identifications were to be the fruit of another three centuries of research.

Hans Ernstinger in 1595 also commented on the remaining column in the Basilica of Maxentius and the fact that only three vaults remained (as they still do today), with great pieces of the others lying where they had fallen. His fellow-German, Heinrich Schickhart, four years later

repeated mediæval legend: that every year on Christmas night another piece falls. Schickhart was, however, a sceptic: he checked before and after that date and found that there had been no change![36]

Everyone commented upon the ARCHES in the Forum and nearby, with the palm being given variously – and paradoxically – to that of Severus or Constantine. Thomas in 1549 stated that the reliefs on the Arch of Constantine were 'battered and almost defaced by the weather' and that therefore the Arch of Severus was 'the fairest of all the other', the reliefs 'finely graven' and the 'title in fair Roman letters'. Moryson, as we have seen, at the end of the century declared for the Arch of Constantine. At the same time Ernstinger with more taste drew attention to the Arch of Titus for its beautiful columns, cornice, reliefs and inscription[37] (note that what we know is a restoration of 1820-1824).

Overlooking the Forum was the PALATINE, site of centuries of imperial residence and acquired by the Farnese in the 1540s and laid out as gardens. Few visitors made any detailed comment, for reasons which Fichard made clear: the ruins were very extensive – 'arches and concamerations' – but no plan could be discerned.[38]

Etienne du Pérac, Basilica of Maxentius, *1560s. Note the remaining column to the right of the left-hand vault*

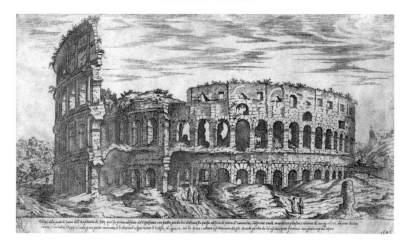

Etienne du Pérac, Colosseum, *1560s*

Near the Forum and Palatine was the mighty FLAVIAN AMPHITHEATRE, long commonly known as the Colosseum. Fichard stated that it was 'so magnificent that no one can ever be satisfied with its contemplation', and recorded that when Charles V reached it on his visit 'he stopped as if amazed and long regarded the majesty of the work'. Its capacity he calculated as 87,000. Thomas also was enthusiastic: it was

> yet standing, one of the perfectest to be seen amongst all the antiquities of Rome, and may indeed be accompted one of the wonders of the world. For though part of it be already fallen down and the rest decaying daily, yet it is not so defaced but that you may see perfectly what it hath been, as well for the marvellous height, great circuit, and fair stone, as also for the excellent workmanship and proportion.

He calculated the seating capacity to be 100,000. This was obviously another matter where guides might be sensational. Ernstinger reported the capacity as 190,000, and stressed that every spectator was able to see as well as any other. Paul Hentzner scaled this down to 150,000, but was still 'stupefied' (*exstupafecti sumus*) at the size of the circuit.

75

Henri, duc de Rohan, at the same time as giving the lowest estimate (85,000), explained the vulgar name of the building as derived from the statue which stood *within*.[39]

On the other side of the Palatine the SEPTIZONIUM overlooked the Circus Maximus. Moryson was five years too late:

> Neere this place (the Circus) were of late three rowes of pillars, one above the other; and this monument is called il Settizonio di Severo, of seven souldiers engraved thereupon, and is thought to be the sepulcher of Septimius Severus, but the Pope Sixtus the fifth pulled it down.[40]

This was done in 1588-89 by Domenico Fontana; we may hope that the motive was safety rather than cheap building material, but the archives indicate a strong interest in the latter: hundreds of blocks of marble and travertine used under the Vatican obelisk, for the restoration of the Column of Marcus Aurelius, and for the tombs of Sixtus V and Pius V.

The other main forum of classical Rome was the FORUM BOARIUM, or Cattle Market (see ill. opposite). Moryson was one of the few to pay much attention to this:

> At the foot of the bridge S Maria, as you come out of the Iland and enter into Rome, is the ruined house of Pontius Pilate and opposite to that is the most ancient Church consecrated to the Moone [S Maria Egiziaca, now taken to be the temple of Portunus, the god of harbours] and upon the other side another to the Sunne [S Maria del Sole, long taken to be originally a temple of Vesta, but now thought to be a temple of Hercules].

Attention was already paid also to S Maria, 'called the Greeke Schoole', namely in Cosmedin, with its drain cover universally known as the Bocca della Verità. Villamont claimed that the drain represented Rhea or Cybele. As for Pilate's House, so called, Thomas Nashe was very direct: 'I saw Pontius Pilate's house and pissed against it.' Fichard informs us that it was an insult in Rome to tell someone 'go to Pilate's house'![41]

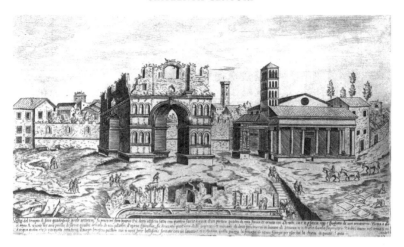

Etienne du Pérac, Forum Boarium, *1560s. The Arch of Janus is central, with S Maria in Cosmedin on the right*

Nearby was the AVENTINE hill. Villamont was simply repeating mediæval legend in stating that adjoining S Saba was a sarcophagus containing the ashes of Vespasian and Titus.[42]

The great BATHS OF DIOCLETIAN (see ill. overleaf) overwelmed Fichard: they were huge, like a number of churches combined, so that he could not conceive of their form. 'One may admire rather than understand such places,' Buchell in 1587 almost wept over the state of their ruin. Moryson in 1592 was much more positive:

> A man cannot sufficiently wonder at the ruins of Diocletian's Baths, by which it seemes they were of incredible greatnesse; and they report that this Emperor compelled many thousands of Christians to worke upon this building for many yeeres. Under the earth are gates and divers passages of unknowne extent. Upon these Bathes Pope Pius the fourth in the year 1561 built the Church Saint Mary of the Angels, and with the consent of the people of Rome gave it to the Carthusian Friers. In the roomes of this Bath Pope Gregory the thirteenth in the year 1575 built a Granary for Corne.[43]

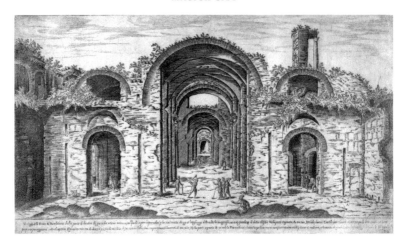

Etienne du Pérac, Baths of Diocletian, *1560s*

It is striking that Moryson does not mention the name of Michelangelo here.

The IMPERIAL MAUSOLEA could not fail to attract attention, since that of Hadrian was the main fortress of the city. Fichard noted only two things: that the pope's bathhouse was decorated with paintings of naked women, and that the castle could hold only a small garrison. Villamont was interested in the pine-cone from the summit, now in the Vatican 'under a beautiful tabernacle supported by eight porphyry columns'. Moryson gave a good outline of the history of the castle: built by Boniface VIII (1294-1303), garrisoned by Alexander VI (1493-1503), who also built the escape corridor from the Vatican to it, and decorated with fine chambers by Pius IV (1559-1565). Most importantly he indicates what visitors were shown: 'the head of Adrian, the statue of Saint Peter, a bunch of Grapes of brasse, the place where the cardinal Caietan escaped out of prison, and a Trap doore where prisoners are let down into a dungeon'.[44] This is an example of fiction: the Caetani who *attempted* to escape was the brigand Cesare Caetani, executed in 1583.

The remains of the Mausoleum of Augustus were much more ruined and concealed. Fichard in 1536 reported that a broken obelisk was

lying between it and the Tiber. This was the obelisk found in 1519 and set up on the Esquiline by Sixtus V in 1587. Moryson gave a more comprehensive account:

> Near to the Church of Saint Rocco, lies the Sepulcher of Augustus, called the Mausoleum, the ruines whereof yet remaine. He built it for himselfe and other Emperours, of a round forme, and adorned it with stones of marble and Porphery, and like pillers and Obeliskes, placing his own statue of brasse upon the top, so as they daily dig up goodly Images out of the Cave and Garden neere it. The Pinnacle of this Monument Pope Sixtus the fifth removed to the Church of Saint Marie Maggiore, and this monument with the Grove planted about it, reached from the Church of Saint Rocco, to Saint Marie del popolo.[45]

The other tomb which attracted most attention was the PYRAMID OF CESTIUS, the so-called Pyramid of the Epulones (see ill. overleaf). Schickhart strangely thought that it had been standing for 1200 years,

Etienne du Pérac, Mausoleum of Augustus, *1560s. It has been transformed into the Soderini gardens, but the broken obelisk can be seen on the right*

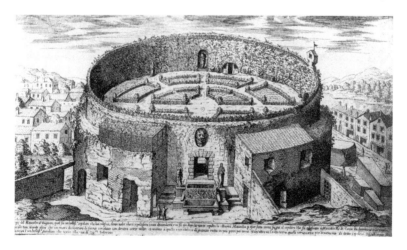

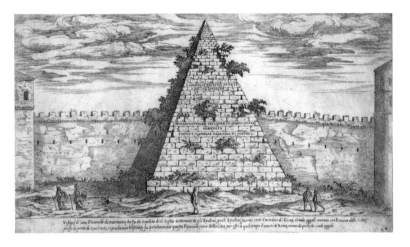

Etienne du Pérac, Pyramid of Cestius, *1560s*

but by his time it was slightly more than sixteen hundred years old. He was told that it was the high priest's grave, but he knew that it was not, by the inscription. The mention of Cestius as *epulo* (one of a board of seven priests in charge of banquets for the gods), Schickhart realised, was responsible for the idea that it was the common grave of this priesthood.[46]

Nearby was the TESTACCIO. Jacques le Sage was told that the pots which composed it were the vessels in which tribute had been brought to Rome from the whole world. Thomas expatiated on the same theme, but then revealed that 'learned men allow not this vulgar opinion, thinking it hath grown rather of the broken pots that have been thrown out of the seventh college of potters founded by Numa Pompilius'. Thomas himself inclined to a more significant reason: 'me seemeth it half incredible that the Romans would suffer so fair a ground to be occupied with potsherds unless there were some further purpose', but then admitted that he could not imagine what it was. He had ridden up one end of the hill and down the other.[47]

As well as the three famous arches: Titus, Severus and Constantine, there was another arch in sixteenth century Rome, on the via Flaminia by the church of S Lorenzo in Lucina: 'the arch of Domitian, as they

say (wrote Thomas), and is now called L'arco di Tripoli – nothing of beauty comparable to any of the rest'.[48] This was better known as L'ARCO DI PORTOGALLO (see ill. overleaf) from the nearby embassy of that nation, and belonged to Hadrian or Antoninus Pius. It was to be demolished in 1662, and its very beautiful reliefs are now in the Capitoline Museum.

Much in evidence were two special classes of monuments: columns and obelisks. Thomas had climbed the COLUMN OF TRAJAN and declared (*recte*) that it contained 185 steps inside and 45 windows. He judged the reliefs so fine 'that it should seem impossible to paint a thing better'. This also had been transformed by the end of the century, as Moryson noted:

> It is seated in a little market place, and was consecrated by Pope Sixtus the fifth to Saint Peter, whose image of brasse guilded over, is set upon the top thereof… The victories and actions of Trajan are ingraven upon it, and his ashes were of old placed in the top [*sic*], and here also was the horse of Trajan.

G. B. Falda, The Column of Trajan, *1660s, showing it as left by the clearance of Sixtus V at the end of the previous century*

CHIESA DEDICATA ALLA MADONNA DI LORETO DE FORNARI NELLA REGIONE DE MONTI.
Architettura di Antonio da San Gallo eccettuando il lanternino della Cupola et le Porte laterali di Giacomo del Duca.
1 Colonna Traiana 2 Palazzo et Corridore di S.Marco. 3 Monasterio di Santa Eufemia.

G. B. Cavalieri, Arco di Portogallo on the Corso, *1569*

Moryson stated that the stairs were 223, but did not boast that he had climbed them. Obviously he had not. Buchell recorded that the installation of the statue was celebrated with a great 'bombardment' from Castel Sant'Angelo.[49]

The COLUMN OF MARCUS AURELIUS was almost universally ascribed to his predecessor Antoninus Pius. It was 'much more decayed than Trajan's pillar, for it is almost cleft from the top to the base, so that if it be not looked into the sooner (as I think it shall not) it must needs fall'.[50] This column had suffered severely in the great earthquake of 1349, and contrary to Thomas' pessimism, it was heavily restored by Sixtus V in 1588.

The situation regarding the OBELISKS for which Rome, among modern cities, was to be famous, was very different before the 1580s. Thomas in 1549 rightly wondered at the enormous work of their extraction from the quarries.

In effect, there is but one of them standing, which is in the *Vatican* on the south side of St Peter's Church, called *la Guglia* (the spire), being seventy-two foot high of the very stone itself, besides the base and four great lions of marble that it is set upon, and hath on the top a great ball of brass gilt, with the ashes of Cæsar in it, as some hold opinion. Octavian August brought two very great ones from Heliopolis in Egypt; the one whereof, being 122 foot high, brake in two pieces as they would have erected it, and the other, of 110 foot, lieth in Campo Marzio. There lieth one in Girolo, that sometime was Sallustius' garden, – and two other lie beside the Church of St Roch, the one of them in the highway. The other two are but small and seem rather pieces than whole stone; the one is in the garden of Ara Cœli in the Capitol and the other is in the street of San Macuto.[51]

Here we find the obelisk in piazza San Pietro still in its original position south of the church (see ill. overleaf). How strange that several years after its transfer to the main piazza (1586), Buchell in 1587-1588 described this obelisk as lying broken on the left of the church (its old

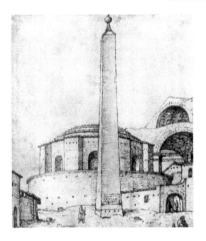

Martin van Heemskerck, Detail of the Vatican obelisk, *1530s, in its original position, south of the basilica, by S Andrea*

position).[52] Augustus did indeed bring two obelisks from Heliopolis in 10 BC, one for the Circus Maximus (now in piazza del Popolo, but not recovered until 1587), the other for his sundial in the Campus Martius (still in Montecitorio, discovered in pieces in 1512). No accidents are known to have occurred in Augustus' time. The Girolo, Sallust's garden, was near the porta Salaria: this is the obelisk erected at S Trinità dei Monti in 1789. The two by S Rocco obviously come from Augustus' mausoleum, one erected behind S Maria Maggiore in 1587, the other on the Quirinal in 1786. The obelisk on the Capitol came from the Isæum and was erected in the thirteenth century, the other came from the same place and is now in front of the Pantheon (1711), but in the sixteenth century was by S Macuto near piazza Colonna.

There were some categories of monuments, on the other hand, of which little trace remained. As Thomas lamented,

> Many of these theatres have been in Rome, but the most notable were these three of Pompeius, of Marcellus and of Cornelius Balbus, of which there remaineth so little memory at this day that almost no man can tell where they stood.

The Theatre of Marcellus was certainly identifiable, even though it was now an Orsini palace; that of Pompey can still be traced in the outline of the streets in the Campus Martius; that of Balbus in Thomas' time would have been untraceable. There were in fact remains of other theatres to be seen by the attentive, such as the 'Amphiteatrum Castrense' by Santa Croce in Gerusalemme, called by Fichard

the theatre of St Taurus, following Marliani, 'but I now regret my negligence and did not visit it'.[53]

There were two classical monuments apart from the Colosseum which were indispensable for every visitor to see. The only surviving bronze equestrian statue was that of MARCUS AURELIUS, although the identity was not yet sure, which had stood in the Lateran until Michelangelo moved it to the Capitol in 1538. Observe the confusion of Thomas:

> But of all these (equestrian statues) there are now none to be seen, saving one of brass on horseback at St John Lateran, which some ascribe unto Marcus Aurelius Antoninus, some to Lucius Verus, and some to Severus, and another there is in the Capitol called il Gran' Villano!

Thomas has, in other words, duplicated the unique statue, referring to it in both its old and new position. How unflattering that, apart

Antonio Lafréry, The piazza of the Capitol with the statue of Marcus Aurelius
(after Michelangelo transferred it there from the Lateran in 1538)

Hendrik van Cleef, The Pantheon and its piazza before the 1580s. *Notice the many modern buildings attached to the portico on the right*

from its various imperial identifications, it was known as 'the big peasant'! By the time of Villamont (1588) it was reported that the Venetians had offered to buy the statue for its weight in gold.[54]

The most perfectly preserved classical monument was the PANTHEON. Montaigne, paradoxically, does not seem to have mentioned it, but must have visited it. Villamont called it 'the most magnificent of all the Romans built'. Ernstinger was much taken with the door and the oculus, and the columns in the portico so large that 'three men were needed to enclose them': we may imagine the *ciceroni* encouraging the visitors to conduct the experiment. Schickhart dismissed the fable that rain never entered by the oculus (9 m in diameter): he saw it pouring in. Buchell provided the clearest statement that three columns were missing from the porch.[55]

Such were the comments on the major monuments made by sixteenth century visitors and which go beyond mere guide book

details. It was already a strong fashion at this time, at least for young German princes, to make a tour to 'improve' themselves. The itinerary of Prince Karl von Kleve, guided by Stefan Pigge in 1574-5 is preserved: it included the Colosseum, the Pantheon, baths of Caracalla, Constantine and Diocletian, triumphal arches, columns (Trajan and Marcus Aurelius), pyramids, obelisks, the Horsetamers on the Quirinal, and river statues (such as the Tiber and the Nile on the Capitol).[56]

COLLECTIONS OF ANTIQUITIES

The famous collections of the Vatican Belvedere and the palazzo Farnese have already been described under 'palaces'. There were many others. The earliest public museum in the world was the CAPITOLINE, opened in 1471 by Sixtus IV. In 1536 Fichard recorded the river gods Nile and Tigris, the huge bronze head, the gilded bronze Hercules from the Forum Boarium, the colossal leg, foot and head, reliefs of Verus' and Marcus Aurelius' Parthian or Dacian wars (from S Martino), the Satyr, and the boy extracting the thorn (the 'Spinarius'). Villamont claimed that the last statue represented Æneas! Buchell mentioned the Marius togatus, Flora, Hadrian, fragments of the colossus, the funerary urn of Agrippina the Elder, the columna rostrata of Duilius, the she-wolf (perhaps the most famous exhibit, and one of the foundation items), the inscription of Pertinax (*CIL* 14.251), Juno, Urania, and Constantine; and later two servants in bronze (the 'Zingara' and Camillo) and the Spinarius. Ernstinger listed the she-wolf, Jupiter Minerva and Ceres, the gilt bronze Hercules, the gilded Æneas, the bronze young man standing, the Spinarius, various busts, gigantic fragments, the bronze head of Commodus, and the *fasti* (lists of consuls). Henri of Rohan added the tomb of Severus and his mother Mammæa (a sarcophagus) and the head of Brutus. The most complete account was provided, however, by Moryson:

> Within the Capitol or Senate house it selfe, we did see many most faire antiquities, namely, statuæs [*sic*] erected to *Iulius*

Cæsar, to *Octavius*, to *Augustus*, and to *Marius* seven times Consull; the Image of *Hercules* of brasse guilded over, which was digged out of the ruines of the Temple of *Hercules*, in the time of Pope *Sixtus* the fourth, also the Images of *Hercules* his sonne, of *Iupiter*, of *Minerva*, and of *Ceres*, all of marble, a head of brasse upon which was engraven *Iunius M. Brutus*; two statuæs [*sic*] of yong men, whereof one standeth upright in the habite of a servant, the other being naked, hath one foot above the other knee, with a needle in his hand to pull a thorne out of it, and both are of brasse guilded over, and of admirable beauty. The Image of *Aventine* digged out of Mount *Aventine*, a brasen image of a shee wolfe which gave sucke to *Romulus* and *Remus*, and it was made of fines imposed upon usurers, a brazen statua of *Æneas*, a brasen statua erected to Pope *Sixtus* the fifth, for repressing the banished men, another of marble erected to Pope *Leo* the tenth. We did see in the hall of Iudgement within this Capitoll, the statuæs of marble erected to Pope *Gregory* the thirteenth, to Pope *Paul* the third, and to King *Charles* made a Senator of *Rome*. Upon the sight of these, a Gentleman told us, that by a Law he was made infamous, who should make mention of erecting a statua to any Pope while he lived. In the foreyard of the Capitoll we did see the fragments of an huge Colossus, and upon the wall neere the staires, the Triumphs of *Marcus Aurelius*, engraven in square marble stones. There we did also see marble fragments digged up under the Arch of *Settimius*, upon which were engraven the names of Consuls, Dictators, and Censors, and under the very porch, the head of an Emperour, the pillar of Navall fights, the sepulcher of *Settimius Alexander Severus*, and of his mother *Iulia Mammea*, brought hither from the field of *Fabricius*; the image of *Minerva*, certaine images of brasse of the Monster *Sphynx*; the bones intombed of *Agrippina* neece to *Augustus*, and wife to *Germanicus*; the Image of a Lyon devouring another beast, and certaine ancient vessels to keepe wine.[57]

The sixteenth century travellers also mention various aristocratic collections. Fichard saw that of CARDINAL ANDREA DELLA VALLE, 'a treasury of antiquities', including a porphyry she-wolf with twins;

the garden seemed to contain everything found in Rome as well as being most select.[58] The great collector was Cardinal Andrea della Valle (1463-1534), whose palace was by the Baths of Agrippa in the Campus Martius, and his collections were illustrated by van Heemskerck.

Fichard also mentioned the COLOCCI collection, but directed his readers to Marliani (Marliani, *Antiquæ Romæ topographia*, 1534). The collection had been formed by Angelo Colocci da Tesi (1474-1549) in his house by the Collegio Nazareno and was famous for its inscriptions, but also had a statue of Socrates embracing Alcibiades, of Jupiter Ammon, of Proteus and Æsculapius, and an equestrian group of Scyphius and Arion.

Ernstinger drew attention to the SAVELLI collection in the theatre of Marcellus: some eighty statues or busts in marble. Buchell was more explicit: the figures of twelve Cæsars (presumable *the* twelve), twelve deities, Hadrian, the dying Cleopatra, a hermaphrodite, a togaed man in porphyry with face, hands and feet in marble, and naked Greek statues.[59]

The two private collections, apart from the Farnese, which attracted most notice, however, were the MEDICI and the Mattei. Cardinal Ferdinando Medici (1549-1609), later Grand Duke, in 1576 bought the palazzo Ricci on the Pincian and there installed his art collection. A very comprehensive description was offered almost twenty years later by Moryson:

> And this Pallace was rich & stately, the staires winding so artificially, as it was a beautiful sight to look in a perpendicular line from the top to the foot, and upon the staires was a faire statua of *Apollo*. Hence there was a Gallery open on the sides towards the Garden, full of beautifull Images, of Lions, a shee-Wolfe, a Ramme, all of white Marble, with other Images, and very faire pillars. And the first Garden had onely flowers; the second in the upper part, had a sweete Grove, and the lower part was full of fruit trees. There was a Fountaine with a brasen Image of *Mercurie* upon it. Upon a Mount called *Pernasso*, were many Images of white Marble, of *Pegasus*, of the Muses and one of *Cleopatra*, fairer then [*sic*] that I saw in the Popes Garden, with

two Images of *Cerberus*, and another monster. There were two
large Cesternes of Porphery. And in a Chamber were the Images,
of a Satyr, a Nimph, and a Gryphon. Lastly, in the Grove were
staires paved with carved Marble, with figures of fishes, and
there was a most faire statua of *Europa* sitting upon a Bulles
backe. The outside of the Grove was all of Firre trees, which are
greene in winter, but the inside had most pleasant walkes among
rowes of many other kindes of trees. In this Grove was a most
sweete Arbour, having foure roofes, and as it were chambers,
one above the other, the first whereof is twentie staires from the
ground, whence lay a most large and most faire Gallery of stone,
under which was a most pleasant solitarie walke, betweene two
walles, all set with Orangetrees, and like fruit.[60]

Ernstinger was impressed with the luxuriously furnished rooms:
tapestries, paintings, marble tables, but of the antiquities he identified
only the Arrotino (the knife-sharpener, 'one of the best art works in
Rome', part of a group of Apollo and Marsyas); in the pleasure garden
the walls were laden with oranges. Schickhart also singled out the
Arrotino with similar comment. Hentzner supplemented Moryson's
list of the statuary: Niobe, Diana, Flora, the weeping Niobids, Jupiter,
Bacchus, the Sybil and her books, Juno, Pallas, Cleopatra, Manlius
Capitolinus, Apollo and the muses.[61]

The other major collection was the VILLA MATTEI on the Cælian,
founded by Ciriaco Mattei (1545-1614). Ernstinger drew attention to
the pleasure gardens, with their orange trees, laurels, cherries, and
olives – like a wood, with statues of many animals, life-size and
coloured, producing the illusion of reality. A much more detailed
account occurs in Schickhart. The alleys were wide, the walls laden
with orange trees which bore fruit even in winter. The garden was
thick with laurel and cherry trees, in which many animals life size and
in colour were placed: deer, geese, pigs, dogs and lynx, standing,
sitting or reclining. There was a small pleasure house, and the walks
were wonderful in summer for their air and coolness. In the great
square was the obelisk (given, in fact, to Mattei from the Capitol by
the Conservatori in 1582). The 'pleasure house' contained many
portraits in oils, a bust of Cicero, a naked Cleopatra, and a reclining

man. In sum, neither cost nor effort had been spared. Schickhart knew something most interesting, namely that Ciriaco had laid down in his will that unless his heirs spent 6,000 *scudi* p.a. on the gardens, they were to go to the pope![62]

CONTEMPORARY ROME

Thomas Nashe in his romance *The Unfortunate Traveller* drew attention to what many later travellers also noticed: a preference for ecclesiastical-style garb in the case of the affluent: 'he is counted no gentleman amongst them that goes not in black'. Men wore their hair short. According to Nashe, no unblunted rapier could be carried. Paul Hentzner stated that no one was allowed to wear a sword in Rome at all. Henry Wotton recorded that in 1592 a public edict banned any weapons by day or night, including knives. Even 'a box on the ears given in the suburbs' was a capital offence. Jacques de Villamont recalled seeing two men in 1588 or 1589 intent on a duel on ponte Sant'Angelo, but agreeing to throw their swords into the river and then falling to with fists.[63]

Montaigne gives us the most detailed account of FOOD in this century:

> there is less fish than in France: notably their pike are worthless, and they are left to the people. Soles and trouts are rare, barbels are very good and much bigger than in Bordeaux, but expensive. Dory here are highly prized and mullet larger than ours and a little firmer. The oil is so excellent that the sour taste which remains in my throat in France when I have eaten a lot of it I don't have here at all. Fresh grapes are eaten here all year long, and still at this time (March) there are very good ones hanging on the trelisses. Their mutton is worthless and little valued.

Further notes on food and drink are provided by Arnold von Buchell. 'The Romans are moderate in dress, proud in character, sparing in food, as the Italian way.' Roman wine he declared

inebriating and liver-inflaming, Alban excellent in summer, Cærullan, perhaps old Cæcuban, superior to other whites in smoothness. In summer they ate beef, veal, goat and sheep; in winter also pork. They ate a lot of salad dressed with vinegar, broths and 'starters', which they called minestrone and antipasti, tripe, vermicelli (maccheroni in Sicily), cabbage, chickpeas, beans, and Neapolitan broccoli. There were various kinds of excellent fruit – 'figs, grapes, chestnuts, apples, pears, nuts, almonds, yellow African apples, oranges and olives'.[64] It is obvious that the classic Italian diet was already well established.

To judge from Hentzner, in 1594 there were only four bakers in Rome: at the Pantheon, in the ghetto, at S Lorenzo in Damaso, and by the Ælian bridge. The general market was in the piazza Navona.[65]

All travellers commented on the WATER of the Tiber, and how unattractive it was at first sight, because of its muddiness. Heinrich Schickhart noted that despite the many fountains the Romans generally preferred the river water for cooking and drinking and actually bought it from water carriers. In connection with water seems the logical place to mention the BATHS. Montaigne was taken with the desire to try them, and went to 'those at San Marco, which are thought the most noble. I was treated in a mediocre way, but by myself and with all respect of which they were capable. The custom is to go there with women friends, if you wish, who are massaged with you by the servants. I learned that the chemical and ointment with which the skin is removed, by applying it for less than quarter of an hour, is composed of quick lime and yellow arsenic, diluted in lye, two parts lime and one part arsenic.'[66]

The two most interesting sections of the population remained always the JEWS and the courtesans. Montaigne showed a kind of interest in the former and visited the synagogue, as well as witnessing a circumcision. It was Paul IV who won infamy by establishing the ghetto in 1555. Montaigne heard

> their prayers where they sing without order, like the Calvinists, certain lessons of the Bible in Hebrew adapted to the calendar. They have equal cadences of sound, but an extreme discord, because of the confusion of so many voices of all ages; for

The ghetto (Nolli's map, 1748). 1. Piazza Giudea outside the ghetto; 2. Same, inside; 12. S Gregorio; 19. Piazza in Pescheria; 20. S Angelo in Pescheria; 36. Vicolo dei Cenci. The boundary in sum ran away from the Tiber in line approximately with via Arenula, along SE to S Angelo in Pescheria, and back to the river behind the Theatre of Marcellus

children, from the earliest age, join in, and everyone understands Hebrew indifferently. They pay no more attention in their prayers than we do in ours, talking meanwhile of other matters, and not showing much reverence for their mysteries. They wash their hands at the entrance, and for them it is execrable to remove their hats, but they lower their heads and bend their knees when devotion requires. They wear on their shoulders or heads certain cloths with fringes; it would be too long to describe everything. After dinner in turn their doctors lecture on that day's Bible passage, translating into Italian. After the lesson another doctor chooses some of the audience, two or three at a time, to argue against the one who has just read, on what he said. The one we heard seemed very eloquent and very lively in his argument.[67]

As for the COURTESANS, Wotton recorded the hypocrisy of Clement

VIII who banished all these women to piazza Padella or hortaccio (halfway along via Giulia, now demolished); the governor made 15,000 *scudi* out of his artful handling of the matter, and the women were said to number more than 40,000. They were further forbidden to wear any silk or gold or to cut their hair in the fashion of Roman women. Buchell reported the annual tax on them as 40,000 ducats. Fynes Moryson noted the Monastery of the Convertite near S Silvestro for such women who repented and became nuns.[68]

WOMEN especially caught the attention of Buchell, although the intrusion of classical allusions is suspicious. When girls reached twelve years of age they were kept at home and rarely went out. Marriages were arranged by parents, and he goes so far as to say that often the bride entered her new home with a man as yet unknown to her. Anyone above the lowest class went about in public in a vehicle, with much make-up and hired clothes and attendants (but he is quoting Juvenal *Satire* 6!). To kiss an unmarried girl or a matron excited suspicion, even danger. And having dilated on the number and influence of courtesans, especially under Pius V (1566-1572), Buchell declared that most Italians favoured 'Venus in reverse'.[69]

The main events in the year for the Roman population were the great Church festivals. Let an intelligent observer record CARNIVAL, an appropriately mindless mass entertainment, with other possibilities thrown in:

> at Rome this year it was more licentious, with the Pope's permission [Gregory XIII] than it had been for several years previously; we found, however, that it was no great thing. Along the Corso, a long street in Rome, named for this reason, they made race four or five children, as many Jews, as many old men completely naked, from one end to the other. You had no pleasure except seeing them pass the spot where you were. They did the same with horses, ridden by children who whipped them, and asses and buffalo spurred on by horsemen. For all the races a prize was offered, called el palo, pieces of velvet or cloth. Gentlemen, in a certain part of the street where the ladies could see more, ran the quintana (jousting at a mannequin), and with

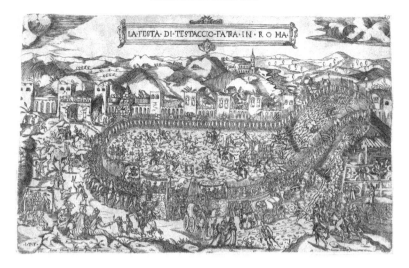

Vincenzo Luchini, The Testaccio festival, 1558, showing the jousting and hurling down the slope of carts full of pigs

much grace; for there is nothing this nobility so generally can do well as ride a horse.

Another appalling example of Carnival entertainment is mentioned by Henri of Rohan in 1600: at Testaccio, bulls pulling carts of Jews were sent plunging down the hill; this had recently been abolished 'with reason'.[70]

The government notoriously controlled both minds and bodies of both citizens and visitors. The first was achieved by the CENSORS AND CUSTOMS service. The most famous case of this in the literature of sixteenth century travel was the confiscation from Montaigne of his own Essays, as he entered Rome. They were returned to him more than three months later by the magistro del sagro palazzo, who was the censor (although Montaigne does not name him, he was the Dominican Sisto Fabri, 1541-1594). Not knowing French, he handed them over to a French friar to check, and now gave Montaigne the critic's comments, leaving it to him to make the corrections which his conscience directed! The critic singled out his use of the word 'fortune',

his reference to heretical poets, his defence of the emperor Julian, his criticisms of the cruelty of punishment beyond the death penalty, and his views on the aims of education. Montaigne stated that these were his opinions, not meant to be errors, and the censor actually defended him vigorously, but Montaigne lost his copy of *La République des Suisses*, Paris 1577, because the translator was a French Protestant![71]

The control over the body was demonstrated by the singular brutality of PUBLIC EXECUTIONS. Montaigne witnessed one in January 1581; it must have been at ponte Sant'Angelo, although he does not say so. The man hanged was a robber and bandit, but then he was hacked into quarters. Montaigne noted that it was at this savagery that the mob cried for pity. Under the severe government of Sixtus V (1585-1590) the death penalty was widely applied. Villamont gave examples. Count Giovanni Pepoli of Bologna was strangled for admitting an outlaw to his house, the nephew of Don Piero de Navarre was hanged at ponte Sant'Angelo for hitting a Swiss Guard, as was a mother for prostituting her daughter, while the seducer, a French nobleman, managed to flee. The heads of bandits were exposed on that bridge.

There was one particularly barbaric punishment, *la corda*. Buchell in 1587 saw it applied to two men in the Borgo prison.[72] With arms tied behind his back the victim was pulled up a considerable height, then dropped by a rope attached to his arms so that his shoulders were dislocated.

WITNESSED EVENTS

THE SACK OF ROME, 1527, as recorded by John Cave, is here translated from the Latin (it is to be noted that Cave's erratic sequence of tenses is retained):

On Sunday, 5 May. Duke Charles de Bourbon with his army reaches the walls of Rome. The captains of the wards, observing the order of war, summon their troops at dawn for battle. Then the citizens were extremely agitated, both with fear and

the seizure of arms; from every main, secondary and cross-street a great force of cavalry and armed footmen was pouring forth. There was certainly no citizen who could fight in battle, although the arms they bore were not inferior.

We unfortunates, however (lamentable to say), trembling with fear, pale, stupid, unskilled in arms (and of that unhappy number I was one), and priests, rushed irresolute and in disorder to the walls in various places where they were assaulted. Soon Renzo[73] undaunted organises our section with his foot soldiers for the defence of the gates. Bourbon finally disposes his forces ready for battle in a level spot behind porta San Pancrazio, to engage on the morrow. Our men, who kept watch all night there, on guard, in silence, often made a noise with the light artillery from the top of the walls. Bourbon, despiser of the gods, on 6 May, when dawn was barely showing, sends five German detachments with light troops to attack the gate and walls, and with ladders placed against the walls, they secretly climb them. Our guards fiercely repelled them, taking from them five banners, which were carried to the pope who was encouraging us from his palace.

The remains of the Germans quickly fled on foot through the diggings and vineyards. Bourbon very carefully summons the fleeing Germans in order to reduce this fear, and exhorts them to fight again, but they refuse. Together with some clever Spaniards, Bourbon himself with his own followers tries his fortune; ladders are brought up to the walls, and he advances, and taken by force, they climb them. Our men, not without losses, retire, the artillerymen and guards descend from the walls to the ground, and here they remained, while the enemy rush the gates and break down the bulwarks. Every enemy enters without resistance; our men who were stationed on this side of the walls for separation and defence, seek safety in flight in the suburb of St Peter's. The fierce enemies then slip away immediately from Monte Aureo (which is called the Vatican) and take up their post at Sant'Onofrio, and there draw up their order of war. Nature is magic (God knows, wonderful to say),

and a dense frost covers our enemies, so that in its darkness we lost sight of them, and thus enclosed they hasten to porta del Torrione to occupy the walls of the city. When they finally are revealed, we attend to our artillery. The unfortunate, too unfortunate Bourbon, leader of such a crime, is wounded fatally by an artillery bolt in the upper thigh or the groin. His men then removed him from the battle, stretched out on the ground and covered in blood; the wound notwithstanding, with a bold and unaffected mind, although pale at his fatal wound, he addresses his men in these words: 'Unconquered fellow- soldiers. You have lost nothing by this fear. The victory is ours. Fortune favours us.' Then, after a short time, he auspiciously gave up his spirit, uncertain of its place, and paid the just penalty for treason and sacrilege. News then spreads of Bourbon's death. We are all glad; although the battle is not ended, we shout victory to the skies unrestrainedly. Our defenders of this bastion threw stones and rocks at their adversaries, and utter these words: 'Jews, traitors, Moors, Spaniards, Lutherans'. Where, however, the unfortunate enemy sensed Bourbon's loss, since they had been allowed before the conflict no, or at least only a moderate, pause to attend to themselves, and for almost the whole day they had eaten nothing because of the heat and slaughter, they seemed to lack all strength. Now their minds were seized by fear of the arrival of the papal army under the duke of Urbino from Monterotondo and the fearful enemy rushed upon the semi-prostrate strength of the Romans in desperation. Soon the hope of future safety is lost to both sides, and they raged against the other. Each army renews the battle and each fights with the greatest persistence. Artillery is fired fiercely from Castel Sant'Angelo. Fortune, long doubtful and wavering, hangs on the sword; the air resounds with shouting, din and clanging; the enemy savagely presses on, and unperturbed, deprived of its leader, fights obstinately. Many of our men, in part wounded and crushed by such an unheard of weight, flee; six thousand or more of our foot soldiers were killed in that struggle. We then set fire to the powder of our artillery, and abandon two thunderbolts of war especially terrible

to our enemies together with our bastion. With the battle thus, many of our men tried to reach Rome by ship, including the deputy-accountant of the Cancelleria, Mauricius by name, our intimate friend, but were shipwrecked, the ships being sunk in the deep Tiber by the excessive number crowding on board. The cruel imperial troops (lamentable to relate) murdered all the sick in the Santo Spirito hospital near the site of the battle. The pope [Clement VII], who urged us to fight from the apostolic palace, seeing the great massacre of his men, betook himself to Castel Sant'Angelo along the walls of his palace as a safer protection. The enemy shortly after as destructively as possible attacked our men who were defending the palace and the atrium of St Peter's. The Swiss fall gloriously; Congeus[74] the excellent captain falls. Captain Imperozio with his forces likewise is fatally wounded, nor was the outstanding noble Matteo Saxo Orsini safe. Soon the infantry and cavalry in confusion seek to flee from Rome; the cavalry, by the impetus of their horses, trampled to the ground the infantry, who threw away their arms in order to flee swiftly. The fierce enemy, thirsting for our blood, ran after us in via ponte Sant'Angelo. The way was crowded by such a mass of fleeing people, that no little doorway was empty. The iron chains of the gate of the bridge were suddenly lifted on hinges so that the enemy following us might not enter the city. Many of our men were thus suffocated in the crush. The artillery of Castel Sant'Angelo then fiercely attacked the enemy, so that they drew off afar. About noon, the decomposed body of the unfortunate Bourbon was brought into St Peter's, where it lay for some days covered with decorations in his shrine, and there some priests of St Francis de Paola prayed to God. Meanwhile, Renzo, seeing no hope of victory, together with his son Giovanni Paolo, some cardinals and other Roman fugitives, enters Castel Sant'Angelo. The enemy rested for a little for lunch and then crossed into Trastevere and the Colonna area, which the bed of the Tiber separates from Rome. They then attack the two Sistine bridges and others, by which access to Rome lay open to them, but the Romans deferred applying themselves to

their destruction, having rejected Renzo's wise counsel on this matter, but they fortified them with crossed beams and large pots by way of defence, without any human help. Some of our men hastened to defend them. The clever enemy, now surging forward, now retreating, then closer and unnoticed everywhere advanced with bodies bent, and there was no human defence to be found, and they threw the beams and pots in the Tiber as they moved higher. Our men, few in number, fall gloriously at the end of the bridge defending it.

At the twentieth hour, two o'clock in the afternoon French time, on Monday 6 May, in the year 1527 after the birth of Christ, shouting with a mighty noise 'Empire! Victory! Spain! Spain!', the enemy, ever bolder, with a sword in one hand and fire in the other, enter Rome. Running everywhere, they release the prisoners, by breaking open the gaols; among them was Francesco Orsini, abbot of Farfa. We most unfortunate and unhappy run here and there trying to avoid their cruelty. They indeed like rapacious wolves, thin from hunger, pursue us as if we were sheep. Whomever they come across unarmed or armed they kill to a man. As many as possible of ours fled to the churches for better protection, but they, so help me God, thinking to offer a pious sacrifice to God, sacrificed them as a holocaust. Those who were at home, thinking to appease them, cried in a loud voice 'Empire! Spain!', repeatedly, and offered them cups of wine and food at the doors of their houses, in order to win their friendship. The Germans, who understood neither speech nor writing, struck those who addressed them peacefully with heavy blows. Some break into monasteries sacrilegiously, and violate the holy nuns and the modest and young virgins enclosed there in the presence of their mothers, who were tortured with livid bruises, their hair undone, arms twisted, weeping, bare breasted, and their clothes torn in their defense; they also defile chaste matrons before their husbands' eyes. Others, with criminal hands red with human blood, seize temples and pillage various ornaments dedicated to God, the holy communion and relics of the saints. They turn out the

bones of the dead from the tombs, thinking that money was hidden there. Spaniards, more cunning than Germans, who had previously lived in Rome, ran to plunder the homes of cardinals, bankers and rich Romans. Everywhere they break down doors; where there is resistance, the doors are burnt, and the master, servants and everyone else are slaughtered. The air resounded with the grief of women, the crying of infants, the clash of arms, the barking of dogs, the whinny of horses, the crashing of houses, and the crackling of flames and the noise of artillery.

The city was taken and nothing unplundered remained to us wretched defeated, vainly begging for mercy. The Germans loaded up clothing, cloth, linen, stockings and shoes to take them away. The Spaniards and Burgundians are more clever, taking sacks full of silver vases, smashed with hammers and stones, and precious gems, golden chains, rings, ducats and other more precious things, along with their unfortunate captives, to the palaces, now plundered by them. Some of our people were mixed with this plunder; the enemy interrogated and beat them in various ways. Those indeed who favoured the enemy and previously had wished them at Rome (as we predicted) were visited with other various more cruel losses and torments, notwithstanding whatever service to the Emperor was alleged, because, as was said, they had not aided their attack. The Romans and inhabitants of the city who hid in storerooms and secret places in their houses were unfortunately found by the enemy. No house of anyone, of any nation, not even the chosen ambassador of the Emperor, was immune from sacking. When a certain Roman woman had been violated by the enemy, in tears she approached her husband who had found refuge in Castel Sant'Angelo; when he came out, she related the violence offered to her, and when her husband tried to lessen her grief, impatient of her lost chastity, in front of her husband, she flung herself headlong into the Tiber.

As the common rumour spread to us everywhere suggested, Cardinal [Pompeo] Colonna, vice chancellor of the Apostolic See, on 8 May approached Rome from Naples. Soon Roman

matrons in a vast crowd with their infants and servants fled to his palace of San Giorgio, which they call the New Cancelleria, entrusting themselves humbly to his care without any supplies, and lay down on the bare ground day and night, carrying out important and modest natural functions. There was such a fetid odour there from the excessive number of these women and the Germans that anyone healthy who came there fell sick. The pleasure of which their husbands deprived these women, the Germans and Spaniards one after another shamelessly and openly supplied in dog fashion. The imperial army donned superb clothing of the Romans, woven with gems and gold, and furs, made ugly and cheapened by this disgrace. The nymphs of Venus, commonly called courtesans, who used to offer their bodies for not less than ten ducats for one embrace, not without much pandering, offered themselves to anyone indiscriminately for a mouthful of bread. The Germans, covered in dust from the artillery, wore silk clothing, velvets and brocades with fine gold to the ankles under their artillery. Some of them on horseback, with pontifical headress and cardinals' ornaments, in contempt of the Church and the pope, pronouncing the most criminal name of Luther as pope, made the sign of the cross in papal fashion to their accomplices who showed their buttocks.

Some Romans paid enormous sums of ducats to some Spaniards known to them for the defence of their houses, whom they secretly lured away from the conflict and looting; among them the most reverend cardinal [Andrea] della Valle, a Roman who favoured the emperor's side, paid 36,000 ducats down for this reason. After three days the Germans, wanting to sack part of the house, attacked this house which was defended by the Spaniards; the door was fired, and the aforesaid Spaniards, together with these Germans, seizing money and the richer fittings, plundered the house of the major riches, things that did not belong to them. They set fire to towers and houses provided with defence, and the defenders, driven by the fire at its greatest velocity, gave themselves to precipitate flight. Nine days and nights, without an hour's respite, were consumed in this first

enslavement of people and plundering of goods. Coming out of a house now empty of booty, about ten or twenty Germans and Spaniards mixed together, and others as many or often more, would go in three or four times a day, to see if anything unplundered remained save the bare walls. A captive given his freedom by his owner who paid his ransom and returning to his home was revisited by others, who subjected him anew to captivity and ransom. When they had finished plundering, they then visited the secret places, sewers, cellars, crypts, and cisterns. If it was believed that the captives had any furnishings, there was no delay in investigation, and they took the unhappy prisoners to the upper levels of the houses or to the cellars to be shown where they had hidden their money.

Some they hung from beams by the testicles, their hands tied behind their backs by a rope and their body supine; others' thumbs, so to speak, they crushed with machines of torture; of some they bound the forehead with a rope knotted every so often which they cruelly tightened by twisting a stick inserted in it, a torture called *templetas*; they burned the soles of others' feet; some they tied to posts, torturing them in various ways and starving them. A priest (may God help me) in the house of my scientific patron, Jerome de Castello, abbreviator of the greater presidency, a prisoner and almost dead from hunger after two days I restored by pressing into his mouth some bread moistened with wine; the Spaniards had deprived him of any food and drink, and his hands were tied behind his back, always up against a wall, under guard, to keep him on his feet; he was tortured until he fetched forth his property and paid the fee for his release. No kind of torture remained untried; many died from the violence of the pain. Some under torture and many of them believing that it would bring an end to their suffering stripped the places which contained their property; deprived of this and broken by torture they were condemned to pay enormous sums of ducats by a certain day, under pain of death for their release. Artisans, who did not have even a quatrino, least of all avoided the suffering of these tortures. The godless

Germans subjected their prisoners to the extremes of torture, for not paying their ransom when the day came, as long as the most miserable life remained in their afflicted body. They together with the Spaniards captured a certain rich Roman (so it is said) and, in no way agreeing on his fate, mutilated him so that neither of them should have it.

After nine days and nights of plunder, shedding of human blood, defiling of virgins and robbing of churches, without an hour's peace, Juan d'Urbina,[75] an exceedingly warlike Spaniard, was appointed to command the officers of the imperial army in place of Bourbon; the army of armed cavalry was placed under the authority of Prince Auraria;[76] [Alberini] La Motte occupied the post of deputy emperor in the Roman senate. Each of them obtained the rank befiting his warlike valour. When the troops had been reviewed, the aforementioned d'Urbina announced by a herald that whoever wished to don a sword and follow the imperial standards would receive a generous wage, and ordered the capital penalty for rebels and that whoever joined his standard as a cavalryman or foot-soldier, he would allow his wife and children to go away unharmed, and equally those who had paid their ransom, and that their army should resume its old character. Many Spaniards, as is their nature, were contemptuous of the edict of Juan d'Urbino, and went *bouscatum* (to use their word), that is robbing; Prince Auraria tied them by a cord around their throat to the columns of the house windows. Meanwhile Germans, Spaniards, Burgundians and as many as possible rejected French diverted themselves in streets and open spaces with dice and other games, like animals, in great numbers, lying on the ground in various places. Some of them had huge piles of ducats, others *scudi*, most *giulii* and *carlini*, and parts of solid silver vases dedicated to divine and profane cult, others ecclesiastical ornaments, for both men and women, woven with gold, as well as precious stones, chains, necklaces, rings beaten out of purest gold, which fortune had exposed to play in great numbers. The now fetid bodies of the dead, eaten by dogs and which lay in the places where the fatal conflict had

CAPTA VRBE, ADRIANI PRAECELSA IN MOLE TENETVR
OBSESSVS CLEMENS, MVLTO TANDEM AERE REDEMPTVS. *1527.*

Martin van Heemskerck, German troops attacking Castel Sant'Angelo, *1555-6*

taken place, had some of them been covered with a little earth while still breathing; others in truth scattered through the public streets lay in great number naked on the ground and received a poor burial. The father left the body of his son, the son the father's, the husband the wife's, the mother her children's in the open, uncovered, unburied within sight of their houses. The bodies of horses which remained from the greedy dogs were burned; their remains were carried from the public streets to the fields by the treacherous Jews who had by good fortune escaped death, in accordance with their office.

The enemy laid siege by circumvallation to the pope, who was protected by Castel Sant'Angelo, but with no, or very small, supplies. Two of our captured war machines they placed against it, and their care was entrusted to the Germans [see above]. When these indulged their character [drunkenness ?], the pontifical arquebuses issued forth secretly against eighty enemy defenders and dragged them by force to the fort. Meanwhile

the duke of Urbino with his army, who after the capture of the city held Mons Rotundus, a town not far away, increased his frequent attacks on the enemy up to the city walls. The Colonna with the Spaniards, who were protecting the kingdom of Naples, approached Rome in support of the imperials, who plundered the city indiscriminately no less hostilely than before. There was no peasant on their side (and their number was large) who did not take loads of furnishings to their houses; nothing to them was too light or too heavy to be useless to them. The pope, besieged and terrified of death, made an agreement with the enemy on these conditions: that, when he had prepaid a huge sum of money and rich Romans had given hostages for the payment of the remaining ducats for his ransom, the advocates of the princes who were with him and as many other nobles and wealthy men with their property and a safe conduct could leave and without punishment go their way, and that he should allow the enemy to take possession of the aforesaid castle. These conditions were accepted and the aforementioned departed. The imperial troops then entered the first defences of the castle. There remained three standard bearers for the guarding of the pope, so that he would not depart unacknowledged. On payment of the pope's ransom, they set him free.

Rome was then visited by an appalling plague and the surviving French left for home. Cave himself travelled overland suffering the most severe conditions, but finally regained Paris.

THE VISIT OF EMPEROR CHARLES V (1536), described by François Rabelais

(The emperor) is at present in Naples, and will leave there, so he has written to the pope (Paul III) 16 January. The whole city is full of Spaniards and he has sent to the pope an ambassador to announce his coming. The pope grants him half the palace and whole Borgo di Sant Pietro for his people and prepares three thousand beds in the Roman fashion, that is mattresses; for the city is deprived of them since the sack of the landsknechts ['country workers', the contemptuous name for the troops of

Charles V in 1527], and he has provided hay, straw, oats, and barley, as much as he can get, and all the wine which has arrived at Ripa [the main harbour on the Tiber]. I think it will cost him dear, which he could well do without, given his state of poverty, greater and more obvious than any pope in the last three centuries. The Romans have not yet decided how they must manage, and there have often been assemblies by order of the Senator, the Councillors [Conservatori] and Governor, but they cannot agree. The emperor by his ambassador has announced that he does not intend that his people should live at their own pleasure, that is, without paying, but at the discretion of the pope. This grieves the pope even more, for he understands that by these words the Emperor wants to see how and with what affection he will treat him and his people...

Great preparations have begun in this great town to receive him. By the pope's orders, a new road has been built by which he must enter, that is, from porta San Sebastiano towards the Capitol, Templum Pacis [Basilica of Maxentius] and Amphitheatre, passing under the triumphal arches of Constantine, Vespasian and Titus, and Numetianus [i.e. Septimius Severus] and others, then alongside the palace of S Marco and from there by the Campo dei Fiori and in front of the palazzo Farnese, where the pope used to live, then by the banks and under Castel Sant'Angelo. To build and level this road more than two hundred houses and three or four churches have been demolished and razed to the ground, which many take to be a bad omen. On the feast of the conversion of St Paul [25 January] our Holy Father went to hear mass at S Paolo and dined all the cardinals; after dining, he returned along the mentioned road and lodged at the palazzo S Giorgio. But it is a pity to see the ruin of the houses which have been demolished, without any payment or recompense to their owners.

In the same year, Johann Fichard records that by the palazzo Venezia there was a silvered arch for the emperor's entrance which was still extant, but strong rains were destroying it.[77]

THE CONCLAVE ON THE DEATH OF PAUL III WHICH ELECTED JULIUS III
(Nov. 1549-Feb.1550) reported by John Hoby

When we arrived in Roome we saw dailie in St Peter's churche verie solemn masses of requiem for the pope's deathe, after the maner of Roome, song by the cardinalles, everie on(e) sitting according to his degree in a chappell, where the image of pope Xistus [IV] liethe all in brasse curiouslie wrought, with the Muses all abowt him. Abowt the later end of November, at the certain time limited for all cardinalls of the seea of Roome to repaire thither for the election of a new pope, all such cardinalles as were then in Roome, after on[e] solemn masse of the holie ghost song emong them, entred into the conclave according to the accustomed maner; that is to saye, into suche rowmes as are belonging unto the pope in his palaice, as the utter chambares, the hall above, the chappell and suche other wide places, where everie cardinall had beforehand a little cabbin prepared for him, hanged and separated from the rest with his owne hangings, withowt anie light at all, except so muche as he lettethe in by the pinnings uppe of the hanging in the place where he entrethe into this cabbin, within the whiche he had so muche place that sufficed for a litle standing cowrt bedd for himself, a pallet for two of his servants, whom he lysted to have within with him, on[e] litle square table and a coffer for his stuff. When they were all entred together into this conclave everie dore and wyndowe where anie yssue was in anie place round abowt them was after the maner mured uppe, saving a litle part of the verie toppe of the wyndowes on highe, in manie places owt of manne's reache, whiche to lett in light was left open, and a litle dresser in that great dore that menn used most communlie to cum in and owt at. Throwghe this dresser everie cardinalle's owne provision, browght thither from his owne palaice by his servaunts, was putt in and delivered unto the ij [2] servaunts he had within attending upon him, the assaye or tast thereof first taken, whatsoever was browght thither. In this sort remained they a good space attending for viij or ix cardinalles owt of Fraunce, for before their arrivall the

Cardinall of Ferrara with the rest of the French partie would goo abowt nothing. When all were cum and convayed in emong the rest they remaine thus shutt uppe untill suche time as by agreement of the most part they have elected a new pope, except they find themselves yll at ease, as iij or iiij of them were at this time, whiche were permitted to go lye at their owne palaices, where on or two of them diede. During this time of vacation of the seea of Roome the consistorie (by the meane of Cardinall Farnese, then cheefe doer, and the Cardinall of Saint Angelo his brethren) confirmed unto Duke Octavio the Dukedom of Parma and unto Horatio his younger brother the Dukedom of Camerino, and appointed him also generall for the churche over fyve or sixe thowsand souldiers which during this time were there taken uppe to serve the churche. To the custodie of the castle of Saint Angelo was appointed a bisshoppe, and afterwards was rewarded with a red hatt [the cardinalate]. The pope that diede laye buried under a heape of earthe by the walles side within Saint Peter's churche, paled in, untill suche time as a more honorable sepulture were made readie for him, which his fowre nephewes Cardinall Farnese, Cardinall of Saint Angelo, Duke Octavio and Duke Horatio had cawsed to be taken in hand for him by Michael Angelo.

And we taried the longer to see yf the cardinalles wold elect a new pope. It was thowght Cardinall Poole shulde have bine pope. Yf he had receaved the cardinalles' offer overnight as he entended in the morning folowing, he had surelie bine so. And in the morning when all the souldiers of Roome, and a great multitude of people besides, were assembled in the Markett place of Saint Peter's to have seene Cardinall Poole proclamed pope, he had lost by the Cardinall of Ferrara his meanes the voice of manie cardinalls of the French partie, persuading them that Cardinall Poole was both Imperiall and also a verie Lutherian! So that morning passed withowt anie thing done, contrarie to the expectation of all menn. After the election of Cardinall Poole was thus passed the commune opinion was, that by the reason of the factions Emperiall and Frenche that were emong them, they would not so soone agree afterward, for

there was no on in the hole Consistorie that was generallie so well beloved as he was of them all, and never declared himself neyther Emperiall or Frenche. But Don Diego labowred what he colde to make him pope, and so did all the Emperiall Cardinalles that were within the conclave, but the Frenche partie was against him.[78]

Cardinal Poole was Reginald Pole (1500-58), who disapproved of Henry VIII's divorce (for which reason his mother and brother were executed). He became archbishop of Canterbury on Cranmer's deprivation.

THE VISIT OF THE RUSSIAN AMBASSADOR (1581) according to Montaigne

The ambassador of the Muscovite [the legendary Ivan Grozny] arrived here today (early March), dressed in a scarlet cloak and a tunic of gold cloth, with a hat in the shape of a nightcap of furred gold cloth, and underneath a cap of silver cloth. This is the second ambassador of Muscovy who has come to the Pope. The other was during the time of Paul III. It is believed that his mission was to move the Pope to intervene in the war waged by the king of Poland on his master, claiming that it was the latter who had to sustain the first attack of the Turk, and that if his neighbour weakened him, he would be incapable of waging another war, and that this would open a great opportunity for the Turk to reach us; he further offered to give way in some differences of religion which he had with the Roman Church. He was lodged in the Castello as was his predecessor, and fed at the Pope's expense. He made a great fuss about not kissing the Pope's feet, but only his right hand, and would not give way until he was shown that even the Emperor was subject to the same ceremony; for the example of kings was not enough. He could not speak any language but his own, and had come without interpreter. He had only three or four retainers, and said that he had crossed Poland only with great danger. His country is so ignorant of matters here that he carried to Venice letters of his master addressed to the great governor of the dominion

of Venice. Asked about the meaning of this inscription, they thought that Venice was under the Pope's jurisdiction, who sent governors there, as to Bologna and elsewhere. God knows with what reaction the Venetian grandees received this ignorance. He gave presents there and to the Pope, of sables and black fox, a fur still more rare and costly.[79]

JUBILEE YEAR (1600) described by Heinrich Schickhart

The pope [Clement VIII] was suffering from gout, so the opening of the Holy Door [Porta Santa] was not on Christmas Eve but New Year's Eve. The procession from the Vatican to St Peter's was headed by singing musicians in white choir cloaks, then people in beautiful red clothes, then more musicians in white, and others with silver staves or candles. Next came forty-two bishops wearing white hats, long red clothes, carrying candles, followed by fifty cardinals wearing long red dress under a white garment, white damask hats and carrying candles, and accompanied by their servants in white. Then came sixteen men in black, each carrying a silver sceptre. Finally came the pope in his chair borne by eight carriers in red and his fanbearers. He carried a candle and a white cloth.

The crowd at St Peter's was so dense that the Swiss guard could scarcely make a space for the door to be opened. The pope beat on the door three times with a gilded hammer. Thereupon it was torn down, and the people rushed forward to snatch a souvenir; for this was regarded as a relic. They also believed that gold was hidden behind it (it was also called the Golden Door). Included in the credulous was a young and very strong German aristocrat, who managed to obtain two handfuls of stone and cement – but not gold.

Reliable sources stated that there were 30,0000 pilgrims in Rome.[80]

PORTRAITS

Johann Fichard described the newly elected PAUL III Farnese (1534-49) (see ill. opposite, left) as 'small, white-haired'. He was present at a mass in St Peter's: 'During the mass he sat immobile to the left of the altar until the Gospel, then servants helped as he rose. He descended from his throne and genuflecting before the altar, prostrate he saw the *Corpus Domini* and so remained almost to the *Agnus Dei*, then was returned to his throne. The cardinals sat when he sat, rose when he rose. His devotion seemed slight.'[81]

Montaigne had an audience with GREGORY XIII Buoncompagni (1572-85) (see ill. opposite, right):

> The Pope's language is Italian, revealing his Bolognese prattle, the worst speech in Italy, and then by nature his conversation is awkward. For the rest he is a very handsome old man, of medium build, erect, a face full of dignity, a long white beard, then aged more than eighty, very healthy for this age, as active as one could wish, not suffering from gout, colic, stomach disorders or ailments of any kind. He is kindly, taking only a slight interest in worldly affairs, a great builder, and thus he will leave in Rome and elsewhere special honour to his memory. He is charitable beyond all measure. Among proofs of this there is no girl to be married whom he does not help to find housing if she is of the lower class, and counts his generosity as ready money. (Also various colleges established, where students are completely provided for.) He gives as many audiences as one likes. His replies are short and decided, and one wastes time combatting his reply with new arguments; when he thinks something right, he takes no notice of anyone else, and not even for his son whom he loves desperately [Jacopo Boncompagni 1548-1612] would he depart from his justice. He favours his relatives but without harming any rights of the Church, which he upholds inviolate. He is very generous in public building and repair of streets in the city. In truth his life and manners

Left, Titian, Paul III and his nephews Alessandro and Ottaviano, *1546; right,* Gregory XIII,
c. 1581, formerly attributed to Agostino Carracci

are in no way extraordinary on either side, but incline much
more to the good side.[82]

Henry Wotton closely observed CLEMENT VIII Aldobrandini (1592-
1605) (see ill. overleaf):

Clement, the eighth of that name, and third pope of Florence,
is a man of scant reasonable stature, sooner pale of complexion
than otherwise, gross of body, of countenance apt enough to
authority, and hath indeed the greatest presence amongst the
cardinals, except Montelbero [Gregorio Petrocini Montelparo]
and [Enrico] Cajetan; which some account one of his helps to
the seat. His years, fifty-five, he bears well, though his spirits
have been somewhat weakened with the gout; yet some say
that he feigns that disease, being very commodable to excuse
a coming forth now and then where the occasion requires; as

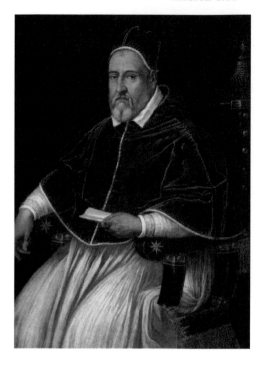

Anon.,
Clement VIII,
date unknown

hath been noted in other popes, and in him once since the coronation. The colour of his face was, as all generally agree, more fresh during the time of his cardinalship than since; and certain speculative wits, that search out the causes of things, have found that upon a pasquinata set forth against him in the form of a prophecy, wherein stood expressed the 28th of March for the day of his death, he fell into trouble of mind, which is taken to have wrought that effect in his body; a report truly, though mixed with envy, yet not wholly without ground, as hath appeared by the sensible alteration in his countenance since April began; and upon the expiring of that day in March, he is said to have used unto Don Diego del Campo [a chamberlain] very cheerful words at night concerning that prophecy. Superstition never impaired the complexion of St Peter, though it have a stroke in his successor.[83]

It is unfortunate that Jacques de Villamont gives no portrait of SIXTUS V Perretti (1585-90), one of the most striking men ever to occupy this throne, and whose impress was far out of proportion to the mere five years that he was pope. He does, however, describe a progress, which gives a very lively picture of his love of pomp and provides some notes on his decrees, which certainly stress his severity. First came his domestic servants in livery, leading a palfrey and a mule, then a litter carried by two white mules. There followed the Swiss Guard in pairs, mounted officers and chamberlains dressed in violet, one carrying a cross before the pope, and the master of ceremonies, crying 'Down, down'. The pope was in a litter of crimson velvet, giving the benediction, with the mules of his litter controlled by two bare-headed grooms. The cardinals followed on their mules, then the archbishops, bishops, abbots, and protonotaries, all in dress appropriate to their rank. The rear was brought up by a company of light horse. When Sixtus went to St Peter's, fifty cardinals came to the palace, and entered the church in pairs. The pope came in a chair of crimson velvet borne by eight men dressed in red; he wore the triple crown, and alongside were two fanbearers in red, and trumpets were sounding. The papal throne was at the top of six steps, and on each side was a cardinal, to act as deacon and sub deacon; also alongside the pope was the ambassador of France, always standing; the other ambassadors were placed lower. Then came the cardinals each with a chamberlain. On the right of the altar was the cardinal who celebrated the mass, while below it were the auditors of the Rota (judges in the supreme criminal court),

Philips Galle, Sixtus V, c. *1585*

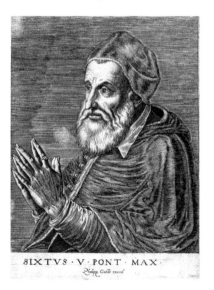

SIXTVS · V · PONT · MAX ·

the papal chamberlains, the papal doctor, the consistorial advocates, the Apostolic sub deacons, and the master of the sacred palace, all in red. On the left of the altar was the cross bearer, two secretaries, and two chamberlains, one of whom was first auditor of the Rota (chief judge of the criminal court).

Sixtus' severity was amply demonstrated by the inflicting of the death penalty, no matter what the status of the offender, for harbouring outlaws, for assaulting a Swiss Guard, for the prostitution of a daughter, and for drawing a weapon except in self-defence. And the Inquisition threatened those who spoke ill of the Church, or the pope; spies were everywhere.

Arnold von Buchell, similarly, tells us only that Sixtus was 'an austere man, and made more so by his old age', but his notes on papal government are most eloquent: a position as judge cost thousands of ducats; there was an increase in spies, but in order to curb banditry; he solved the grain shortage; he excommunicated Henri de Navarre; he issued an edict against healthy beggars (but provided for those in need with a college); he was very nepotistic (one nephew was governor of Rome, another cardinal and governor of Bologna); he honoured the daughter of his washerwoman as a priestess; he imposed the death penalty for adultery; but most telling: when Farnese came to obtain the release of a prisoner, Sixtus sent orders for his immediate execution, then told Farnese that he would grant his request if he found the man still alive. When Farnese reached the prison, the man had, of course, been strangled, at which Farnese railed at 'the mercy of a monk'. This was reported back to Sixtus, who kept Farnese prostrate at his feet for half an hour, and warned him not to try further 'the mercy of a monk'.[84]

Of the next grade of persons in Rome, the cardinalate, Fynes Moryson in 1594 offers two portraits. To obtain some protection during his visit he went to the English College to see CARDINAL WILLIAM ALLEN (whom he calls Allan) (1532-1594, so this was the year of his death at the age of 62). He had finally removed from the England of Henry VIII to the Continent in 1565, and had founded the seminary at Douai, before going to Rome, where he founded the English College in 1579 and was intended to be the main theologian in England had Philip of

Spain made good his claim to the English throne. His hopes had, as Moryson revealed, been shattered by the defeat of the Spanish Armada. He now protected English visitors to Rome:

> He being of goodly stature and countenance with a grave look and pleasant speech bad me rest secure, so I could command my tongue, and should abstaine from offence. Only for his duties sake, hee said, that he must advise me, and for the love of his Countrey intreate me, that I would be willing to hear those instructions for religion here, which I could not heare in England.[85]

Moryson tells nothing more about receiving any such instruction.

His other portrait is of ROBERTO BELLARMINO (1542-1621), who did not become a cardinal in fact until 1599, but as a Jesuit was professor of 'controversial theology' at the newly founded Collegio Romano from 1576: one of his antagonists was James I of England. He upheld papal temporal authority, but only in an indirect sense:

> Thus I came into Bellermine's chamber, that I might see this man so famous for his learning and so great a Champion of the Popes: who seemed to me not above forty yeares old [he was fifty-two], being leane of body, and something low of stature, with a long visage and a little sharp beard upon the chin, of a browne colour, and a countenance not very grave, and for his middle age, wanting the authority of grey heires.[86]

When Moryson boldly asked to be able to come 'to enjoy his grave conversation', he promptly told his novice to admit Moryson any time that he came to see him.

We may conclude with a small vignette of the kind of person always to be found in Rome, on the border between the educated scientist and the eccentric or even lunatic. Johan Fichard in 1536 met DR GYSBERT HORSTIUS of Amsterdam at the Hospital of Consolation, who showed him his collection of snakes. He was testing popular beliefs of reptilian copulation and birth, namely that in conjunction with that act the female bites off the male's head, and that the young are

born by perforating the mother's belly. His observations had indicated that neither of these beliefs withstood examination![87]

We may finally regret that Erasmus has not left us from his visit of 1509 any portraits of the elevated figures with whom he consorted, not even one who later became pope:

> In Rome there was not one cardinal who did not welcome me as a brother, though I myself sought no such reception: in particular, the cardinals of St George [Raffaele Sansoni, called Riario, 1461-1521] and of Bologna [Francesco Alidosi, d. 1511], Cardinal Grimani [Domenico Grimani, 1461-1523], the cardinal of Nantes [Robert Guibe], and even the cardinal who is now the supreme pontiff [Giovani de' Medici, Leo X].[88]

SOURCE NOTES

1. For a charming general discussion of Montaigne's travels, see Donald Frame, *Montaigne, a biography*, chap. 12.
2. The only thing mentioned in *Martin Luther: Dokumente seines Lebens u. Werkens*, Weimar 1983, 31.
3. Luther, *Werke*, 31.226: 1530; 38.211: 1533; 31.226; 2.72, 14.394, 45.28; 47.425: 1538; Luther, *Works*, 54.2908-9, 237, 427.
4. Heinrich Boehmer, *Luthers Romfahrt*, 159; a summary of this, omitting Boehmer's lively interest in matters such as the number and influence of courtesans, is Ernest Schwiebert, *Luther and his times*, 174f.
5. J. Fitzmaurice Kelly, *Miguel de Cervantes*, 16f.; Richard Predmore, *Cervantes*, 59f.
6. Erasmus, *Collected Works*, 2.214
7. Fichard, 24; Thomas, 46; Montaigne, 210.
8. Thomas, 22; Ernstinger, 85
9. Montaigne, 210; Moryson, 128-9.
10. Montaigne, 199-200; Moryson, 122.
11. Rabelais, 551; Moryson, 102.
12. Cervantes, *Three Exemplary Novels*, trans. Putnam, 85-86.
13. Nashe, 286.
14. Cervantes, *Journey to Parnassus*, trans. Gibson, lxii-lxiii.
15. le Sage, 23f; Fichard, 45; Thomas, 51-52;

Moryson, 129; Ernstinger, 88; Schickhart, 45; Hentzner, 407. – The tomb of St Paul III was built by della Porta 1552-1555, and originally had the statues of four virtues: Prudence (the matron), Justice (the young woman), Peace, and Abundance: the latter two were later removed to the palazzo Farnese. The bronze covering of Justice was added in 1595 by della Porta's son Teodoro, on the orders of Cardinal Eduardo Farnese. That son was still engaged in 1604 in a law suit with the Farnese for the payment owing to his father (d. 1577) for the work. See Leon Cadier, 'Le tombeau du pape Paul III', *MEFR* 9 (1889), 49-92.
16. Moryson, 129; Fichard, 60; Montaigne, 239; Villamont, 66f.; Ernstinger, 90, and so Schickhart, 47; Hentzner, 419.
17. Moryson, 134; Ernstinger, 95.
18. Ernstinger, 96.
19. Moryson, 136.
20. Montaigne, 236.
21. Montaigne, 237.
22. Montaigne, 241-2.
23. Moryson, 141.
24. Thomas, 47-49.
25. Moryson, 130.

26. Nashe, 269.
27. le Sage, 23f.; Montaigne, 219-221.
28. Hentzner, 425-431.
29. Thomas, 53, Villamont, 54; Moryson, 140; Hentzner, 425.
30. le Sage, 25; Fichard, 49; Hentzner, 414; Thomas, 52; Moryson, 131; Ernstinger, 89.
31. Montaigne, 222-225.
32. Moryson, 131; Schickhart, 50; Hentzner, 423.
33. Moryson, 137; Hentzner, 425.
34. le Sage, 26.
35. Thomas, 21.
36. Fichard, 33; Buchell, 2.64f.; Villamont, 64; Moryson, 138-139; Ernstinger, 94; Schickhart, 62.
37. Thomas, 33; Ernstinger, 94.
38. Fichard, 37.
39. Fichard, 35; Thomas, 35-36; Ernstinger, 86f.; Hentzner, 433; Rohan, 67.
40. Moryson, 133.
41. Moryson, 133; Villamont, 65; Nashe, 269; Fichard, 65.
42. Villamont, 56.
43. Fichard, 37; Buchell, 2.82; Moryson, 137.
44. Fichard, 51; Villamont, 61; Moryson, 132.
45. Fichard, 54; Moryson, 135.
46. Schickhart, 63.
47. le Sage, 27; Thomas, 43-44.
48. Thomas, 33-34.
49. Thomas, 39; Moryson, 134; Buchell, 2.75.
50. Thomas, 39.
51. Thomas, 40-41.
52. Buchell, 1.63.
53. Thomas, 35; Fichard, 63.
54. Thomas, 42; Villamont, 52.
55. Villamont, 65; Ernstinger, 90; Schickhart, 46; Buchell, 2.57.
56. Pigge, 281f.
57. Fichard, 27f.; Villamont, 52; Buchell, 2.61, 63; Ernstinger, 90f.; Rohan, 65f.; Moryson, 139.
58. Fichard, 68.
59. Buchell, 2.50f.

60. Moryson, 136.
61. Ernstinger, 97; Schickhart, 54; Hentzner, 437.
62. Ernstinger, 97, and so Hentzner (1599), 438; Schickhart, 55.
63. Nashe, 326; Hentzner, 440; Wotton, 275; Villamont, 85f.
64. Montaigne, 230; Buchell, 3.108-109.
65. Hentzner, 430.
66. Schickhart, 64; Montaigne, 230.
67. Montaigne, 213; 214.
68. Wotton, 276, 277; Buchell, 3.125; Moryson, 136.
69. Buchell, 3.109-110. Research has failed to discover the exact meaning of 'Venus in reverse'!
70. Montaigne, 216-217; Rohan, 72.
71. Montaigne, 232.
72. Montaigne, 208-9; Villamont, 85f.; Buchell, 1.49.
73. Lorenzo Orsini, called Renzo da Ceri (d. 1536), the famous condottiere who led the defence of Rome.
74. The captain of the Swiss Guard was called Röust. Congeus is presumably Congi or Congio.
75. Juan de Urbina died in the siege of Hispelo (1530).
76. i.e. Arausio (Orange), Philibert de Chalon (1502-1530).
77. Francois Rabelais, to Geoffrey d'Estissac, 10 Dec. 1535, 28 Jan. 1536; Fichard, 58.
78. Hoby, 23-24, 25-26.
79. Montaigne, 221-2.
80. Schickhart, 68f.
81. Fichard, 68f.
82. Montaigne, 205-206.
83. Wotton, 274-5.
84. Villamont, 77f.; Buchell, 2.86.
85. Moryson, 122.
86. Moryson, 142.
87. Fichard, 72.
88. Erasmus, 2.297-8.

THE SEVENTEENTH CENTURY

THE TRAVELLERS

The most frequent European visitors to Rome in the seventeenth century were, not unexpectedly, the French. JEAN ANTOINE RIGAUD, who is known only by his brief account of his travels in Italy, went because of the Jubilee Year in 1600. HENRI, PRINCE DE CONDÉ (1588-1646), whose father had had to flee France because of his Protestantism, was himself reared as a Catholic and was a partisan of Richelieu. He was in Rome 24 December 1622-12 January 1623; his account is necessarily brief. CLAUDE LORRAIN (1600-1682), properly Claude Gelée of Lorraine, one of the most celebrated landscape painters of the century, although his Nature was a very tamed one, often within a mythological framework, was in Rome from about 1615 to 1625 and then continuously from 1627 until his death. He was therefore more of an immigrant than a visitor; we have a biography of him by Filippo Baldinucci (d. 1696). Another leading painter followed the same path. NICOLAS POUSSIN (1594-1665) of Normandy, founder of the French classical school, was under the patronage of Cardinal Barberini, and specialised in mythological and religious subjects; he was in Rome 1624-40, and from 1643 until his death. JEAN JACQUES BOUCHARD (c. 1606-1641) had an excellent classical education but was so debauched that he had to leave France in 1631 and came to Rome as sieur de Fontenoy, and became secretary of Latin to Cardinal Francesco Barberini and a clerk of the Sacred Consistory, but was beaten to death by the French ambassador for making accusations against one of his household. FRANÇOIS DU VAL, marquis de Fontenay-Mareil (c. 1594-1665) was a leading military figure during the reign of Louis XIII; his memoirs describe the election of Innocent X in 1644. BALTHASAR GRANGIER DE LIVERDIS (1610-79), bishop of Treguier, visited Rome 14 December 1660-12 March 1661 and 30 March-17 April

1661; he was particularly interested in villas and gardens. BALTHASAR MONCONYS (1611-65) was better known for his travels in the East, but was in Rome May-June 1664. JACQUES DE GRILLE, marquis de Robias d'Estoublan, defeats all biographical references, despite his status and his published letters of travel; he was in Rome in 1669 for three months. ROBERT JOUVAIN, similarly, can be placed no more exactly than 'late seventeenth–early eighteenth centuries'; his four volumes of travels covered Europe and the East and were published 1672-6; that he was in Rome in the 1670s is all we can say. JEAN BAPTISTE COLBERT (1651-90) was the eldest son of the great Colbert, who as part of an amazing educational programme to fit his son as a royal minister sent him all over Europe, including Italy to study art; he was in Rome 25 March-15 April 1671. JACQUES SPON (1647-1685), one of the leading numismatists of the age, accompanied Louis XIV's antiquary, Jean Vaillant, to Rome for Jubilee Year, 1675, and spent five months there. One of the greatest scholars of the century, the Benedictine JEAN MABILLON (1632-1707) during his visits 15 June-10 October and 13 December 1685-4 March 1686 primarily surveyed libraries. MAXIMILIEN MISSON (1650-1722) was a Huguenot who fled to England after the revocation of the Edict of Nantes, but accompanied the young comte d'Arran on his European travels, being in Rome in 1688. PHILIPPE EMMANUEL COULANGES (1633-1716), after an unsuccessful life as a magistrate, came to Rome in 1689 and remained in Italy more than two years. AUBREY DE LA MOTTRAYE (1674-1743), another Huguenot, travelled widely (Europe, Asia, and Africa) and was in Rome June 1696-January 1697, and again September-October 1710. Finally, another famous Benedictine, BERNARD DE MONTFAUCON (1655-1741), the founder of palæography, visited Rome 1698-1701.

The list of British travellers begins with an anonymous Catholic, who was in Rome c. 1605. GEORGE SANDYS (1578-1644) was a poet (translator of Ovid's *Metamorphoses*) who travelled to Italy and the East and was in Rome c. 1612; he went to Virginia in 1621, and on his return was a member of the Great Tew Circle. JOHN MILTON (1608-1674) was in Rome briefly in October-November 1638, it seems.

The greatest English diarist after Pepys was JOHN EVELYN

(1620-1706), who arrived in Rome on 4 November 1644 and left on 5 May 1645; he has left us nearly one hundred pages of detailed description, the outstanding account of the century. Esmond de Beer produced a *tour de force* in his full edition of the diary with commentary (6 vols, 1955). He states (2.575) that Evelyn relied on a number of contemporary accounts, notably the German Johann Pflaumer, the English-man John Raymond (see below) and the Italian Pompilio Totti (*Ritratto di Roma antica*, 1627 and *Ritratto di Roma moderna*,

Van der Borcht, John Evelyn, 1641

1638). Any reader who places Evelyn's account alongside the first two will, on the contrary, see the chasm between them.

Nothing is known of JOHN RAYMOND, in Rome 1646-7. FRANCIS MORTOFT (*c.* 1635-?), in Rome from 27 December 1658 until 27 March 1659, provides 'an excellent idea of what the seventeenth century traveller thought it incumbent on him to see' but he was also very interested in music; the edition by Malcolm Letts is exemplary. JOHN RAY FRS (1627-1705) was a naturalist who travelled for scientific reasons; he was in Rome 6 September 1663 until 24 January 1664. He was accompanied by Philip Skippon, later knighted, son of the homonymous father who was the famous Parliamentary general. RICHARD LASSELLS (*c.* 1603-68) was a Catholic priest, who had taught at Douai; he states that he was five times in Italy but does not give any dates. His account is very defensive and proselytising. He invented the term 'grand tour'. Of JOHN CLENCHE no details are known, but he was in Rome in 1675. ELLIS VERYARD reveals only that he was a physician, in Rome in the early 1680s, but his comments suggest that he was Catholic. TRANCRED ROBINSON (1657/8-1748) was another

physician (in ordinary to George I: knighted 1714) FRS and FRCP, in Rome 1683-84. GILBERT BURNET (1643-1715), leading supporter of the House of Orange, to be bishop of Salisbury, historian of the Reformation and author of a *History of My Own Time*, travelled abroad to escape the Stuarts, and visited Rome in 1685. WILLIAM BROMLEY (1663-1732), the fiercely Tory member for Oxford from 1701 until his death, arrived in Lent, apparently in 1688. JAMES HOWARD (1648-1716), fourth earl of Perth to 1687 and Jacobite first duke from 1690, finally, left letters of his brief visit in mid-1695.[1] Influenced by Charles II's deathbed conversion, he had converted to Catholicism in 1685, as a Jacobite was imprisoned 1688-1692 and freed on condition that he live abroad. He was now James II's envoy to the pope, and was to be governor to the prince of Wales (the Old Pretender) in 1696.

German travellers begin with GASPAR ENS (?-?), a learned Lutheran theologian from Lorich, in Rome in 1609. JOHANN GOTTFRIED VON ASCHHAUSEN (1575-1622) was bishop of Bamberg and Würzburg and a leader of the Counter-Reformation; he visited Rome 20 December 1612-8 March 1613 as ambassador of the Holy Roman Emperor Matthias (1612-1619); his German is barbarous and his Italian worse. JOHANN WILHELM NEUMAYER (1570-1644) was in Rome in 1620; he accompanied Duke Johann Ernst of Sachsen-Weimar (1595-1626). The Catholic JOHANN HEINRICH PFLAUMER (d. 1649) came to Italy aged seventeen; his account, published in 1628 and dedicated to the bishop of Constance, is concise yet detailed. HIERONYMUS WELSCH (1610-65) was in Rome in 1631, then served in the French army and was a treasury official in Stuttgart in Wurttemberg until his death (therefore presumably Protestant). MARTIN ZEILLER (1589-1661), the son of a pastor, studied at Wittenberg of all places, was in Rome before 1640, and became an inspector of schools. FRIEDRICH CALIXTUS (1622-1701), a Lutheran theologian, was in Rome 15 June-26 July 1651. Almost all these German travellers, therefore, were Protestants.

There are finally some more individual travellers. The Dutchman VAN SOMMELSDIJCK (?-?) was in Rome Christmas 1653-Easter 1654. The great Spanish painter DIEGO RODRIGUEZ DE SILVA Y VELÁZQUEZ (1599-1660) first went to Rome (1629-31) at the urging of Rubens, and again

1648-51, partly to collect art for Philip IV. A Russian aristocrat, finally, BORIS PAVLOVICH CHEREMETEF (1652-1719), a leading diplomat and general, came to Rome following his victory over the Turks at Azov 1695 (he also defeated the Swedes at Dorpat 1701), and was in the city 21 March-4 April 1698.

INTRODUCTION

Joannes Pflaumer in the 1620s had no regrets for old Rome: he celebrated the replacement of the pagan by the Christian city. And he noted the changes in topography: the Campus Martius, which used to be outside the city, was now its centre and what had been the city was now almost bare hills, gardens, fields and shapeless ruins. Martin Zeiller in 1640 made the same point, and stated in particular that from S Alessio on the Aventine to the walls in the south was all fields. Albert Jouvain in the 1670s remarked on how the Aventine had been the most inhabited quarter of the city, but was now the most abandoned. He walked under the walls, noting their porticos and galleries, on which it would be fine to walk, but they were broken in various places. The builder of the defences he claimed was unknown! One could usually see several cardinals walking here, because their students were playing ball nearby.[2]

Gilbert Burnet in 1685 described the *campagna*,

as I passed from Mont Fiascone to Viterbo, this appeared yet more amazing; for a vast champain country lay almost quite deserted; and that wide town, which is of so great a compass, hath yet so few inhabitants, and those look so poor and miserable, that the people in the ordinary towns of Scotland, and in its worst places, make a better appearance. When I was within a day's journey of Rome, I fancied that the neighbourhood of so great a city must mend the matter. But I was much disappointed; for a soil that was so rich, and lay so sweetly, that it far exceeded any thing I ever saw out of Italy, had neither

inhabitants in it, nor cattle upon it, to the tenth part of what it could bear. The surprise that this gave me, increased upon me as I went out of Rome on its other side, chiefly all the way to Naples, and on the way to Civita Vecchia: for that vast and rich champaign country that runs all along to Terracina, which from Civita Vecchia is above a hundred miles long, and is in many places twelve or twenty miles broad, is abandoned to such a degree, that as far as one's eye can carry one, there is often not so much as a house to be seen, but on the hills that are on the north side of this valley. And by this dispeopling of the country, the air is now become so unwholsome, that it is not safe to be a night in it all the summer long: for the water that lies upon many places not being drained, it rots; and in the summer this produces so many noisome steams, that it is felt even in Rome itself; and if it were not for the breezes that come from the mountains, the air would be intolerable. When one sees all this large, but waste country, from the hill of Marino, twelve miles beyond Rome, he cannot wonder enough of it.[3]

The population figures are given by only two of our travellers: 120,000 by John Ray in 1663, and 100,000 by Ellis Veryard *c.* 1682. Charles Bourdin in 1695 offered some interesting statistics. Rome was composed of 92 parishes, 41 national churches, 64 monasteries, 46 convents, 30 hospitals and 106 companies of penitents.[4]

Most travellers presumably came by road from the north, but Jean Rigaud specifies that he arrived by sea. The grandest entrance was by the imperial ambassador Bishop Johann Gottfried van Aschhausen, who in fact entered twice, first on 20 December 1612, with fifty-four carriages and accompanied by six cardinals through porta del Popolo, thence to the Borgo where he was met by another eight cardinals, and was instantly received by Paul V. The whole performance was repeated on 30 December, the 'solemn entrance' with five hundred horsemen, thirty-six carriages, the papal light horse, two hundred Germans, the bishop himself in blue and green accompanied by the pope's brother Francesco Borghese, followed by thirty-six cardinals and prelates and almost one hundred aristocrats.[5]

Complaints about customs were legion. Jean Jacques Bouchard in 1631 described the officers as public thieves, but it was the Dominican monks who checked books who aroused his anger. Anything fine was liable to be stolen. All his luggage almost had to be sent back to Civita Vecchia, where they had spent forty-eight days (!) in quarantine, because they did not have the required declaration to that effect. He spent eight days and nights running around to various prelates begging them to intervene. Jacques de Grille in 1669 described the search even under his horses' saddles. In sum it was more severe on Catholics than at Geneva – and then they had the impudence to demand a tip![6]

Many travellers tell us where they stayed, and the information indicates a fundamental change in the tourist areas of Rome. François Rigaud stayed at Eiguière near porta S Angelo and the contemporary anonymous Englishman at the Sword:

> When you come to Rome, enquire for the Black Bear, or Sword, both which are lodging for strangers, where you shall have good entertainment and be well used; but most commonly the chiefest persons lodge at the Sword on monte Giordano, in Italian, alla Spacta.

Johann Neumayer in 1620 lodged at the very famous Orso, north of piazza Navona, John Raymond in 1647 by the palazzo Borghese, while as late as the 1660s, Richard Lassells stayed near S Giovanni dei Fiorentini. The significant shift, however, is registered as early perhaps as 1631, by Bouchard. He stayed at Monte Brianzo, a famous hostelry on the Tiber 'beyond l'Orso', but he noted that, although at first he found Rome an 'enchanted city', this quarter was 'the most unpleasant and dirty' in the whole city. Thus John Evelyn in 1644 arrived about five at night,

> and being greatly perplex'd for a convenient lodging, wandred up and down on horse back, till one conducted us to Monsieur Petits, a French mans [sic], who entertained strangers, being the very utmost house on the left hand as one ascends Monte Trinità.

Jean Mabillon in 1685 also stayed at Trinità de'Monti. Jouvain in

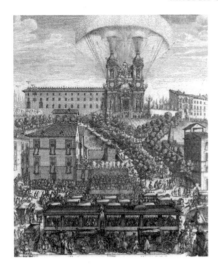

Vincenzo Mariotti,
Piazza di Spagna and
Sta Trinità, c. *1687.*
The Spanish Steps do
not yet exist

the 1670s lodged at the Ville de Londres in via del Babuino, while
Aubrey de la Mottraye in 1696 stayed at the Monte d'Oro in Piazza
di Spagna.[7] The great shift to the piazza di Spagna as the centre of
lodging for travellers had taken place.

The earl of Perth in 1694 had perhaps special connections to stay in
a palace near porta Pinciana. Henri of Condé in 1622 for obvious
reasons lodged with the French ambassador at palazzo Capo di Ferro,
near the Farnese, and Velázquez in 1629 lived at the Vatican – by order
of the pope's nephew. Velázquez found that lodging, however, too
isolated; he then moved for two months to the much more airy villa
Medici, and finally lived with the Spanish ambassador. It was poor de
Grille in 1669 who, more harassed, also suffered three moves: first
above the piazza di Spagna, but the landlady was like Corisca in *Il
pastor Fido* (emotional and highly amorous), then Monte d'Oro above
Trinità de'Monti where he could not stand the noise, and finally to
piazza Navona, presided over by an old Marseillaise.[8]

The travellers stayed in Rome from a few days to months, even years.
There were also a few recommendations to other visitors. Rigaud
noted that he spent a month busily sight seeing, and mocked the
Mirabilia, which suggested that the important things could be seen

in three days. To see everything in a week, he cautioned, it would be necessary to have Rome at one's command, ready to open when you arrived. Raymond stated that one could see Rome in a fortnight, 'walking about from morning to evening', but to understand it would take a year. Jacques Spon stated that it required five hours to visit the four main basilicas to obtain indulgences (St Peter's, S Giovanni, S Maria Maggiore and S Paolo). Montfaucon, finally, suggested that twenty days were sufficient for an intelligent tour. De la Mottraye alone added the human touch: he tried to leave, but every time he went to say goodbye to a friend, he was asked whether he had seen something: 'oh, you can't leave without seeing that, when you are so close'![9] Zeiller concluded his account with a suggested four days' itinerary, and Montfaucon divided his account into his suggested twenty days.

It does not yet seem the age of the *cicerone* – or 'Sights man' as Evelyn called him. The more educated visitors presumably were conducted about by the scholars whom they mention. Only Aschhausen of all these travellers names his guide: Hans Gross, the Swiss Guard[10] – but then he was an imperial ambassador!

Little is said about expenses. Evelyn alone revealed the cost of his lodging: 20 *scudi* per month. The anonymous English visitor of 1605 noted that a coach cost a crown and a half a day. On that matter, de Grille complained that they were very badly sprung – enough suffering to kill one – but he had to take one, being so far from St Peter's, and it was very wet; on foot one would be shipwrecked.[11] Most travellers at this time were apparently on modest budgets, with few exceptions. One was, naturally, Aschhausen, who as ambassador in two and a half months spent 32,754 gold crowns, and the Boyar Cheremetef, who in less than two weeks in 1698 spent 500 gold ducats on rent and tips.

All these travellers seem to have behaved themselves, with the exception of some Germans with Bishop Aschhausen. He related how one of his men staying at a famous inn at porta Septimiana became very drunk and visited a Swiss courtesan called Annalina. He got into her bed, when her Italian lover arrived, and demanded precedence, whereupon the German 'purged himself top and bottom'. He

admitted, in fact, that there was constant brawling among his German retainers, with drunkenness and insults. A Swiss guard, on the other hand, drained a huge beaker and fell to his death out of a window.[12]

Guidebooks will not be cited among our travellers, but the scene for the seventeenth century may be set by considering the kind of counsel which they could follow. A famous example was that of Franciscus Schott (1548- 1622), whose *Itinerari Italiæ rerumque romanarum libri tres* appeared at Antwerp in 1600; it was then translated into Italian: *Itinerario ovvero vera descrittione de' viaggi principali d'Italia*, Vicenza 1615, and finally into English: *Italy in its original glory, ruins and revival...*, London 1660.[13] With this book in hand, Rome could be seen in a mere four days.

The first day was devoted to the Cesi collection (which alone made Rome worth a visit, Schott declared), the Vatican, the Janiculum, the Forum Boarium, the Aventine, Testaccio, the Pyramid of Cestius, and S Paolo. The second day was even fuller: the Sforza and Lancelotti collections, the Cancelleria, palazzo Farnese, the Aquigno, Massimi and Pasqualino collections, Aracœli, the Capitol, palazzo dei Conservatori, the Forum Romanum, the Palatine, Circus Maximus, via Appia, the Cælian, S Giovanni, S Croce, and the Colosseum. The third day was devoted to the palazzo Altemps, piazza Navona, the Pantheon, S Maria Maggiore, S Pietro in Vincoli, S Agnese fuori le mura, the Baths of Diocletian, gardens of Cardinal Carpente and the Quirinal Palace. The final day began with the Mausoleum of Augustus and the villa Giulia, then up to the Milvian Bridge, back to the Arco di Portogallo, palazzo Ruccelai, piazza del Popolo, the collection of Antonio Paleozo, piazza Colonna, Montecitorio, and S Trinità.

Schott sounded an interesting caution on one subject of interest to every cultured and artistic visitor. Aristocratic collections were previously easily opened to visitors:

> but of later years the malignity of this depraved Age hath so ill gratified those Persons for their Kindness, by many injuries received from such their free admission, that now unless recommended by some friend to some particular person in Rome, or contracting a Friendship through long familiarity, 'tis not

easie for a stranger to obtain an inspection of those precious curiosities.[14]

The following accounts, it is pleasing to record, do not bear out this pessimism. More particular advice was conveyed by James Howell's *Instructions for forraine travel*, published in London in 1642. Howell (1594-1666) was a Fellow of Jesus College, Oxford, had travelled widely on the Continent, was MP and diplomat, imprisoned for many years as a royalist and finally became Historiographer Royal. He recommended, significantly, that the traveller be 'well grounded' in his own religion, and 'well versed in the Topography, Government and History of his own country', carrying a diary and a description of all countries through which he passes. On reaching a new city, he should 'repair to the Chief Church (if not idolatrous) to offer up his sacrifice of thanks that he is safely arrived thither' and perhaps climb the highest steeple 'to take a landskip' (landscape, i.e. bird's eye view) of the town. A fault of all travellers at all times was castigated: 'the greatest bane of English gentlemen abroad is too much frequency and communication with their own countrymen'. So much for generalities. 'Being now in Italy… he must be very circumspect in his carriage, for she is able to turn a saint into a devil and deprave the best nations.' One had to beware particularly of touters of worthless manuscripts. The best rule was to imitate Italian manners and deportment: the Italian stands 'twixt the Gravity of the Spaniard, the Heaviness of the Dutch and the Levity of our next neighbours' (i.e. the French). The English tourist had to learn 'not to be prodigal of speech when there is no need, for with a nod, with a shake of the head, and a shrug of the shoulders they will answer to many questions'.

BASILICAS, CHURCHES AND CATACOMBS

The dedicatory inscription of st peter's blazons the name of Paul V Borghese (1605-1621). The major basilica of Rome was thus complete

for seventeenth century visitors. It was dubbed by Johannes Neu-
mayer in 1620 the 'eighth wonder of the world'. Hieronymus Welsch
in 1631 commented on the portico with its eight enormous columns,
creating seven wide portals, and how each of the chapels inside was
like a beautiful church. The tomb of Urban VIII was by this time
under construction. The bronze statue of St Peter was an object
of great veneration: all visitors rubbed their heads against it (as a
sign of submission) or kissed it. The basilica's relics are again listed:
half the bodies of Peter and Paul, the pillar from Jerusalem against
which Jesus leaned, the Veronica, her body, the lance, Andrew's head,
Luke's head and arm bones, Joseph of Arimathæa's arm, and bones
of Stephen and Christopher. Martin Zeiller ten years later judged
that St Peter's excelled all churches in 'majesty, marble and art': one
cannot sufficiently marvel. The tomb of Paul III was still exciting
interest: some Italian had fallen in love with the younger woman's
statue. Even the Protestant Evelyn was impressed; 'that most stu-
pendous and incomparable basilica, far surpassing any now extant
in the world and perhaps (Solomon's Temple excepted) any that was
ever built'. He climbed the globe over the dome and 'engrav'd (his)

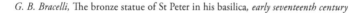

G. B. Bracelli, The bronze statue of St Peter in his basilica, *early seventeenth century*

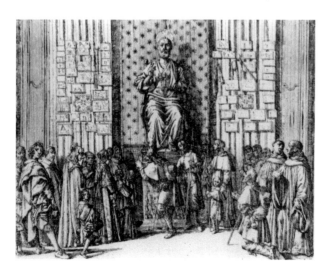

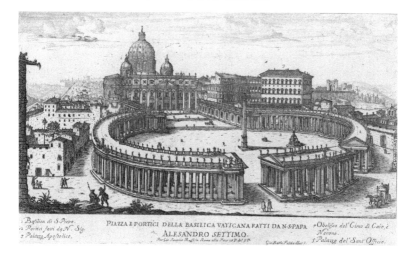

G. B. Falda, St Peter's, *1660s, now completed with Bernini's great colonnade*

name in, amongst other Travellers'. Evelyn also told a good story about the four great statues under the cupola. That of St Andrew was 'the work of one Fiamingo… It is reported this excellent Sculptor dy'd mad, to see his statue plac'd in a disadvantageous light, by Bernino [*sic*] the chief Architect, who found himself outdone by this Artist.' The sculptor was François Duquesnoy, known as François Flamand, who died in 1643.[15] For Evelyn, the profaner of Paul III's tomb was a Spaniard, and so for John Clenche. The bronze statue of St Peter, Evelyn believed, was originally a Jupiter Capitolinus, and again Clenche agreed. By the time Francis Mortoft arrived in 1659 he noted the building of a 'very stately and magnificent walke', that is, Bernini's colonnade, completed in 1667. He also began to notice the famed mosaics: 'being not painted but only certain little stones of all colours set so artificially together, that it would astonish any person to think how any man could be capable to represent life so much'. The basilica was to be counted 'the most absolute wonder of the world'. Mortoft finally observed something to which few drew attention, by the tomb of Leo XI in the left aisle. 'Just over against this statue is a tomb wherein the Body of the last Pope Innocent (that is,

the Tenth, died 1655) is enclosed, but is shortly to be removed from thence, and is to be interred in a Church that is now building in Piazza Novo.' The enthusiasm continued with John Ray (1664): 'in my opinion the most stately, sumptuous and magnificent structure that now doth, or perhaps ever did stand upon the face of the earth'.

Richard Lassells commented on several interesting features: that each of the bronze columns around the high altar weighs 25,000 lbs, and that only one secular person is buried here: Countess Matilda, translated from Mantova by Urban VIII in 1633. Clenche in 1675 declared the basilica 'the first church of the World for Beauty and Architecture, infinitely surpassing in both, either the Temple of Solomon or that of Diana of Ephesus'. These must have been the contemporary guides' comparisons, conforming to the scale showing the proportions of other churches now to be seen on the pavement. By the time of Jean Mabillon in 1685, the second fountain in the piazza had been installed. He noted that Pepin, king of the Franks, kissed each step when he visited the basilica (this was, in fact, Charlemagne in 774), just as pious women still climbed the steps of Santa Maria Maggiore and S Maria in Aracœli on their knees; he drew attention to Michelangelo's *Pietà*, and recorded that Urban IV (1261-4) forbade anyone to be buried in St Peter's without papal permission.[16]

The cathedral of Rome is S GIOVANNI IN LATERANO (see ill. opposite). The main interest of the visitors was in relics: the anonymous Englishman of 1605 listed essentially the same things as had the travellers in the sixteenth century: the pillar on which the cock crowed, the wooden table of the Last Supper, Moses' staff with which he led the Israelites across the Red Sea, Aaron's rod, a stone table on four pillars recording Jesus' height, against which everyone measures himself and no one ever is found to fit perfectly, three doors from Herod's palace, a little window where Mary sat for the Annunciation – and of course the *chaise percée* on which the newly elected pope sits 'to see whether he be fitted as a man'. Neumayer added the heads of Peter and Paul (skin and hair included), the cup from which Domitian forced John to drink poison – but without effect, the chain in which John was brought back from Ephesos, the clothing which Pilate gave Jesus, a piece of the Cross, the *sudarium* from the tomb, water and blood from

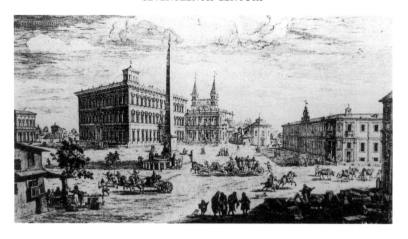

Alessandro Specchi, S Giovanni in Laterano, the Lateran palace and the Lateran obelisk, *1694*

Jesus' side, a column split down the middle when Jesus expired (the split was declared genuine, because it was crooked), and the Ark of the Covenant brought back by Vespasian. Johann Pflaumer gave a graphic description of Peter's head:

> clearly uncorrupted... the same in shape and lineament of the face as Nicephorus described, namely face a little pale, indeed white, the hair of head and beard crisp and thick, eyes black and almost bloodshot from constant grief, eyebrows plucked, a rather long nose, but rather pressed flat, and bald on the top of his head.

Modern travellers can see only the two reliquaries supposedly still containing the heads. Pflaumer also alluded to the tradition that the columns around the altar came from ships' beaks captured at the battle of Actium (31 BC), and fulminated against the stories of Pope Joan and the 'testing chair' (as did Lassells, Mabillon and Montfaucon). Welsch also was shown the cloth with which Jesus wiped the Apostles' feet, his baby shirt, the hair and clothing of Mary, her veil worn at the Crucifixion, the head of Zacharias (John the Baptist's father), the Baptist's ashes and blood, and the table on which the soldiers gambled

for Jesus' clothing. Mortoft recorded that when the heads of Peter and Paul are exposed (usually at Easter), locals present receive an indulgence of 3,000 years and those who come from afar 12,000 years. Albert Jouvain was highly enthusiastic: 'an unparalleled ravishment of everything which met our gaze'; for magnificence and grandeur only St Peter's could be compared. Neumayer also noted the old story that the tomb of Silvester II sweats and the bones are heard to rattle when a pope is about to die, but he claimed that this was easy to explain: the church was so badly aired!17

Nearby was the famous SCALA SANTA. Every visitor mentions, of course, the ascent on knees of the twenty-eight steps, and the Sancta Sanctorum at the top. William Bromley made the amazing assertion that Cardinal Philip Howard had admitted that these were not the true stairs, but that this truth could not be revealed. It is Lassells, a Catholic priest, who tells of a famous relic:

> Anciently, (as the Records here mention) the Holy Prepuce, or *Foreskin of our Saviour* was kept here too; but being taken away in the sack of *Rome*, by one of *Bourbons* soldiers, it was left in a country towne called *Calcata*, some fifteen [m]iles distant from Rome by the same soldier, who could not rest day nor night, as long as he had that *relick* about him. I once passed by that towne *(Calcata)* by chance, and by the civilityes of the Lord of the towne, *Count of Anguillara*, at whose house we were nobly entertained all night, had the happiness the next morning, to see this *precious Relick* through the *crystal case*. This *Count keeps* one key of it, and the *Parish Priest* the other, without both which, cannot be seen.18

At S MARIA MAGGIORE interest also focussed on relics. Welsch listed Jesus' cradle, made by his foster-father (*sic*) Joseph, the head of the apostle Matthew and the head and arm of the evangelist Matthew. Zeiller mentioned the custom of going on one's knees through the basilica to ensure a happy marriage or reform a bad spouse. For Evelyn, S Maria was 'absolutely (in my opinion at least) after St Peter's the most magnificent', and the chapels of Sixtus V and Paul V were 'of incomparable glory and materials'. In the former he was shown the

bodies of some of the Innocents slain by Herod, but that of Paul was 'beyond all imagination glorious', and 'most incomparable' the painting of its cupola.[19]

Mortoft on 24 February 1659, St Matthew's day, went to see the exposition of his head in a crystal cup. 'Both priests and people praying to it, and happy was he that could get but his hands to touch the outside of the Cupp where in this head was. The teeth of it are perfectly to bee seen, and it is affirmed to have the same flesh, beard and haire as it had when St Matthew was alive.'

Jouvain agreed with Evelyn that after St Peter's no church was more beautiful 'for its structure, sculpture, paintings and rich ornaments'. The tomb of Paul V 'is the most superb to be seen in Rome because of its columns of green marble, statues larger than life size of white marble, and the five panels filled with reliefs of the same which represent the most memorable events of his pontificate'. Clenche, however, was much more dismissive: 'relics enough to fill a charnel house'. Mabillon told how Sixtus V tried to remove the body of St Jerome to another church by the Tiber, but the canons hid the body.[20]

S PAOLO FUORI LE MURA attracts our attention because of its destruction by fire in 1823. The travellers' descriptions, therefore, allow us to imagine the appearance of the old basilica, built by Constantine, then remodelled in the fifth century (see ill. overleaf). It was adjudged by Neumayer 'externally a very bad building', but better inside. The Constantinian structure with its dark interior and wooden ceiling imitated old temples, he observed, but there was nothing artistic to see. Evelyn described the roof, supported by one hundred marble columns, one of which bore an inscription of Asellus, prefect of the city in the late fifth century (*CIL* 6.1668), the doors of bronze, made in Constantinople in 1070, the pavement of precious oriental marble, a painting of the Stoning of Stephen by Lavinia of Bologna, and pictures in the Chapel of the Sacrament by Lanfranco. Mortoft claimed that twenty-four of Constantine's original columns remained. There were paintings of both Paul's conversion and death – 'one of the rarest pieces in the world' – and the high altar was supported by four great pillars of porphyry. Jouvain, finally, described the chapel of St Gregory to the right of the door, with beautiful marble reliefs

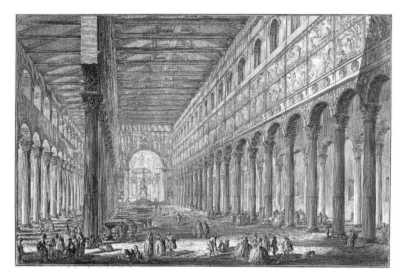

G. B. Piranesi, S Paolo, 1749

of Peter, Paul and Bartholemew. On the left of the altar was a paint-
ing of the martyrdom of St Stephen, on the right St Benedict and the
conversion of Paul. The transept had four beautiful marble statues of
SS Lucina, Brigid, Scolastica and Justine in niches supported by ten
granite columns 34' high; the columns in the naves were not so high:
eighty in four rows. Pflaumer listed the relics: half the bodies of Peter
and Paul, the bodies of the five Bethlehem boys, and of Sts Timothy,
Celsus, Julianus, Basilissa and Martinella, an arm of Anna (Mary's
mother) and of James, Nicholas and Alexis, Dionysius' shoulder, the
head of the woman of Samaria, and Paul's chains. Evelyn was also
shown the crucifix which conversed with St Brigid.[21]

For SANTA CROCE Evelyn provides a basic description:

> The Edifice without is *Gotic*, but very glorious within, espe-
> cialy the roofe, & one Tribune well painted: Here is a chapel
> dedicated to st. *Helena*, the Floore whereof is of Earth brought
> from *Jerusalem*, the walls of faire Mosaic, in which they suffer
> no Women to enter save once a yeare: Under the high Altar of
> the Church is buried St Anastasius in *Lydian* marble, Benedict

the VIIth and they shew a world of Reliques, expos'd at our request, with a Phial of our *B: Saviours* blood, two thornes of the Crowne, three Chips of the real Crosse, one of the Nailes, wanting a point, St Thomas's doubting finger, and a fragment of the Title, being part of a thin board, some of *Judas's* pieces of silver, and innumerable more, if one had faith to believe it. To this venerable Church joynes a Monasterie, the Gardens taking up the space of an antient Amphitheater.

Mortoft commended the painting in the apse,[22] now attributed to Antoniazzo Romano.

s LORENZO was, as one of the great basilicas, apparently on the main itinerary of all visitors, but no comments beyond description are offered.

s SEBASTIANO, finally, was adjudged by Evelyn 'a meane structure (the faciata excepted) but venerable Church, especially for the Reliques and Grotts, in which lie the Ashes of many Holy men. Here is also kept the Pontifical chair sprinkl'd with the Blood of Pope Stephanus,

Anon.,
S Sebastiano,
seventeenth
century

to which great devotion is paied, also a Well full of Martyrs bones, and the Sepulchre of St Sebastian, with one of the Arrows, [and] the Vestigia [footprint] of Christ when he met St Peter at Quo Vadis.'[23]

We may now turn to comments of interest on the other churches, in alphabetical order. At s ADRIANO Mortoft recorded that the building of the church was not yet finished (in 1659) and over the altar was an inscription stating that under it lay the bodies of Shadrack, Mesech and Abednego – 'but without doubt a most grevous lye'! At s AGOSTINO, Balthasar Monconys had the taste to note Raphael's *Prophet*, Caravaggio's *Madonna of the Pilgrims*, and Daniele da Volterra's *Descent*, but then he did purchase paintings from Claude Lorrain. At s ANDREA DELLA VALLE Evelyn noticed the Barberini chapel 'of curious incrusted marbles of severall sorts, and rare paintings'. Lanfranco's painting in the cupola he thought 'an inestimable work, and so is the entier fabric and Monasterie adjoining'. Friedrich Calixtus in 1651 claimed that S Andrea was accounted second only to St Peter's. At s CECILIA IN TRASTEVERE, Evelyn noted that the saint's body had only recently been found and that Cardinal Paolo Sfondrati had built the altar; he was also shown the baths of St Cecilia. The columns of the portico were taken from the Baths of Septimius Severus. Mortoft drew attention to something else of interest to his countrymen: the tomb of Adam Hereford, titular of this church (d. 1396). At the CHIESA NUOVA, Evelyn commented on 'divers good pictures, as the *Assumption* of Girolamo Mutiano; the *Crucifix* [by Scipione da Gæta] the *Visitation of Elizabeth*, the *Presentation of the Blessed Virgin* [both by Federico Baroccio], *Christo Sepolto* of Reni [in fact Caravaggio's *Deposition*, now in the Vatican], Caravaggio, Arpino and others'. Mortoft noticed s FRANCESCA ROMANA, 'which is but little, but what it wants in bignesse, it hath in richnesse, the high altar being as Rich a piece of worke as any in Rome'. He put his hands into the cracks in the stones on which Peter prayed against Simon Magus. Neumayer accounted the GESÙ the most beautiful of modern churches. The same noted that at s GIACOMO SCOSSA CAVALLI were kept the stone on which Jesus was circumcised and that on which Isaac was to be sacrificed. Philip Skippon recorded a popular tale about s GIORGIO IN VELABRO, that it was once a temple dedicated to one of Scipio Africanus'

captains: the authentic voice of popular tradition or the *ciceroni* comes through (this is a variant on the idea that it was the site of the house of Scipio himself: see in the eighteenth century, vol. 2). Trust Lassells to draw attention to the smallest church in Rome! By Trinità di Monti was S ILDEFONSO, which had 'all the lineaments, features and meen of a Church, but also all the noble parts'.[24] This is in via Sistina, built in 1667 for the Spanish Augustinians.

Evelyn saw people climbing the more than one hundred marble steps to S MARIA IN ARACŒLI on their knees. It contained a Madonna reputedly painted by St Luke and the footprint of the angel which appeared on Castel Sant'Angelo. Jouvain claimed that women climbed the steps in this way on Mondays. Neumayer alone noted the graves of Biondo and Platina in the forecourt. Evelyn visited the Capuchin church of S MARIA DELLA CONCEZIONE:

> here's a pretty church built by the Cardinal [Onofrio Barberini in 1624] full of rare Pictures, and there lies the body of S Felix that dos (they say) still do Miracles. The Piece at the great Altar is of Lanfranc, 'tis a Lofty Edifice, with a beautiful avenue of Trees, and in good aire.

Now the church is famous for the adjoining cemetery. Neumayer thought S MARIA IN COSMEDIN 'an old ugly building'. Everyone, of course, mentioned the Bocca della Verità, and it is not surprising that Montfaucon knew what it was: a drain cover, but he credited the discovery to a Danish scholar, Frederick Rostgaard. S MARIA EGYPTIACA in the Foro Boario was an Armenian church and the learned Montfaucon attended a service there, the main feature of which was deafening noise, produced especially by a kind of cymbal. As late as 1620 Neumayer was still retailing mediæval legends in the case of S MARIA LIBERATRICE: the Romans claimed that Pope Silvester killed a dragon here. Jouvain judged S MARIA DELLA PACE 'one of the most remarkable in all Rome for sculpture and painting'. At S MARIA DEL POPOLO Evelyn noted the 'miraculous shrine of the Madona which Pope Paul the 3d brought barefooted to the place supplicating for a victorie against the Turks 1464. In the Chapell of the Ghisi [Chigi] are some rare paintings of Raphael and noble sculptures. Those two

in the Choire are of Sansovino, and in the Chapel de Cerasii a piece of Caravaggio.' In this chapel, to the left of the altar, in fact are both the *Conversion of St Paul* and the *Crucifixion of St Peter* by Caravaggio. Aubrey de la Mottraye in 1696 noted the fine sculptures: 'that of Elias (by Lorenzetto) carries the Day in the Opinion of all good Judges', and Carracci's *Assumption* is 'esteemed one of the finest pieces of painting in all the world'. S MARIA IN PORTICO (or in Campitelli) was visited by travellers for a remarkable column which emitted light – but Welsch was very proud of himself for discovering that it was in reality translucent alabaster. S MARIA IN TRASTEVERE was known principally for the tradition of the fountain of oil which sprang forth there in the third year of Augustus' reign, to announce the Saviour's birth, but Evelyn also noted that the high altar was 'very faire' and the *Assumption* (by Domenichino) 'an esteemed piece'. S MARIA DELLA VITTORIA was more frequented because of its decorations with the banners taken from the Turks. It 'presents us with such a front as would even ravish the beholder with astonishment... I observed that the high altar here was infinitely frequented for an image of the Vergine. It has some rare statues, as Paule ravish'd into the 3rd heaven by Ger. Fiamengo, and other good Pictures.' It was, however, Mortoft who noticed what the church is now especially famous for:

> In which church is a statue called Santa Tarasea [*sic*] languishing for charity and wounded by an Angel, made by Barnino [*sic*], the famous Engraver, and that so much to the life that the more one beholds, the more one hath cause to admire it.[25]

S PIETRO IN MONTORIO, Neumayer told his readers, contained 'something of the excellent painter Raphael to see' – restraint which is difficult now to credit. Evelyn recorded that there was 'a round oratory of incomparable designe by Bramante... The church adjoining it is exquisitly painted by the inimitable hand of Raphael d'Urbin and amongst the rest of the figures his own Effigie to the life, which piece is estemmed one of the rarest in the World.' Evelyn seems to be referring to the *Transfiguration*. Mortoft in 1659 finally spoke clearly:

> on the high altar is one of the livelyest pictures that ever was

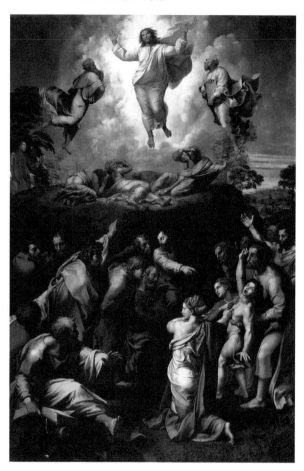

Raphael, The
Transfiguration,
*1516-20 (S Pietro
in Montorio; after
1815 in the Vatican
Museums)*

done by any mortal Person, and wherein the Lymner has shewed
soe much Art that more cannot be expressed. It is concerning
the transfiguration of our Saviour, where every motion is made
so lively that noe lively person can better represent those actions
than is on this picture.

By the time of Jean-Baptiste Colbert (1671), this was 'the first picture
in the world'.[26] A companion piece was to be found at S PIETRO IN
VINCOLI. Neumayer remarked on the cloister full of orange trees, a

beautiful pleasure garden. Pflaumer, however, declared that it was Michelangelo's Moses which 'can never be sufficiently praised'; it is 'never sufficiently to be admired', agreed Evelyn, who also listed the bodies of the seven Maccabean brethren under the altar as the focus of much devotion. Jouvain recorded that the Jews wanted to buy the statue for 100,000 *scudi*; 'an outstanding specimen of art', agreed Mabillon. The other attraction of the church was the chains of St Peter: on the feast day (22 July) they were taken out of their silver casket on the altar and on application one might kiss them and hang them around one's neck.[27] Evelyn noted the devotion paid to S PUDEN-ZIANA because of the well 'filled with the blood and bones of severall Martyres' and the 'incomparable' tomb of Cardinal (Enrico) Caietani (d. 1599: in the family chapel), and the altar at which Peter said his first mass in Rome and the stone on which he knelt, and at nearby S PRASSEDE the pillar at which Jesus was said to have been scourged, 'at which the devout sex are always rubbing their chaplets, and convey their kisses, by a stick having a tassle on it'. On the Aventine at S SABA were two marble chests reputed to be the tombs of Vespasian and Titus, while at S SABINA, Neumayer opined that there was nothing special to see. Evelyn, however, listed an 'admirable picture' by Livia Fontana, set about with columns of alabaster, and the stone which the devil cast at St Dominic. S SUSANNA was noticed by Evelyn: 'the faciata of this church is extraordinary noble, the Soffito within guilded and full of Pictures; especially famous is that of Susanna by Baldassar of Bologna, Also the tribunal of the high Altar of exquisite worke, from whose incomparable stepps of marble you descend under grownd the repository of divers saints.' The same man did not miss the TRE FONTANE: 'perfectly well built although but small… having a noble Cupola in the middle'. The waters of the fountains were reported to be medicinal: Evelyn found them a little sharp. Reni's *Crucifixion of Peter* he called 'excellent'.[28]

Most travellers simply recorded what they saw in the churches, listing them as would a guide book. The above represent some of the more perspicacious judgements, allowing us to see what was especially recommended for attention by the visitor, and giving us some idea of taste during the seventeenth century. The churches, it is clear, were

still mainly frequented for their relics. The Protestant travellers often noted what they were told, with a 'let him believe it who will'. The German Catholic Pflaumer addressed the question more directly. He recognised that the nails of the Cross kept everywhere were too many. The only answer, he counselled, was to banish all doubt from one's mind and remember what Ambrose said: we do not worship the iron but the Passion, and he quotes Paulinus: the Cross miraculously provides all those fragments without ever being diminished![29] This was obviously preaching to the converted.

Mortoft saw the BLESSING OF THE HORSES AT S MARIA MAGGIORE on 16 January 1659.

> *January the 16th,* being St Anthonie's day, which was held by the Catholickes to be a very holy man in doing many strange miracles in his life tyme, and accounted the Patron of horses, for which cause all the horses as is beleeved that was in Rome were lead to this Church which is called by his name, and standing close by the Church of St Mary Maggiora, where at one of the doores stood a young Priest with a kind of a Brush in his hand and some holy water by him, and as the horses came by he gave them St Anthonye's Benediction, in sprinkling some water upon them, and every horse went about three tymes, and so had it in the name of the father, sonne and Holy ghost, and this was his worke from Morning to night, there being an infinite number of Coaches and horses heere all this day, and abundance of gentrye in them. Being very desirous, it seemes, to be pertakers with their Horses in St Anthonye's Benediction.[30]

The next day, 17 January was the day of ST PETER'S CHAIR:

> *January the 17th,* wee went to St Peter's Church in the Vattican, where we saw another Ceremony. On this day it is held that St Peter came first to Rome, for which cause his Chaire, which stands upon an altar on the left hand as one goes in[to] the Church, and was exposed to publicke view, where all Persons that came into the Church were very Ambitious to have their

Beads and Chaplets touch the side of the Chaire, which was two or three persons worke to doe from Morning to night. And I dare affirme truely there were more Beads touched the side of the chaire this day than would load a Cart.[31]

February the 2nd, which was CANDLEMAS DAY, was a Cappelle, as they call it, held in the Pope's Chappell, where came the Pope [Alexander VII Chigi] and some 35 Cardinals to observe those Ceremonies which are apppointed on this day. The Cardinals were this day habited like Bishops, but there [*sic*] Habits exceeding Rich, and every Cardinall having his Mitre on his head. When part of the Masse was said, the Venetian Embassador, who sate by the Pope, kissed his hand, and received a great Wax Candle from his hand. Afterwards all the Cardinals kissed his Robe and received Candles from him. Then Came the Priests that said Masse, every one of them kissed his foote, then the Pope receiving a Candle out of a Priest's hand that was by him, gave each of them with his owne hand a Candle. Afterwards came, I thinke, about 30 of these men, which are cloathed in Red Velvet, and serve to carry him in his Chaire, and such like offices, and every one of them, one after another, received a Candle from him.

Then came those Gentlemen which could gett in to the Chappell, which is something difficult, kissed his foote and received Candles from him. And I by chance getting into this Chappell, but with very much trouble, kissed his Foote and Received a Candle from his owne hands. Soe did Mr Hare, Mr Stanley, and Mr Hare's man, and thereupon wee all went away very well contented.[32]

The same English traveller describes important ceremonies in LENT, which began in 1659 on 26 February.

February the 26th, and first day of Lent, I went to the Pope's Pallace, where was a Cappello of Cardinals, and masse said after the usual manner. Afterwards he was not carryed out in his Chaire by sound of Trumpetts, but walked out of the Chappell on foote, which was accounted for a great matter; then he went

into his Sedan. Before him Marched 6 or 7 stately horses. Then some of his Guard of Swizzers. Then came his Holinesse, and after him 16 Cardinals upon Mules. Every one of them having his Hatt upon his head, which the Pope used to send to a Man when he makes him A Cardinal. After these Marched 10 Monsignors upon their Mules, having there [sic] Capps of the same fashion of the Cardinals, but there's [sic] was blew, and the Cardinals' Capps red.

After these Marched about 200 light horsemen; having there swords drawne as they marchd along, the Pope never going abroad without these Men to attend on him, and after him Moltitudes of Coaches and people in them to see him passe, and soe passing up the Hill called the Aventine to the Church named Sabinia, where going behind the Altar he read a little in a Booke, with his Capp, where I could see his shaved Crowne, and there, as others say, gave Ashes to his Cardinals, but I did not see it. Having stayed about halfe An hower [hour] in the Church, he went again into his Litter, where, all the way as he went, he was making Crosses with his hand and blessing the People. The People also, being so nursd up in superstition, that as soone as ever they had put a glimps of him, presently they downe upon their knees, and continue crossing themselves till he is passd by them, esteeming themselves most happy if they can but run after him as he passes a long, to receive his Blessing from him.[33]

March the 14th, hearing that the Pope, according to his usual custome in this Lent, came from his Pallace of Monte Caval to St Peter's Church to performe some devotion there, wee went there, and after a little while tarrying wee saw the Pope coming: where coming over the Bridge upon the Tiber by the Castle of St Angelo. All the soulders stood upon the walls of the Castle to salute him with shot as he passd by, then passing from thence up to St Peter's, first came three white horses, lead by 3 severall men, the cloaths upon them having the Pope's armes wrought in gold, then came some Bishops and Gentlemen upon very fine horses, then followed the Pope's Nephew and some

Dukes and great Persons, then came the Pope in his Sedan. After him came about 20 Cardinals on their mules, and after them some Monsignors, then followed the Pope's Coaches, and two horselitters, and after came the Pope's Guard of Swizers, and after them followed the Pope's light horsemen with their naked swords in there hands. Then the Pope going out of his Sedan went into the Church on foote, and knelt before the Altar where, they say, St Ambrose is buried. He having prayed a little while here, and at the end of his devotion signing himselfe with the signe of the Crosse, he rose from thence, and walked behind the great Altar, and there did performe the like devotion for about halfe a quarter of an hower. From thence he went and kneeld before this High Altar and there did the like. So having performed these pieces of devotion, he went out of the Church into his Sedan, and as he was going into his chaire came multitudes of People, calling him their most holy Father and desiring his benediction. So smiling and laughing and crossing himselfe, he went into his Chaire, and was carryed againe to his Pallace of Monte Caval.[34]

A good summary of EASTER celebrations in 1645 is given by Evelyn: the pope is Innocent X Pamphili (1644-1655):

> The rest of this weeke we went to the *Vaticane* to here the Sermons at st. *Peters* of the most famous Preachers, who discourse on the same subjects & Texts yearely, full of Italian Eloquence, & action. On our Lady day we saw the *Pope & Cardinals* ride in pomp to the *Minerva*, the greate guns of the Castle st. *Angelo* discharging, when he gives portions to 500 *Zitelle* [unmarried girls] who kisse his feete in procession; some destind to Marry, some to be Nunns: The Scholars of the Colledge celebrating the B: Virgin with their composures &c: The next day his holinesse was buisied in blessing of golden roses, to be sent to severall greate Princes, & the procurator of the Carmelites preaching on our Saviors feeding the Multitude with 5 loaves, the Ceremonie ends: The Sacrament being this day exposd, & the Reliques of st. Crosses, the concourse about the streetes is extraordinarie:
>
> On Palme sonday was a greate procession, after a papal Masse,

& on the 11th of April, was exposd at st *Peters st Veronicas* Volto Santo [Holy Veil], & next day the Speare, with a world of ceremonie: on Holy Thursday the *Pope* said Masse, & afterward carried processionaly the Host about the Chapell with an infinitie of Tapers; this finish'd his holinesse was carried in his open Chaire on Mens shoulders to the place where reading the Bull in *Cæna domini* he both Curses & blesses all in a breath, then the gunns againe went off: hence he went to the Ducal hall of the *Vatican* where he wash'd the feete of 12 poore-men, with all that ceremonie almost as tis don at Whitehall, they have Clothes, a dinner, & almes, which he gives with his owne hands, & serves at their Table: They have also gold & silver Medails, but their garments are of white wollan, long robes as we paint the Apostles: The same Ceremonies are don by the Conservators & other Officers of state at st. Jo: *de Lateran*: & now the Table on which they say our B: L. celebrated his last Supper is set out, & the heads of the Apostles; Every famous Church buisy in dressing up their pageantries, to represent the holy Sepulchre, of which we went to visite divers:

Good Friday we went againe to s *Peters*, where the Volto, Launce, & Crosse were all three exposd & worship'd together: All the confession Seates fill'd with devout people, & the Night a procession of severall people that most lamentably whipped themselves till all the blood staind their clothes, for some had shirts, others upon the beare back, with vizors & masks on their faces, at every 3 or 4 stepps, dashing the knotted & ravelld whip-cord over their shoulders as hard as they could lay it on, whilst some of the religious Orders & fraternities sung in a dismal tone, the lights, & Crosses going before, which shewd very horrible, & indeede a heathnish pomp: The next day was much ceremonie at s Jo: de Laterano, so as this whole weeke we spent in running from Church to Church, all the towne in buisy devotion, greate silence, and unimaginable Superstition: Easterday was awakn'd with the Guns againe from st. *Angelo*, we went to s *Peters*, where the pope himselfe celebrated Masse, shew'd the Reliques formerly nam'd, & gave a publique benediction, & so we went to dinner:[35]

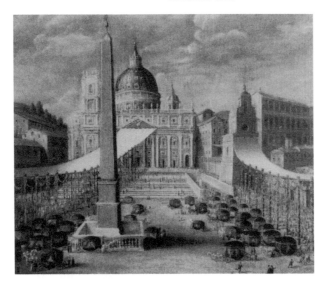

Anon., Corpus
Christi, *1640s*
*(Museum of
Rome)*

Jean-Antoine Rigaud was present on CORPUS CHRISTI, at the end of
May 1600. He described the pope (Clement VIII) leaving St Peter's
carrying the Corpus Domini 'a pie teste nue' [on foot with uncovered
head], with the cardinals preceding him in threes, wearing white
mitres, and after him the ambassadors of the Holy Roman Empire,
France, and Venice, the Swiss Guards, and on either side the light
cavalry with helmets covered with tinsel and armed with lances. The
procession went as far as S Giacomo Scossa Cavalli in the Borgo, with
the canon of the fort firing loudly.

This was followed shortly by ST JOHN'S DAY (24 June). The evening
before the pope in cavalcade went with almost all the cardinals, bish-
ops and aristocracy to dine at the Quirinal: one hundred and fifty
carriages, seven or eight hundred gentlemen 'in harness'. After mass
the next morning the pope was carried around S Giovanni giving
blessings, then transferred to his litter to return to the Quirinal.

Five days later was ST PETER'S DAY (together with St Paul). On the
day before vespers were celebrated in St Peter's, after which the pope
was carried out in his red velvet litter borne by ten men dressed in violet.
There was fine music, with many trumpets. That night, three hundred

Swiss Guards left the palace and marched to Castel Sant'Angelo, where they exchanged salvoes and arbuscades with the garrison, accompanied by drums and fife. They then returned to the palace and repeated the fire, to which the castle replied, including the famous girandola (fireworks display): 'the whole castle was on fire'. On the day itself, there

Ambrogio Brambilla, Castel Sant'Angelo and the Girandola, *1579*

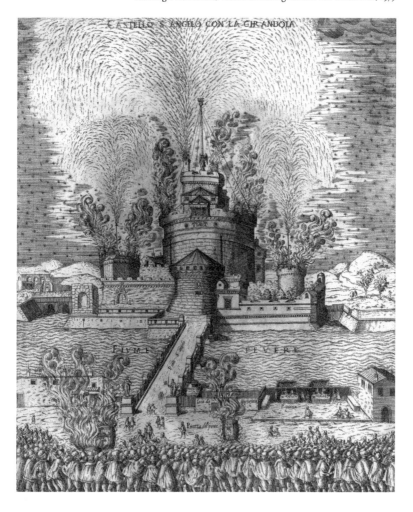

was more firing from the castle and the pope was carried into the basilica for mass attended by six penitential priests in scarlet. On the altar were the twelve Apostles and the four Evangelists in silver. The cardinals all paid homage to the pope who sat on his great throne. On leaving the church, he met the Spanish ambassador who presented him with a white palfrey, which knelt before the pope, and 80,000 *scudi*, the tribute from the king of Spain for the kingdom of Naples, which had been in Spanish hands since 1504. This ceremony was called the Chinea (from the Greek *chioneos*, snowy white). In the evening there was again exchange of canon, which brought down the papal standard on the castle. The aristocrats had fireworks displays at the doors of their palaces, and most windows were illuminated. In 1651, Calixtus described the same festival under Innocent X, where the pope led the mass with 'so many gesticulations and ceremonies' that the attention of the congregation was completely distracted. Others describe the Neapolitan tribute being brought in January by thirty horses and mules carrying chests, their hangings of silk, velvet, gold and silver.[36]

Anon., The Chinea, 1746. This depiction of the offering of tribute from Naples comes from the eighteenth century, but shows the cavalcade about to cross Ponte S Angelo with the famous palfrey loaded with gold in the middle, and a temporary pavilion in the background

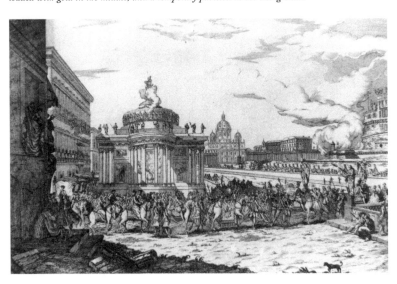

Skippon threw a brief human light on the exposition of the VERON-
ICA (8 November). It was 'shown to the people on their knees, beating
their breasts; we observed one priest among the crowd seemed a little
unsatisfied until he had put on his spectacles and used the help of a
perspective glass'.[37]

Ellis Veryard explained that at this time there were four main CATA-
COMBS: Ciriaco-Lorenzo; Agnese; Callisto-Sebastiano; and Pancrazio,
and that it was 'generally belived that they all communicated with
each other'. A visit to the Neapolitan catacombs produced a long
discussion by Gilbert Burnet, who denied that the early Christians
could have excavated such vast cemeteries at Rome, and asserted that
they were pagan in origin, going back to earliest times.[38]

The most visited were, of course, those on the via Appia: S SEBAS-
TIANO and S Callisto.[39] Evelyn visited the former. The Fulgentine monks

> led us down into a Grotto, which they affirm'd went diverse
> furlongs under ground, the sides of Walls as we pass'd, fill'd with
> dead bones and bodies, laied as it were on shelfes, whereof some
> of them were shut up, with broad stones, and now and then a
> Crosse or Palme cut in them: here were also at the end of some of
> these subterranean passages square roomes, with Altars in them,
> pretending to have formerly been the receptacles of Primitive
> Devots in the times of the Persecution, nor seemes it improbable.

Of what he called S CALLISTO, Neumayer told an extraordinary tale.
This catacomb had been discovered by a Dutch artist, who noticed a
depression in the ground on one of his walks. He is not named, which
is extraordinary, considering that he guided Neumayer and his brother
on their visit. He was granted an exclusive licence by the pope to
investigate, and found a gold ring, but otherwise only the black stones
with which the *loculi* (burial niches) were closed, from which he made
a table and gave it to a cardinal, some glass vessels with red liquid in
them, bones of course (one of which he presented to Duke Johann
Ernst, while the pope gave a whole skeleton to the duke of Bavaria),
and a domed space with walks painted with animals (a chapel). By
1651 what was called S Callisto was closed after an earth-fall trapped
some visitors. The Catholic priest Lassells visited them several times

with a good experienced guide and wax lights (torches being too 'stifling'). He left a moralising assessment:

> no man enters into the catacombs but he comes better out than he went in. Catholicks come out farre more willing to dye for that faith, for which so many of their ancesters have dyed before them. The Adversaryes of the Roman Church come out more staggered in their fayth, and more milde towards the Catholick Religion, to see what piety there is even in the bowels of Rome; Atheists come out with that beleef, that surely there is a God, seing so many thousand of Martyres have testifyed it with their blood.

The basic reaction, however, was one of caution, as exemplified by the great scholar Montfaucon:

> one cannot enter far in the underground passages, even if, when they were open, they could be widely traversed, because they extend all around with passages in every direction. Because in truth for the inexperienced the deeper reaches cannot be penetrated without danger, the passages have deliberately been blocked and are not open far. They say that some aristocrat who with his retinue rashly plunged in never reappeared. Not long ago I came on the account of a French visitor who seemed to be shrewd, and he told how he and a few friends entered these obscure paths and wandered about for more than five hours without any way of determining how to escape, if they had not come upon some workers who were excavating bodies.[40]

A visit to the catacombs of s CIRIACO at S Lorenzo was much rarer. Mortoft gives a description in 1659:

> Afterwards wee tooke, every one of us, a great Candle, and went downe under ground, being so narrow and low that wee were almost constraind to creepe along, and where the Man that went with us [showed] the places all along the moist earth, where the Bodyes of the Christians used to be buried, and going

along this dismal and darke place, wee came at last to a place where a great quantity of there bones are preserved, as the Reliques of holyer men, I beleeve, then are at this tyme in Rome.[41]

Montfaucon visited in addition to the catacomb of S Ciriaco that of S AGNESE. Here he mentioned that he was given a portrait of St Peter from a grave, and the leaden head of a man from his wife's grave. S PANCRAZIO was visited by Jouvain, guided by a Flemish gentleman who, when they lost their way, dropped the torch and extinguished it. Jouvain asserted that with calm he could retrace their steps, and they managed to refind the light. An anxiety to visit such tombs, Jouvain warned, might result in being buried alive. Evelyn graphically described a visit, perhaps to S DOMITILLA:

> We therefore now tooke Coach a little out of Towne, to visite the famous *Roma Subterranea*, being much like those of st. *Sebastians*: here in a Corn field, guided by two torches we crep't on our bellies into a little hole about 20 paces, which deliver'd us into a large entrie that lead us into severall streetes and allies, a good depth in the bowells of the Earth, strange & fearefull passages for divers miles, as *Bossius* [Antonio Bossio] has describ'd & measur'd them in his book: we ever & anon came into pretty square roomes, that seem'd to be Chapells, with Altars, & some adorn'd with antient painting, very ordinary: That which renders the passages dreadfull is, the *Skeletons* & bodies, that are placd on the sides, in degrees one above the other like shelves, whereof some are shut up with a Course flat Stone, & *Pro Christo* or [*] & Palmes ingraven on them, which are supposed to have ben Martyrs: Here in all liklyhood were the meetings of the Primitive *Christians* during the Persecutions, as *Plinius Secundus* describes them: As I was prying about, I found a glasse phiole as was conjecturd filld with dried blood, as also two *lacrymatories*: Many of the bodyes, or rather bones, (for there appeard nothing else) lay so intire, as if placed so by the art of the Chirugion, which being but touch'd fell all to dust: Thus after two or 3 miles wandring in this subterranean Meander we return'd to our Coach almost blind when we

came into the day light againe, & even choked with smoake: A French bishop & his retinue adventuring it seemes too farr in these denns, their lights going out, were never heard of more.

Nothing more is known of the identity of this French bishop, but the story is entirely credible, as the present writer can testify. Montfaucon again, finally, visited the catacomb of SS PETER AND MARCELLINUS in company with several abbots and a large retinue; again they had trouble refinding the exit.[42]

PALACES

The majority of visitors to the VATICAN paid most attention to the library and the Belvedere. Evelyn in 1644 left notes on many other wonders. The Raphael Loggie 'are so esteemed, that Workmen come from all parts of Europe to make their stydys from these designes'. The Sala di Gregorio XIII was 'one of the most Superb and royall Appartiments in the world, much too beautiful for a guard of gigantic Swizzers who do nothing but drinke, and play at Cards in it'. The Sistine Chapel 'tooke up much of our time and wonder', with the Last Judgement 'a vast designe and miraculous fantasy, considering the multitude of Nakeds, and variety of posture'. The Raphael Stanze were already celebrated: 'you shall never come into them, but you find some young man or other designing from them, a civility which in Italy they do not refuse them where any rare pieces of the old and best Masters are extant'.[43]

The LIBRARY, however, is what most visitors mention, and what they were shown varies considerably. The anonymous Englishman in 1605 saw three books by Virgil, which he credulously thought to be 1600 years old, obviously claimed to be in Virgil's own hand, a book in Arabic, the tables of Moses on which were written the Ten Commandments (!) and Indian books 'written with barks of trees, but not with letters, only figures'. 'Then, finally taking leave, bestow something to drink' (what the French accordingly call a *pourboire*). Johann Pflaumer saw only two Virgils, a Terence, autographs of Petrarch, some notes

of Aquinas, and a Hebrew MS in roll form. The Acts of the Apostles in Greek, decorated with gems, and given by Catherine of Cyprus to Innocent VIII, had been stolen during the sack of 1527. Martin Zeiller regretted the lack of a catalogue – which must have made scholarly use of the treasures difficult. Evelyn accounted this library 'doubtless the most nobly built, furnish'd, and beautified in the world, ample, stately, light and cherefull, looking into a most pleasant Garden' – and he compared it directly with the Bodleian. The statues of Aristides and Hippolytus stood at the entrance. The books were 'all shut up in Presses of Wainscot'. He knew that the Virgils were, in reality, a thousand years old. What the English most enquired after was Henry VIII's book against Luther. In a separate wing was the Heidelberg library (the Heidelberg or Palatine library belonged to the Elector of Palatine. Frederick V, the 'Winter King', who lost Heidelberg to Count Tilly in 1622 in the Thirty Years' War. The library was presented to Gregory XV in 1623 by Duke Maximilian of Bavaria). Friedrich Callixtus in summer 1651 was taken to see the library by none other than Athanasius Kircher, because it was closed until September. The librarian was Cardinal (Luigi) Capponi. Francis Mortoft listed a great many curiosities including 'wrighting on the Barke of a tree. A Turkish Alcoran. A China story, and an Æthiopian song. American Hieroglyphics', of course Henry VIII's letters to Anne Boleyn 'which by the reading of them appeares to be very good English and the words placed in a very orderly Method', and an edition of St Chrysostom by Henry Saville, tutor to Queen Elizabeth. Balthasar Monconys judged the library 'one of the most important things in Rome, but the popes have not taken the care of it which it deserves'. Richard Lassells, like Evelyn, described the arrangement of the library: at the entrance was a a kind of scriptorium for a dozen copyists, with the portraits of all the librarians since the reign of Sixtus V. The library itself was a long room, lined with cupboards, with the wall on the right showing in fresco the councils of the Church, and on the left the famous libraries of the world. This room at its end opened out into two wings. Lassells was guided by Lucas Holsten, keeper 1653-1661, and shown the Urbino library (acquired in 1657) and the Palatine. Jean Mabillon in 1685 paradoxically mentioned only the kindness to him of the 'prefect' Emmanuel

Schelstrate (keeper 1683-1692) and the other deputy keeper Lorenzo Zaccagni (keeper 1698-1712). Bishop Gilbert Burnet was also on very close terms with Schelstrate, and describes the days which he spent with him examining manuscripts of the Council of Constance regarding the dispute over papal infallibility and the precedence of councils over popes. Needless to say, they disagreed. Bernard Montfaucon in 1698 noted the acquisition of the Alexandrian library (from Queen Christina in 1690). The library surpassed any other in size and magnificence and contained 12,000 codices, equal to the Royal Library in Paris, but inferior in printed books. He listed a Bible in Greek uncials of the fifth or sixth century, an Acts of the Apostles in gold, a Hebrew Bible, an uncial Virgil which had belonged to a certain Dionysius in the thirteenth century, two Terences (one ninth century), a very old German Bible, and a Minucius Felix. The keeper now was Zaccagni.[44]

For the BELVEDERE, most travellers simply gave a list of the statues. Mortoft revealed more of the contemporary reaction. In the garden were 'many Orange trees and a gallery of Lemon trees. At the farre end, under the great Arch, is the Brazen Pine Apple [that is, the famous pine-cone] which was placed on the topp of Adrian's Sepulcher... Neere it are two Brazen Peacockes, which were on Scipio Africanus his tomb. Within that Arch wee passed into a square Court' where they saw Apollo, Commodus like Hercules, Antinoüs, Venus 'coming out of a Bath, and which appeares with soe much Grace Beauty and Majesty, that the true Venus herselfe could not carry away the prize for Bæuty from this statue', and the Laocoön. 'In the middle of the Court is a maimed statue which was a Coppy to Michael Angelo' (the Torso). 'On the one side of it is a great statue of the Tiber... on the other the representation of Nilus... In a little passage Cleopatra stretched out at length, having a most lively dying looke. Beyond it a leaden shipp which formerly sprouted out water, but now suffers shipwracke.'[45]

The armoury, finally, attracted attention. 'I hardly believe any Prince in Europe is able to show a more compleatly furnish'd Library of Mars, for the quality and quantity, which is 40,000 compleate for Horse and foote, and most neately kept.' Mortoft stated there were arms for 60,000 and pride of place was given to the display of the arms of Bourbon, killed in 1527.[46]

The truly inquisitive and persistent visitor to the Vatican palace in the seventeenth century, however, could see much more. The anonymous Englishman of 1605 offers two examples:

> Enquire where the Pope keeps his consistorium or council which is commonly every Monday and Friday, in the mornings; and courteously saluting the guard of Switzers, who are appointed there to attend, they will let you in, where you may see the pope, with all his cardinals, and how they kiss his feet.
>
> You may try to see the pope's chamber of treasure, but it is a very difficult thing to get leave, where are certain chests, in every of which is kept the treasure that each pope did leave, shortly before their deaths; it is not possible to be described. I had the fortune to get in, with a princess great with child, whereby I had a sight thereof.[47]

After the Vatican, the two most visited palaces were the Farnese and the Borghese. Outside the PALAZZO FARNESE, the anonymous English

Alessandro Specchi, Palazzo Farnese, *1699*

Louis Chaix, The cortile of the palazzo Farnese, *c. 1750.* The Hercules is dominant

visitor *c.* 1605 remarked on 'the two mighty kettles of stone', that is, the granite fountains from the Baths of Caracalla. Inside, he noted 'a mighty ox and three statues; a dog, a shepherd and a concubine' made of one whole block of stone. Goodness knows what story was told him of the tale of Dirce. A much rounder picture was presented by Johann Neumayer in 1620: the palace was 'most finely and elegantly built'. In the courtyard were two Hercules, a gladiator with a short sword, Commodus, captive Parthians, and an Armenian king. Inside were more marble statues, 'the like of which cannot be seen in any other place in the city': Cicero, Cæsar, Hadrian, Augustus, Ganymede, Mercury, Apollo, an hermaphrodite, Minerva, Æsculapius, Securitas, Venus, Silenus with Bacchus on his shoulder, Flora, Roma enthroned (a composite statue of porphyry and metal) and others. Behind the

palace in a shed was the 'most famous piece of art in Rome', the Farnese Bull. About the same time another German, Pflaumer, noted that if you were lucky you might be allowed upstairs to see the library (if unlucky, you could try money). A qualitative leap is constituted by Evelyn, who visited the palace twice. On his first morning in Rome he went straight away to see it, notably 'that famous gallery painted by Caraccio, and than which nothing is certainly more rare of that

Diana Scultori, The Farnese Bull, *engraving dated 1581*

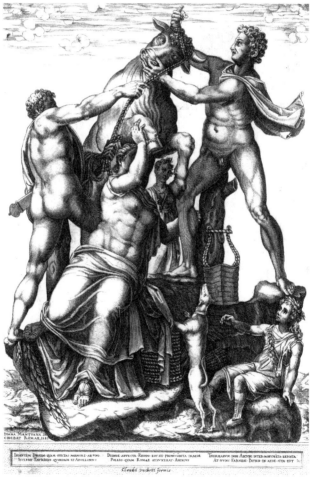

Annibale Carracci, Bacchus and Ariadne, *1598-1602 (Farnese Palace)*

Art in the whole world, so deepe and well studied are all the figures'
(see ill. above). He also saw the history of Hercules in chiaroscuro. It
was the antiquities which he could not see, because the majordomo
was not in, so he returned almost three months later.

> I went againe to Palazzo Farneze to see some certaine statues
> & antiquities, which by reason of the Major domo's not being
> within, I could not formerly obtaine: In the Hall stands that
> Triumphant Colosse of one of the Family [Alessandro Farnese],
> upon 3 figures, a modern, but rare piece; about it stood some
> Gladiators; and at the entrance into one of the first Chambers
> two cumbent figures of age & youth brough(t) from St Peters
> hither to make roome for the Longinus under the Cupola:
> Here was the statue of a ramm running at a man on horsback,
> a most incomparable piece of fury, cut in stone, and a table of
> Pietra Comesse [mosaic] very curious; the next Chamber was
> all painted a fresca by a rare hand, as was the carving in wood
> of the Ceiling, which as I remember was in Cedar, as the Italian
> mode is, and not poore plaster, as ours are, and some of them
> most richly gilt. In a third rome stood the famous Venus, and
> the Child Hercules strangling a Serpent of Corinthian bras,

Antique, on a very curious Bass relievo: Also the Sacrifice to Priapus [a relief of Dionysos, now in Naples], the Ægyptian Isis in the hard black Ophit stone taken out of the Pantheon greately celebrated by the Antiquaries: likewise 2 Tables of brasse containing divers Old Roman Laws [*CIL* 1.2.583, 588-9]. At another side of this Chamber was the statue of a Wounded Amazon falling from her horse in greate [*sic*], a piece worthy the name of the excellent Sculptor who ever the Artist was; and neere this a Bassrelievo of a Bachanalia with a Silenus most rarely curious: in the 4th Roome it was totaly invirond with Statues, especialy observable was that so renouned piece of a Venus pulling up her smock, and looking backwards on her buttocks [now Naples], with sundry other naked figures all cut in marble by the old Greeke masters: Over the doores, are Two Venus's one of them looking on her face in a Glasse by M. Angelo [not looking in a glass, but kissing Cupid, now Naples], the other is painted by Caracci [now lost]: I never saw finer faces, especialy that under the Masque, whose beauty, & art are not to be describd by words. The next chamber is also full of statues, most of them the heads of Philo(so)phers, very antique, One of the Cæsars, and another of Hanibal cost 1200 crounes: Now I had a 2d view of that never to be sufficiently admired Gallery painted in deepe relievo, the Worke of 10 yeares study for a trifling reward:

In the Wardrobe above they shewd us incomparab(l)y wrought plate, porcelan, Mazers [goblets] of beaten & solid Gold, set with diamonds, rubies, Emralds, a treasure inestimable, especialy the workman ship considerd: This is all the Duke of Parmas: but there was nothing which to me seemed more curious and rare in its kind, then that compleate service of purest Chrystal for the Altar of the Chapell, not so much as the very bell, & cover of a booke, Sprinkler &c but was all of the rock, incomparably sculpturd with the holy Story in deepe Levati [relief]: thus was also wrought the Crucifix, Calic, Vasas, Flowr-pots, the greatest, largest & purest Christall that ever my Eyes beheld, truely, I looked on this as one of the rarest

curiosityes I had seene since my being in Rome: In another place were Presses furnish'd with antique Armes, German Clocks, Perpetual motions, Watches, and severall curiosities of Indian Workes: The Picture of Pope Eugenius very antient: also a st. Bernard, and an head of Marble found long since, supposd the true portrait of our B: Saviours face.

Here we have the collection inside the palace arranged according to rooms.

Another and divergent description is given by Mortoft. In the court were Hercules ('counted by all the wonder of the world'), Flora, Commodus as a gladiator, another gladiator (his helmet at his feet), Julius Cæsar, and Fortune. The Bull is described with approximately correct details but no names ('so extream lively, that it puts everyone into an Amazement that ever looks upon it'). Upstairs the Nile and Tiber; in the first room the duke of Parma trampling on the Protestant party (!), the Horatii and Curiatii, two statues of Abundance; in another room busts of the twelve Cæsars, Clorinda, and Tancredi; in another sixteen or eighteen heads of the ancient philosophers, and Caracci's painting, the foremost artist of his time. Lassells subsequently stated that this painting 'may be compared if not preferred, before all the Galleryes of Rome, or Europe; and the very cutts of it in paper pictures, sold at the stationers shops, are most admirable, and worth buying'. Balthasar Liverdis thought the palace 'one of the most beautiful and magnificent in Italy for its architecture, sculpture and painting'. There were stories about that offers had been made for the bull paying its weight in gold: Ellis Veryard identified the would-be purchasers as the Venetians.[48]

The PALAZZO BORGHESE, built by Martino Longhi and Flaminio Ponzio (late sixteenth-early seventeenth centuries) deeply impressed Evelyn: 'This Palace is for Architecture and magnificence, pompe & state, having to it 4 fronts, & a noble Piazza before it, one of the most considerable about the Citty' (see ill. opposite).[49] The reader should be alerted, however, to the fact that he then proceeds to describe the villa Aldobrandini!

Lassells concentrated much more on the art: the *Queen of Sheba* and

Alessandro Specchi, The palazzo Borghese, *1699*

the *Rape of the Sabines* by a Capuchin lay-brother; *Hercules and Antæus*; a self-portrait by Raphael; Titian's *Last Supper*; and in a little back gallery, portraits of Luther, Machiavelli, Cesare Borgia, and Paul V (the last in mosaic), and an *Assumption* by Titian; a self-portrait by Titian[50] and Michelangelo's *Crucifixion*, so realistic that some claimed he used a crucified man as a model. Montfaucon was most interested in the library, and told a cautionary tale. It was not readily accessible to outsiders, but he was allowed to look quickly at the Greek codices, and contrary to popular report, they were not numerous, because five hundred had been 'removed or dispersed', that is, sold. The Borghese perhaps were responsible themselves for some of the inflated accounts. Aubrey de la Mottraye reported that in one apartment there were three hundred Raphaels and Titians, valued at two

Alessandro Specchi, The palazzo Giustiniani, 1699

million *scudi*. And John Clenche was fascinated by a peculiar matter: he noted 'the Bed Chamber hung with all the naked Venus's in several postures'.[51]

The next most mentioned palace was the PALAZZO GIUSTINIANI opposite S Luigi, for its collection of antiquities. Its fortune was that it was situated on the Baths of Nero. Giuseppe Giustiniani employed Domenico Fontana as architect after 1590, and the work was continued by Borromini after 1650. Giuseppe's son Vincenzo (1564-1637) was the great collector. Most visitors, like Mortoft, were simply overwhelmed: 'that which makes this Pallace so famous, is a long gallery, where in are Six hundred Ancient statues and heads of old Romans' making'. Lassells was more critical:

> From hence I went to the Pallace of Iustiniani, which is hard by. Here I saw so many statues of the old Haethen Gods, and such roomes full of old marble feet of them, that you would almost sweare the Heathen Gods, when they were banished out of the Pantheon, had been committed hither as to a prison: or

that some of the ancestors of this house had been shoemakers to the old Gods, and therefore was obliged to have their lasts and measures.

In short, the statues 'clog rather than adorne' the palace. Montfaucon believed that there were more than 1500 of them there. The visitor who gives most detail is de la Mottraye in 1697, although many of the identifications are obviously unreliable: Marciana as Hygeia (now in New York); Scipio Africanus, C. Cestius and Ceres (Torlonia) in the courtyard; Gallienus, Septimius Severus, Antoninus and Vespasian on the stairs; at the top, busts of Agrippina the Elder, Jupiter, Maximilian (sic), Antoninus Pius, Berenice 'in her hair' (Giudea capta ? New York), a relief of Jupiter drinking milk from a horn (Vatican), two gladiators, Minerva (from that church, valued at 60,000 scudi), Rome Triumphant, the consul Marcellus (Capitoline), a Sybil, a small bronze Hercules, a Vestal (the most valuable after the Minerva) (Torlonia), and Nero. Paintings included Caracci's Christ talking to Mary, and Christ before Pilate (which Bromley ascribed to Titian and valued at 50,000 scudi) and Correggio's Virgin.[52]

Much visited, naturally, was also the PALAZZO QUIRINALE (see ill. overleaf). Hieronymus Welsch declared that he had seen nothing more beautiful in all his life, especially the waterworks in the Garden. Evelyn also was enthusiastic:

Opposite to these statues is the Popes Summer Palace, built by Greg: XIII, and in my opinion it is for largenesse, & Architecture one of the most conspicuous in Rome, having a stately Portico, which leads round the Court under Columns, in the center of which there runs a beautifull Fountaine: The Chapell is incrusted with such precious materials, that certainly nothing can be more rich & glorious; nor are the other ornaments & moveables about it at all inferior: The Hall before it is excellently painted by Lanfranci & others: The garden in an incomparable ayre & prospect, is (for the exquisitenesse of the fountaines, close-walkes, Grotts, Piscinas or stews of fish, planted about with venerable Cypresses, and refresh'd with

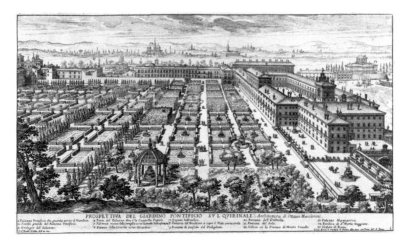

G. B. Falda, The Quirinal palace and gardens, *1660s*

water-musique, Aviaries & other rarities) cal'd the Belvedere di
Monte Cavallo, in emulation to that of the Vaticane.

The waterworks were described in more detail by Liverdis. In a
grotto was a water organ, in which the water turned wheels which
played. 'The movement of the water makes the wheels turn, which
raise the keys of the organ on one side and lower them on the other,
as if they were touched by the organist's hand, and the falling water
produces a quantity of wind which is led along the pipes of the organ
and produces a very agreeable harmony.'[53]

The other palaces may be listed in alphabetical order. Skippon visited
the PALAZZO ALDOBRANDINI, and noticed a Raphael, five naked
Venuses (one like Titian), Jupiter and Leda, a Roman bust, a boy
riding a goat, a man 'struggling' with a woman (perhaps a nymph and
satyr), and most famously, the *Aldobrandini Wedding* found on the
Esquiline, now in the Vatican. Lassells visited PALAZZO ALTEMPS,

in which I saw the great Hall, and in it, the Triumph of Bacchus
on a basso rilievo cut in marble with exquisite arte. I saw also
here the representation of a Towne, cut in wood, an ancient

and curious piece. The picture of our B. Lady with her son in her armes, valued at five thousand pistols, is of Raphael's hand. The neat Library full of divers good manuscripts and other books.[54]

One of the grandest palaces is the PALAZZO BARBERINI, built by Maderno, Borromini, Bernini and da Cortona 1625-1633. Evelyn described it shortly after (1644):

the Palazzo Barberini, design'd by the now Pop(e)s Architect Cavaliere Bernini, & which I take to be as superbe, and princely an object, as any moderne building in Europ for the quantity: There is to it a double Portico, at the end of which, we ascended by two paire of Oval Stayres all of stone, & voide in the well; one of these landed us into a stately Hall, the Volto whereoff was newly painted a fresca by that rare hand of Pietro Berettieri, il Cortone: To this is annexed a Gallery compleately furnish'd (with) whatsoever Art can call rare & singular, & a Library full

Alessandro Specchi, The palazzo Barberini, *1699*

FACCIATA PRINCIPALE DEL PALAZZO BARBERINO DELL'ECC.ᵐᵒ SIG. PRENCIPE DI PELLESTRINA CON LI DVE FIANCHI CHE LA CONPONGANO nel monte Qyirinale. Architettura del Caualier Bernino.

of worthy Collections, Medails, Marbles, and Manuscripts; but above all, for its unknowne material, and antiquity an Ægyptian Osyris: In one of the roomes neere this hangs the Sposaliccio of St Sebastiano, the original of Hanibal Caraccio, of which I procured a Copy, little inferior to the prototype; a table in my judgment Superior to anything I had seene in Rome. Descending into the Court we spied a Vast Gulio, or Obelisque, broaken, having divers hieroglyphics cut on it.

The *Marriage of St Sebastian* by Correggio is, in reality, *The Marriage of St Catherine* by him (Louvre); the obelisk of Antinoüs is now on the Pincian. Calixtus in 1651 visited the library with Lucas Holsten, and described bibles, Church Fathers, scholiasts, books on law, philosophy, natural history, poetry (French royal editions), medicine, mathematics, geography and history, Greek and Latin manuscripts and the Samaritan Pentateuch, coins, and an urn from the tomb of Alexander Severus. In 1688 Maximilien Misson declared the palace the greatest in Rome after the Vatican.[55]

Few visitors mentioned one of the most noble palaces, that of the CANCELLERIA, which bears the date 1495, but Evelyn did not omit it.

Palazzo della Cancellaria belonging to Card: Francesco Barberini, as Vice-Chancelor of the Church of Rome, & Protector of the English: The building is of the famous Architect Bramanti, & is built of incrusted Marble with 4 ranks of noble lights, the principal Enterance of Fontanas designe, and all of Marble, the Portico within sustaind with massie Columns: In the second (Peristyle) above the Chambers are rarely painted by Salviati & Vasari: & so ample is this Palace, that 6 Princes with their families have been receivd in it at a time without incommoding each other.[56]

The architect is now thought to be Andrea Bregno.

The PALAZZO CAETANI (later RUSPOLI) by Bartolomeo Ammanati, 1556-1586, was described by Evelyn as 'the grace of the whole Corso'. Jacques de Grille (1669) revealed that all palaces overlooking the Corso paid a tax of 100 *scudi* per window. In the mid-century it was the French embassy.[57]

Alessandro Specchi, Palazzo Chigi, *1699*

The PALAZZO CHIGI on the Corso had the most complicated history but was owned by the Aldobrandini from 1578 until 1659 when it passed to the Chigi. Montfaucon was most interested in the library, 'none more splendid' for its printed books and manuscripts. He states that he could not examine the Latin ones, but gives a list of the Greek. He especially wanted a copy of notes in a codex of the Hexapla, but in vain: 'I long waited at the entrance, and called on very eminent men to intervene, but the prince [Agostino II] was never to be moved.'[58]

The PALAZZO COLONNA was built between the late fifteenth century and 1730. De Grille in 1669 mentioned that Mme Connestable Colonna (Maria Mancini, wife of Lorenzo) had turned her palace into a Louvre.[59]

One of the most extravagant palaces is PALAZZO PAMPHILI (see ill. overleaf) at the end of the Corso, constructed from 1489 over more than three centuries. Lassells was impressed with the contents: 'more riches and rare furniture than in any house in Rome or almost in

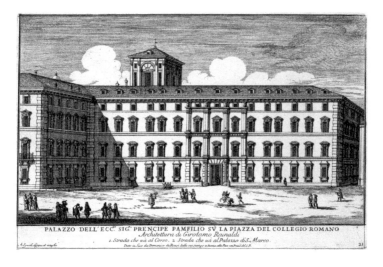

Alessandro Specchi, The palazzo Pamphili, 1699

Italy', gold and silver plate, a silver crucifix worth 12,000 *scudi*, a gold basin set with Turky stones, 'besoars stones as big as pearmanes', 'a world of curious originals of the best painters hands'.[60]

Evelyn described the PALAZZO ROSPIGLIOSI (Pallavicini) on the Quirinal:

> After dinner we went to take the aire in Cardinal Bentivoglio's delicious Gardens, now but newly deceased, he has a faire Palace built by several good masters on part of the Ruines of Constantines Thermæ, well adorned with Columns and paintings, especially of Guido Rheni.[61]

The palace was in fact built by Scipione Borghese at the beginning of the century, and passed through many hands in quick succession. The Bentivoglio acquired it in 1622. Cardinal Guido Bentivoglio died in September 1644.

PALAZZO SPADA, finally, was built in the mid-sixteenth century for Cardinal Girolamo Capodiferro and sold to Cardinal Bernardino Spada in 1632. '(I)t has a most magnificent hall painted by Daniel

Volterra and Giulio Piacentino, who made the fret [decorative carving] in the little court. But the Perspectives are of Bolognesi.'[62]

Burnet in 1685 made some very acute general observations on Roman palaces:

> In the apartments of Rome, there are a great many things that offend the sight. The doors are generally mean, and the locks meaner, except in the *palace of Prince Borghese*; where, as there is the vastest collection of the best pieces, and of the hands of the greatest masters that are in all Europe; so the doors and locks give not that distaste to the eye that one finds elsewhere. The flooring of the palace is all of brick; which is so very mean, that one sees the disproportion that is between the floors and the rest of the room, not without a sensible perception and dislike. It is true, they say their air is so cold and moist in winter, that they cannot pave with marble; and the heat is sometimes so great in summer, that a flooring of wood would crack with heat, as well as be ate up by the vermin that would nestle in it: but if they kept in their great palaces servants to wash their floors with that care that is used in Holland, where the air is moister, and the climate more productive of vermin, they would not find such effects from wooden floors as they pretend. In a word, there are none that lay out so much wealth all at once as the Italians do upon the building and finishing of their palaces and gardens, and that afterwards bestow so little on the preserving of them. Another thing I observed in their palaces: There is indeed a great series of noble rooms one within another, of which their apartments are composed; but I did not find at the end of the apartments, where the bed chamber is, such a disposition of rooms for back stairs, dressing rooms, closets, servants rooms, and other conveniencies, as are necessary for accommodating the apartment. It is true, this is not so necessary for an apartment of state, in which magnificence is more considered than convenience; but I found the same want in those apartments in which they lodged: so that, notwithstanding all the riches of their palaces, it cannot be said that they are well lodged in them. And their gardens are yet less understood, and worse kept than their palaces.[63]

THE VILLAS

It was, in fact, in the villas that the visitors were more interested, given their fame as an outstanding feature of the city. The five most famous were the Borghese, Ludovisi, Montalto, Matthei and Medici. The VILLA BORGHESE was designed for Scipione Borghese in the early seventeenth century by Flaminio Ponzio, Giovanni Vasanzio and Girolamo Rainaldi, and comprised the casino, the garden and a natural park (see ill. opposite). Johann Aschhausen in 1612 wrote of the 'newly begun state palace'. All was completed by the time Evelyn saw it in 1644:

> I walked to *Villa Burghesi*, which is an house and ample Garden on Mons Pincius, yet somewhat without the Citty Wales; circumscrib'd by another wall full of small turrets and banqueting houses, which makes it appeare at a distance like a little Towne, within it tis an Elysium of delight; having in the center of it a very noble Palace (but the enterance of the Garden, presents us with a very glorios fabrick, or rather dore Case adorned with divers excellent marble statues): This Garden abounded with all sorts of the most delicious fruit, and Exotique simples: Fountaines of sundry inventions, Groves, & small Rivulets of Water: There is also adjoyning to it a Vivarium for Estriges, Peacocks, Swanns, Cranes, &c: and divers strange Beasts, Deare & hares: The Grotto is very rare, and represents among other devices artificial raines, & sundry shapes of Vessells, Flowers &c: which is effected by (changing) the heads of the Fountaines: The Groves are of Cypresse and Lawrell, Pine, Myrtil, Olive &c: The 4 Sphinxes are very Antique and worthy observation: To this is a Volary [aviary] full of curious birds: The House is built of a Square fabric, with turrets, from which the Prospect towards Rome, & the invironing hills is incomparable, cover'd as they were with Snow (as commonly they continue even a greate part of summer) which afforded a sweete refreshing: About the house

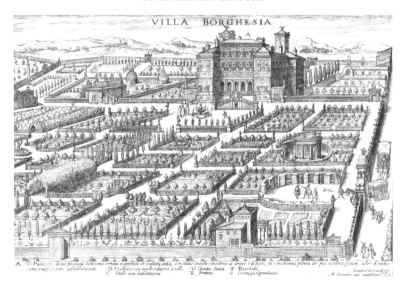

Matthaus Greuter, Villa Borghese, *1618*

there is a stately Balustre of white Marble, with frequent jettos
of Water & adorned with statues standing on a multitude of
Bases, rendering a most gracefull ascent: The Wales of the
house, are covered with antique incrustations of history; as
that of Curtius's precipitation [leap into the chasm in the
Forum], the representation of Europa's ravishment, & that
of Leda &c: The Cornices above them consist of frutages &
Festoons; betwixt which are Niches furnishd with statues,
which order is observed to the very roofe: In the Lodge at the
Entry are divers good statues of Consuls &c, with two Pieces
of Field Artillery upon Carriages (a mode much practiz'd in
Italy before the Greate mens houses) which they looke on as
a piece of state, more then defence: In the first Hall within
are the 12: Rom: Emperors of most excellent marble, twixt
them stand Porph(y)ry Columns, & other precious stones of
vast height & magnitude, with Urnes of Oriental Alabaster;
Tables of Pietra-Commessa [mosaic]: And here is that renown'd

Diana which Pompey worship'd (of) Eastern marble: The
most incomparable Seneca of touch [stone, i.e. schist, in fact
marble], bleeding in a huge Vasa of Porphyrie ressembling the
dropps of his blood [in fact, not the philosopher who evoked
such emotion for centuries, but simply an old fisherman]: The
so famous Gladiator, Hermaphrodite, upon a quilt of stone;
from whence that small one of Ivory which I brought out of
Italy with me was admirably Copied by that signal Artist Hans
Fiammengo, esteemed one of the best statuaries in the World:
The new Piece of Daphny, and David, of Cavaliero Bernini,
observable for the incomparable Candor of the stone, & art
of the statuary plainely stupendious: We were also shewed a
world of rare Pictures of infinite Value, & of the best Masters;
huge Tables of Porphyrie, and two exquisitely wrought Vasas
of the same; In another chamber divers sorts of Instruments of
Musique, amongst other toyes, as that of the Satyre which so
artificialy express'd an human Voice, with the motion of eyes
& head; that would easily affright one who were not prepared
for that most extravagant vision: They shew'd us also a Chayre,
which Catches fast any who but sitts downe in it, so, as not to
be able to stirr out of it, by certaine springs conceiled in the
Armes and back theroff, which at sitting downe surprizes a man
on the suddaine, locking him in armes & thighs after a true
tretcherous Italian guize: The Perspective is also considerable,
compos'd by the position of looking glasses, which renders
a strange multiplication of things, resembling divers most
richly furnish'd roomes: Here stands a rare Clock of German
worke, in a word, (nothing) but magnificent is to be seene in
this Paradies.

John Raymond was entranced: the villa 'without except may for all
excellencies be prefer'd before any other about Rome or in Italy...
The gardens and parke want nothing which should make a man
conceive himself in Paradise.' Inside he noted the two 'new pieces':
David and Daphne. Van Sommelsdijck was unrestrained in praise of
the garden, with its maze of alleys and its perspectives and the plant-
ings with diverse trees. Most remarkable of all, the villa was open to

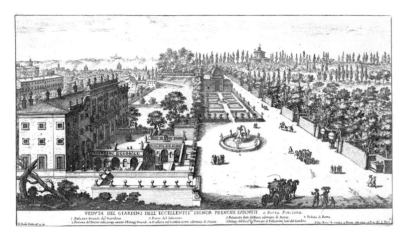

VEDVTA DEL GIARDINO DELL ECCELLENTIS." SIGNOR PRENCIPE LVDOVISI. a Porta Pinciana.

G. B. Falda, The Villa Ludovisi, c. *1670*

everyone. A more complete list of the art works was given by Francis Mortoft.[64]

The VILLA LUDOVISI extended from the porta Pinciana to the porta Salaria and was formed by Cardinal Ludovico Ludovisi (1575-1632) on the site of the Gardens of Sallust. The architect was Domenichino. Evelyn set the scene:

> We went to see Prince Ludovisio's Villa, where was formerly the Viridarium of the Poet Salust [in fact, the historian]: The house is very magnificent, and the extent of the Ground exceeding Large, considering it is in a Citty: This Garden is in every quarter beset with antique statues, and Walkes planted with Cypresse, at the extreame of one, stands a Bassrelievo of white marble very antient & good: To this Garden is also a house of retirement [casino], built in figure of a Crosse after a particular Ordonance; especialy the stayre Case. The whit(e)nesse & smothnesse of the excellent pargeting [plastering] was a thing I much observed, being almost as even & polite as if it had been of marble: Above is a faire Prospect of the Citty: In one of the Chambers hang 2 famous Pieces of Bassano, the one a Vulcan, the other a Nativity: also they shewd us a German Clock full

of rare & extraordinary motions; and in a little salett' below
are many precious Marbles, Columns, Urnes, Vasas & noble
statues, of Porphyrie, Oriental Alabaster and other rare mate-
rials. About this fabrique is an ample Area, environ'd with 16
vast & huge Jarrs or Vasas of red Earth [terra cotta], wherein
the Romans were wont to preserve their oyle; or Wine, rather,
which they burried; & such as are properly called Testæ. In the
Palace I must never forget that famous statue of the Gladiator
[the Dying Gaul, now in the Capitol], spoken of by Pliny, and
so much followed by all the rare Artists, as the many Copies and
statues testifie, now almost dispers'd through all Europ, both in
stone & metall. Also an Hercules [now in Naples], an head of
Porphyrie [a red marble mask, now in the Museo Nazionale],
& another of M: Aurelius. There is likewise in the Villa house a
mans body flesh & all Petrified, and even converted to marble,
as it was found in the Alps, and sent by the Emp: to the Pope;
It lay in a Chest or Cofin lined with black velvet; where one
of the armes being broken; you may see the perfect bone from
the rest of the flesh, which remaines intire. There is here also
the rape of Proserpine, cutt in a marble so exquisitely white,
as unlesse the driven snow, I never saw any thing approch it,
it is the worke of Ca: Bernini [still in the Villa Borghese]; and
in the Cabinet neere it are an innumerable many brasse figures
in little, with divers other exotique curiosities: But what some
looke on as exceeding all the rest, is a very rich bed stead (which
sort of grosse furniture, the Italians much glory in, as formerly
our Gra(n)dfathers in England, in their inlay'd wodden ones)
inlayed with all sorts of precious stones, & antique heads, both
Onyx's, Achates, & Cornelian; esteemed to be worth 80, or
90000 Crownes: Here are also divers Cabinets, & Tables of
the Florence worke, besides Pictures in the Gallery, especialy
the Apollo.

As usual, Mortoft gave a more detailed inventory of the collection,
'esteemed for the Rarityes that are in it the chiefest house in Rome
that are worthy of a Stranger's Curiosity'. Balthasar Liverdis singled
out the Dying Gladiator, Proserpine carried off by Pluto, the 'bust'

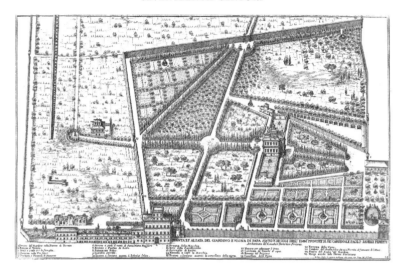

G. B. Falda, The villa Peretti Montalto, *1668*

of Seneca, the child on the dolphin, busts of Cicero and Caligula, a child wearing an old man's mask, the Four Seasons, Raphael's *Madonna*, and Reni's *Ceres*. Richard Lassells accounted Reni's *Madonna* (Louvre) 'the best picture of her that ever I saw', and the bedstead 'the most rare thing in this villa, or perchance in any in Rome', valued at 100,000 *scudi*. By the 1680s matters had changed. Maximilien Misson stated that the villa was 'very much out of repair, by reason of the absence of the Prince of Piombino, who is master of it'. More straws were in the wind in 1691: the prince was poor – but could not be tempted by the French king's offers to buy.[65]

The VILLA PERETTI MONTALTO was designed for Felice Peretti (Sixtus V) by Domenico Fontana and occupied the area now where the Termini station (named after the *terme*, baths) stands. Evelyn described it as 'a spacious Parke full of Fountaines… The Cypresse-Walkes are so beset with Statues, Inscriptions, Rilievos and other ancient Marbles, as nothing can be more solemn and stately: But that which much surpriz'd me, were the monstrous Citron Trees.'[66] We can rely again on Mortoft for the detail. A gladiator in touchstone, another

in marble ('a most incomparable piece'), statues of Augustus, and the young Nero, paintings of Sophonisba, ladies bathing, Susanna, Sebastiana, and heads of Agrippina and Bacchus; in another room: Baglioni's *Magdalene*, a head of Trajan; in another, 'a perspective of marbles inlaid with landskep in colours'.

In the second palace (the Casino): outside, a dozen large stone oil jars, a seated senator; a double sided painting of David and Goliath, portraits which appear differently according to how they are observed; in another room, many classical busts, an urn of alabaster; in another a table of oriental marble, a boy holding a duck; in another a bronze peasant catching birds; upstairs, Arpino's *Deposition, St Andrew and the Cross*; in another, a bronze bust of Sixtus V, a painting of Susanna, a bronze Europa; in another, Reni's *Bacchus and Ariadne* (see ill. p. 182), a mosaic landscape, a bronze Hercules and the centaur; in another, a bronze boar, Venus and satyr, a painting of John the Baptist, *Jesus crowned with thorns*, Reni's *St Michael*;[67] in another a painting of Venus and Cupid. In the garden were statues of Æsculapius, fountains, a fish-pond with Neptune by Bernini, a satyr fountain which emitted water from mouth or eyes, a clock which wet those who studied it, and a box of bowls which similarly wet anyone taking one. A very different catalogue is given by Skippon just seven years later: a head of Pyrrhus, the statue of a gladiator in black marble, Cincinnatus with the plough, a mosaic table, Germanicus by Cleomenes, Agricultura, Bacchus on a tiger, Nero and his harp; paintings of John the Baptist, the Magdalene, the bust of cardinal Peretti by Bernini (inside). In the garden palace, a relief of Roman marriage, heads of Geta, Caracalla, Antoninus Pius and Drusus, Marsyas, Perseus and Diana; paintings of *David and Goliath* (Volterrano), dancing boys (Fontana), *Mars and Venus in Vulcan's net*, a prospect ('Ann. Carraggio'), and *Jesus and the Baptist* (Giulio Romano; see ill. opposite).

Lassells in the 1660s was most interested in the oddities of the collection: 'the picture of David killing Goliath. It turnes upon a frame and shows you both the foreside of those combatants, and their backsides two' (*sic*), and 'pictures in stones of several colours which held one way, represents nothing but a bunch of herbs; but held up another way, it represents a man's head and face'. Misson gave a quick guide

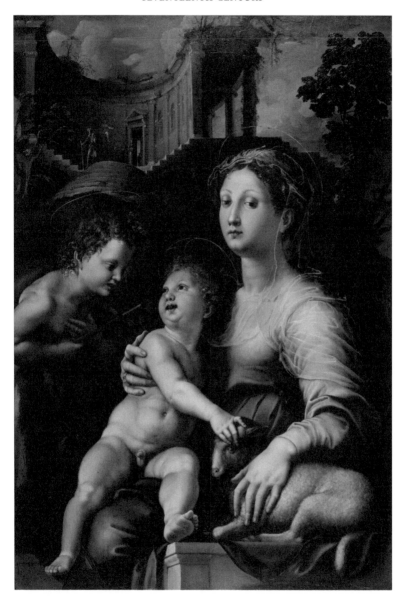

Giulio Romano, The Madonna and Child with St John the Baptist, *c. 1523*

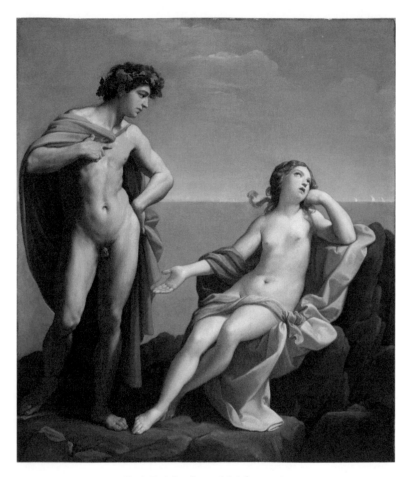

Guido Reni, Bacchus and Ariadne, c. *1620*

to the highlights: 'the Germanicus, the Pescennius Niger, the Scipio, the Goddess Nænia, the Adonis and the Gladiator, are reckon'd the principal Antiquities'.

This area had been transformed by Sixtus' aqueducts. Liverdis described the gardens in 1660:

> Among several alleys which kept their green in all seasons, I admired the one to be seen at the entrance, both because of its length, and because of the palisades of laurels on both sides, refreshed by streams which ran all along it. I looked with pleasure on the espaliered oranges and lemons along the walls. I observed the various statues arranged everywhere, the animals, baths and urns, round and square. It is wonderful to see the fountains gushing on all sides, which sometimes, from the direction you least expect, thoroughly soak you... In a word, whatever precaution you take, you come out absolutely wet.

Van Sommelsdijck, indeed, thought the villa Montalto surpassed the Borghese for its fountains, alleys, shade and freshness.[68]

On the Cælian, rich in classical remains, Ciriaco Mattei (1545-1615) employed Giacomo del Duca to transform a vineyard into the VILLA MATTEI (see ill. overleaf), but it was Domenico Fontana who erected the Capitoline obelisk there in 1587. It is described by Johann Pflaumer in the 1620s as by far the most pleasing villa in Rome with its antiquities and shady cypresses. The antiquities included a complete Hercules, Cleopatra, three reclining girls with their limbs most elegantly entwined, a large head of Alexander, a shepherd and nymph, and satyrs. Two aviaries contained 'a mass of singing and nesting birds', there were statues of animals which seemed alive and breathing, and a multitude of elegant fountains. This was the one major sight of the city that Evelyn omitted, although he knew its upkeep cost 6,000 *scudi* per year, and the owner was bound to expend that sum on pain of forfeiture. The same mistake was not made by Mortoft. In the first room were two statues of Ceres, and Trajan on horseback; in another, Venus with her robe slipping low, Amicitia, a head of Virgil, another Ceres, and four great marble columns; in another, three sleeping Cupids, a drunken Silenus, Nero's head, Cicero's bust, a painting of

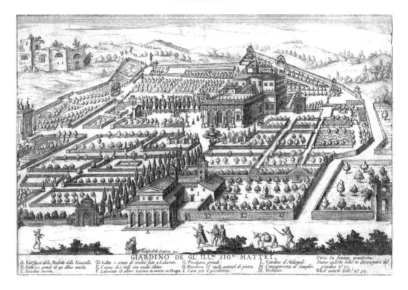

Matthaus Greuter, Villa Mattei, *1618*

Joan of Naples 'the famous whore', and two Egyptian gods; in another, an urn of speckled marble, another Ceres, Claudia, and Antinoüs; in another, Jupiter in Egyptian marble, Julia, Bona Dea, a naked Antoninus Pius, and Brutus and Portia hand in hand. In the garden were Augustus holding a globe, a ship's fountain, Hercules killing the Hydra, a walk lined with tombs, a huge head of Alexander, Apollo and Marsyas, Andromeda chained to the rock, and a sarcophagus with the nine Muses. Bernard Montfaucon was fascinated by the head of 'Alexander', measuring some 8 royal feet, so that the total height would have been about 64', the largest statue in the city; the villa also had more sepulchral urns than any other collection.[69]

On the Pincian, on the site of the famed Gardens of Lucullus, the vigna Crescenzi was sold in 1564 to the Ricci brothers, who employed Nanni di Baccio Bigio to build a small palace. This was in turn bought by Cardinal Ferdinand de Medici in 1576, and Bartolomeo Ammannati completely remodelled the building. which was therefore known as the VILLA MEDICI (see ill. opposite). The anonymous English traveller

of 1605 devoted more space to this than anything else, because it was remarkable for its sumptuousness in tapestries, statues and paintings. Johann Neumayer also waxed eloquent over its magnificence. Of the statues in the gallery he mentioned a naked Manlius grasping a knife (the Arriotino, knife sharpener, from a group of Marsyas and Apollo: see ill. Vol. II), Autumn holding a small child which reaches for fruit, the consort of Neptune on a sea horse, and a Sibyl with books. The garden was full of fruits, flowers and herbs, and antiquities, notable being Niobe (see ill. Vol. II), and in the upper garden were cypresses and an artificial hill with a fountain on top, drawing on the Aqua Vergine. Twenty years later Evelyn gave a more general impression:

> This is a very magnificent strong building, having a substruction very remarkable, and a Portico supported with Columns towards the Gardens with two huge Lions of marble at the

Domenico Buti, Villa Medici, *1602*

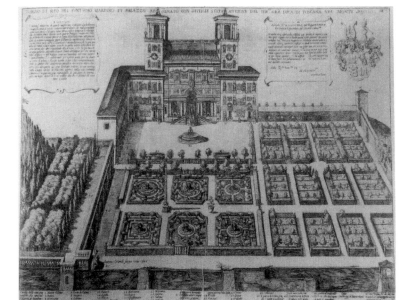

end of the Balustrads: the whole out side of this facciata is (incrusted) with antique & rare Basse-relievis & statues: Descending into the Garden is a noble fountaine govern'd by a Mercury of brasse, and a little distance on the Left hand, a Lodge full of incomparable Statues, amongst which the Sabines, antique & singularly rare: In the Arcado neere this stand 24 statues of infinite price; and hard by a Mount planted with Cypresses, representing a fortresse, with a goodly fountaine in the middle: Here is also a row balustr'd with white marble, on which are erected divers statues and heads, covered over with the natural shrubbs, Ivys & other perennial Greenes, as in niches: At a little distance Those fam'd statues of the Niobe & her family, in all 15 as big as the life, of which we have ample mention in Pliny, being certainely to be esteemed amongst the best pieces of worke in the world, for the passions they expresse, & all other perfections of that stupendious art. There is likewise in this Garden a faire Obelisque full of Hieroglypics.

The fountain, the Niobids and the obelisk are now all in Florence. Three weeks later he made another visit for the antiquities:

I a second time visited the *Medicean Palace* being neere my Lodging, the more exactly to have a view of the noble Collections that adorne it; especialy the Bassrelievi & antique frezes, inserted about the stone-worke of the house: The Saturne of mettal standing in the Portico is a rare piece; so is the Jupiter & Apollo in the Hall, and now we were lead above into those romes we could not see before; full of incomparable Statues & Antiquities, above all, & happly preferrable to any in the World are the two Wrestlers, for the inextricable mixture with each others armes & leggs plainely stupendious; In the great Chamber is the naked *Gladiator* whetting a knife; but the *Venus* is without parallel, being the master piece of [Evelyn omitted the name: it was Kleomenes of Athens] whose name you see graven under it in old Greeke characters, certainely nothing in Sculpture ever aproched this miracle of art. To this add *Marcius, Ganymede*, the two wrestlers, a little *Apollo* playing on a pipe;

some *Relievi* incrusted on the palace walles & an Antique *Vasa* of Marble neere 6 foote high: I saw in one of the Chambers, a Conceited *Chayre*, which folded into so many varieties as to turne into a *bed*, a *bolster*, a *Table*, a *Couch*. The Cabinets & Tables of Pietra Commessa, I passe over, being the proper invention of the Florentines; Of Pictures, I observed, the Magdalen, st. Peter weeping, excellent paintings; & so refreshing myselfe with another walke about the Gardens, where I tooke special notice of those two huge Vasas or Bathes of stone.[70]

The two wrestlers, the Arrotino, the Venus, Marcius (Marsyas). Ganymede, Apollo, and the large vase are also all now in Florence.

The other villas are mentioned much less frequently and may be listed in alphabetical order. The VILLA ALDOBRANDINI on the Quirinal was built by the Vitelli in the mid-sixteenth century, but was given by Clement VIII to his nephew Cardinal Pietro Aldobrandini in 1600. The architect was Giacomo della Porta and the villa soon housed the art collection of Lucretia d'Este and the antiquities gathered by Pietro and his brother, Cardinal Ippolito. Evelyn initially confused the villa with the palazzo Borghese, but went on to describe the collection:

The st. Sebastian, & Hermaphrodite [now Doria Pamphili] are of stupendious art: For paintings, our Saviours head by Carragio, sundry pieces of Raphael; whereof some in little: some of Bassano [Veronese]; The Leda, and two admirable Venus's are of Titians Pensill [the Chamber of Nudities: no *Leda* is known in Titian's œuvre; his *Sacred and Profane Love*, and *Venus blindfolding Cupid*, both in the Borghese]; so is the Psyche & Cupid, the head of st. John borne by Herodias [Titian's *Judith and Holophernes*? Doria Pamphili]: Two heads of Albert Durer [Massys' *Two Tax Collectors*? Doria Pamphili] very exquisite. We were shew'd here a glorious Cabinet, and Tables of Florence worke in stone: In the Garden are a world of fine fountaines, the wales all coverd with Citron trees which being rarely spread invest the stone worke intirely; and towards the streete at a back gate the port is so handsomly cloath'd with Ivy, as much pleas'd me: About this Palace are divers noble & antique Bassirelievi;

two especialy are placed on the ground, representing Armor,
& other military furniture of the Romans; beside these stand
about the Garden an infinity of rare statues, Altars, and Urnes;
above all for antiquity and curiosity (as being the onely rarity of
that nature now knowne to remaine in the World) is that piece
of old Roman Paynting, representing the Roman Sponsalia or
celebration of their Marriage, judged to be 1400 yeares old;
yet are the Colours very lively, and the designe very intire (tho
found deepe in the ground); for this morcell of paintings sake
onely 'tis sayd Burghesi purchas'd the house, because being on
a wall in a kind of banqueting house in the Garden it Could
not be removed, but passe with the inheritance.

The collection is now best remembered for the last item, the *Aldo-
brandini Wedding* (see p. 335), found in 1605 and removed to the
Vatican in 1818. Van Sommelsdijck in 1654 noted the collection and
that the cardinal (Baccio Aldobrandini) was most welcoming.[71]

Coming down the via Quattro Fontane from the Quirinal to
S Maria, Montfaucon visited the VILLA CHIGI: 'of small extent, but
very elegant. The garden is full of gushing fountains, the palace inte-
rior is tastefully decorated and there are innumerable rarities of
various kinds to be seen: gems, ancient vases, every kind of arms, even
a treated human skin, thicker than a calf's; it is called Egyptian
mummy, a woman's body preserved with aromatics, as the Egyptians
were accustomed to do.'[72] This gem has now vanished.

On the Palatine among the ruins of imperial Rome was set the VILLA
FARNESE, the work of Cardinal Alessandro Farnese between 1570 and
1589 and Cardinal Odoardo Farnese in the first third of the seven-
teenth century. Liverdis in 1660 stated that it was rather neglected,
but nonetheless a charming place to walk in the heat in the shaded
avenues refreshed by the fountains. Albert Jouvain in the 1670s,
however, stated that this was the most esteemed villa after the Borgh-
ese. He described the large court near the entrance with the statues
of Venus and Hercules near the grotto, and the palace as 'one of the
most superb for its architecture, galleries, beautiful paintings and
other [*sic*] pieces of sculpture'.[73]

G. B. Nardini, Villa Farnesina, *1560s*

One of the gems of the early Renaissance is the VILLA FARNESINA (so named from its later owners after 1579) built for Agostino Chigi by Baldassare Peruzzi (1508-1510) to which Raphael contributed much of the decoration. Evelyn visited it in 1644:

> The next excursion was over the river Tiber which I cross'd in a Ferry-boate to see the *Palazzo de Ghisi* standing in Transtevere, and fairely built, but famous onely for the painting a fresca on the Volto of the Portic towards the Garden, the story is the Amours of Cupid & Psyche, by the hand of the celebrated Raphael d'Urbin: Here you shall always se(e) Paynters designing, and Cop(y)ing after it, it being esteem'd one of the rarest pieces of that Art in the world, & certainly with greate reason; not to omit that other incomparable fable of Galateo (as I remember) so carefully preserved in the Cuppord, at one of the ends of this walke to protect it from the aire, because it is a most stupendious lively painting: Here are likewise excellent things of Baldassarre & others.[74]

An amazing omission by most visitors was the VILLA GIULIA, built

Dominique Barrière, Villa Pamphili, *1664*

by Pope Julius III (1550-55), designed by Ammannati and Vignola. Neumayer in 1620 declared that it was 'very noble and artistic', with a sunken 'theatre' and many antiquities.[75]

The VILLA MADAMA was built by Raphael on Monte Mario for Leo X Medici from 1518, and after Raphael's death finished by Giulio Romano and Antonio da Sangallo. It is so named from Margherita of Parma, wife of Duke Alessandro de Medici. Misson described the villa as 'neither great nor magnificent, but its beauty is regular and unaffected'; for him it was the view which counted: 'On one side it enjoys a prospect of Rome, with several Gardens and many pleasant Seats, on the other the Eye is ravished with a beautiful Landskip of little and well cultivated Hills: over against it the Tiber creeps thro' Fields and Meadows, and at a distance the snowy tops of the Appennin [*sic*] do insensibly mingle with the Clouds: behind is a shady wood of tall Trees, adorn'd with cool and solitary Walks, which are incomparably charming. The Gardens rise into Terras walks, and want neither Fountains nor Statues.'[76]

The VILLA PAMPHILI was bought by the family in 1630 and created by Alessandro Algardi the sculptor and Giovanni Grimaldi the painter.

Liverdis in 1660 described the alleys bordered with cypresses and the parterre which in winter seemed like spring, and the view as far as Ostia. Inside, the collection included *Jacob and Angel*, a girl on a lion, a statue of Seneca, busts of the twelve Cæsars, paintings of the *Crucifixion of Peter* and the *Conversion of Paul*, the *Entry of the Animals into the Ark*, and *Agar and Sarah*. Misson told the amusing story that the prince was inveigled by the Jesuits into covering all naked statues with plaster, but he later freed himself from their influence, and ordered them uncovered, only to find that they had in fact been defaced.[77]

Hard by the Baths of Diocletian, finally, was the VILLA STROZZI. Montfaucon described it as small in area, but refined; many finds were made there daily. Most recently a Meleager had been dug up, headless but of fine workmanship, and a good Venus.[78]

ANTIQUITIES

Richard Lassells in the late 1660s indulged in interesting meditations:

> Though *Rome* be growne againe, by her new pallaces, one of the finest *Cyties of Europe*, yet her very *ruines* are finer then her new buildings. And though I am not ignorant how *Rome*, since her Ladiship governed the world, and was at her greatness, hath been six several times ruined, and sacked, by the envy and avarice of barbarous nations (*Visigoths, Wandals, Erules, Ostrogoths, Totila* who set fire on Rome 18 dayes together, and the *Germans* under *Bourbon*) whose malice was so great against *Rome*, that of thirty six *Triumphal Arches* once in *Rome*, there remaine but four now visibly appearing; that of ten *Therme* anciently, but two remain any way visible; that of seven *Circos*, but one now appeares, yet as of fair Ladyes, there remain even in their old age, fair rests of comelinesse; so the very *ruines of Rome* which malice could not reach to, nor avarice carry away, are yet so comely that they ravish still the beholders eye with their beautyes, and make good the saying of an ancient author, that *Roma iacens quoque miraculo est; Rome is a miracle even in its ruines.*

The German Catholic Johann Pflaumer, on the other hand, had already asked (in the 1620s) why Rome was so denuded of antiquities. He seems to have been caught between two loyalties: the barbarians and 'all that destructive and fatal excrement of the north' were the main plunderers, while the popes did their best to protect Rome, contrary to Machiavelli's slanders![79]

Gaspar Ens, the Lutheran theologian, provided a list in 1609 of the major sites and art works, a checklist of contemporary interest and taste: 'The educated guest is stunned and cannot satisfy his gaze.' The Colosseum is 'more praised than the seven wonders', not to mention the Pantheon, baths of Caracalla, Constantine and Diocletian 'as extensive as provinces', triumphal arches and columns, the Pyramid of Cestius, the immense shafts of the obelisks, to carry which special ships had to be constructed, the giants sculpted out of one piece of stone such as the Castors and their horses (on the Capitol), and the reclining bodies of great rivers. The famous statues included Apollo, Hercules, Venus, Cleopatra, the Laocoön, the Tiber with wolf and twins, the Nile showing the height of the flood, Egyptian flora and the pygmies, the Capitoline colossus, Marforio, and the Marcus Aurelius. In a strict minority, on the other hand, was Van Sommelsdijck in 1653, who asserted that there were few antiquities worth seeing: the Pantheon, Colosseum, arch of Constantine (that of Titus was not so beautiful), the 'temple of Peace', the columns of Trajan and Marcus (the city could do with twenty more!), the baths of Caracalla and Diocletian, the mausoleum of Metella, and the catacomb of St Sebastian.[80]

On the copying and purchase of antiques in the seventeenth century we learn most, not unexpectedly, from two artists, Poussin and Velázquez. Nicholas Poussin, in Rome 1624-40 and 1643-1665, had endless trouble obtaining copies of paintings and purchasing antique busts from Ippolito Vitelleschi for his friend Fréart de Chantelou. Later he was trying to obtain another four busts (a Ptolemy for 50 *scudi*, 'Lucretia' (50 *sc.*) which had belonged to the famous engraver Cherubin Alberti, Julia Augusta (30 *sc.*) and Drusus (30 *sc.*)). They were very hard to export, because Cardinal Pamphili had ordered that no antiques leave Rome (this was in 1644, when that cardinal was collecting for his villa). Poussin also claimed that there had been a

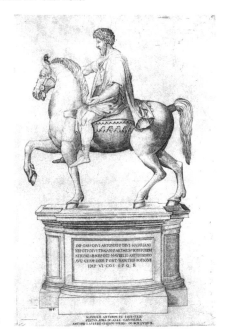

Nicolas Béatrizet,
The equestrian statue
of Marcus Aurelius,
engraving dated 1581

complete upheaval in the papal government, and that there was no Commissario delle Antichità, whose licence was essential, but in fact Niccolo Menghini was in office from 1638 until 1655. The licence was obtained in February 1646.

As for copies, Poussin was admittedly working for very highly placed employers, but the scale is staggering. Paintings included Raphael's *Transfiguration* (although he noted that no one dared do it), and antiquities included the Farnese Hercules! It took up half Poussin's house. On Velázquez's second visit to Rome (1649-51) he had copies made for Philip IV of endless statues, the chief pieces of every collection, including the Laocoön, the Farnese Hercules, the Nile, the 'Cleopatra' (Ariadne), the Belvedere Apollo, the Ludovisi Gladiator, and the Borghese Hermaphrodite[81] – the last certainly a revealing desideratum.

On the CAPITOL, the EQUESTRIAN STATUE OF MARCUS was lavishly praised: 'incomparable', 'esteemed one of the noblest pieces of worke now extant in the world', wrote Evelyn. Mortoft went further;

193

Nicholas Beatrizet, Marforio, *before 1560*

esteemed by all Persons such a rare piece that the like was never made by any man, the horse indeed is made so lively, that it wants nothing but life to make it a perfect horse, which made the famous Carver Isaak [*sic*] Angelo goe every day to view it. It is esteemed such a Rare piece that the Venetians offered the waight in gold for it.

Whatever possessed Jouvain, however, to describe it as a bronze statue of the emperor on a marble horse? And Montfaucon, who called it 'an outstanding work', thought it was beaten not cast[82] – or so the learned (*periti*) thought.

The reclining statue called 'MARFORIO' (moved from the Forum to the Capitol in 1588) excited Neumayer's attention. Its identity varied

wildly. One of the most inventive suggestions was Jupiter Panarius, who was connected with the Gallic siege where the Romans threw down bread (*panis*) from the Capitol; others thought it the Rhine, part of a Domitianic triumphal statue.[83]

The 'TROPHIES OF MARIUS', in reality monuments of the late first-early second century, had been moved by Sixtus V in 1590 from the nymphæum of Severus Alexander (modern piazza Vittorio) on the Esquiline to the balustrades of the Capitol. Here they were noted by Neumayer and Evelyn.[84]

A standard view of the FORUM (see ill. overleaf) can be found in Jouvain in the 1670s. He described the fine alley of trees in two rows, the temple of Concord (Saturn) half buried, Jupiter Tonans (Vespasian), Jupiter Stator (Castor), Saturn (S Adriano) and Castor (SS Cosma and Damiano). The Arch of Severus was half-buried. The Mamertine prison was much visited. The so called temple of Concord still bears an inscription that it had been damaged by fire: Neumayer predictably identified this as Nero's fire. Seeing the temple of Faustina, Lassells could not resist making an egregious error: poor Antoninus 'could not make an honest woman of her in her lifetime, and yet he

Etienne du Pérac, Trophies of Marius, *1560s, on the Esquiline, before their removal to the Capitol*

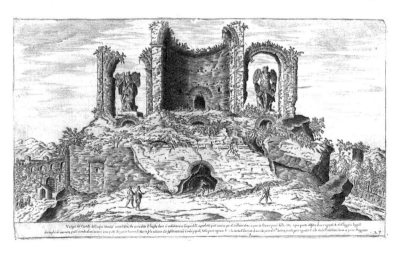

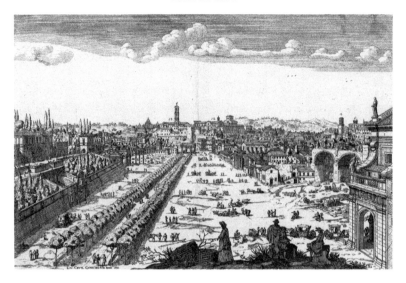

Leuven Cruyl, The Forum, *1666*

would needs make her a goddesse after her death'. Poor Lassells: he has confused Faustina the Elder with her daughter, the wife of Marcus. The best example of the fantasy which the Forum could still inspire, however, comes from the anonymous English traveller. He described the Lacus Curtius (the Lake of Curtius, into which traditionally he plunged to save Rome) as 'a mighty and ugly hole, which for the space of a long time did yield a very noisome smoke and stink; and whoever did smell the same, he suddenly fell down and died'. It was necessary for a young man to leap into it, and Curtius agreed on condition that for one year 'he might have free liberty to accomplish his lust and desire with fair and beautiful women and virgins'.[85] Wherever did the *ciceroni* find this story?

The ARCH OF SEVERUS presented a sorry picture for Pflaumer: blackened by fire, mutilated, and more than half-buried in the earth. Despite all that, Neumayer perversely stated that it surpassed all others in beauty, and he gave a very unusually detailed description of the reliefs and stressed its value for military history. Lassells in the 1660s was struck only by its degradation: 'half of it is buryed under ground,

the other half is sore battered with the ayre' – in reality, Time 'which taketh a pride to triumph our Triumphs'. It was, however, the oldest surviving and simplest arch, that of TITUS, which attracted most attention for its historical connections. Evelyn gave a detailed description of the reliefs on either side (but failed, as many did, to notice that in the ceiling) and had his painter make a copy. Mabillon noted the interesting fact that in old guides the arch was called the *Arcus ricordationis* (in memory of the fall of Jerusalem). Montfaucon noted the outstanding art of the reliefs, especially the musculature of the horses, but that the scale of the booty of the temple is much reduced.

Evelyn commented that the BASILICA OF MAXENTIUS (see ill. p. 74), then identified as the Temple of Peace, 'thought to be the biggest and most ample as well as richly furnished of all the Dedicated places... is now a heape, rather than a Temple'.[86]

On the other side of the Palatine, at its south-eastern corner, the SEPTIZONIUM (see ill. p. 26), a Severan building had been destroyed by Sixtus V in 1588, yet it still continued to excite interest. For Jouvain it was both a lighthouse and the tomb of Septimius Severus. Tancred Robinson thought it a mausoleum – but recognised that it was different from all others. Even Mabillon accepted that it might have been the emperor's tomb, but that it was so high that those sailing to Africa could worship his ashes! Montfaucon had the notes of some 'anonymous architect' who had seen the structure and observed that the materials came from different buildings, because some columns were fluted and others not. The CIRCUS MAXIMUS was also given attention. Pflaumer noted that there were only a few ruins at one end and that it was used as an olive grove. Twenty years later Evelyn described it as 'converted into gardens, and an heape of ougly ruines'. Jouvain in the 1670s recorded the same state (herb gardens), watered by a little river.[87]

Neumayer described the COLOSSEUM (see ill. overleaf) as one of the seven wonders, even in 1620, when it was mostly fallen, with huge stones hanging free and the lowest level half full of rubbish. Pflaumer about the same time painted a brilliant picture:

> its height has diminished so much, either the mass has collapsed under its own weight, or the level has risen with the multitude

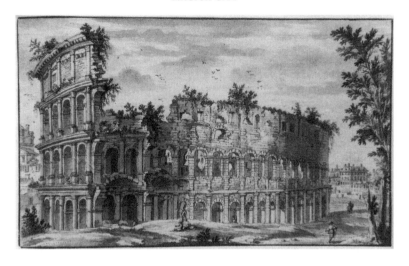

Israel Silvestre, Colosseum, c. *1650*

of ruins. The *cavea* and *carceres* are filled up; the entrances are obstructed by ruins; the podium is falling in; the little columns which Vitruvius indicated stood in this area have been stolen for I know not what use; the steps or seats of the slope… have been torn out of the body of the amphitheatre, are broken, scattered and lie slightly buried on the ground; the precincts of the animals have left scarcely any traces; the entrances and *vomitoria* by which one ascended from the arcades to the orchestra and the partitions in the wedges of seating and the rows of seating are confused and not easily discerned.

Evelyn gave a more reassuring view: 'the three rows of circles are yet entire… That which still appears most admirable is the contrivance of the Porticos, vaults and staires.' He also mentioned the chapel high up, 'where there lives only a melancholy Heremite'. Lassells knew that the Colosseum was built by Vespasian and Titus, but still could not resist mentioning Nero and the Christians! He also gave one of the highest estimates for the seating (usually 70-80,000), at 200,000, and mentioned that three palaces had been constructed from its stones:

S Marco, the Farnese and the Cancelleria. The learned Montfaucon stated that 'there was nothing in the world more magnificent, either for the builder's expertise, or its sublimity, or the elegance of the porticos, or the grace of the columns and pilasters'. He erroneously claimed that the whole circuit of the building survived until the time of Paul III (in truth the earthquake of 1349 had wrought enormous damage).[88]

The ARCH OF CONSTANTINE (see ill. Vol. II) was variously judged. Pflaumer noted Bernardo Gamucci's criticisms of its poor quality, a pastiche of stolen items, and the missing heads. Evelyn gave a perfectly factual account, while Francis Mortoft claimed that 'it is esteemed to be one of the best pieces of worke in Rome'. Mabillon brought an expert's eye: the arch was made from an arch of Trajan, and while soldiers' boots were hobnailed, the horses wore no shoes. Ellis Veryard, on the other hand, clearly repeated a *cicerone's* tale: the arch was built during the battle at the Milvian Bridge, to be dedicated to whoever won!

Nearby was the META SUDANS (and so it remained until senselessly destroyed in 1936: see ill. Vol. II). This was a Domitianic fountain, in the shape of a turning-marker (*meta*) from a circus. It was a fascinating puzzle at this time. Neumayer thought it was for the theatre's spectators to quench their thirst. Evelyn thought it was for the gladiators.[89]

The two imperial columns were favorite sights, 'the two most wonderful pieces of Rome', said Raymond. The COLUMN OF TRAJAN in his forum (see ill. p. 81) is called 'this stupendious pillar'. It was thought to be the work of Apollodorus, and the change in levels was shown by the descent to the plinth. The column contained, he stated, one hundred and ninety-two steps lit by forty-four windows. Jouvain in the 1670s reported an alarming procedure. Louis XIV wanted to erect 'something similar' in Paris, so sculptors were copying the reliefs and the column was surrounded by scaffolding, requiring holes to be made in it. The English traveller Veryard recorded that it 'passes for the most beautiful piece of antient sculpture now extant in the whole world'.[90]

In the Forum Boarium, the dreary BOCCA DELLA VERITÀ, a prosaic drain cover, was as popular then as now, and the only visitor who

Martin van Heemskerck, Ruins of the Temple of the Sun *('Frontispiece of Nero'), 1530s. The understructure is possibly invented by Heemskerck. The crater on the left is the one in the courtyard of Santa Cecilia in Trastevere, and was never near the ruins, which were part of the Colonna palace gardens*

deviates from the standard myths is Mortoft: 'a huge round Iron with a most horrible visage in the middle out of which the Devil used to give his Oracles to the Heathens'.[91]

The traveller might turn now to other hills. Among the most famous sculptures were the QUIRINAL 'HORSETAMERS' (see ill. Vol. II). Neumayer declared them excellent art and one of the most noble (*furnembsten*) things in Rome. Evelyn provided an interesting slant on them. He admired the 'two rare horses', which had been sent to Nero from Armenia, and which 'are govern'd by two naked slaves'. Jouvain presumably recorded a *cicerone's* tall story: that the two statues, which bore inscriptions stating that they were the works of Phidias and Praxiteles, were the result of a competition between the two masters to represent Alexander and Bucephalos – and after long consideration, asserted Jouvain, one cannot decide who won![92]

A most important temple of classical Rome was Aurelian's TEMPLE OF THE SUN, also on the Quirinal, otherwise known as the Frontispizio Neronis. Neumayer in 1620 noted the existence of a high piece of wall of square stone, a fine large cornice, and on one side a large fluted column. By 1663, however, Ray stated that a piece of this temple standing until recently in the Colonna gardens was 'now quite thrown down'.[93]

Skippon recorded an old name for 'MINERVA MEDICA', on the Esquiline, the pavillion of *c*. AD 300, namely Galluzzo, a corruption of Gaius and Lucius Cæsar, the grandsons of Augustus for whom the building was thought to have been erected. Montfaucon declared (recte) that the remains resembled neither a basilica nor baths, and he plumped for Minerva Medica.[94]

The outstanding classical monument was the PANTHEON (see ill. overleaf), as it still is, in the Campus Martius. Pflaumer in the 1620s asked 'who would not marvel at the unsupported vault, as if it were hanging suspended in the air'? At this time the portico contained only thirteen of its sixteen columns (three were missing on the left hand corner). One descended to the temple: the earth had subsided either unable to bear the weight, or 'indignant at the imposition'! Pflaumer had heard the story that the Pantheon once contained the statues of the Roman provinces, and that whenever a revolt was planned, the statue of that province would turn around. And Raphael's grave was

Pieter de Molijn, Travellers at the Temple of Minerva Medica, near Rome *(detail),*
early seventeenth century

PIAZZA DELLA ROTONDA AMPIATA DA N·S·PAPA ALESANDRO·VII.
(Portico e Tempio di Gioue Vltore, detto Pantzeone fatto da Marco Agrippa, dedicato adesso a Santa Maria della Rotonda—)

G. B. Falda, The Pantheon, 1660s, shortly after Bernini's addition of the appalling belltowers (the 'asses' ears'), demolished in the 1880s

obstinately believed to be in S Maria sopra Minerva. Evelyn knew better: ''tis of all the Roman Antiquities the most worthy notice: There lies interr'd in this Temple the famous Raph:Urbine, Perin del Vaga, Federigo Zuccharo and other painters.' Van Sommelsdijck was amazed: the most extraordinary thing is that the whole building 'has no point of union'. Mortoft, conversely, noted that it had no windows but was sufficiently lit by the *oculus* alone. John Ray specified that one descended eleven steps to the temple instead of climbing seven as in antiquity. Lassells produced a nice conceit: 'it hath no pillars to bear up that great roof. Indeed it hath thrust all the pillars out of dores, and makes them wait in the Porch.' He declared the capitals to be the best in Rome of the Corinthian order.[95]

As for the COLUMN OF MARCUS AURELIUS, the anonymous Englishman in 1605 told that part of it had fallen down and for years no one could climb it, but that the last pope repaired it (the main repairs known to us are those under Sixtus V in 1588). Balthasar Liverdis claimed that an inscription on the base stated that the column was dedicated by Marcus to his father Antoninus:[96] no such inscription is known.

In 1620 Johann Neumayer was still able to see the ARCO DI PORTOGALLO on the Corso (see ill. p. 82: soon to be demolished), a fine arch with one gate, built up against houses, and which he judged to be work of Domitian.

Of the MAUSOLEUM OF AUGUSTUS (see ill. p. 79), Pflaumer commented in the 1620s that 'almost all ornaments have disappeared from the mausoleum, and it can scarcely be imagined what kind of a stupendous building it was'. Evelyn described it as 'exceedingly ruined' and converted to a garden (that of the Soderini). Liverdis claimed that the coffin of Augustus had been found and given to a German duke. Lassells suggested that it was once 'one of the neatest structures in Rome', but Montfaucon stated that inside were vaults where remains of ancient painting had almost disappeared.[97]

Another major category of antiquities which fascinated visitors was BATHS. Those of CARACALLA were then, as now, the most imposing ruins. Evelyn remarked only on the thickness of the walls. Perhaps the explanation is given by Francis Mortoft in 1659: 'esteemed to be the most largest and Vastest buildings in Rome, but not admitted to be seene by any stranger, in regard the Jesuits have the place in their

Aloisio Giovannoli, Baths of Caracalla, *1615*

power and permits it not'. More than a decade later Lassells does not state that he entered the baths, but describes them as 'more like a town than a bathing place', with 1600 seats of polished marble, and asserts that some parts were paved with silver and some of the pipes were of the same metal, and that they were full of statues and paintings. 'Now these bathes serve only for the Roman Seminarists to recreate in.' Mabillon in 1685 obviously did not visit them, giving no details ('a great and magnificent work'). Everyone called them the 'Antoninian baths'; Montfaucon made clear that Caracalla built them, quoting the *Historia Augusta*, and he knew that the infamous Lateran 'testing chair' was simply a latrine from such baths. Veryard in 1682 referred to the 'Baths of Constantine' at the foot of the Quirinal, 'the most entire, tho' there's hardly one third remaining'. This would seem to be another name, alongside the Baths of Æmilius Paullus, for the Markets of Trajan. The BATHS OF DIOCLETIAN, unfortunately, although mentioned by most travellers, afford no comments beyond two: that the church of S Maria degli Angeli had been inserted into one hall, and the repeated story that they were built by thousands of Christian slaves. Only Montfaucon mentioned the BATHS OF HELEN on the eastern Cælian, 'almost whole' (they are now entirely destroyed). He described them as comprising twelve small rooms, with access to each other, and furnished with water by the Claudian aqueduct; there were also many funerary urns. And only Albert Jouvain mentioned the BATHS OF NERO, great brick vaults behind the palazzo Medici, i.e. Madama. Evelyn 'walked a turn amongst the BATHS OF TITUS, admiring the strange and prodigious receptacles of water, which the vulgar call the Sette Sali, places of wonderful amplitude and receipt, but now all in heapes'. This was the traditional provenance of the Laocoön. Neumayer agreed: they were baths, not cisterns, and he noted the special water-proof cement about one-third of a finger thick: with effort a piece could be broken off! Montfaucon, on the other hand, declared that they were to hold water and were perhaps the Nymphæum of Claudius.[98] The spaces are in fact Trajanic cisterns.

Jean Mabillon in 1685 waxed eloquent over a little noticed marvel of classical Rome closely connected with baths: the AQUEDUCTS. With friends he visited the Claudia, Martia, Tepula and Vergine. 'This was

the one miracle of the city, drawing such an abundance of water from various sources with great labour as to suffice not only for public use but also for pleasure, so that the street fountains surpassed the sumptuous springs of our gardens in abundance, constancy, variety and art. The present flow, however, is much less than the old magnificence of the Romans; then public baths and naumachiæ were abundantly supplied, which in more recent times are totally lacking.' Charles Bourdin singled out the aqueducts as demonstrating the greatness of the Roman Empire.[99] Neumayer declared the Porta Maggiore 'one of the finest antiquities, still whole and unbroken, to be seen at Rome'.[100]

The OBELISKS naturally attracted much attention. That of S Giovanni Laterano was fulsomely described by Evelyn: 'most worthy admiration', a 'miraculous monument', about which Kircher was about to publish a book explaining its decoration.[101]

Many visitors were fascinated by TESTACCIO, the pottery dump of ancient Rome. The anonymous Englishman of 1605 repeated a story obviously still told by the *ciceroni*: 'on a time the emperor would tax the world, he did desire that from every part thereof each one should bring him for a tribute a pot full of earth to that place; and so the hill was made'.[102] As a useless exercise this ranks high.

The nearby PYRAMID OF CESTIUS (see ill. p. 80) is a unique tomb and puzzled visitors in many ways. Neumayer in 1620 declared that there was nothing to be seen inside, and criticised the *Epulones*, the priesthood to which Cestius belonged, as being 'greedy' – misunderstanding their task of arranging feasts for the gods. Pflaumer in the same decade described it as 'dirty, with shrubs having taken root in it' (*innatis fruticibus squalida*). Evelyn, always most appreciative, viewed the pyramid 'with much admiration', presumably only from the outside. Fantasy returned with Mortoft: 'Here is also a Pyramid which is built halfe within the wals and halfe without, and is Called Nec in Urbe, nec in Orbe. The body of Sestius [he could not even read the inscription!], A great Eater, being buried in it.' The tomb was cleaned and repaired by Alexander VII in 1659-1663. Despite this, Veryard in 1682 stated that the inscriptions were not easily read because of shrubs growing again in the interstices of the stone, and that it was entered by a hole towards the city.[103] This seems to have

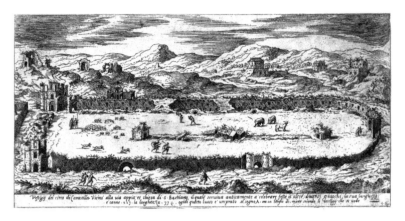

Etienne du Pérac, Circus of Maxentius, *1560s*

been the original robbers' entrance, but Alexander had also constructed a passageway, on the Testaccio side.

It is shocking to read of the state of the VIA APPIA in 1660: the tombs and temples 'both for the most part ruined and their miserable remains are completely denuded of ornament'.[104]

The CIRCUS OF MAXENTIUS along this road was described by Neumayer in 1620 as the best -preserved circus; the obelisk was still there (it was removed in 1647 and erected in the piazza Navona). Evelyn recorded that the earl of Arundel had wanted to buy it and bring it to England, but it could not be moved to the sea – although the Romans brought it from Egypt and it was moved across Rome by Bernini. The circus was still known as that of Caracalla.

Of the MAUSOLEUM OF CÆCILIA METELLA, Van Sommelsdijck was somewhat dismissive: it was built for eternity to judge by the width of the walls, and had an eightfold echo to magnify the mourners' lamentations – but it did not work. Philip Skippon was told that it was a corner tower of the camp of the Prætorians; the camp was presumably identified with the nearby circus. Lassells told the story that it was going to be demolished for the Trevi fountain, but Cardinal Barberini prevented it. The tomb's usual name at the time was Capo di Bove because of the decoration of bulls' heads which it bore,

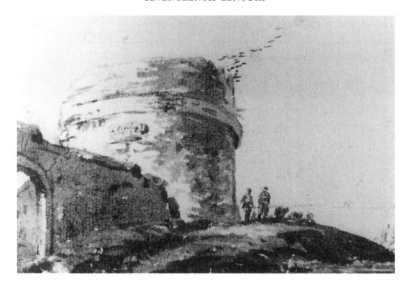

Pietro Santi Bartoli, Mausoleum of Cæcilia Metella, *1607*

but Veryard was told that it was because two hundred oxen were sacrificed at her funeral.[105]

And up the via Nomentana was the MAUSOLEUM OF S COSTANZA. Veryard told the uplifting story here that Paul II (1464-1471) intended to move the sarcophagus, but that he died during the transport of it. He did, in fact, remove it to palazzo San Marco in 1467, but Sixtus IV moved it back in 1471. Montfaucon rightly noted the contradiction between the Bacchic decoration of the mausoleum and the tradition of its construction for Constantine's daughter.[106]

COLLECTIONS OF ANTIQUITIES

John Clenche in 1675 usefully provided a list of the main collections: Farnese, Borghese, Palestrino, Pamphili, Massimo, Pighini, Cancelleria, Capo di Ferro (Spada), Giustiniani, Altemps, Mattei,

Falconieri, Lancellotti, Verospi, Aldobrandini, and Medici.[107] Those existing in palazzi and villas have already been described. The others will be mentioned in alphabetical order.

Few people had such privilege in gathering antiquities as LEONARDO AGOSTINI (1593-1669), who was Commissario di Antichità from 1655 and who excavated in the Forum and the Forum of Trajan. A detailed description of his collection was given by Philip Skippon in 1664: busts of Trajan, Homer, Agrippina, Vespasian, Gordian, Paris, Seneca, and Britannicus (in green marble), an Egyptian priest standing at an altar, a bronze Cybele, swords, cameos, an engraving of Caligula and his sisters sacrificing to Priapus(!), measures, brooches, coins of the twelve Cæsars, a relief of an hermaphrodite, and a half-figure of Cleopatra in agate.[109]

The collection of FRANCESCO ANGELONI (c. 1590-1652) was well known.

> The 13th we were againe invited to Signor Angelonis study, where with greater leasure we survey'd the rarities, as his cabinet of Medaills especialy, esteem'd one of the best collections of them in Europe: He also shew'd us two antique lamps, one of them dedicated to Palas, the other Laribus Sacrum, as appear'd by their Inscriptions: Some old Roman Rings, Keyes; the Ægyptian Isis cast in Yron, sundry rare Bass-relievos: good pieces of Paynting, principally the Christ of Corregio, with this Painters owne face admirably don by himselfe, divers Things of both the Bassanos, a very greate number of Pieces by Titian; particularly the Triumphs; an infinity of naturall rarities, dryd animals, Indian habits & Weapons, Shells &c; amongst other a Sea mans Skin, as he affirm'd; divers statues of brasse very Antique; some lamps of so fine an Earth as they resembld cornelian for transparancy & colour: Hinges of Corinthian brasse, and one huge nayle of the same mettal found in the ruines of Neros golden house.[108]

Agostini's successor as commissario was GIOVANNI BELLORI (1615-1696). It is Skippon again who provided the best list of his museum. It followed the same pattern of diverse 'curiosities': a relief of a circus

scene with inscription Anniæ Arescæ (not known to *CIL*), a bronze head of Isis, a strigil, various *pateræ* (libation saucers), a relief of Silvanus with sceptre and pine branch, a coin of Caligula, sacrificial instruments, Hercules and Jupiter in bronze, bronze lictors, a 'shield' with relief of Bacchus' head, lamps, the case of one of Pietro Valla's mummies, a bronze Janus, masks, a cupbearer, a marble head of Serapis, a young boy wearing a *bulla* (child's pendant), and various objects from the catacombs, especially lamps.[110]

Jacob Spon mentioned, without details, the BRANCHESI collection for coins, along with those of Queen Christina, Cassiano dal Pozzo and the Massimi.

The most famous collection of antiquities was, of course, the oldest public museum, the CAPITOLINE. Various lists are given, by Johann Neumayer in 1620 and Francis Mortoft in 1659, but we are interested in comments on particular exhibits. Johann Pflaumer in the 1620s was, of course, struck by the fragmentary colossal statue (probably Constantine: see ill. p. 22) and claimed that 'men of the greatest and most uncommon wickedness made their own enormous statue so that by insane works equal to their crimes, their fame might be eternal'! Some said the foot came from Nero's colossus but the head was Commodus', which replaced Nero's. For him the 'most celebrated' statue was the she wolf, but he also waxed eloquent over the *Spinario*, a boy drawing a thorn from his foot: 'the most pleasing depiction by an outstanding sculptor of another's pain'. Having said that, he averred that 'nothing among all the other monuments

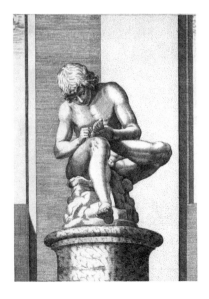

Diana Scultori, The Spinario, 1581. The sculpture is still in the Capitoline Museums

of the Capitoline is so worth seeing as the *fasti*. These were the lists of the consuls of Rome, set up on Augustus' arch in the Forum, which was demolished in the 1530s, but the fasti were rescued by Cardinal Alessandro Farnese, and set up in the Capitoline Museum by Michelangelo. Martin Zeiller in 1640 added the *lex de imperio Vespasiani* (the law conferring power on Vespasian AD 70) to the she-wolf and the fasti. Evelyn made his way to the Capitol on his third day in Rome, and noted the 'so renown'd' column of Duilius (the celebration of the naval victory over the Carthaginians in 260 BC), the lion and horse 'exceedingly valu'd', the relief of Marcus Aurelius sacrificing, which he so admired that he had his painter Carlo Maratta copy it, and *Spinario* 'so much admir'd by Artists'. Richard Lassells in the 1660s referred to the sarcophagus traditionally identified as that of Alexander Severus and his mother Mammæa (perhaps belonging to a member of that family, but the relief does not represent the rape of the Sabines but the deeds of Achilles), the Column of Duilius (but finding the Latin too difficult, he was happy to leave the commentary to Petrus Ciaconius, 'a flegmatick Spaniard': Pedro Chacon, *In columnæ rostratæ inscriptionem… explicatio*, Rome 1608!), the reliefs of Marcus Aurelius ('so well cut that you doubt whether it be the Emperour, or the Sculptor that triumphs here'; he noted acutely that the emperor's chariot had recently been given new wheels, and his horses new shoes and feet); and the *lex de imperio Vespasiani* (which by this time had reverted to its mediæval identity as the Twelve Tables, the first Roman law code, 450 BC). The 'best statue here' was the Spinario, about which Lassells was obviously told a romantic tale: that he had been a messenger for the senate, and although in pain had not stopped before he delivered his message, and the statue was decreed by the senate as his reward. Albert Jouvain in the 1670s noted both the lion and horse and the Aurelianic panels as esteemed and constantly studied by sculptors. Gilbert Burnet in 1685 in the midst of much moralising about past glories singled out the *fasti* ('none more glorious as well as more useful') and the Column of Duilius ('without doubt, the most valuable antiquity in Rome').[111] What is striking about these accounts is the seriousness of their interests.

We catch a last glimpse of the CESI collection, the richest of the

fifteenth century, which passed mostly to the Ludovisi collection in 1622. Johann Aschhausen in 1613 mentioned the statue of Africanus and the beautiful laurel garden.[112]

Most visitors who met QUEEN CHRISTINA were fascinated by her appearance and society (see ills pp. 259 and 261). Maximilien Misson in 1688 listed some items in her collection: Augustus in alabaster, with head and feet of bronze, sixteen columns of *giallo antico* and two of alabaster, a Venus (legs restored), Castor and Pollux with Leda, an altar of Bacchus, and an old Silenus.[113]

Evelyn wrote in 1645 of going to see the 'medails of Signor Gotefredi, which are absolutely the best collection in Rome'.[114] This was FRANCESCO GOTTIFREDI (1596-1669), antiquarian, in fact, to Queen Christina, and a specialist in numismatics.

Evelyn is also our source for the GUALDI collection, presumably belonging to Francesco Gualdi (1576-1657) of Rimini:

> We were invited to see Cavaliero Gualdis Collection, a knight of eminent Learning, curiosity, and Civility to Strangers: In his Study he shew'd us an antiq and I think, the onely Tripos of Apollo extant, with its Bason on it, a (Sistrum), the Sacrificing knife, the Acerra [box] for Insence, divers old Lamps, the Prefericolus [bronze dish], out of which they pourd the Wine that wash'd the Victime. Divers antiq Rings, worne by the Romans, which were first of Iron, then brass, after of Gold: Some excellant Achats and Cornelians especialy that (with) Herculus's head, perfectly to the life of the Farnezian Venus's. Divers Ægyptian Idols; as the Canopus & Isis, a Book Engraven on the Bark of a Tree, with the incisory Stylos, sharp at one extream, Triangular at the other & flat with an edge to scrape out. The Roman Stater and Ballance, Raffling Bones to cast dyes [bones cast as dice] in use amongst the Romans, Tessaras [dice] &c also (as he believed) the true Remora which he had described in a print, with the history of that (Fish's) retentive property: It was about the bigness of an Hering and not much unlike it in length or Shape, onely the upper Jaw was sharp'd like a Pike, (the nether) seem'd as if wanting, & supplied with

a Sucker like a Leach: He shewed us also the knee Bone of a Gyant 23 Inchees in compass all Anotamist's concluding it to have been of a Man, twas found at Trepone in Sicilea. Divers Roman Locks and antiq keys, the forted horn or (trompet) which of old the Romans Sounded at their Sacrifices and Wars. Some Hieroglypical stones, many natural Curiosit(i)es, antient Armour & not a few rare Pictures.[115]

Gualdi lived by the Forum of Trajan.

Jacob Spon in 1675 named another important collection of coins, that of Cardinal de Massimi. This was presumably CAMILLO MASSIMO (1620-77).

Opposite the palazzo Farnese Evelyn visited the collection of Signor PICHINI, 'especially the Adonis of Parrian Marble which once my L. of Arundel would have purchas'd, if a greate price would have been taken for it'. More than twenty years later Lassells mentioned also a statue of Venus, and stated that Arundel offered 12,000 crowns for them. By 1696 the value of the Adonis had risen to 40,000 *scudi*.[116] These two statues were acquired by the Vatican in 1772.

The ODESCALCHI collection of Duke Livio (1652-1713) was described by Bernard Montfaucon in 1695 as containing an outstanding collection of coins and a 'fine quantity' of elegant gems, that is, cameos, especially one with Alexander and Olympias.[117]

One of the most famous collections, partly antiquities, partly curiosities, was that of CASSIANO DAL POZZO (1584-1657), near Sant'Andrea della Valle. Evelyn gave a good description:

> On the 21 I was carried to a great Virtuoso one *Cavalliero Pozzo*, who shew'd us a rare Collection of all kind of Antiquities, a choice Library, over which are the Effigies of most of our late men of polite literature: That which was most new to me was his rare collection of the Antique Bassirelievos about Rome, which this curious man had caus'd to be design'd in divers folios: he shew'd us also many fine Medails, and amongst other curiousitys a pretty folding ladder, to be put in a small compasse, one of wood, another of cord: a number of choyce

designes & drawings. He also shew'd us that stone *Pliny* calls *Enhydrus* of the bignesse of a wallnut: it had plainly in it to the quantity of halfe a sponefull of Water, of a yellow pibble colour & another in a ring without foile, paler than Amethyst, which yet he affirm'd to be the true *Carbuncle* & harder than the diamond: twas set in a ring without foile or any thing at the bottome, so as t'was transparant of a greenish yellow, more lustrous than a Diamond. He had very pretty things painted on Crimson Velvet, designed in black & shaded, hightned with white, I suppose in oyle, & set in frames; Cavaliero Pozzos Carbuncle was of this shape & bignesse [here Evelyn provides the roughest of sketches] of a yellowish red, & far more sparkling than a diamond, though set transparantly without foile.

By the time the naturalist John Ray arrived in 1657 Pozzo's heir, his nephew Carlo Antonio, was showing visitors twenty volumes of drawings of antiquities, the famous 'paper museum', now in Windsor. Skippon in 1665, as well as folios of pictures of plants and birds, saw many volumes of antiquities: sacrificial instruments, musical instruments, lamps, priapi, weights and measures.[118]

The STROZZI collection was visited by Montfaucon. This is ascribed to Leone Strozzi (1657-1722) and was situated in the palazzo Strozzi in the Campus Martius. The collection included an Egyptian *sistrum* and other musical instruments, a book made of very thin marble leaves, illustrating every type of that stone, precious gold coins, a fourteenth century codex of Homer, and a chronicle from Creation to 1200.[119]

Of the collection of IPPOLITO VITELLESCHI (d. 1654) Evelyn provides the most lively description:

certainly one of the best collections of statues in Rome; to which he frequently talkes & discourses, as if they were living, pronouncing now & then Orations, Sentences, & Verses, somtimes kissing & embracing them: Amongst many he has an head of Brutus scarr'd in the face by order of the Senat for his killing of Julius, this is esteem'd much: Also a Minerva & divers other of greate Value: Tis sayd this Gentleman is so in

love with these Antiquities &c, that he not long since purchased
land in the Kingdome of Naples in hope by digging the ground
to find more Statues, which it seemes so far succeeded, as to be
much more worth then the Purchase.

Vitelleschi lived opposite the Accademia degli Umoristi, in the
Corso, where Lassells also saw ten chambers filled with 'a rare collec-
tion of pictures and statues', including Cincinnatus and the defaced
Brutus. Aubrey de la Mottraye in 1695 gave a more complete list:
statues of Pertinax, Ceres, Diogenes, Apollo, and Ganymede and heads
of Antonia, Scipio Africanus, Matidia, Marciana and Plotina.[120]

CONTEMPORARY ROME

It is strange that travellers did not pay more attention to the GATES of
the city. They almost all entered by the porta Flaminia, and Aubrey
de la Mottraye declared it the finest.[121]

Few STREETS drew comments. Johann Neumayer noticed the via de'
Banchi, thronged with merchants, morning and night. Here lived
most bankers, and the 'Jubilirer' (retired), and the 'charletans' (quacks)
'with their tomfoolery'. The goldsmiths' quarter, however, was by the
Cancelleria, where an amazing amount of gold and silver was to be
seen. Albert Jouvain remarked on the wide, straight street between
the Palatine and Cælian, bordered with trees and a fine prospect of
the arch of Constantine: the via S Gregorio. John Evelyn visited
S Costanza outside the walls and 'at our looking back, we had the
intire view of the Via Pia, which downe to the two horses, before the
Monte Cavallo... I thinke to be one of the most glorious sights for
state and magnificence that any City in the Earth can shew a Travel-
ler.' And Bernard Montfaucon identified another key viewpoint, the
Quattro Fontane: 'at this crossroads is a most delightful view of
everything in the city: on the east to S Maria Maggiore, on the north
to porta Pia, on the west to Monte Mario, to the south the (Quirinal)
horses: there is no obstruction and everything is clear.'[122]

Gaspare van Wittel, Santa Trinità, *1683*

The city was noted by visitors for its PIAZZAS. Balthasar Liverdis observed that the piazza di Spagna should rather be named di Francia, because this was where that nation assembled and lived. In the 1660s one descended from Trinità dei Monti to the piazza by 'a long alley of two rows of trees' (see ill. above). Neumayer called Campo de'Fiori piazza dei'Fiori: it was already a daily market-place where one could buy antiquities, but it was very likely that one would be cheated. The square that attracted most attention was, of course, the Navona, the best paved market in the city (see ill. overleaf). Evelyn spent an afternoon there to see what antiquities he could buy 'as to heare the Mountebanks prate and debite their Medicines'. He admired the three fountains, the Pamphili palace and the church of S Giacomo. At the end of his stay he observed one of the mountebanks wearing a darkstoned ring, which when he rubbed it with a wet finger, gave off a flame as bright as a small candle. He regretted that he did not purchase the 'receipt' at whatever price. In Liverdis' estimate the piazza Navona was 'without doubt the most beautiful, spacious and magnificent in Rome'. Philip Skippon thought it contained 'the stateliest fountain

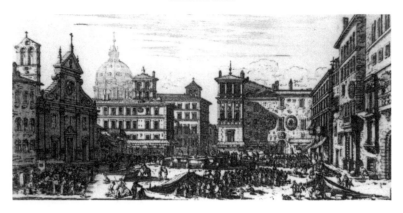

Israel Silvestre, Piazza Navona, c. *1650*

in Europe'. The fountain was the best in Italy, even in the world, thought Jouvain – except for Palermo! The fruit market was held every Wednesday.[123]

The FOUNTAINS of Rome were described by Gilbert Burnet as what delighted a visitor more than anything else.

> That old aqueduct which Paul V restored [aqua Paola] cometh from a collection of sources five and thirty miles distant from Rome, that runs all the way upon an aqueduct in a canal that is vaulted and as liker a river than a fountain. It breaketh out in five several fountains, of which some give water about a foot square. That of Sixtus V. the great fountain of Aqua Travi [see ill. opposite], that hath yet no decoration, but dischargeth a prodigious quantity of water; the glorious fountain in the Piazza Navona, that hath an air of greatness in it that surpriseth one; the fountain in the Piazza de Spagna, those before St Peter's, and the Palazzo Farnese, with many others, furnish Rome so plentifully, that almost every private house hath a fountain that runs continually. All these, I say, are noble decorations, that carry an usefulness with them that cannot be enough commended; and give a much greater idea of those who have taken care to supply this city with one of the chief pleasures

and conveniencies of life, than of others, who have laid out millions merely to bring quantities of water to give the eye a little diversion; which would have been laid out much more nobly and usefully, and would have more effectually eternized their fame, if they had been employed, as the Romans did their treasures, in furnishing great towns with water.

Trevi was described by Neumayer in 1620 as a fountain with water running out strongly at three points, each able to drive two water-wheels. The 'Fontana delle Therme' (aqua Felice) with its famous relief of Moses striking the rock, was 'a worke for the designe and vastnesse truely magnificent'; the water came 22 miles. The aqua Paola of Paul V 'makes a most glorious show to the Citty, especially when the sun darts on the waters as it gusheth out'.[124]

Hieronymus Welsch in 1631 reported that the TIBER was very danger-ous because of its eddies. Many persons were drowned in it every year, especially pilgrims who went to bathe. Neumayer in 1620 commented on the many water-mills near the Tiber Island and that the ponte Santa Maria, previously the pons senatorius, was newly built. In the

G. B. Falda, Trevi fountain, *1670, with the church of Saints Vincenzo and Anastasio on the right*

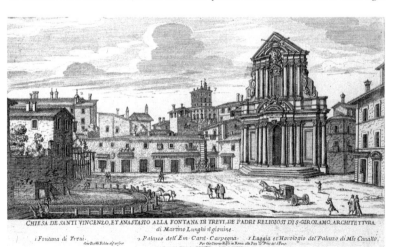

217

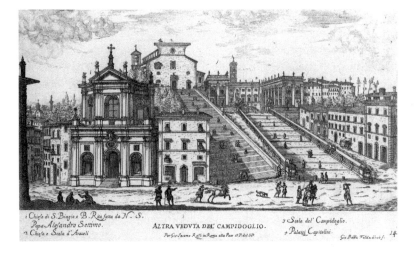

G. B. Falda, The Capitol, c. 1670. The church of S Rita (on left) was removed to near the Theatre of Marcellus in the 1930s

1670s, Jouvain noted that, given the fact that there were still only four bridges, ferries were used to cross the river, worked by pulleys.[125]

The CAPITOL was the political centre of the city. Michelangelo's project was completed in the seventeenth century, so that the palazzo del Senatore was flanked by that of the Conservatori on one side and the New Palace on the other. That of the Senators was described by Neumayer in 1620 as 'fine, large and square', three storeys high, with the lowest underground, used as a prison. Double stairs on the front led up to the middle storey, with the two river statues, as now. Inside were statues of Gregory XIII and of King Charles in Sicily, and the colossal metal head thought to be Commodus (now in the Conservatori). On the roof were many marble statues which could be visited. And from here on both sides paved roads led down to the Forum. From the clock-tower, one had the best view of the whole city. Jouvain in the 1670s commented on the fine stairway to the Capitol built by Michelangelo, but imagined that the fountains at the bottom were dogs[12] – indicating that he had never seen them.

The tomb of Hadrian, now CASTEL SANT'ANGELO (see ill. opposite),

served as the home of the garrison of Rome, a notorious prison and a refuge for popes in times of danger. The anonymous Englishman of 1605 preserves details: on the first rampart were two houses of artillery and arms for six hundred horsemen and twelve hundred musketeers. He was shown the rope ladder by which the brigand Cesare Caetani (executed 1583) almost escaped. In the same room was a 'fall trap; and when they intend to despatch an offender (some great person) secretly they bring him in the said room, where, stepping inawares aside, he doth suddenly fall down, most fearfully, upon sharp iron pricks and saws that cut him all in pieces; you will wonder to see it'. Hieronymus Welsch in 1631 judged it a very weak fortress. Skippon also visited the castle in 1664 and noted that one had to leave one's sword with the guard. The garrison numbered three hundred. Among the prisoners was the prince of Matrici (Alessandro Orsini, imprisoned in 1648 for poisoning his wife, condemned in 1674, but pardoned in 1678). Ellis Veryard in the 1680s recorded that Dr Francesco Borri had also been incarcerated here for heresy and was saved from execution by curing the pope.[127] Francesco Borri (1627-1695), a doctor, had a vision in 1654 to reform the Church. He gained considerable influence in Lombardy with the lower clergy, was condemned by the Inquisition in 1661 and fled to Germany and then Holland, where he became famous for

Gaspare van Wittel, Castel Sant'Angelo, *1689 (Capitoline Museums)*

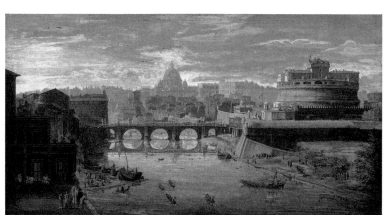

Anon., The portico of Octavia in the Ghetto, c. *1610*

curing eye ailments and also practised alchemy until 1667. He then intended to move to Turkey, but was arrested in Austria and returned to Rome, where he was condemned to life imprisonment. During this time he attended many people, including Innocent XI.

No traveller failed to comment on the Jewish GHETTO. Neumayer in 1620 described it as a small city with five gates, but very unhealthy. The Jews were mostly clothes-sellers. According to Welsch in 1631, who was in a decided minority, the Jews had great freedom, having 'their own city' – into which they were shut each night, and they had

to wear yellow on their hat or head, but all cardinals and aristocrats employed them. Evelyn told a story that they used to wear red, until a cardinal mistook them for a colleague. In 1646 John Raymond told of a scheme by the Jews to divert the Tiber in order to search for treasure; they offered 15,000 *scudi*, but the project was declined, for fear of pestilence. Francis Mortoft in 1659 was still asserting that the Jews wore red, but Liverdis in 1660 described their colour as orange. Skippon noted that the Roman Jews were poorer than their Venetian counterparts, since they were forbidden all merchandising and trade except brokerage. They held a market every Wednesday in piazza Navona. Veryard in the 1680s described the men as 'distinguished by a red hat and the women with a little piece of cloth of the same colour hanging behind on their neck'. They were forced to advance vast sums of money to maintain their privileges, and yet were kept 'very low'.[128]

The most famous features of the Ghetto mentioned by travellers were the obligatory preaching and circumcisions. Of the former the notable description was by Evelyn: 'a sermon was preach'd to the Jewes at Ponte Sisto, who are constrain'd to sit, til the houre is don; but it is with so much malice in their countenances, spitting, humming, coughing and motion, that it is almost impossible they should heare a word, nor are there any converted except it be very rarely'. Liverdis described the sermon as being delivered every Saturday by a Dominican, and not altogether as lighthearted as Evelyn implied: there was a spy with a big stick to keep order. This took place at S Trinità de Pellegrini, near ponte Sisto, and Skippon stated that one hundred men and fifty women had to be present. Richard Lassells, more devout, raised the number to three hundred, and claimed that he had seen 'divers of them baptised'.

It was perfectly possible for any visitor to witness a circumcision, but the details may be left to the curious. Only one of our travellers attempted an estimate of the Jewish population: Jean Antoine Rigaud stated that they were 7-8,000 in 1600.[129]

Neumayer provides a description of TRASTEVERE in 1620. Around S Crisogono, S Francesco and S Cecilia the architecture was uninteresting. Here were mostly the homes of sailors and fishermen, and the wharf where wine was unloaded and taxed.[130]

It was, of course, English travellers who were most outspoken about the GOVERNMENT AND POLITICS of Rome. Burnet, a moderate presbyterian and one-time chaplain to Charles II, who had stripped him of all posts, was to play a leading role in 1688, but in 1685 was in virtual exile when he cast his eye on the papal government:

> It is the greatest solecism in government, for the prince to be elective, and yet absolute: for an hereditary prince is induced to consider his posterity, and to maintain his people so, that those that come after him may still support the rank which they hold in the world. But an elective prince hath nothing of that in his eye, unless he hath a pitch of generosity which is not ordinary among men, and least of all among Italians, who have a passion for their families which is not known in other places. And thus a pope, who comes in late to this dignity, which by consequence he cannot hope to hold long, doth very naturally turn to those counsels, by which his family may make all the hay they can during this sunshine. And though anciently the cardinals were a check upon the pope, and a sort of a council, without whom he could do nothing even in temporals; yet now they have quite lost that; and they have no other share in affairs than that to which the pope thinks fit to admit them; so that he is the most absolute prince in Europe. It is true, as to spirituals they retain still a large share; so that in censures and definitions the pope can do nothing regularly without their concurrence; though it is certain, that they have not so good a title to pretend to that, as to a share in the temporal principality: for if the pope derives any thing from St Peter, all *that* is singly in himself, and it is free to him to proceed by what method he thinks best; since the infallibility, according to their pretensions, rests singly in him. Yet because there was not so much to be got by acting arbitrarily in those matters, and a summary way of exercising this authority might have tempted the world to have inquired too much into the grounds on which it is built; therefore the popes have let the cardinals retain still a share in this supremacy over the church, though they have no claim to it, neither by any divine or ecclesiastical warrants. But as for the endowments of

the see of Rome, to which they may justly lay claim, as being in a manner the chapter of that see; there is so much to be got by this, that the popes have ingrossed it wholly to themselves. And thus it is, that the government of this principality is very unsteady. Sometimes the pope's family are extremely glorious and magnificent; at other times they think of nothing but of establishing their house. Sometimes the pope is a man of sense himself; sometimes he is quite sunk, and, as the last pope [Clement X] was, becomes a child again through old age. Sometimes he hath a particular stiffness of temper, with a great slowness of understanding, and an insatiable desire of heaping up wealth; which is the character of him that now reigns [Innocent XI]. By this diversity, which appears eminently in every new pontificate, that commonly avoids those excesses that made the former reign odious, the counsels of the popedom are weak and disjointed. But if this is sensible to all Europe, with relation to the general concerns of that body, it is much more visible in the principality itself, that is subject to so variable a head. There hath been in this age a succession of four ravenous reigns: and though there was a short interruption in the reign of the Rospigliosi [Clement IX, 1667-9], that coming after the Barberini, the Pamphili, and the Ghigis, did not enrich itself; and yet it disordered the revenue by the vast magnificence in which he reigned, more in twenty-nine months time, than any other had done in so many years. The Altieri [Clement X, 1670-6] did in a most scandalous manner raise themselves in a very short and despised reign, and built one of the noblest palaces in Rome. He that reigns now doth not indeed raise his family avowedly, but he doth not ease the people of their taxes; and as there is no magnificence in his court, nor any public buildings now carrying on at Rome, so the many vacant caps occasion many empty palaces. And by this means there is so little expence now made at Rome, that it is not possible for the people to live, and pay the taxes; which hath driven, as is believed, almost a fourth part of the inhabitants out of Rome during this pontificate. And as the pre-emption of the corn makes, that there is no profit made by the owners out of the

cultivation of the soil, all that going wholly to the pope; so there are no ways left here of employing one's money to any considerable advantage; for the public banks, which are all in the pope's hands, do not pay in effect 2 per cent. though they pretend to give 4 per cent. interest. The settlement is indeed 4 per cent.; and this was thought so great an advantage, that actions on the pope's bank were bought at 116 per cent. But this pope broke through all this; and declared he would give all men their money again, unless they would pay 30 per cent. for the continuing of this interest. And thus for a hundred crowns principal, one not only paid at first an hundred and sixteen, but afterwards thirty; in all, an hundred and forty six for the hundred; which is almost the half lost; for whensoever the pope will pay back their money, all the rest is lost. And while I am here, there is a report, that the Pope is treating with the Genoese for money at 2 per cent.; and, if he gets it on those terms, he will then pay his debts; and the subjects that have put in money in his bank, will by this means lose 46 per cent. which is almost the half of their stock. A man of quality at Rome, and an eminent churchman, who took me likewise for one of their clergy, because I wore the habit of a churchman, said, that it was a horrible scandal to the whole Christian world, and made one doubt of the truth of the Christian religion, to see more oppression and cruelty in their territory, than was to be found even in Turkey; though it being in the hands of Christ's vicar, one should expect to find there the pattern of a mild and gentle government. And how (said he) can a man expect to find his religion here, where the common maxims of justice and mercy were not so much as known? And I can never forget the lively reflection that a Roman prince made to me upon the folly of all those severe oppressions; which as they drive away the inhabitants, so they reduce those that are left to such a degeneracy of spirit by their necessities.[131]

Veryard, perhaps a Catholic, was much more complimentary:

The politics of Rome are probably the most refined in Europe,

the members of their councils being, for the most part, either men of eminent learning or such as have serv'd as legates and nuncios in most courts of Europe, and consequently must be men that have thoroughly studied the world and are fit to be at the helm of state.[132]

The same traveller stated that the annual income of the papal states in the 1680s was equivalent of two million pounds sterling (about eight million *scudi*); a cardinal's income was 7,000 *scudi* p.a. Skippon in 1665 calculated state income at more than 7 million *scudi*. John Clenche in 1675 stated that the main elements in that income were customs (375,000 – so presumably pounds), the Marche (250,000) and Romagna (233,000). 'The Traffick of the State of the Church consists in Oyl, Allum, Silk and Corn; of which last they have great quantities, and would have four times more, were all the Campagna till'd.' John Ray FRS, a naturalist, was one of the few visitors to notice manufactures, such as they were: 'Rome is noted for several commodities and manufactures, as viol and lute strings the best in Europe; perfumed gloves; combs of buffles horns, women's fans, vitriol, essences.'

A large part of the economy depended on charity. Jouvain attempted to sum this up. It took so many forms that few beggars were to be seen on the streets in the 1670s. Food was delivered to poor houses everywhere, and money was regularly distributed. He especially mentioned the ceremony at the Minerva of the Annunciation where three hundred girls received a dowry of 50-100 *scudi*.[133]

So much for the ecclesiastical government. Lassells alone went out of his way to explain the ADMINISTRATION OF THE CITY. Rome had a governor – 'some Prelate of great Parts', assisted by the *bargello*, or captain of the police. They particularly checked that the prices which had to be shown everywhere were not exceeded. Lassells had observed them during the Jubilee Year of 1650 disguised as pilgrims making sure that they were not cheated. A very different view of the spies was given by Jacques de Grille. He felt surrounded by them: even priests, women and children betray you! It seemed only just that stones should speak (Pasquino and Marforio) when men were silenced.

The municipal councillors of Rome were the Conservatori. In January 1645 Evelyn saw their installation: 'We saw passe the new Officers of the People of Rome, especially for their noble habit most conspicuous were the three consuls, now call'd Conservators, who now take their places in the Capitol, having been sworne the day before betwene the hands of the Pope.'[134]

At the Baths of Diocletian were the GRANARIES of Rome, remarked on by various visitors. Mortoft stated that they belonged to the pope, and that no baker could buy grain except from here. Liverdis noted that they had been built by Gregory XIII and Paul V, and he recorded the inscription of the former: 'Gregorius XIII p.m. adversus annonæ difficultatem subsidia preparans horreum in Thermis Diocletianis extruxit' (Gregory XIII in preparation of assistance against difficulties in the food supply built storerooms in the Baths of Diocletian). Lassells described the internal activities:

> Having seen this *Church* and *Monastery*, I went to see the *Popes Graneries*, vast buildings two stories high, and alwayes full of wheat for present use of the whole city. A world of officers and overseers belong to these *Graneries*, and are alwayes turning over, and keeping the vast heapes of wheat from spoyling and corrupting. By sticking up *canes* in the *heapes of wheat*, they can tell, smelling at the ends of these canes, whether the wheat begin to moisten and corrupt, or no, and accordingly give order either to turne it, and ayre it, or presently to give it out to the *bakers*. These *Graneries* were also built upon the ruines of *Diocletians Baths*.[135]

The seventeenth century travellers were much interested in Roman life and CHARACTER. Rigaud in 1600 found Italians in general very mercenary: one had to dispense tips and charity, otherwise one saw nothing. Van Sommelsdijck in 1653 described life in Rome as 'lazy, licentious and unworthy of a well bred man'. The Romans, he claimed, rose late, and went to church only to ogle women or pay court to the powerful. Veryard in the 1680s declared that 'the Romans are generally quick-witted, judicious, crafty, vainglorious, and much addicted to jealousy'; their women were closely guarded. 'The better sort of people

are very civil and obliging, but nothing can be more brutal than the vulgar. They know no medium, but are either your greatest friends or mortal enemies.' This socially-nuanced estimate may serve to introduce more favourable views. Burnet in 1685 found that

> There is a universal civility that reigns among all sorts of people at Rome, which, in great measure, flows from their government; for every man being capable of all the advancements of that state, since a simple ecclesiastic may become one of the Monsignori, and one of these may be a Cardinal, and one of these may be chosen Pope; this makes every man behave himself towards all other persons with an exactness of respect; for no man knows what another may grow to. But this makes professions of esteem and kindness go so promiscuously to all sorts of persons, that ought not to build too much on them.

Mottraye in 1696 complimented the Romans on their 'Politeness, Affability and officious Civility'. The nobles took pleasure in showing the treasures of their palaces, and he met the English artist Jonathan Talman, who was allowed to sketch anything, even the papal mitres. The most extraordinary estimate, however, was given by the English naturalist Ray, in 1663:

> The present Romans seemed to me in their houses and furniture, particularly their beds and lodging, in their diet, in their manners and customs, and in their very pronunciation (so liquid, plain and distinct) more to symbolise and agree with the English than any other people of Italy.

A little earlier, however, he had been shocked at their food. They eat 'such birds as in England no man touches, viz. kites, buzzards, spar hawks, kestrels, jayes, magpies and woodpeckers. They spare not the least and most innocent birds, viz. robin red breasts, finches of all kinds, titmice, wagtails, wrens etc.' Roman confectionery was already famous. Johann von Aschhausen in 1613 dined at the palazzo Borghese with Cardinal Scipione. He remembered the vast array of silver, and the 'artistic sugar confections of all kinds of fruit, especially a melon

which seemed to be real and a rather large galley made of sugar'.[136]

RELIGION naturally attracted much comment. One of the most interesting observers under this head was Milton in 1638. He had, it will be remembered, been entertained at the English College.

> As I was about to return to Rome [January? 1639], merchants warned me that they had learned by letters that if I returned to Rome, plots were being prepared against me by the English Jesuits, because I had spoken too freely about religion. For I had made up my mind never to begin an argument about religion myself in those parts, but if questioned about my faith, not to conceal anything, whatever I might suffer.

As it happened, Milton did return to Rome for another two months and defended the Protestant religion most freely. Skippon had a bizarre note on the fate of Protestant visitors who died in Rome. Like prostitutes they were buried outside porta del Popolo – but if they consented to take a piece of the Host they were granted 'the usual solemnities'. This reminds us that the so-called Protestant cemetery did not come into use until the later eighteenth century. Milton's experience was duplicated by Burnet in 1685.

> I confess, the *Minerva*, which is the Dominicans, where the inquisition sitteth, is that which maketh the most sensible impression upon one that passeth at Rome for an heretic; though, except one committeth great follies, he is in no danger there; and the poverty that reigns in that city maketh them find their interest so much in using strangers well, whatsoever their religion may be, that no man needs be afraid there. And I have more than ordinary reason to acknowledge this, who having ventured to go thither, after all the liberty that I had taken in writing my thoughts freely both of the church and see of Rome, and was known by all with whom I conversed there; yet met with the highest civilities possible among all sorts of people, and in particular both among the English and Scottish Jesuits, though they knew well enough that I was no friend to their order.

And Mottraye in 1696 declared that 'a man may live there very freely

and talk without any danger of Religion, provided he don't meddle with the Government'.[137] He told, indeed, of a very vigorous dispute between an Italian and a Swiss Calvinist, which covered everything from indulgences, the wealth of the Church, and transubstantiation, to the worship of the saints. The Swiss finally admitted that he had been overbearing!

We hear of another theological question, debated with much more civil scholarship by the Vatican librarian Emmanuel Schelstrate and Gilbert Burnet in 1685. This sprang out of the former's long controversy with the French Jesuit Louis Maimbourg over the Council of Constance (1414-18) and the relations of pope and council, many asserting that this council laid down the submission of the pope to such bodies. Schelstrate showed Burnet various manuscripts in which the vital words were missing, and had found a bull of Martin V in which these words were also not included. Burnet was promised a sight of this bull, but being secret, it could not be found before his departure. Its very secrecy made Burnet doubt its efficacy.

And the German Lutheran theologian Friedrich Calixtus in 1651 came to Rome to discuss church unity. He had a long discussion with people such as Cardinal Giovanni Battista Palotta and Athanasius Kircher in which, he claims, he induced them to admit that it was very unchristian that the Council of Trent (1545-63) had anathematised doctrines not established by the early church. He recorded Palotta as claiming that since the Gregorian reform of the calender (1582) the miracle of Saint Januarius had moved to the new time – showing God's approval of the Church's leader![138]

The Church did, in fact, actively proselytize. Evelyn recorded that he was invited by a Dominican who preached to the Jews to be godfather to a converted Turk and a Jew.

> The 25t invited by a Frier *Dominican* whom we usualy heard preach to a number of *Jewes*, to be Godfather to a Converted *Turk & a Jew*. The Ceremonie was perform'd in the Church of *S: Maria sopra la Minerva* neere the *Capitol*. They were clad in White, then exorcis'd at their entering the church with aboundance of Ceremonies, when lead into the Quire, they

were baptizd by a Bishop in *Pontificalibus*: The *Turk* lived afterwards in *Rome*, sold hot waters, & would bring us presents when he met us, kneeling, & kissing the hemms of our Cloaks: But the Jew was believ'd to be a Counterfeit.

The Index was, of course, very much in operation, but only the scholar Jean Mabillon tells us of it. There was a meeting of its congregation in the Vatican, at which Jean de Launoi's (1603-1678) *De regia in matrimonium potestate* (concerning royal power over marriage, ie. the precedence of state over ecclesiastical power) was placed on the Index, and Mabillon himself was consulted about [Isaac] Vossius' view that the flood was not universal![139]

The disposal of the dead in Rome was usually achieved by burial in a church, under the floor. There was, however, a famous cemetery in Rome at St Peter's, the Campo Santo. The earth consisted of 'severall ship Loads of mould transported from Jerusalem, which has the vertue to consume a Carcasse in 24 houres'.[140]

Rome was the centre for the education of Catholic priests. Many travellers described the JESUIT COLLEGE (see ill. opposite). Neumayer noted its princely quality with many beautiful rooms, the square court with many auditoria around, and the industrious reading and disputation in all faculties, but he was also shocked by the 'playfulness' and even drunkenness of the students: one would not think that they were theologians. A more 'architectural' account was given by Evelyn:

> I went the next day to the Jesuites Colledge againe at Collegium Romanum, the front whereof gives place to few in Europ for its Architecture; most of its ornaments being of rich marble; it has within a noble Portico & Court sustain'd with stately Columns, as is also the Corridor over the Portico, at the sides of which are the Scholes for the Arts & Sciences, which are here taught as the University: Here I heard Father Athanasius Kercher upon a part of Euclid which he expounded: to this joynes a Glorious & ample Church for the Students, & a second not fully finish'd, & to that two noble Libraries where I was shew'd that famous wit & historian Famianus Strada.

COLLEGIO ROMANO DELLA COMPAGNIA DI GIESV FONDATO DA PAPA GREGORIO XIII.
Architettura di Bartolomeo Amannati.

Alessandro Specchi, Collegio Romano, *1699, now the Liceo Ennio Quirino Visconti*

For Kircher, see museums (p. 237) and portraits (p. 264); Strada (1572-1649) was an historian of the Netherlands. Another English Protestant, William Bromley, recorded another activity. The college had an excellent *spiceria* (herbalist's) where some of the fathers made treacle and all sorts of essences and chemical preparations. He described a furnace in the centre of their room where sixty five retorts could be used at once. These activities kept the church in repair.[141]

The ENGLISH COLLEGE was even more famous with English visitors. Its 'travellers' book' under 30 October 1638 records that 'we entertained in our college the illustrious Lord Cary, brother of Baron Falkland, Dr Holding of Lancaster, Lord Fortescue, and Lord [*sic*] Milton, English nobles, and they were magnificently received'. The Republican poet would have been horrified at this ennoblement. Evelyn noted being shown the relics of Becket and many paintings of their martyrs, especially Champion (*sic*). Mortoft mentioned that the college was located not far from the palazzo Farnese, and in 1657 had about forty students. The adjoining church was very small and had excellent acoustics for music. Evelyn was also invited to dinner for the feast of

Thomas of Canterbury, and afterwards saw an Italian comedy acted by their alumni before the cardinals. Equally amazing was the comedy Mortoft saw there during Carnival 1659, about a Danish king of England, who had two sons, who were converted to Christianity. The father killed them in a rage, but then went mad, until he repented of his deed and was in turn converted. At the end of each act, three boys and a man sang very well. The whole performance lasted until midnight. The college was in poor circumstances, having been deprived of much of its income by Sixtus V, but Lassells noted that the students had part of the Farnese gardens on the Palatine for their recreation. Veryard in the 1680s praised the most famous rector Cardinal Howard: he 'has begun a noble Fabrick', and there were then about twenty scholars (on Howard, see p. 264). Bishop Burnet was taken aback to see the portrait of Edward Oldcorne among their martyrs, since he was executed for being part of the Gunpowder Plot, which the Jesuits did not deny. Bromley in 1691 recorded that the college had six fathers and seventeen scholars.[142]

It is strange that more notice was not taken of the Sapienza, the UNIVERSITY at S Ivo. Lassells complimented the recent beautification by Urban VIII and the library by Alexander VII, and noted two Englishmen who taught here: Doctors Hart and Gibbs.[143] James Gibbs (1611-1677) taught at the Sapienza from 1655.

It is not surprising that the great numismatist Jacques Spon bothered to make a list of EMINENT SCHOLARS in 1675: Athanasius Kircher in languages and mathematics (at the Collegio Romano: see pp. 237 and 264), Lorenzo Fabri in theology and mathematics (he taught at the Sapienza), Johannes Lucius in history and archæology, Andrea Suarez for antiquities and history, Pietro Bartoli for physics and humanities, Rafaello Fabretti for antiquities, Francesco Cameli, librarian to Queen Christina, and Francesco Nazari for literature (also at the Sapienza). Philip Skippon and Veryard both mention a famous optician, Giuseppe Campani.[144] Many of these figures will be found again under the section on portraits.

It is Evelyn who gives us a glimpse of one of the many ACADEMIES for which Rome was famous, that of the Umoristi:

I was invited (after dinner) to the *Academie of the Humorists*, kept in a spacious Hall, belonging to Signor Mancini, where the Witts of the Towne meete on certaine daies, to recite poems, & prevaricate on severall Subjects &c: The first that Speakes is cal'd the Lord, & stands in an eminent place, & then the rest of the virtuosi recite in order: by these ingenious Exercises the learn'd discourses, is the purity of the Italian Tongue daily improv'd: This roome is hung round, with enumerable devises or Emblemes all relating to something of *humidum* [moisture] with Motos under them: Several other Academies there are of this nature, bearing the like fantastical titles: It is in this Academie of the Humorists where they have the picture of *Guarini* the famous Author of *Pastor fido*, once of this Society.

This academy, founded in 1603, flourished until the 1660s. It met at the bottom of the Corso, opposite palazzo Doria. Aschhausen in 1612 attended a lecture at the newly founded Accademia dei Lincei.[145]

There was one feature of old Rome which impressed every visitor, namely the HOSPITALS. The anonymous Englishman of 1605 described that of Santo Spirito as having three hundred beds and thirty staff

G. B. Falda, The hospital of Santo Spirito, *1660s*

and no sick person was turned away. This was in the Borgo, near the Tiber. Liverdis noted that 'nothing is lacking for the relief of the poor who are treated charitably here'. Skippon described the grate through which unwanted infants could be passed. Santo Spirito was the most famous hospital, but Liverdis in 1660 listed S Maria della Consolazione in the Velabro as another public institution, and many private (national) ones. The most complete description of any was Evelyn's of what he called Christ Hospital:

> Hence we went to Dr Gibb's a famous poet & Countryman of Ours [the same who taught at the Sapienza, above] who had some intendency in *Christ Hospital*; which he shewed us: The Infirmitory where the sick lay was all rarely paved with variously colour'd Marbles, and the Walls hung with noble Pieces. The beds are very faire: In the middle is a stately Cupola, under which an Altar decked with divers marble statues, all in sight of the sick, who may both see, & heare Masse as they lye in their beds: The Organs are very fine, & frequently play'd on to recreate the people in paine: To this joyns an Apartiment destind to the Orphans, & there is a Schoole: The Children weare blew like ours in Lond: at an Hospital of the same appellation: Here are 40 Nurses who give suck to such Children as are accidentaly found expos'd & abandon'd: In another quarter are Children of bigger Groth 450 in number, who are taught letters, In another 500 Girles under the tuition of divers Religious Matrons, in a Monastry as it were by it selfe: I was assurd there were at least 2000 more maintain'd in other places: I think one Appartiment had in it neere 1000 beds: These are in a very long rome having an inner (passage) for those who attend, with as much curiosity, sweetenesse and Conveniency as can be imagin'd, the Italians being generaly exquisitely neate. Under this Portico the sick may walke out and take the ayre: Opposite to this are other Chambers for such as are sick of maladies of a more rare & difficult cure, & they have romes apart: At the end of the long Corridore is one of the fairest & well stord Apothecarys shops that ever I saw, neere which chambers for

Persons of better quality who are yet necessitous: What ever the poore bring is at their comming in delivered to a Tresurer, who makes the Inventory, and is accoumptable to them, or their heyres if they dye. To this building joynes the Palace of the Commendator, who with his Officers attending the sick make up 90 Persons, besides a Convent & an ample Church for the Friers and Priest who daily attend: The Church is extreamely neate, and the Sagrestia very rich: Indeede 'tis altogether one of the most pious and worthy Foundations that ever I saw, nor is the benefit small which divers Young Physitians & Chirurgions reape by the experience they learne here amongst the sick, to whom those students have universal accesse: The Hospital is built on the antient Via Triumphalis.

He also visited S Giacomo degli Incurabili, a hospital 'where only the desperate are brought for cure [care]'; this was in the Corso. Liverdis described the hospital at S Giovanni in Laterano: 'a multitude of beds', and remarkable for cleanliness, where the poor were treated by cardinals and aristocrats who offered charitable work. This was very similar to the work of SS Apostoli, which chose each year twelve nobles, and a prelate called their prior, whose task was to seek out the poor who were ashamed to beg. There was a coffer into which these poor could place their names.[146]

There were also asylums for the mentally sick, and Veryard told of the famous English Quakers who came to convert the pope, and were confined there and 'purg'd almost of their life' until rescued by a fellow countryman. A closer account was provided by Bromley in 1691: 'two handsome Courts and diverse Apartments for Men and Women. but not in so regular an order as those in Bedlam. In most of the Chambers there are three Beds, and they that are much distempered be chained by their Necks to a Ring fastened in the Wall.'[147]

The private hospitals were the national ones. Lassells gave a list: that of the English College was once a hospital for the English, that of the Anima for the Germans, S Luigi for the French, S Giacomo for the Spanish, S Antonio di Padova for the Portuguese, S Giuliano for the Flemish, S Ambrogio for the Lombards, S Ivo for the Britons,

S Geronimo for the Illyrians, S Maria Egyptiaca for the Armenians, S Stefano for the Hungarians, and S Stanislao for the Poles, 'besides a world of many others'. These 'hospitals' looked after the poor and sick of their nation, and especially pilgrims. Lassells also mentioned S Trinità, which in Holy Year 1600 'treated at table in one day fifteen thousand pilgrims, and in the whole year five hundred thousand'. Lassells himself was present for the Jubilee of 1650 when the same hospital in one day treated nine thousand, who were served at table by Innocent X and many cardinals. This hospital, in fact, granted each pilgrim three days' accommodation with meals. Clenche was present in 1675 and records that the pilgrims' hospital in 1650 had taken in 444,000 men and 25,000 women.[148]

Apart from hospitals, another institution with which Rome was richly endowed was LIBRARIES and one visitor was intensely interested in them: Jean Mabillon. As well as the Vatican library, which everyone visited, there was the biblioteca Altemps, from which many of the codices had been removed to the Vatican by Paul V. Mabillon was highly excited to see in the catalogue Cicero, *liber de republica* (Cicero's *Republic*), long thought lost – but his joy was shortlived, for when the codex arrived, it turned out to be the *First Philippic*, which began with those words. The biblioteca Angelica was founded by the Augustinian Angelo Rocca in 1605. The librarian was Giuseppe Sabbatini. The biblioteca Barberiniana attracted considerable attention. Its librarian Moroni had died and Mabillon bought some of his books for the royal library in Paris. The current librarian (1685) was (Carlo) Petrini, and the library was the largest after the Vatican. Mabillon described many of its treasures, especially a letter of Louis XIII asking Urban VIII not to make a treaty with Sweden which would weaken the Austrians, because he planned to combine with them to war on the heretical Germans and French. The biblioteca Capranica was founded by Cardinal Domenico de Capranica (d. 1458). Mabillon does not name the librarian, but describes its holdings in law, the works of Josephus, and the *Professio* of Boniface VIII with glosses. The biblioteca Chigiana was headed by Tommaso de Giulii, a friend of Holsten. It contained many manuscripts of Alexander VII, the diary of Sixtus V, a Greek codex of four prophets, a Latin codex on the Council of

Chalcedon, and of printed books the polyglot Bible printed in Paris, of which three Dutch printers changed the title-page to dedicate it to Alexander VII. The library of Queen Christina contained 1145 ancient codices, by Holsten's estimate, including one which was eight hundred years old, the works of bishop Pacianus, which included notes on the council of Chalcedon and the second Nicene council, and the letters of Abbot Godfrey of Vindocina. Cardinal Pietro Ottoboni, amazing to say, allowed Mabillon to take codices home in order to study them. The biblioteca Pamphiliana was presided over by the kindly abbate Spina. The library at Santa Croce, presided over by Carlo Emmanuele Scotti from Milan, 'a most learned young man', contained 172 codices. That at the Sapienza or University (S Ivo) contained many books but few codices. The biblioteca Vallicelliana, where the librarian was Father Leandro Colloredo, contained many ancient codices, and Mabillon singled out an Acts of the Apostles, a Bede, and a Sacramentarium once at Subiaco. Finally, the library at St Peter's, under Giuseppe Balduini, contained more than one hundred codices;[149] Mabillon singled out Bede's *Martyrologium*.

As well as collections of antiquities and art, Rome was famous for her MUSEUMS. The best known of these belonged to the Jesuit Athanasius KIRCHER. Evelyn visited it with him in 1644 (see ill. overleaf): 'with Dutch patience he showed us his perpetual motions, Catoptrics, Magnetical experiments, Modells, and a thousand other crotchets [fancies] and devises, most of them since published, either by himself, or his industrious Scholar Schotti' (Kasper Schott, 1608-1666). Calixtus described it in 1651 as a mass of machines, instruments, clocks, amazing waterworks, Oriental manuscripts, including a Syrian translation of the Evangelists, and hieroglyphic inscriptions. Kircher was working on secret writing (codes) and a way to be able to compose music for those without any musical skill! Balthasar Monconys in 1664 encountered even stranger experiments: how to mix dried flies with rain water to produce live flies, and his discovery under the microscope that plague bubos were full of worms. Skippon at the same time saw an organ that imitated bird song, the rib and tail of a Maltese syrene (an aquatic mammal), a painting by Raphael on a terracotta dish, a Chinese shoe, Japanese razors and sword, Canadian coins, a hoop that

Anon., Museo Kircheriano, *1709*

moved without falling off a plane, an engine in perpetual motion, a female oracle (words whispered far away were heard by listening at her breast), flies and lizards in amber and the like.

Mabillon visited another such collection of curiosities, the 'museum

of the noble Roman LANDI', which previously belonged to his uncle Magnino. It contained many curious instruments by which the martyrs were executed, all kinds of arms, including Belisarius' bronze votive shield depicting the execution of king Vitiges, gems, shells etc... and various stones with inscriptions.' And Skippon mentioned the natural history collection of FRANCESCO CORVINO.[150]

Seventeenth century Rome offered much in the way of entertainment. Of the excesses of CARNIVAL, the judicious Evelyn will suffice:

> We were taken up the next morning in seeing the impertinences of the *Carnoval* when all the world are as mad at Rome, as at other places, but the most remarkable were the 3 Races of the Barbarie horses, that run in the strada del Corso without riders, onely having spurrs so placed on their backs, & hanging downe by their sides, as with their motion to stimulate them; Then of Mares: Then of Asses, of Bufalos, of Naked Men – old men, young, & boys: and aboundance of idle & ridiculous Passetime: One thing yet is remarkable, their acting Comedies upon a Stage placed on a Cart, or *plaustrum* where the Scene or tiring place is made of bowghs, in a Pastoral & rural manner, this they drive from streete to streete with a yoake or two of Oxen, after the antient guise; The streetes swarming with whores, buffoones & all manner of rabble.

Mortoft paid great attention to the many aristocrats who participated: 'All these Princes doing nothing but riding up and downe from one end of the Curso [*sic*] to the other till night came on.' How diverting![151]

Rome was also rich in other entertainments, such as JOUSTING:

> a Just & Turnament of severall young Gentlemen upon a formal Defy, which was perform'd in the Morning, to which we were invited, the prizes distributed by the Ladies after the Knight Errantry way: The Launces & swords running at tilt at the Barrieres with a greate deele of clatter, but without any bloud shed, which gave much diversion to the Spectators, & was very new to us Travellers.

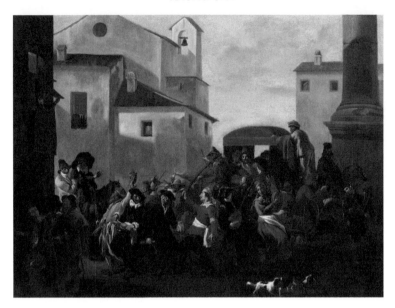

Jan Miel, Carnival in a Roman piazza, c. *1650*

THEATRE was very important. Mortoft saw a production at the Comedy, near palazzo Farnese:

> a Representation of Queen Elizabeth and the Earle of Essex, where indeed she that acted the Part of the Queene did so admirable well and with so much grace that all that came to see it had great content and satisfaction, and since it is reported that there is a Roman that hath offered 300 Crownes to have a night's lodging with her.

If only we knew the actress' name! Skippon in 1664 saw *Il schiavo* (The Slave), an attack on the Jesuits. There was 'nasty spitting out of the boxes upon the people in the pit'.[152]

It is MUSIC, however, which was clearly an outstanding feature of Roman cultural life at this time. The priestly envoy Aschhausen in 1613 was invited to dinner with Cardinal Scipione Borghese, followed by an innovative concert of viols and theorbos (a kind of lute).

It was at a similarly splendid occasions at the palazzo Barberini that Milton heard Leonora Baroni (1611-1670) singing. Born in Mantova, she came to Rome in 1633, and was much favoured by Cardinal Barberini. To her Milton wrote three epigrams. The second runs:

> Another Leonora enchanted the poet Torquato, who went mad through passionate love for her. Ah, wretched man, how much more happily he might have been destroyed, Leonora, in your time and for your sake! He would have heard you singing with Pierian voice as you touched the golden strings of your mother's lyre! Even if his eyes had rolled more wildly than those of Dircean Pentheus, or if his mind had completely collapsed, yet you with your voice could have set right his faculties wandering in blind disorder; and, breathing peace into his sick heart, you could with your soul-animating song have restored him to himself.

Milton also mentions in his letter to Holsten attending a truly magnificent public music entertainment at the palazzo Barberini. It has been contended that this was none other than the first comic opera, *Chi soffre, speri* ('The sufferer also hopes'), with music by Antonio Maria Abbatini and Marco Marazzoli, and libretto by Giulio Rospigliosi, later Clement IX. That, however, was performed in February 1639 and this letter seems rather to refer to October-November 1638; besides Milton is extremely vague if referring to such a particular performance.[153] Evelyn also saw plays and opera:

> We were entertain'd at Night with an English play, at the *Jesuites* where before we had dined, & the next at the *Prince Galicanos* [Pompeo Colonna, d. 1661], who himselfe compos'd the Musique to a magnificent Opera [*Proserpina Rapta*], where were *Cardinal [Camillo] Pamphilio* the Popes Nephew, the Governors of Rome, the Cardinals, Ambassadors, Ladies & a world of Nobilitie & strangers.

Cardinal Camillo Pamphili (d. 1667) renounced his cardinalate in 1647 in order to marry.

Another aristocratic venue for music lovers. Mortoft noted, was the palace of Queen Christina, 'it being her custome every Wensday night to have the best Musitianers at her Pallace, she being much delighted in Musicke'. And Clenche declared twenty years later that there 'every Tuesday the choicest Voyces and musick of Rome is heard'. Evelyn in 1644 gave a most useful summary:

> The chi(e)fe Masters of Music after *Marc Antonio* the best Trebble, is *Cavalier Lauretto* an *Eunuch*, the next *Card*: [Alessandro] *Bichis* Eunuch, *Bianchi* Tenor, & Base *Nicholai*.

All of these famous singers are unknown to standard biographical and musical reference works, with the exception of Giuseppe Bianchi, the castrato, who had an international reputation, and who flourished from the 1630s to the 1660s. The fact that they were known mostly by first name makes them, of course, harder to trace.[154]

It is Lassells who in the 1660s devoted a long section of his *Voyage to Italy* to Rome's church music.

> Now the best *musick* I heard, was the *musick* of the *Popes Chappel* consisting of pure voyces, without any *organ*, or other instruments: every singer here k[n]owing his part so well, that they seem all to be masters of *musick*. Then the *musick* of the *Chiesa Nova*; of *S Apollinaris*; upon *S Cecilyes* day in the *Church* of that *Saint* the *Patronesse* of singers; of the *Oratory of S Marcello* every Friday in *Lent*; of the *Iesuits* dureing the *Quarante hore* in *Shroftide*; of every good *Church of Nunns* upon their *patrons day*; especially that of the *Nunns* of *Campo Marzo*, where I heard often *Fonseca* sing so rarely well, that she seemed to me, to cheere up much the *Church* in its *combats*; & to make the *Church Militant* either looke like the *Church Triumphant*, or long for it. In a word, whosoever loves musick and hears but once this of *Rome*, thinks he hath made a saveing iourney to *Rome*, and is well payed for all his paynes of comeing so farre.

The Vatican was, of course, famous for its singing. Mortoft also noted the 'very excellent Musicke made by at least twenty eunuchs,

whose voyces made such melody that one's eares received farr more contentment with hearing that Melodious and harmonious Musicke, than one does with beholding St Peter's pretended Chaire'.

S Apollinare was next to the German College. Neumayer praised the Sunday vespers, with excellent singing and the best musicians playing, so that it was hard to get in. Mortoft also went more than once to that church 'where we heard a Consort of most sweet Musicke, which was so rare and sweet, that it would have enchanted any man's Eares that heard it'. He reported that the music master had 3,000 *scudi* a year to provide music every Sunday. That master was none other than Giacomo Carissimi (1604-74), the longest serving *maestro di cappella* this century, from 1630 until his death. Even after his demise, Veryard in the 1680s still found this church's music 'esteem'd the best in Rome' – and claims that no one was permitted to transcribe it, on pain of death.

The small church in the Campo Marzo, where a nun sang, was where Van Sommelsdijck found the best music, and when it was known that she would perform, the church was crowded – but the noise was so great that she often had to stop! It is Lassells who, as we have seen, provides a name: Fonseca.

Mortoft named two other churches: Gesù e Maria of the barefoot Franciscans provided 'extreme good Musicke', and there was 'most sweet music' at S Giacomo in piazza Navona. At Easter in 1691 Bromley heard the best Tenebræ at the latter.[155]

Two churches, however, stand out. Behind S Marcello in the Corso was an oratory.

> The most ravishing music I have heard in Rome is at the oratory of S Marcello, composed of all the best musicians, both voices and instruments, in the city. They assemble here every Friday night and play the most melodious concert one can imagine; for the best composers in Italy compete here to show off the excellence of their pieces, and the musicians strain to outdo their companions, for they always have in the audience at least a dozen cardinals and most of the foreign and Roman nobility.

So Van Sommelsdijck, and Mortoft recorded every foreigner in

Rome waiting some two hours for a concert of a dozen voices, with a lute, violin and organs. 'Once out of Rome it must never be expected to hear the like again.'[156]

The palm seems, however, to go to the Chiesa Nuova. Evelyn attended a concert of motets, which 'in a lofty cupola richly painted were sung by Eunuchs, and other rare voices, accompanied by Theorbas, Harpsichors and Viols'. Mortoft, who had a strong interest in music, was enraptured. 'The Musicke was so sweete and heavenly that I never looke to heare better as long as I am upon the Earth, it being enough to make a man out of his senses to heare those most ravishing voyces that excels all others.' Within a week he returned, and this time gives the programme. 'The subject was Made by A Prince of Rome and composed by Charissima, who for that is accounted the best in the world, and sung by Bonaventure [Domenico Giuseppe Bonaventura], Sinesia and the two Vuulpies, all which made so sweete a harmonye, that never the like must be againe expected, unless in heaven and in Rome.' And a third time, to hear again the eunuch Bonaventura, 'who is estemmed to have the most famousest and sweetest voyce of any in Rome; and whose voyce did sound so sweetly this night, that it might well be counted more than human'. Lassells agreed. Every Sunday and holiday evening in winter here was 'the best Musick in the world'.[157]

By way of introducing other people, some visitors made general notes on the LEADING ARTISTS, which provide us with very useful overviews. John Evelyn described the situation in 1644:

> For scultpors & Architects *Cavalier Bernini & Algordi* were in greatest esteeme: *Fiamingo* who made the *Andrea* in st. *Peters* & is said to die madd, that it was plac'd in an ill light. Painters, *Antonio de la Cornea* who has an addresse of count(e)rfiting the hands of the antient Masters, as to make his Copies passe for Originals: *Pietro de Cortone*, Monsieur Poussine a French man, & innumerable more, *Fioravanti* for Armour plate, dead life &c Tappsry &c:

John Ray in 1663 noted that the most eminent painter was Pietro da Cortona. In the 1680s, according to Veryard, the leading painter was

Carlo Moret (i.e. Maratta) and the leading musician Archangelo Corelli.

Many travellers to Rome commented on the PROSTITUTION. Neumayer in 1620 stated that the Campus Martius was now the main haunt of these women. Evelyn noted that outside porta del Popolo was the Muro Torto ('twisted wall') where they were buried, *sans cérémonie*. Lassells waxed eloquent over the convent for penitent prostitutes (especially in comparison with a similar institution which he had seen in Amsterdam), and inserted a long digression in the form of his rebuttal of a Dutchman's claim that prostitution was both permitted and taxed in Rome. He made all the world of difference between permission and approval. As for taxes, he roundly denied any such thing and listed all the charity given to young girls to save them from such a life, and the indulgences granted to men who would marry prostitutes. Penalties visited upon them, however, were heavy: they were forbidden to attend public meetings where women gathered (the Corso in the evening, marriages, operas), to travel in coaches in the day or go out at night, to live together, to work in Lent and Advent, to take the Sacrament or have Christian burial, or to make a will. Such was the hypocrisy of the times.

Jacob Spon had trouble in Jubilee Year 1675 finding rooms, for the pope had forbidden courtesans to take boarders, and their landlady, fearing accusation, cancelled their lodging. Spon, apparently, was upset. His mischievous fellow-countryman, Maximilien Misson, claimed that the number of courtesans was almost infinite. Paul had said that it was better to marry than to burn. 'The Romans, indeed, are not willing to burn, but they find the best Extinguishers at the Bawdy house.'[158]

Two visitors commented finally on LANGUAGES at Rome. The German bishop Aschhausen in meeting cardinals found a younger one placed next to him, because he spoke better Latin and therefore could converse with the bishop.[159] This sounds extraordinary, but the source is highly respectable. More than sixty years later the French scholar Spon listed the main spoken languages as Italian, French, German and Latin (in that order): 'les pierres parlent Latin et les obelisques Egyptien' (the stones speak Latin, the obelisks Egyptian); only a few learned persons knew Greek.

WITNESSED EVENTS

Not unexpectedly for those acquainted with the *Diario di Roma*, apart from church festivals, the major events in Rome were deaths. None was more calamitous, although at the same time usually quite expected, than that of a pope, with the following conclave for his successor. One of the most controversial was the ELECTION OF INNO-CENT X in 1644, observed by the marquis de Fontenay. On the death of Urban VIII there were two main contenders: Cardinals Giulio Sachetti and Giambattista Pamphili. The former was vetoed by the Spaniards because as papal nuncio he had not 'blindly supported all their passions' and by the duke of Tuscany, because he was not Tuscan (the infamous *esclusiva* – exclusion or veto – by secular powers was in the hands of the French and Spanish kings and the Holy Roman Emperor, and continued until 1903). The Jesuit Valentini stated that the merit of any candidate could never be as beneficial to the Church as upsetting such a prince as the duke of Tuscany would be prejudicial to it. Then Cardinal Giulio Bentivoglio died and others fell sick.

To further his candidacy, Pamphili concocted a conversation to be overheard by the main French agent, Cardinal Antonio Barberini, the camerlengo. Pamphili was told by his accomplice that everyone wanted him to be pope, to which he replied that he himself did not want the office and that it would divide the Barberini and that he owed much gratitude to Urban – but that if his election did come about, Barberini would have more power than even in the reign of his uncle. The latter was completely taken in by this! He now had to evade his promise to the French to veto Pamphili; Mazarin in particular feared his election. Meanwhile the French ambassador, Saint-Chaumont, sent for instructions, but Pamphili's friends told Barberini that the French would probably allow his election and that if he awaited the return of the messenger he would gain no credit. Pamphili was thus elected. Mazarin was furious, and confined the ambassador to his house and forbade Barberini to have the French arms over his door.[160] Innocent's first act was to call the Barberini to account for their corruption under Urban! The whole family fled to France for refuge.

It is Evelyn, however, who has given us the most detailed – almost unbelievably so – account of a papal ceremony, the POSSESSO OF INNO-CENT X on 23 November 1644, after his election just two months earlier:

The 23rd of this Moneth of November was the sollemne, and greatest ceremony of all the state Ecclesiastical, viz, the Caval-cado or Procession of his Sanctity Pope Inn(o)centius X to st. Jo: de Laterano which standing on the stepps of Ara Celi neere the Capitoll, I saw passe in this manner.

First went a guard of Swizzers to make way, and divers of the Avantguard of horse Car(r)ying Lances: next follow'd those who caried the robes of the Cardinals, all two & two: then the Cardinals Mace bearers, the Caudatari on Mules, the Masters of their horse: The Popes Barber, Taylor, Baker, Gardner & other domesticall officers all on horse back in rich liveries: The Squires belonging to the Guard. Then were lead by 5 men in very rich liverys 5 noble Neapolitan Horses white as Snow, coverd to the ground with trappings gloriously embro-dered, which is a Service payd by the King of Spaine for the Kingdomes of Naples & Sicily pretended foedatorys to the Pope: 3 Mules of exquisite beauty & price trapped in Crimson Velvet, next followd 3 rich Litters with Mules, the litters were empty: After these the Master of the horse alone, with his Squires: 5 Trumpeters: The (C)amerieri estra muros: The Fiscale & Consistorial Advocates: Cappellani, Camerieri di honore, Cubiculari & Chamberlaines cald Secreti, then followed 4 other Camerieri with 4 Capps of the dignity Pontifical, which were Cardinals hatts carried on staffs: 4 Trumpets, after them a number of Noble Romans & Gentlemen of quality very rich, & follow'd by innumerable Staffieri & Pages: The Secretaries

Overleaf: Possesso of Gregory XV, 1621. *One of the most splendid displays of pageantry in Rome was the procession in which a new pope travelled from St Peter's, after his coronation, to St John Lateran. Over the centuries it became an opportunity for the pope not only to show himself for the first time to his people but also to establish himself as the humble successor of Christ and heir to the Roman emperors. This print (in two sections) of Gregory XV's possesso shows the pope in a litter (right hand side, on p. 249) proceeded by his men at arms and followed by his chamberlain, his secretary, his doctor and his cardinals. Ahead ride magnificently dressed Roman patricians.*

ORDINE DELLA CAVALCATA PONTIFICALE DAL VATICANO AL POSSESSO

DI S. GIOVANNI LATERANO SOLITA DA FARSI D'OGNI NVOVO PONTEFICE.

Cortegiani et gentilomini de' Card.ᵉˢ

Caudatari de SS.ʳⁱ CC.ˡⁱ

Mazzieri de' SS.ⁱ Cardinali

Offitiali Alᵗᵉ trecento

Romeo R.ᵗᵒ e ... pato e' Castaldi honore ... havere ...

Alcuni Patricij Romani et Sig.ʳⁱ titolarj

Maestri Cattolica per il possesso pacifico delli e Sicilia

Stafieri servienti alla guardia di SS.ᵗⁱ

d' hombre

Cubiculari

ch Camerari secreti

4 Camerini con 4 Capelli della pontificali dignità

4 trombette del popolo

Baroni et Nobilta Romana et forestieri

Abbreuiatori Acoliti

Secretarii della Cancellaria

Illᵐⁱ Cardinali Vescoui

Cardinali Preti

Cardinali Diaconi

M.ᵈⁱ Camera et Coppiera

Secretario di Medici

Patriarchi Archivescoui et Vescoui assistenti

Protonotari Aptici

Auditor di Cam.ᵃ et Thesoriero

Cursori et Baldachino maneggiato dal N.S.P.P. GREG.XV. o maggiori del Pop. Rom.

Referentari

Chierici di Camera

Vescoui non assistenti

RP-P-OB-38.850

of the Cancellaria, Abbreviatori-Acoliti in their long robes & on Mules: Auditori di Rota, The Deane of the Roti, and Master of the Sacred Palace, on Mules, with grave, but rich foote Clothes, & in flat Episcopal hatts: Then went more of the Roman & other nobility Courtiers with divers pages in most rich liveries on horseback; After them 14 drums belonging to the Capitol: Then the Marshals with their Staves, The 2 Sindics: The Conservators of the Citty in robes of Crimson damasc; next them the knight Confalonier & Prior of the P.R: in velvet tocqus: Six of his holynesse's Mace bearers: Then the Captaine or Governor of the Castle of St Angelo upon a brave prancer: Next the Governor of the Citty, on both sides of these 2 long rankes of Swizzers. The Masters of the Ceremonies, The Crosse bearer on horse, with two Priests on each hand a foote, Pages footemen & guards in aboundance. Then next the Pope himselfe carried in a Litter, or rather open chaire of Crimson Velvet richly embrodred, & borne by two stately Mules; as he went holding up his two fingers, & blessing the people & multitudes upon their knees, looking out of their windoes & houses with lowd viva's & acclamations of felicity to their new Prince: This was follow'd by the Master of his chamber, Cuppbearer, Secretary, Physitian. Then came the Cardinal Bishops, next the Cardinal Priests, Card: Deacons, Patriarchs, Archbishops, and Bishops all in their several & distinct habits; some in red, others in greene flat hatts with tossles, all on gallant Mules richly trapp'd with Velvet, & lead by their servants in greate state & multitudes: After these the Apostolical Protonotari, Auditor & Tresurer, Referendaries. Lastly the Trumpets of the reareguard, 2 Pages of Armes in Helmets with might(y) feathers & Car(ry)ing Launces, 2 Captaines, Then the Pontifical (Standard) of the Church, The two Alfieri, or Cornets of the Popes light horse who all followed in Armor & car(ry)ing launces, which with innumerable rich Coaches, litters & people made up the Proceeding; but what they did at st. Jo: di Laterano I could not see by reason of the intollerable Crowd; so as I spent most of the day in admiring of the two Triumphal Arches, which had

been purposely erected a few days before, and til now covered; the one by the Duke of Parma in the foro Romano; the other by the Jewes in the Capitol with flatering Inscriptions, but of rare and excellent Architecture, decor'd with statues, and aboundance of ornaments proper for the Occasion, since they were but temporary, & made up of boards, cloath &c painted & fram'd on the suddaine, but as to outward appearance solid and very stately. The night ended with fire workes; that which I saw was that which was built before the Spa(n)ish Ambassadors house in the Piazza del Trinita, & another of the French: the first appeard to be a mighty rock, bearing the Popes Armes, a Dragon, and divers figures, which being set on fire by one who flung a Roquett at it, tooke fire immediately, yet preserving the figure both of the rock & statues a very long time, insomuch as 'twas deemed ten thousand reports of squibbs & crackers spent themselves in order: That before the French Ambass: Palace (which, I also saw) was a Diana drawne in a Chariot by her doggs, with aboundance of other figures as big as the life which plaied with fire in the same manner; in the meane time were all the windows or the whole Citty set with innumerable Tapers, which put into lanterns of sconces of severall colour'd oyl'd papers, that the win'd may not annoy them, render a most glorious shew, in my conceite, nothing prettier; & besides these, there were at least 20 other glorious fire workes of vast charge & rare art for their invention before divers Ambassadors, Princes & Cardinals Palaces, especialy that on the Castle of st. Angelo, being a Pyramid of lights of an excessive height fastned to the ropes and cables which support the standard pole; Thus were the streetes this night as light as day, full of Bonfires, Canon roaring, Musique pla(y)ing, fountaines running Wine in all excesse of joy and Triumph.[161]

In February 1645 Evelyn saw the catafalque for QUEEN ISABELLA OF SPAIN in S Giacomo degli Spagnoli:

In this Church was now erected a most stately *Cataphalco* or *Chapelle Ardente* for the Death of the Queene of Spaine: The

Church all hung with black, & heare I heard a Spanish sermon or funebral Oration, spent the rest of the time in viewing the statues, divises, and Impreses hung about the Walls, the Church, & Pyramid stuck with thousands of lights & tapers, which made a glorious shew.[162]

In January 1659 Mortoft witnessed the lying in state of CARDINAL CAMILLO MELZI:

Cardinal Melcius being dead, was buried in the Church in the Corso, where in the morning we saw him lye in a Rome within the Church, with his face uncovered, and seemed a handsome old Man of some 70 yeares of age. In the After noone wee went againe, where in the middle of the Church was his Body upon a high Beere, being drest in all his Cardinal's Robes, having his Red Capp on his head and his Cardinal's Capp at his feete, with a new paire of shoes, and about 120 torches standing all about his Body. The Church was all hung in blacke, and his Armes In Paper Scuchions all about the Church.

There came here about 25 or 30 Cardinals, every one of them, one after another, saying a dirgy for the health of his soule; And al the while he lay in this sort there was some 6 men, 3 on one side and 3 of the other side of him, with great flaggs in there hands, waving it continually about his dead Body. After the Ceremony was ended Every Person was put out of the Church by the Priests and officers, and his Body taken from thence and wrapt in Lead and so buryed in the Church, and his Cardinal's Capp, as the manner is, hung just over the same place where he was buried.

In 1659 it was then the turn of CARDINAL FABRIZIO SAVELLI, buried in S Maria in Aracœli. And Skippon mentioned the funeral of CARDINAL BACCIO ALDOBRANDINI in 1665 in the Chiesa Nuova.[163]

On the death of Clement IX in December 1669 after a reign of only eighteen months there followed a conclave of five months to elect CLEMENT X ALTIERI. Jacques de Grille was present in Rome. Pasquino was very vocal, declaring that 'Roma sta male si non ritorna Pietro'

(Rome will be in a bad way if Peter does not return). Cardinal Flavio Chigi had twenty-eight supporters, but was opposed by the Barberini (Cardinals Francesco and Antonio), and vice versa. De Grille considered that Giovanni Bona, the general of the Cistercians, would make a saintly successor to Clement. The conclave had reputedly come to blows, and some cardinals were leaving (which had not previously been allowed). The duke de Chaume was bringing the French king's advice on the conclave, and it was thought that this time he would not veto anyone. De Grille left before the resolution.[164]

In September 1685 Mabillon recorded solemn celebrations of thanksgiving in the presence of Innocent XI for the capture of cities in Hungary and the Peloponnese from the Turks; there were great fireworks in the city.[165]

In January 1686 Mabillon also recorded the funeral of another SAVELLI, CARDINAL PAOLO, in Aracœli, with the body lying in state and four servants one at each corner waving large fans 'to keep away the flies, which because of the season, were not numerous, but the ceremonial laws prescribed it'.[166]

Much more excitement was caused, at least in some quarters, by the EMBASSY OF ROGER PALMER, earl of Castlemaine, in 1686, on behalf of James II. Clenche recorded his cold reception, and the rejection of his requests for cardinalates for James' relatives and favourites: Prince Rinaldo d'Este (his queen's uncle) and Father Petre, who was denied because he was a Jesuit. Angered, Castlemaine spoke too freely, and was denied further audience.[167]

Surely, however, nothing in the century quite equalled the VISIT OF BORIS PETROVICH CHEREMETEF, 21 March-4 April 1698. He came with two brothers and a suite of eleven. Within a few days he had an audience with Innocent XII, and boasted of making peace between Russia and Poland (that of 1686 which brought Russia into the 'concert of Europe' against the Turks) and of victories over the last (the battle of Azov, 1695): he gave graphic detail of filling plains with bodies and the destruction of towns, hence this pilgrimage to pay his vows to Peter and Paul. Innocent responded by thanking him for his victories over the enemies of the Cross and prayed for the definitive ruin of the Muslims. Shortly after, the pope sent as presents a painting of the

agony in the garden and two cases of gloves, soaps and biscuits. In return Cheremetef gave Innocent a tapestry of gold cloth, embroideries in gold and silver, and furs, and also furs to the governor (in fact, secretary of state), Cardinal Fabrizio Spada; the commander of Rome (the governor, Giambattista Spinola); and other papal functionaries.[168]

PORTRAITS

The visitors unfortunately offer us little by way of portraits of popes during the first half of this century. Aschhausen, for example, had half a dozen audiences with Paul V Borghese (1605-21), but gives no details. Evelyn had an audience with INNOCENT X PAMPHILI (1644-55) (see ill. opposite), but also tells us nothing of the pope himself. The Dutchman Van Sommelsdijck, however, provides one of the most comprehensive pictures of any pontificate. Innocent was 'tall and thin, with a thin voice, and a far from pleasing face'. His enemies said that he resembled a satyr. Alongside Van Sommelsdijck's pen portrait we may place one of the greatest portraits ever painted, of the same man, by Velázquez, on his second stay in Rome 1649-51. His character was 'very hidden and obstinate'. He was completely controlled by his step-sister, said to be his concubine. He was very ignorant of theology, his main study being law. He was characterised by 'black avarice': everything was sold, from benefices to cardinalates, and he retailed stories of Innocent tricking even his barber into revealing his income, and mulcting him. In Germany a medal had been coined, showing Innocent wearing Olympia's headdress and she the papal crown – because he wanted to excommunicate the emperor for making the Peace of Münster; that is, Westphalia (1648), which brought an end to the Thirty Years' War, and which consolidated the Reformation in Germany and explicitly overrode objections by any person whatsoever!

Van Sommelsdijck went on to record some comments on the cardinals, whose number was fixed at seventy. They were nominated by the pope, the emperor, the king of France and the king of Spain. Each of

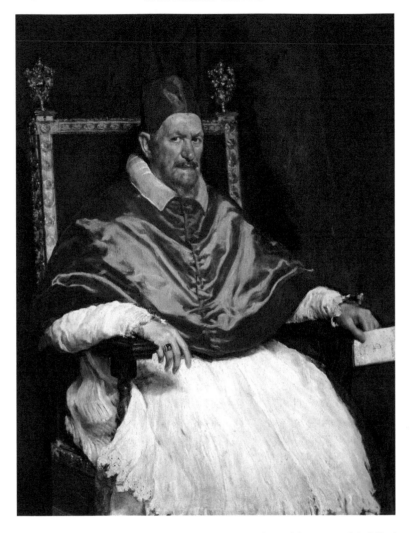

Diego Velázquez, Innocent X *(1644-55) (Doria Pamphili Gallery)*

these rulers had a 'patron' at Rome: the emperor, Cardinal Girolamo Colonna; France, Cardinal Rinaldo d'Este; Spain, Cardinal Carlo Medici. The Spanish faction was strongest when Van Sommelsdijck wrote (1650s). The cardinals were the subject of much gossip:

Left, Giovanni Morandi, Innocent XI *(1676-89), seventeenth century; right, Anon.,* Innocent XII *(1691-1700), seventeenth century*

Trivulsio (Teodoro Trivulzi) kept a large German lad called Alberty; (Virginio) Orsini had a married couple as servants, and abused them both; Muldaquin (Francesco Maldachini) was much addicted to courtesans. The richest man in Rome (400,000 *scudi* p.a.) was Borghese.[169]

CLEMENT X ALTIERI (1670-6) received a much more flattering portrait from Veryard: 'a man of good judgement, uninterest'd [*sic*], a vigorous asserter of the privileges of the clergy, constant and inflexible in all his purposes. He's extremely devoted to the House of Austria.'[170]

A much less flattering account of his successor INNOCENT XI ODES-CALCHI (1676-89) was given by the Protestant Gilbert Burnet: 'a particular stiffness of temper with a great slowness of understanding, and an insatiable desire of heaping up wealth'.[171]

INNOCENT XII PIGNATELLI (1691-1700) was naturally depicted very warmly by the Catholic convert James Drummond:

> The Pope, when I went to pay my duty to him, was very, very kind; he made me enter his chamber with sword, hatt and gloves, a thing never almost practised but to princes, and after

having discourse with me by an interpreter for near an hour he gave me a chaplett (i.e. a rosary) for myself and one for my wife. Some days after he sent me a present of wine, souger, and wax lights, and yesterday another of cheese, the finest in Italy, and excellent wine... he is a very handsome old man as ever I saw.[172]

In sum, reactions tended to be very prejudiced.

A leading cultural figure in the middle of the century was CARDINAL FRANCESCO BARBERINI (1597-1679), who so impressed Milton: 'on the topmost summit of dignity, nothing more kind, nothing more courteous'.

It was Jean Mabillon in 1685-6 who had the inestimable good fortune to make excursions with Pietro Santi Bartoli, Raffaele Fabretti and Emmanuel Schelestrate, and to know GIOVANNI PIETRO BELLORI, but he gives us portraits of only the last. Bellori (1615-96), Commissario delle Antichità 1670-94, was 'famous for his writings, but not less commendable for his probity, kindness and modesty'. Burnet

Carlo Maratta,
Giovanni
Pietro Bellori,
*seventeenth
century*

described him as 'deservedly famous for his knowledge of the Greek and Roman antiquities and for all that belongs to the mythologies and superstitions of the Heathens; and has a closet richly furnished with things relating to those matters'.

Of GIOVANNI LORENZO BERNINI (1598-1680), architect, sculptor and painter, Evelyn, after mentioning the high altar of St Peter's, revealed another aspect of this amazing genius,

> who a little before my Comming to the Citty, gave a Publique Opera (for so they call those Shews of that kind) where in he painted the seanes, cut the Statues, invented the Engines, composed the Musique, writ the Comedy and built the Theater all himselfe.

Colbert in 1671 visited St Peter's with him at the time he was working on the statues for ponte Sant'Angelo.[173]

The DUCHESS OF BRACCIANO made a great impression on Burnet: this Frenchwoman

> hath, by the exactness of her deportment amidst all the innocent freedoms of a noble conversation, recovered, in a great measure, the credit of those liberties that ladies beyond the mountains practise with all the strictness of virtue; for she receiveth visits at public hours, and in public rooms; and by the liveliness of her conversation, maketh that her court is the pleasantest assembly of strangers that is to be found in any of the palaces of the Italians at Rome.[174]

A foreigner thus taught Roman aristocratic women how to behave.

The most famous woman in seventeenth century Rome was another foreigner, QUEEN CHRISTINA OF SWEDEN (1626-89), who abdicated after ten years' rule in 1654, converted to Roman Catholicism, and came to Rome in 1655 (where the porta del Popolo bears the inscription 'Felici faustoque ingressui': for a happy and auspicious entry) (see ill. opposite and p. 261). She lived first in Cardinal Mazarin's palazzo Rospigliosi, but moved in 1659 to the palazzo Corsini. The earliest description is by Francis Mortoft in 1659:

MARIA ALEXANDRA CHRI STINA SVECIÆ REGINA.

Magnus Alexandro quem soluit in Vrbe Philippus,
 Froenas imperÿs, Regia Virgo, tuis. D.H.Q.
 Ioseph. Testan Inv. Fecit.

At uictrix ut Regna domes maiora relictis,
 Dat Tibi Alexander Nomen, et omen Equus.
 Gio. Iacomo Rossi, le Stampa e le Vende in Roma alla Pace.

J. Testan, Christina on her entry into Rome, *1655*

Afterwards wee went to the Pallace of the Queene of Sweth land, which is close by the Pope's Pallace, and belongs to Cardinal Mazarine, bought by him of Cardinal Bentivoglio. Here wee saw her enter into her Coach and followed her to the Jesuits Church to see her at Masse, where I stood close by her, and had a very perfect view of her, seeming to be a woman of A great spirit and majesticke Countenance, and also somewhat handsome. She was in a Velvet gowne and in her haire. I afterwards saw her led by a Jesuite into her Coach to whome she seemed very pleasant and merry.

January the 7th, wee went to the Queene of Sweedland's Pallace, which is close by the Pallace of the Pope, and belongs to Cardinall Mazarine, where wee saw her in her chamber converse with many Gentlemen that came to heare Musicke that night. It being her custome every Wensday night to have the best Muscitianers at her Pallace, she being much delighted in Musicke. She is a Woman but of a low stature, yet of a very manly Countenance, and, by all Relation, one of the greatest wits and spirit[s] of in [*sic*] this Age, her whole delight and pleasure being to coverse with Men of Witt and spirit, not caring for the Company of Women. Here she was very merry, holding discourse sometymes with one man, and sometymes with another, so that the Melody of the Musicke could bee but little observed, in regard of her continual talking and walking up and downe. I remember she had on her a Velvet Jerkin, with a Red sattin petticoate layd all about with white lace, and little buttons in every seame where the lace went, with a Blacke scarfe about her necke, and a Blacke hood, with a great lace on it, upon her head. At present the report goes that she is much out of the Pope's favour, and the Italians doe not so much respect [her] as when she came first to Rome; yet she alwayes seemes to be very merry and jocond, noe adversity being able to daunt her, being extreamly ambitious and desirous to live in all the Pomp and splendor that any Earthly person can desire.

Jacques de Grille in 1669 judged her one of the three most remarkable people in Rome. She had by now contracted her ambition to the

W. Heimbach,
Christina aged 41, *1667*

common life she led, living in a 'little palace' in the Borgo with half
a dozen servants. He described her as 'fiery in temperament, lively,
changeable, noble, arresting her restlessness for ten or twelve hours
by reading'; She spent four or five days a week in the Vatican library.
Skippon in 1664 attended a musical performance at her palace. She
was playing with her little dog. 'She is crook backed, was dressed in
her hair, had a cravat about her neck, and a coat with short sleeves
on, and had linen sleeves like a half shirt about her hands.' Shortly
before her death, Burnet in 1685 described her situation:

At the Queen of Sweden's, all that relateth to Germany, or the north, is ever to be found; and that princess, that must ever reign among all that have a true taste either of wit or learning, hath still in her drawing rooms the best court of the strangers; and her civility, together with the vast variety with which she furnisheth her conversation, maketh her to be the chief of all the living rarities that one sees in Rome. I will not use her words to myself, which were, 'That she now grew to be one of the antiquities of Rome.'

Mabillon praised the queen for her kindness in allowing access to her excellent library: 'there was almost no other in Italy to which we had easier access'. The last view was the year before her death by Maximilien Misson:

You are not ignorant of the learning and merit of the Princess. She is above sixty years of age, of a very low stature, extreme fat and thick: her complexion, voice and countenance are masculine, her nose is great, her eyes are large and blew, yellow; she has a double chin strew'd with some long hairs of a beard, and her under lip sticks out a little. Her hair is of a bright chestnut colour, about a hand breadth long, powder'd and brush'd up, without any head dress; she has a smiling air, and is very obliging. As for her habit, imagine a man's *justaucor* [jerkin] of black Sattin, reaching to the knee, and button'd quite down, a very short black coat, which discovers a man's shoe; a great knot of black ribbon instead of a caravat, and a girdle above the *justaucor*, which keeps her belly, and makes its roundness fully apparent.[175]

Of CARDINAL CESARE D'ESTRÉE (1628-1714) Burnet gave a very encouraging account:

One sees in cardinal d'Estrée all the advantages of a high birth, great parts, a generous civility, and a measure of knowledge far above what can be expected from a person of his rank: but as he gave a noble protection to one of the most learned men that this age hath produced, Mr Launoy,[176] who lived many years

with him; so it is visible, that he made a great progress by the conversation of so extraordinary a person. And as for theological learning, there is now none of the college equal to him.[177]

One of the most famous antiquarians of the century was RAFFAELE FABRETTI (1619-1700), noted for his works on the aqueducts and Trajan's Column. Burnet described him as 'justly celebrated for his understanding of the old Roman architecture and fabrics'. He showed all his works to Mabillon, including excavations of a cemetery at porta Maggiore, and took him to Portus. Bernard Montfaucon named him 'the leading antiquarian of his time in Rome'; he shared, of course, common interests and had some other (unspecified) connection, but 'jealous death destroyed our late friendship'. He lived near S Maria Transpontina in the Borgo, where he had an extensive collection of antiquities.[178]

LORENZO FABRI was described by Burnet as 'the chief honour of the Jesuits' college and much above the common rate both for philosophy, mathematics, and church history'.[179]

One of the leading humanists of the century was the German LUCAS HOLSTEN (1596-1661), who lived in Rome from 1627, becoming librarian to Cardinal Francesco Barberini in 1636 and keeper of the Vatican library in 1653. He showed extraordinary kindness to Milton in 1638:

For, when I went up to the Vatican for the purpose of meeting you, you received me, a total stranger to you (unless perchance anything had been previously said about me to you by Alexander Cherubini), with the utmost courtesy. Immediately admitted with politeness into the Museum, I was allowed to behold both the superb collection of books, and also very many manuscript Greek authors set forth with your explanations – some of whom, not yet seen in our age, seemed now in their array, like those in Maro, – 'souls enclosed within a green valley, about to go up to the threshold above' [Virgil, Æneid 6.636-7] – to demand the active hands of the printer, and a delivery into the world; others of whom, already edited by your care, are eagerly received everywhere by scholars; I myself, too, being dismissed by you, richer than I came, with two copies of one which you presented to me.

When Friedrich Calixtus visited him in 1651 he was in a monastery because of ill health. The Lutheran theologian spent four hours with him talking about church unity: Holsten did not think any agreement was possible, because of the disunity and quarrelsomeness of the Protestants. Shortly before his departure, Calixtus visited him again, and the last thing which Holsten told him was that he had converted to Catholicism because he thought it true, but that he detested those who, in combatting the Lutherans, relied on insults rather than reason.[180]

One of the best known figures in the late century was CARDINAL PHILIP HOWARD (1629-94), a Dominican, who became chaplain to Queen Catherine, wife of Charles II, until he was driven out of the England by popular feeling in 1674. He was created cardinal the next year, and Burnet knew him well:

> Cardinal Howard is too well known in England, to need any character from me. The elevation of his present condition hath not in the least changed him: he hath all the sweetness and gentleness of temper that we saw in him in England; and he retains the unaffected simplicity and humility of a frier, amidst all the dignity of the purple. And as he sheweth all the generous care and concern for his countrymen that they can expect from him; so I met with so much of it, in so many obliging marks of his goodness to myself, that went far beyond a common civility, that I cannot enough acknowledge it.

Among antiquarians, ATHANASIUS KIRCHER (1601-1686) holds a high place, with his famous museum in the Jesuit Roman College. He was to be described by Rodolfo Lanciani as 'one of the most genial archæological blunderers of the seventeenth century'. No one describes his character or appearance, but much can be gained from the accounts of the museum and his experiments (see p. 237).[181]

The second of de Grille's three most remarkable people in Rome was a nun, MATILDA DE GESÙ, a multilingual poet.[182]

ABATE FRANCESCO NAZARI (1612-1770) taught at the Sapienza. Burnet paid him high tribute:

And he to whom I was the most obliged, Abbot Nazari, hath so general a view of the several parts of learning, though he hath chiefly applied himself to philosophy and mathematics, and is a man of so engaging a civility, and used me in so particular a manner, that I owe him, as well as those others whom I have mentioned, and whom I had the honour to see, all the acknowledgments of esteem and gratitude that I can possibly make them.[183]

Of CASSIANO DAL POZZO (1584-1657), another famous antiquarian, unfortunately no visitor provides a portrait; Poussin simply recorded his death. The French painter worked on his tomb in the Minerva. His collection of antiquities has been described above (p. 212).[184]

The third of de Grille's marvels was MARC ANTONIO ODESCALCHI (?-1670), a young Milanese with an income of 100,000 *scudi*, all of which he spent on charity.[185]

Burnet finally offers a strangely anonymous description:

I was told, the Pope's confessor was a very extraordinary man for the Oriental learning, which is but little known in Rome. He is a master of the Arabic tongue, and hath writ, as Abbot Nazari told me, the most learned book against the Mahometan religion that the world hath yet seen, but it is not yet printed. He is not so much esteemed in Rome, as he would be elsewhere; for his learning is not in vogue. And the school divinity, and casuistical learning, being that for which divines are most esteemed there, he whose studies lead him another way is not so much valued as he ought to be.[186]

This is, in fact, LUIGI MARRACCI (1612-1700), Orientalist and professor at the Sapienza.

SOURCE NOTES

1. Two English visitors give very useful lists of English residents in Rome or visitors at the same time as themselves: Evelyn in 1644 (Evelyn, 116-7, 204) and Skippon in 1664-5 (Skippon, 663). – Skippon's list (those in DNB asterisked): James Oxinden, James Palmer, Hudson (a Catholic), Broome (merchant), (Henry) Compton*

(bishop of London), Waters, Paschal, Laur. Threele, Golding, Lowther, Farewell, Jeanes (Trinity Coll. Camb), (Henry) Palman* (St John's Camb), Soames, earl of Sunderland, Lord Castlemaine (Roger Palmer*), Lord Hinchinbrooke (Edward Montagu*), Sir Ed. Stradling, Henry Savil(e)*, Wormly, Slingsby Bethel*, Steele, Townley, Dr (James) Gibbs (Sapienza), Thos Normington (Benedictine friar), Brown (son of a Norwich doctor), (William) Trumball* (All Souls Oxford), Sir Ed. Widrington, Somerset, Noel (Lord Camden's eldest son), Skippwith, (Christopher) Anderton (Rector of the English College). These names included both monarchists and parliamentarians.

2. Pflaumer, 392; Zeiller, 140, 145; Jouvain, 490-1.

3. Burnet, 145-6.

4. Ray, 309; Veryard, 199; Bourdin, 181.

5. Aschhausen, 87, 96f.

6. Bouchard, 243f.; de Grille, 97.

7. Rigaud, 59v; Anon., 94; Neumayer, 139; Raymond, 96; Lassells, 243; Bouchard, 243f.; Evelyn, 116; Mabillon, 1.1.48; Jouvain, 415; Mottraye, 1.2.

8. Perth, 81; Condé, 107; Harris, 192; de Grille, 97, 145.

9. Rigaud, 594; Spon, 37; Mottraye, 1.45f.

10. Evelyn, 117; Aschhausen, 105.

11. Evelyn, 116; Anon., 94; de Grille, 108.

12. Aschhausen, 117, 126.

13. This guidebook is frequently misattributed to its English translator, Edmund Warcupp. For example, 'Warcupp's four day itinerary would probably have killed even a seventeenth century traveller, if it had been seriously attempted.' (M. Letts, ed., *Francis Mortoft, his book*, xxiv).

14. Schott, 217.

15. Welsch, 50f.; Zeiller, 144. – The story is known to the *Grove Dictionary of Art*, ed. Jane Turner (9.410), and some substance may underlie it: 'St Andrew was allocated a niche diametrically opposite to the one originally intended, somewhat compromising the figure's composition and gesture when the marble was installed in 1631.' The sculptor died, however, twelve years later.

16. Evelyn, 135f., Clenche 45; Mortoft, 79f.; Ray, 313; Clenche, 43; Mabillon, 49-52.

17. Anon. 1605, 103f.; Neumayer, 184f.; Pflaumer, 304; Lassells, 107f., Mabillon, 58-9 (the only thing he discusses) and Montfaucon, 137; Welsch, 55, also Zeiller, 146, Evelyn, 144-5, Lassells, 290; Mortoft, 88; Jouvain, 510; Neumayer, 192.

18. Bromley, 160; Lassells, 115-6.

19. Welsch, 58; Zeiller, 147; Evelyn, 129-30, so Mortoft, 86-7, Lassells, 156-9.

20. Mortoft, 140; Jouvain, 521, 524; Clenche, 46; Mabillon, 66.

21. Neumayer, 171; Evelyn, 160-1; Mortoft, 92-4; Jouvain, 493f.; Pflaumer, 398, so Welsch, 55.

22. Evelyn, 195, so Lassells, 160-1; Mortoft, 92, for relics, see 160.

23. Evelyn, 187.

24. Mortoft, 70; Agostino: Monconys, 2.443f.; Andrea: Evelyn, 193; Calixtus, 282; Cecilia: Evelyn, 185; Mortoft, 108; Nuova: Evelyn, 124; Francesca: Mortoft, 73; Gesù: Neumayer, 249f.; Neumayer, 146; Giorgio: Skippon, 672; Idelfonso: Lassells, 183-4.

25. Aracœli: Evelyn, 121; Neumayer, 235; Jouvain, 477; Concezione: Evelyn, 190. Lassells, 182, mentions only tombs in the church. Cosmedin: Neumayer, 167; Montfaucon, 187; Egyptiaca: Montfaucon, 188; Liberatrice: Neumayer, 220; Pace: Jouvain, 440; Popolo: Evelyn, 192; Mottraye, 1.35f.; Portico: Welsch, 61, so Zeiller 150; Mortoft in 1659 was still credulous, 98; Trastavere: Evelyn, 152; Vittoria: Evelyn, 128; Mortoft, 109.

26. Neumayer, 162; Evelyn, 164; Mortoft, 106-7; Colbert, 154, so Mabillon, 48.

27. Neumayer, 206; Pflaumer, 381; Evelyn, 146-7; Jouvain, 483; Mabillon, 77; the chains: Calixtus, 301, Jouvain, 483.

28. Pudenziana and Prassede: Evelyn, 130-1; Saba and Sabina: Neumayer, 180, and on the tombs, Montfaucon, 165; Evelyn, 186, Mortoft, 122; Susanna: Evelyn, 127; Tre Fontane: Evelyn, 161.

29. Pflaumer, 312.

30. Mortoft, 103-4.

31. Mortoft, 104.

32. Mortoft, 117-8.

33. Mortoft, 141-2.

34. Mortoft, 150-1.
35. Evelyn, 196-7.
36. Rigaud, 60ff.; Calixtus, 278; Aschhausen (1613), 113.
37. Skippon, 676.
38. Veryard, 174; Burnet, 164-172.
39. It must be realised, however, that for centuries these two catacombs were confused, S Sebastiano being taken for S Callisto. The matter was finally sorted out by G. B. de Rossi in the nineteenth century.
40. Evelyn, 187-8; Neumayer, 173f.; Calixtus, 291; Lassells, 94-5; Montfaucon, 154.
41. Mortoft, 91.
42. Montfaucon, 117, 209; Jouvain, 445; Evelyn, 198. A very similar account is given by Calixtus, 291; Montfaucon, 113.
43. Evelyn, 156-7.
44. Anon. 96; Pflaumer, 270; Zeiller, 143; Evelyn, 158-9; Calixtus, 282; Mortoft, 131-3; Monconys, 2.443f.; Lassells, 59-66; also de Grille, 150; Mabillon, 62; Burnet, 183-6; Montfaucon, 176-8.
45. Zeiller, 143, Evelyn, 159-60; Mortoft, 129-131.
46. Mortoft, 128.
47. Anon., 96f.
48. Anon., 110; Neumayer, 258f.; Pflaumer, 33; Evelyn, 161-2; Mortoft, 146-50; Lassells, 221; Liverdis, 395; Veryard, 193. It is strange that Mabillon does not mention this palace, and Montfaucon, 256, devoted only nine lines to it, singling out the portrait of Caracalla: 'nothing to equal it in Rome, perhaps in the world'.
49. Evelyn, 150.
50. Titian's *Last Supper*: there are such paintings in the Escorial and Urbino, but such a subject still exists in the Borghese collection, once attributed to Titian, now to Jacopo Bassano. Titian's *Assumption*: there are such paintings in Venice and Verona, but neither via the Borghese. Titian's *Self-portrait*: now regarded as a copy. Obviously the Borghese dramatically over-estimated their collection of this master's works!
51. Lassells, 239-40; Montfaucon, 210; Mottraye, 1.45; Clenche, 70.
52. Mortoft, 161; Lassells, 232-3; Montfaucon, 250; Mottraye, 1.69, Bromley, 247; also

Skippon, 681. – There is now a splendid catalogue *I Giustiniani e l'antico*, ed. Giulia Fusconi, Rome 2001, which reprints the Sandrart catalogue of 1636.
53. Welsch, 64; Evelyn, 126-7, 151-2; Liverdis, 482.
54. Skippon, 691; Lassells, 242-3.
55. Evelyn, 123; Calixtus, 302; Misson, 2.92.
56. Evelyn, 189.
57. Evelyn, 191; de Grille, 173; Zeiller, 147.
58. Montfaucon, 237-8.
59. De Grille, 157.
60. Lassells, 195-6.
61. Evelyn, 194.
62. Evelyn, 189.
63. Burnet, 181-3.
64. Aschhausen, 137; Evelyn, 133-5, and another visit, 199; Raymond, 94; Van Sommelsdijck, 3.179-81, so Liverdis, 410. Mortoft: In the entrance paintings of the pope's cavalcade to S Giovanni and the Turkish Sultan hunting (both by Tempesta); in another room Bernini's *David*, the 'Dying Seneca', and a red marble wolf with twins; in another Bacchus, Cupid, Bernini's *Apollo and Daphne*, and his *Æneas carrying Anchises*; in another a large head of Pluto, Xenocrates, Melenya, Bacchus and Apollo, a bust of Paul V and Cardinal Borghese, Venus and Cupid with helmet of Mars; in another the Gladiator, Hercules, two Egyptian monkey gods, Saturn with a child, Ceres, and a Gypsy; up the steps to a terrace, a woman in a mantle, a bronze Diana with coat of marble, sleeping Venus, a urinating Cupid, an hermaphrodite, three sleeping cupids, a sleeping cupid, two great urns, a marble profile of Alexander, and Gentileschi's *Julia fainting at the sight of Pompey's bloodstained toga* (opposite which is the catching chair); a room containing portraits of beautiful women; and the Curtius relief on the outside wall (Mortoft, 151-4.): there is another list in Skippon, 667; Lassells, 171-4, Liverdis, 402, Jouvain, 534; Montfaucon, 225, is mainly interested in the exterior; Lassells mentioned that there was a catalogue in octavo.
65. Evelyn, 125-6. Mortoft 124-8: in one room was a naked Venus, and a statue

of Cleopatra (by Stati); in another, Carracci's *Christ*, and Raphael's *St John* and *Lucretia*; then upstairs, a rich and stately bed given to Gregory XV as a bribe by a would-be cardinal; in another, a cabinet with Gregory's portrait in agate and rubies, and the skin of a hydra. In another palace a naked Venus, Marcus Aurelius, Apollo, Pluto, and fourteen heads of Romans; in another room, paintings of St Paul, Judith, and Lucretia; in another a naked gladiator with feet crossed, Nero's head in porphyry, 'a man killing his wife' (the Gaul and his wife), and Proserpina by Bernini; in another a naked Venus, and a boy on a dolphin; in another the head of Scipio Africanus 'made of stone which looks just like Brasse, and for which the Duke of Florence offered 10,000 crowns', the *Four Seasons* (*sic*) by Michelangelo, twelve urns of Oriental marble, a Madonna by Perugino, and the dying Gladiator (for which Cardinal Barberini offered 12,000 crowns to present to the French king); in another Urania and Apollo, Cæsar sacrificing with his hand on the shoulder of another man (both naked); in another a bronze bust of Marcus Aurelius; upstairs the fossilised man 'sent out of Germany as a Present to Gregory XV, and kept in a Truncke lined with red Velvet'; in another an hermaphrodite. In the garden was a 'ridiculous' satyr, a bust of Commodus, and (presumably a sarcophagus) showing a battle, with at least forty figures; Liverdis, 449, see also Skippon, 665; Lassells, 176-182; Misson, 2.66; Bromley, 256.

66. Evelyn, 128.
67. Reni's *St Michael*: there is one in S Maria della Concezione, for which it was commissioned. Reni's *Ariadne and Bacchus*: one was painted for Queen Henrietta of England, but is now lost.
68. Mortoft, 110-115; Skippon, 683; Lassells, 167; Misson, 2.67; Liverdis, 436; Van Sommelsdijck, 181; there were only general remarks in Montfaucon, 207-8.
69. Pflaumer, 299; Evelyn, 187; Mortoft, 133-5; smaller list, Skippon, 683, Lassells, 118, who names the artist of the Andromeda as Oliviero; Jouvain, 503; Montfaucon, 149.

70. Anon., 109f.; Neumayer, 240f.; Evelyn, 123-4. As is his custom, Mortoft (119-121) gave a detailed inventory: by the entrance two lions, and six or eight Roman women; the Great Hall was 'full of very fine pictures and under them many ancient statues'; in another room, 'a slave with his hands bound over his head' (Marsyas); in another, two boys fighting, and a cupid; in another, a naked Venus; in another, a fine table, Hercules, and six Roman heads; in another a naked man cutting a whetstone (which 'may outvye almost all the statues that we have seen yet'); in another a naked Venus (apparently the famous Medici Venus); in the garden, Hercules in bronze holding a child, a bronze Mars, four captive kings in porphyry, Agrippina the Younger, and Niobe and her children. For a smaller selection, see Skippon, 666; Lassells, 175-6 was most succinct but declared that the 'clowne whetting his scythe and hearing the conspirators of Catiline' was one of the best pieces in Rome; Montfaucon, 219-20 mentioned the two lions, the two basins, the head of Jupiter Capitolinus, Silenus and Bacchus, and the Niobe ('nothing is more elegant than these figures, not only for their posture but also their emotions').
71. Evelyn, 150-1; Van Sommelsdijck, 182.
72. Montfaucon, 203.
73. Liverdis, 446; Jouvain, 485.
74. Evelyn, 152. Liverdis in the 1670s also noted the painters always copying the Raphaels, 437.
75. Neumayer, 246.
76. Misson, 2.69-70.
77. Liverdis, 457; compare Skippon, 666. Jouvain, 443, is too general. Misson, 2.68.
78. Montfaucon, 208.
79. Lassells, 119-20; Pflaumer, 346.
80. Ens, 1-5; Van Sommelsdijck, 186.
81. Poussin, 287f., 331; 357; Palomino's biography of Velázquez in Jacobs.
82. Evelyn, 120; Mortoft, 64; Jouvain, 474; Montfaucon, 169.
83. Neumayer, 235.
84. Neumayer 221, Evelyn 194.
85. Jouvain, 478f.; Neumayer, 210f.; Lassells, 134; Anon., 113.

86. Pflaumer, 365; Neumayer, 216; Lassells, 135. Titus: Evelyn , 131, also Mortoft, 74; Mabillon, 131, Montfaucon, 178. Basilica: Evelyn, 118.

87. Jouvain, 502, Robinson, 478; Mabillon, 83; Montfaucon, 145. Circus: Pflaumer, 299; Evelyn, 122; cf.146; Jouvain ,505.

88. Neumayer, 207; Pflaumer, 209; Evelyn, 132; Lasells, 121, 148; Montfaucon, 141.

89. Pflaumer, 377; Evelyn, 132; Mortoft, 74; Mabillon, 75; Veryard, 165. Meta: Neumayer, 210; Evelyn, 248.

90. Raymond, 75; Evelyn, 194; Jouvain, 471; Veryard, 167

91. Mortoft, 100.

92. Neumayer, 201; Evelyn, 126; Jouvain, 527.

93. Neumayer, 210; Ray, 301.

94. Skippon, 674; Montfaucon, 121f.

95. Pflaumer, 345f; Evelyn, 191; Van Sommelsdijck, 186; Mortoft, 158; Ray, 295f; Lassells, 236.

96. Anon., 108; Evelyn, 190; Liverdis, 460. Portogallo: Neumayer, 247, so also Evelyn, 190.

97. Pflaumer, 330; Evelyn, 192; Liverdis, 442; Lassells, 240; Montfaucon, 233.

98. Caracalla: Evelyn, 186; Mortoft, 100. This use of the baths for the exercise of seminarians was to play a fundamental role in a celebrated court case in 1826: R. Ridley, 'Carlo Fea goes to court', *Xenia Antiqua* 5 (1996), 143-58. Lassells, 124-5; Mabillon, 74; Montfaucon, 158-9; Veryard, 166; Helen: Montfaucon, 110; Nero: Jouvain, 464; Sette Sale: Evelyn, 147; Neumayer, 207; Montfaucon, 127.

99. Mabillon, 82; Bourdin, 186.

100. Neumayer, 194.

101. Evelyn, 142, for the piazza del Popolo obelisk, 192, and that in piazza Navona, 187; Lassells, 96.

102. Anon., 101.

103. Neumayer, 170; Pflaumer, 296; Evelyn, 186; Mortoft, 101; Veryard, 170.

104. Liverdis, 415.

105. Van Sommelsdijck, 186; Skippon, 688; Lassells, 95; Veryard, 170.

106. Veryard, 164; Montfaucon, 84.

107. Clenche, 73.

108. Evelyn, 184-5; also Calixtus, 299.

109. Skippon, 691-2.

110. Skippon, 694-5.

111. Neumayer, 221f.; Mortoft, 64-8; Pflaumer, 353f.; Zeiller, 148; Evelyn, 120-1; Lassells, 140-5; Jouvain, 475; Burnet 193, so Bourdin, 1695, 188.

112. Aschhausen, 112.

113. Misson, 2.39.

114. Evelyn, 200.

115. Evelyn, 164-5.

116. Evelyn, 118; Lassells, 224, so Clenche, 73; Mottraye, 1.44.

117. Montfaucon, 241-2.

118. Evelyn, 146; Ray, 308; Skippon, 692, so Mabillon, 143; Lassells, 149.

119. Montfaucon, 248-9.

120. Evelyn, 150; 188; Lassells, 195; Mottraye, 1.45.

121. Mottraye, 1.36.

122. Pflaumer, 256; Jouvain, 506; Evelyn, 128; Montfaucon, 194.

123. Liverdis, 334; Jouvain, 538; Neumayer, 252; 254; Evelyn, 189; 203; Liverdis, 312; Skippon, 660; de Grille's praise was similarly unrestrained: de Grille, 145; Jouvain, 452.

124. Burnet, 190; Neumayer, 239; Evelyn, 127; 164.

125. Welsch, 67; Neumayer, 164, 166; Jouvain, 436-7.

126. Neumayer, 221f.; similarly Evelyn, 119; Welsch, 63; Jouvain, 473.

127. Anon., 94; Welsch, 63; Skippon, 668; Veryard, 169.

128. Neumayer, 164; Welsch, 69; Evelyn, 204; Raymond, 84; Mortoft, 116; Liverdis, 458; Skippon, 690; Veryard, 197.

129. Evelyn, 154; Liverdis, 458; Skippon, 671; Lassells, 18. Circumcision: Evelyn, 154, Mortoft, 116, Skippon, 690, Lassells, 81. Population: Rigaud, 64. It was in fact the Fourth Lateran Council (1215) which imposed 'il segno' (the sign) on the Jews. This was incorporated in the edict of their most notorious persecutor (Paul IV) in 1555 , and from then on the colour worn was generally yellow. (A. Milano, *Il ghetto di Roma*, 37, 72.)

130. Neumayer, 163.

131. Burnet, 145-9.

132. Veryard, 200.

133. Veryard, 201; Skippon, 697; Clenche, 88; Ray, 112; Jouvain, 433.

134. Lassells, 252-3; de Grille, 154; Evelyn, 153-4.

135. Mortoft, 110; Liverdis, 470; Lassells, 169-70.
136. Rigaud, 55v; Van Sommelsdijck, 187; Veryard, 204; Burnet, 190-1; Mottraye, 1.3; Ray, 316; 310f.; Aschhausen, 140.
137. Milton, 493; Skippon, 698; Burnet, 197; Mottraye, 1.17.
138. Burnet, 184; Calixtus, 299.
139. Evelyn, 193; Mabillon, 144. See Patrick Cockburn, An enquiry into the truth of the Mosaic deluge. Wherein the arguments of Isaac Vossius for a topical deluge are examined. London 1750
140. Evelyn, 153.
141. Neumayer, 250; Evelyn, 149; Bromley, 175.
142. Milton, 393; Everlyn, 188; 153; Mortoft, 137; 162; Lassells, 131; Veryard, 188; Burnet, 197-8; Bromley, 193.
143. Lassells, 231. (William) Hart (1596-1660) is unknown to Renazzi, L'Universita' di Roma, 4 vols, 1803, but for James Gibbs: 3.193.
144. Evelyn, 203-4; Ray, 312; Veryard, 199; Spon, 1.22f.; Skippon, 670, Veryard, 199.
145. Evelyn, 188; Aschhausen, 92.
146. Anon., 99; cf. Zeiller, 144; Liverdis, 444; Skippon, 669; Evelyn, 162-3; 191; Liverdis, 431; so Lassells, 117; Lassells, 9.
147. Veryard, 187; Bromley, 210.
148. Lassells, 9; 8; Mortoft, 106; Clenche, 59.
149. Mabillon, 78-9; 93; 99, 133, 145; 150-11; 94; 54; 98; 80; 135; 150; 67-69; 143. – It is appalling to discover that C. Frati, Dizionario bio-bibliografico dei bibliotecarii italiani, 1933, has none of these important figures: Frati did not consult Mabillon!.
150. Evelyn, 123; Calixtus, 281; Monconys, 446; Skippon, 685; Mabillon, 79; Skippon, 669;
151. Evelyn, 195-6; Mortoft, 139; see Van Sommelsdijck, 184, for similar.
152. Evelyn, 198-9; Mortoft, 101; Skippon, 693.
153. Aschhausen, 116; Milton, Poetical works, 156; Milton in French, 1.392; A. Harman and W. Mellers, Man and his music, 383f.
154. Evelyn, 198; Mortoft, 97; Clenche, 75; Evelyn, 203. The following have been consulted: New Grove's Dictionary of Music and Musicians, 29 vols, London

2001, Dizionario enciclopedico universale della musica e dei musicisti, Torino 1983-99, R. Kutsch and Leo Rieman, Grosses Sanger Lexikon, 7 vols, Munchen 2003; Dizionario biografico italiano, or Indice biografico italiano (microfiche).
155. Lassells, 247-8; Mortoft, 104; Neumayer, 255; Mortoft, 118, 143; Veryard, 186; Van Sommelsdijck, 188; Mortoft, 105; Bromley, 221.
156. Van Sommelsdijck, 184; Mortoft, 145, and 163.
157. Evelyn, 125; Mortoft, 144, 146, 158-9; Lassells, 228. – There is nothing on any of these singers (or Fonseca) in the works listed in n. 154.
158. Neumayer, 248; Evelyn, 192; Lassells, 200-5; Spon, 1.22f.; Misson, 2.48.
159. Aschhausen, 115.
160. Fontenay-Mareuil, 2.310-366; also Van Sommelsdijck, 193. – For the conclave of 1644 see Pastor, 30.15-24, who mentions rather 'a decisive conversation' between Barberini, Rapaccioli and Fachinette, who later involved Lugo and Albernoz. The largest faction in the conclave was indeed that of Chigi. The French ambassador, the duc de Chaulnes, did veto a number of candidates. Chigi and the Spanish were ranged against the Barberini, Azzolini and Rospigliosi. The factions eventually came together to accept Altieri, who expressed great reluctance.
161. Evelyn, 147-9; de Beer suggests that Evelyn drew heavily on Tempesta's engraving of the event; he owned a copy: The Diary of John Evelyn, 2.279.
162. Evelyn, 189-90.
163. Mortoft, 115-6. The 'church in the Corso' is rather anonymous, but Moroni, 43. 176, says that he was buried in S Andrea al Quirinale; Mortoft, 142; Skippon, 694.
164. de Grille, 101, 109, 129.
165. Mabillon, 87.
166. Mabillon, 135.
167. Clenche, 202.
168. Cheremetef, 96f.
169. Van Sommelsdijck, 193-9.
170. Veryard, 200.
171. Burnet, 148, 188.
172. Perth, 80-1.

173. Milton in French, 392; Mabillon, 54; Burnet, 186; on Bellori's cabinet see above, 200; Evelyn, 138; Colbert, 140f.

174. Burnet, 192.

175. Mortoft, 63, 97; de Grille, 234, 248; Skippon, 690; Burnet, 191; Mabillon, 54; Misson, 2.38.

176. Jean de Launoy (1603-1678), theologian, accused by Bossuet of being 'half Pelagian and Jansenist', was forbidden to teach. D'Estrée was his student.

177. Burnet, 187.

178. Burnet, 186; Mabillon, 73, 135f., 153; Montfaucon, 273.

179. Burnet, 186.

180. Milton in French, 391; Calixtus, 285, 305.

181. Burnet, 187; Lanciani, *Wanderings in the Roman Campagna*, Boston 1909, 196; see above, 226.

182. de Grille, 234.

183. Burnet, 187.

184. Poussin, 445; see above, 204.

185. De Grille, 234.

186. Burnet, 187-8.

LIST OF POPES

REGNAL NAME	BIRTH NAME	DATES OF REIGN
Leo III	Leo	26 December 795 to 12 June 816
Stephen IV (V)	Stefano Colonna	22 June 816 to 24 January 817
St Paschal I	Pasquale Massimi	25 January 817 to 11 February 824
Eugene II	Eugenio Savelli	8 May 824 to 27 August 827
Valentine	Valentino Leoni	31 August 827 to 10 October 827
Gregory IV	Gregorio	20 December 827 to 25 January 844
Sergius II	Sergio Colonna	25 January 844 to 27 January 847
Leo IV	Leone, OSB	10 April 847 to 17 July 855
Benedict III	Benedetto	29 September 855 to 7 April 858
Nicholas I	Niccolò Colonna	24 April 858 to 13 November 867
Adrian II	Adriano	14 December 867 to 14 December 872
John VIII	Giovanni	14 December 872 to 16 December 882

Opposite: Domenico Fontana, Drawing of the Method of Moving the Obelisk known familiarly as the Spire from the obscure location behind the Church of St. Peter to the plaza facing the main part of the same Church, *1586*

Marinus I	Marino	16 December 882 to 15 May 884
Adrian III	Adriano	17 May 884 to 15 September 885
Stephen V (VI)	Stefano	14 September 885 to 4 September 891
Formosus	Formoso	6 October 891 to 4 April 896
Boniface VI	Bonifacio	11 April 896 to 26 April 896
Stephen VI (VII)	Stefano di Spoletto	22 May 896 to 14 August 897
Romanus	Romano Marini	14 August 897 to November 897
Theodore II	Theódōros	December 897 to 20 December 897
John IX	Giovanni, OSB	18 January 898 to 5 January 900
Benedict IV	Benedetto	1 February 900 to 30 July 903
Leo V	Leone Britigena	30 July 903 to December 903
Sergius III	Sergio di Tuscolo	29 January 904 to 14 April 911
Anastasius III	Anastasio	14 April 911 to June 913
Lando	Lando	7 July 913 to 5 February 914
John X	Giovanni	March 914 to 28 May 928
Leo VI	Leone	28 May 928 to December 928

Stephen VII (VIII)	Stefano	3 February 929 to 13 February 931
John XI	Giovanni di Tuscalo	15 March 931 to December 935
Leo VII	Leone, OSB	3 January 936 to 13 July 939
Stephen VIII (IX)	Stefano	14 July 939 to 30 October 942
Marinus II	Marino	30 October 942 to 1 May 946
Agapetus II	Agapito	10 May 946 to 8 November 955
John XII	Ottaviano di Tuscolo	16 December 955 to 14 May 964
Benedict V	Benedetto	22 May 964 to 23 June 964
Leo VIII	Leone	23 June 964 to 1 March 965
John XIII	Giovanni dei Crescenzi	1 October 965 to 6 September 972
Benedict VI	Benedikt	19 January 973 to 8 June 974
Benedict VII	Benedetto di Spoleto	October 974 to 10 July 983
John XIV	Pietro Canepanora	December 983 to 20 August 984
John XV	Giovanni di Gallina Alba	20 August 985 to 1 April 996
Gregory V	Bruno von Kärnten	3 May 996 to 18 February 999
Sylvester II	Gerbert d'Aurillac, OSB	2 April 999 to 12 May 1003

John XVII	Siccone Secchi	16 May 1003 to 6 November 1003
John XVIII	Giovanni Fasano	25 December 1003 to 18 July 1009
Sergius IV	Pietro Martino Boccadiporco, OSB	31 July 1009 to 12 May 1012
Benedict VIII	Teofilatto di Tuscolo	18 May 1012 to 9 April 1024
John XIX	Romano di Tuscolo	14 May 1024 to 6 October 1032
Benedict IX	Teofilatto di Tuscalo	21 October 1032 to 31 December 1044
Sylvester III	Giovanni Crescenzi Ottaviani	13 January 1045 to 10 March 1045
Benedict IX	Teofilatto di Tuscalo	10 March 1045 to 1 May 1045
Gregory VI	Giovanni Graziano Pierleoni	5 May 1045 to 20 December 1046
Clement II	Suidger von Morsleben-Hornburg	24 December 1046 to 9 October 1047
Benedict IX	Teofilatto di Tuscalo	8 November 1047 to 17 July 1048
Damasus II	Poppo de Curagnoni	16 July 1048 to 9 August 1048
Leo IX	Bruno von Egisheim-Dagsburg	12 February 1049 to 19 April 1054
Victor II	Gebhard II von Calw-Dollnstein-Hirschberg	13 April 1055 to 28 July 1057
Stephen IX (X)	Frederich, Herzog von Lothringen, OSB	2 August 1057 to 29 March 1058
Nicholas II	Gerald de Bourgogne	6 December 1058 to 27 July 1061

Alexander II	Anselmo da Baggio	30 September 1061 to 21 April 1073
Gregory VII	Ildebrando Aldobrandeschi di Soana, OSB	22 April 1073 to 25 May 1085
Victor III	Dauferio Epifanio, OSB	24 May 1086 to 16 September 1087
Urban II	Odon de Lagery, OSB	12 March 1088 to 29 July 1099
Paschal II	Rainero Ranieri, OSB	13 August 1099 to 21 January 1118
Gelasius II	Giovanni Caetani, OSB	24 January 1118 to 29 January 1119
Callixtus II	Guy de Bourgogne	2 February 1119 to 13 December 1124
Honorius II	Lamberto Scannabecchi da Fiagnano Can.Reg.	21 December 1124 to 13 February 1130
Innocent II	Gregorio Papareschi Can.Reg.	14 February 1130 to 24 September 1143
Celestine II	Guido Guelfuccio de Castello	26 September 1143 to 8 March 1144
Lucius II	Gherardo Caccianemici dall'Orso, Can.Reg.	12 March 1144 to 15 February 1145
Eugene III	Pietro dei Paganelli di Montemagno, O.Cist	15 February 1145 to 8 July 1153
Anastasius IV	Corrado Demitri della Suburra	12 July 1153 to 3 December 1154
Adrian IV	Nicholas Breakspear, Can.Reg.	4 December 1154 to 1 September 1159
Alexander III	Rolando Bandinelli	7 September 1159 to 30 August 1181
Lucius III	Ubaldo Allucignoli	1 September 1181 to 25 November 1185

Urban III	Uberto Crivelli	25 November 1185 to 20 October 1187
Gregory VIII	Alberto de Morra, Can.Reg.	21 October 1187 to 17 December 1187
Clement III	Paolo Scolari	19 December 1187 to 20 March 1191
Celestine III	Giacinto Bobone Orsini	30 March 1191 to 8 January 1198
Innocent III	Lotario dei Conti di Segni	8 January 1198 to 16 July 1216
Honorius III	Cencio Savelli	18 July 1216 to 18 March 1227
Gregory IX	Ugolino dei Conti di Segni, OFS	19 March 1227 to 22 August 1241
Celestine IV	Goffredo Castiglioni	25 October 1241 to 10 November 1241
Innocent IV	Sinibaldo Fieschi	25 June 1243 to 7 December 1254
Alexander IV	Rinaldo dei Conti di Jenne	12 December 1254 to 25 May 1261
Urban IV	Jacques Pantaléon	29 August 1261 to 2 October 1264
Clement IV	Gui Faucoi	5 February 1265 to 29 November 1268
Interregnum	————————————	29 November 1268 to 1 September 1271
Gregory X	Tebaldo Visconti, OFS	1 September 1271 to 10 January 1276
Innocent V	Pierre de Tarentaise	21 January 1276 to 22 June 1276
Adrian V	Ottobuono Fieschi	11 July 1276 to 18 August 1276

John XXI	Pedro Julião (a.k.a. Petrus Hispanus & Pedro Hispano)	8 September 1276 to 20 May 1277
Nicholas III	Giovanni Gaetano Orsini	25 November 1277 to 22 August 1280
Martin IV	Simon de Brion	22 February 1281 to 28 March 1285
Honorius IV	Giacomo Savelli	2 April 1285 to 3 April 1287
Nicholas IV	Girolamo Masci, OFM	22 February 1288 to 4 April 1292
Interregnum	————————————	4 April 1292 to 5 July 1294
Celestine V	Pietro Angelerio, OSB	5 July 1294 to 13 December 1294
Boniface VIII	Benedetto Caetani	24 December 1294 to 11 October 1303
Benedict XI	Niccolò Boccasini, OP	22 October 1303 to 7 July 1304
Clement V	Raymond Bertrand de Gouth	5 June 1305 to 20 April 1314
Interregnum	————————————	20 April 1314 to 7 August 1316
John XXII	Jacques d'Euse	7 August 1316 to 4 December 1334
Benedict XII	Jacques Fournier, O.Cist.	20 December 1334 to 25 April 1342
Clement VI	Pierre Roger, OSB	7 May 1342 to 6 December 1352
Innocent VI	Étienne Aubert	18 December 1352 to 12 September 1362
Urban V	Guillaume (de) Grimoard, OSB	28 September 1362 to 19 December 1370

Gregory XI	Pierre Roger de Beaufort	30 December 1370 to 27 March 1378
Urban VI	Bartolomeo Prignano	8 April 1378 to 15 October 1389
Boniface IX	Pietro Tomacelli Cybo	2 November 1389 to 1 October 1404
Innocent VII	Cosimo Gentile Migliorati	17 October 1404 to 6 November 1406
Gregory XII	Angelo Correr	30 November 1406 to 4 July 1415
Interregnum	——————————	4 July 1415 to 11 November 1417
Martin V	Oddone Colonna, OFS	11 November 1417 to 20 February 1431
Eugene IV	Gabriele Condulmer, OSA	3 March 1431 to 23 February 1447
Nicholas V	Tommaso Parentucelli, OP	6 March 1447 to 24 March 1455
Callixtus III	Alfonso de Borja	8 April 1455 to 6 August 1458
Pius II	Enea Silvio Piccolomini	19 August 1458 to 15 August 1464
Paul II	Pietro Barbo	30 August 1464 to 26 July 1471
Sixtus IV	Francesco della Rovere, OFM	9 August 1471 to 12 August 1484
Innocent VIII	Giovanni Battista Cybo	29 August 1484 to 25 July 1492
Alexander VI	Roderic Llançol i de Borja	11 August 1492 to 18 August 1503
Pius III	Francesco Todeschini Piccolomini	22 September 1503 to 18 October 1503

Julius II	Giuliano della Rovere, OFM	31 October 1503 to 21 February 1513
Leo X	Giovanni di Lorenzo de' Medici	9 March 1513 to 1 December 1521
Adrian VI	Adriaan Floriszoon Boeyens	9 January 1522 to 14 September 1523
Clement VII	Giulio di Giuliano de' Medici	26 November 1523 to 25 September 1534
Paul III	Alessandro Farnese	13 October 1534 to 10 November 1549
Julius III	Giovanni Maria Ciocchi del Monte	7 February 1550 to 29 March 1555
Marcellus II	Marcello Cervini degli Spannochi	9 April 1555 to 1 May 1555
Paul IV	Giovanni Pietro Carafa, CR	23 May 1555 to 18 August 1559
Pius IV	Giovanni Angelo Medici	26 December 1559 to 9 December 1565
St Pius V	Antonio Ghislieri, OP	7 January 1566 to 1 May 1572
Gregory XIII	Ugo Boncompagni	13 May 1572 to 10 April 1585
Sixtus V	Felice Peretti di Montalto, OFM Conv.	24 April 1585 to 27 August 1590
Urban VII	Giovanni Battista Castagna	15 September 1590 to 27 September 1590
Gregory XIV	Niccolò Sfondrati	5 December 1590 to 15 October 1591
Innocent IX	Giovanni Antonio Facchinetti	29 October 1591 to 30 December 1591
Clement VIII	Ippolito Aldobrandini	30 January 1592 to 3 March 1605

Leo XI	Alessandro Ottaviano de' Medici	1 April 1605 to 27 April 1605
Paul V	Camillo Borghese	16 May 1605 to 28 January 1621
Gregory XV	Alessandro Ludovisi	9 February 1621 to 8 July 1623
Urban VIII	Maffeo Barberini	6 August 1623 to 29 July 1644
Innocent X	Giovanni Battista Pamphilj	15 September 1644 to 7 January 1655
Alexander VII	Fabio Chigi	7 April 1655 to 22 May 1667
Clement IX	Giulio Rospigliosi	20 June 1667 to 9 December 1669
Clement X	Emilio Bonaventura Altieri	29 April 1670 to 22 July 1676
Innocent XI	Benedetto Odescalchi	21 September 1676 to 12 August 1689
Alexander VIII	Pietro Vito Ottoboni	6 October 1689 to 1 February 1691
Innocent XII	Antonio Pignatelli, OFS	12 July 1691 to 27 September 1700

LIST OF ILLUSTRATIONS

p. 255: Diego Velázquez, *Innocent X,*
　　1644-55; Palazzo Doria Pamphili

p. 256: Giovanni Morandi, *Innocent XI*
　　(1676-89), seventeenth century;
　　location unknown

p. 256: Anon., *Innocent XII, 1691-1700,*
　　seventeenth century; location
　　unknown

p. 257: Carlo Maratta, *Giovanni Pietro*
　　Bellorio, seventeenth century; loca-
　　tion unknown

p. 259: J. Testan, *Queen Christina on her*
　　entry into Rome, 1655

p. 261: Wolfgang Heimbach, *Queen*
　　Christina aged 41, 1667; National-
　　museum (Stockholm)

Back matter

p. 272: Domenico Fontana, *Drawing*
　　of the Method of Moving the Obe-
　　lisk (detail), 1586; Metropolitan
　　Museum of Art

Illustrations on Frontispiece and pp. 10,
48, 57, 95, 133, 193 and 271 courtesy of
the Metropolitan Museum of Art; on
pp. 21, 22, 26, 27, 63, 93, 132, 135, 139,
150, 152, 185, 189, 198, 203, 207, 216 and
220 courtesy of the author's collection;
on p. 43 courtesy of Sotherby's; on
p. 47 courtesy of eBay; on pp. 52 and 53
courtesy of rebuildingrome2015; on p. 55
courtesy of the J. Paul Getty Museum;
on p. 63 courtesy of *The Irish Mirror*; on
pp. 65, 66, 82, 113 (right), 151, 161, 165,
195, 248 and 249 courtesy of the British
Museum; on pp. 73, 171 and 259 cour-
tesy of the collection of the publisher;
on pp. 74, 75, 78, 80, 85, 86, 175 and 184
courtesy of the University of Chicago
Library; on pp. 77 and 195 courtesy of
the British School at Rome; on pp. 79
and 206 courtesy of thehistoryblog.com;
on pp. 81, 159, 166, 168, 169, 172, 177,
179, 190, 217, 218, 231 and 233 courtesy
of Princeton University; on pp. 84 and
200 courtesy of the Kupferstichkabi-
nett; on p. 105 courtesy of venividivisit.
org; on pp. 113 (left), 114, 123, 138, 162,
181, 219, 255, 256 (both) and 257 cour-
tesy of Wikimedia; on pp. 128 and 202
courtesy of the Bibliothèque nationale
de France; on p. 143 courtesy of the
Pinacoteca Vaticana; on p. 160 courtesy
of the University of Marburg; on p. 182
of the LACMA; on p. 196 courtesy of
Cleveland Museum of Art; on p. 201
courtesy of the Rijksmuseum; on p. 209
courtesy of National Gallery of Art,
Washington DC; on p. 215 courtesy of
geocodedart.com; on p. 238 courtesy
of jamesgray2.me; on p. 240 courtesy
of Christie's; and on p. 261 courtesy of
Nationalmuseum (Stockholm)

NOTE ON LEADING ILLUSTRATORS
OF ROMAN TOPOGRAPHY
(FROM THE MIDDLE AGES TO 1700)

Giovanni Battista Cavallieri (1525-1601): born at Trent, he was in Rome from 1559. (*Grove Dictionary of Art*, 6.102)

Hendrik van Cleef (Cleve) (1525-1590/5): born at Anvers, he studied and worked in Italy from 1550, before returning to Antwerp. (*Grove Dictionary of Art*, 7.427)

Etienne du Pérac (1525-1604), born at Bordeaux, he studied in Italy 1550-70, then became Henri IV's architect at St Germain, Fontainebleau and the Tuilèries. He was most famous for his *Vestigi dell'antichità di Roma*, 1575 (40 plates). (*Grove Dictionary of Art*, 9.398)

Giovanni Battista Falda (1643-1678): born at Novara. He is most famous for his *Nuovo teatro delle fabbriche ed edificii* (3 books), 1665-9. His engravings are very realistic and notable for their deep bite and shadow. (*Grove Dictionary of Art*, 10.769)

Martin van Heemskerck (1498-1574): born at Haarlem, he came to Rome 1532-7, where he studied antiquity and was a pupil of Michelangelo, before returning to the Netherlands. Rembrandt was influenced by him. The main collections of his drawings are in two volumes in Berlin. (*Grove Dictionary of Art*, 14.291-4)

Alessandro Specchi (1668-1729), a Roman architect and engraver, who studied with Fontana. Author of *Quarto libro del nuovo teatro de palazzi di Roma*, 1699. (*Grove Dictionary of Art*, 29.373)

Gaspare van Wittel (Vanvitelli) (1652/3-1736): born at Utrecht, he was in Rome by 1675. He is a leading vedutist, and his exquisite watercolours portray much more than the customary ruins: he was mostly interested in modern Rome. (*Grove Dictionary of Art*, 33.268-70). See Giuliano Briganti, *Gaspar van Wittel*, Milan 1996.

SOURCES

Anon., *A true description of what is most worthy to be seen in all Italy* (c.1605) (= Harleian miscellany vol. 12), London 1811

Aschhausen, Johann G. von: *Gesandtschafts-Reise nach Italien und Rom 1612 und 1613*, Tübingen 1881

Benjamin of Tudela: *Itinerary*, trans. Marcus Adler, New York 1964

Boehmer, Heinrich: *Luthers Romfahrt*, Leipzig 1914

Bouchard, Jean Jacques: *Les confessions*, Paris 1881

Bourdin, Charles: *Voyage d'Italie et de quelques endroits d'Allemagne fait ès années 1695 et 1696*, Paderborn 1699

Bromley, William: *Remarks made in travels through France and Italy*, London 1693

Buchell, Arnold von: *Iter italicum* in *Archivio della Reale Società Romana di Storia Patria* 23 (1900), 5-66; 24 (1901), 49-93; 25 (1902), 103-135

Burchard, Johann: *At the court of the Borgia*, trans. Geoffrey Parker, London 1963

Burnet, Bishop Gilbert: *Travels*, London 1752

Calixtus, Friedrich Ulrich: *Beschreibung einer Reise durch Italien, Frankreich, und Niderlande 1651*, in Jean Bernouille, *Sammlung kurzer Reisebeschreibungen*, vol. 17, Berlin 1782

Capgrave, John: *Ye solace of pilgrimes*, ed. C. Mills, Oxford 1911

Cervantes, Miguel de: *Exemplary tales*, trans. Samuel Putnam, New York 1965
—*Journey to Parnassus*, trans. James Gibson, London 1883

Cheremetef, Boyard Boris Petrovich: *Journal du voyage à Cracove, Vénise, Rome et Malta 1697-99*, Paris 1859

[Clenche, John]: *A tour in France and Italy made by an English gentleman 1675*, London 1676

Colbert, Jean Baptiste: *L'Italie en 1671*, ed. P. Clement, Paris 1867

Condé, Henri Prince de: *Voyage en Italie*, Paris 1634

Dictionary of national biography, 2nd edn., 60 vols, Oxford 2004

Dictionnaire de biographie française, Paris 1933-

Dizionario biografico degli italiani, Rome 1960-

Dizionario enciclopedico universale della musica e dei musicisti, ed. Alberto Basso, 16 vols, Torino 1983-9

Ens, Gaspar: *Deliciæ Italiæ*, Köln 1609

Erasmus, Desiderius: *Correspondence*, vols 1-12 in his *Collected works*, 86 vols, Toronto 1974-2005

Erstinger, Hans Georg: *Reisebuch*, ed. P. Walter, Tübingen 1877

Evelyn, John: *Diary* ed. Esmond de Beer, Oxford 1959 (Oxford Standard Authors); the edition by the same, 6 vols, 1955, for commentary

Fichard, Johann: *Italia*, Frankfurt 1815 (= Frank. Archiv f. ältere Literatur u. Geschichte vol. 3)

Fontenoy-Mareuil, François du Val, marquis de: *Mémoires*, 2 vols, Paris 1826

Frame, Donald: *Montaigne, a biography*, New York 1965

French, J.: *Life records of John Milton*, 5 vols, New York 1949-58

Gerald of Wales (Giraldus Cambrensis): *Autobiography*, trans. H. Butler, London 1937

Grille, Jacques de (Roblas d'Estoublan): *Lettres de M. le Marquis de *** écrites pendant son voyage d'Italie en 1669*, Paris 1676

Grove Dictionary of art, ed. Jane Turner, 34 vols, London and New York 1996

Harff, Arnold von: *The pilgrimage of Arnold von Harff*, London 1946 (= Hakylut Society 2.94)

Harman, Alec and Mellers, Wilfred: *Man and his music*, London 1962

Harris, Enriqueta, *Velasquez*, Oxford 1982

Hentzner, Paul: *Itinerarium Germaniæ, Galliæ, Angliæ, Italiæ*, Nuremburg 1629

Hildebert of Lavardin: in William of Malmesbury: *History of the English kings*, ed. and trans. R. Mynors, Oxford 1998

Hoby, Thomas: *Travels and life*, ed. Edgar Powell, London 1902 (= Camden Miscellany 10)

Indice biografico italiano (fiche)

Jacobs, Michael (ed.), *Lives of Velázquez*, 2nd edn, London 2018

John of Salisbury: *Memoirs of the papal court*, trans. Marjorie Chibnall, London 1956
—*Policratus*, trans. Cary Niedemann, Cambridge 1990

Jouvain, Albert: *Le voyage de l'Europe*, 7 vols, Paris 1672-7, vol. 1, part 2

Kelly, James Fitzmaurice: *Miguel de Cervantes*, Oxford 1913

Kempe, Marjory: *The book of Marjory Kempe*, trans. B. Windeatt, Harmondsworth 1985

Kutsch, K. and Riemens, Leo: *Grosses Sängerlexikon*, 4 vols, Bonn 1997

Lassells, Richard: *Voyage of Italy*, London 1690

le Sage, Jacques: *Voyage de Douai à Rome*, ed. H. Duthilloeul, Douai 1859

Liverdis, Balthasar Grangier de: *Journal d'un voyage de France et d'Italie*, Paris 1667

Luther, Martin: *Dokumente seines Lebens u. Werkens*, Weimar 1983
—*Werke*, 121 vols, Weimar, 1883-2009
—*Works*, trans. Theodore Tappert, Philadelphia 1958- (*Table talk* = vol. 54)

Mabillon, Jean: *Museum italicum*, Paris 1687

Magoun, Francis: 'The Rome of two northern pilgrims', *Harvard Theol. Rev.* 33 (1940), 267-89

Milano, A.: *Il ghetto di Roma*, Rome 1964

Milton, John: *Poetical works*, ed. Douglas Bush, Oxford 1966. See also French

Misson, Francois Maximilien: *A new voyage to Italy*, 2 vols, London 1695

Monconys, Balthasar: *Journal des voyages*, Lyon 1665

Montaigne, Michel de: *Journal de voyage en Italie*, ed. Charles Dedeyan, Paris 1946

Montfaucon, Bernard de: *Diarium italicum*, Paris 1702

Moroni, Gaetano: *Dizionario di erudizione storico-ecclesiastico*, Venice 1840-61

Mortoft, Francis: *His book*, ed. Malcolm Letts, London 1925 (= Hakylut Society 2.57)

Moryson, Fynes: *Itinerary*, London 1617

Mottraye, Aubrey de la: *Travels through Europe, Asia and into parts of Africa*, 3 vols, London 1732

Muffel, Nicholaus: *Descrizione della città di Roma nel 1452*, trans. G. Wiedmann, Bologna 1999

Nashe, Thomas, *The unfortunate traveller* (1594), in *An anthology of Elizabethan prose fiction*, ed. Paul Salzman, Oxford 1987, 205-309

Neumayer von Ramssia, Johann: *Reise durch Welschland und Hispanien*, Leipzig 1622

Ottenberg, Veronica: 'Archbishop Sigeric's journey to Rome in 990', *Anglo-Saxon England* 19 (1990), 197-246

Otto of Friesing: *The deeds of Frederick Barbarossa*, trans. Charles Mierow, Columbia 1953

Pastor, Ludwig: *The history of the popes*, 40 vols, London 1938-67

Perth, James (Drummond) 4th earl of: *Letters of James Earl of Perth*, London 1845 (= Camden Society 33)

Pflaumer(n), Johann: *Mercurius Italicus*, Lyons 1628

Pigghe, Stephan, *Hercules Prodicus*, Koln 1609

Poussin, Nicolas: *Correspondence*, Paris 1911

Predmore, Richard: *Cervantes*, London 1973

Rabelais, François: *Oeuvres complètes*, ed. Pierre Jourda, Paris 1962

Ray, John: *Travels through the Low Countries, Germany, Italy and France*, 2nd ed., London 1738

Raymond, John: *An itinerary containing a voyage made through Italy in the years 1646 and 1647*, London 1648

Rigaud, Jean Antoine: *Bref recueil des choses rares, notables, antiques dans les fortresses principales d'Italie*, Aix 1601

Robinson, Tancred: 'Miscellaneous observations made about Rome, Naples and other countries in the years 1683 and 1684', *Philos. Trans. R. Soc.* 29 (no.349) (1716), 473-483

Rohan, Henri duc de: *Voyage fait en l'an 1600*, Amsterdam 1600

Schickhart, Heinrich: *Beschreibung einer Reise*, Mümppelgart 1601

Schott, Franz: *Italy in its original glory*, trans. Edmund Warcupp, London 1660

Schwiebert, Ernest: *Luther and his times*, St Louis 1950

Skippon, Philip: *Journey made thro' part of the Low Countries, Germany, Italy and France* in Churchill's *Voyages*, 6 (1732), 361-376

Spon, Jacob: *Voyage d'Italie*, 3 vols, Lyons 1678

Suger of Saint Denis: *The deeds of Louis the Fat*, trans. Richard Cusimano and John Moorhead, Washington 1992

Tafur, Piero: *Travels and adventures*, trans. Malcolm Letts, London 1926

Tellenbach, Gerd: 'La città di Roma dal IX al XII secolo vista dai contemporanei d'oltre frontiere', in *Studi storichi in onore di Ottorino Bartolini*, Pisa 1972, 2.679-734

Thomas, William: *History of Italy* (1549), ed. George Parks, Ithaka 1963

van Sommelsdijck, Cornelis van Aerssen: *Voyage d'Italie*, in Pelissier, 'Quelques documents utiles pour l'histoire des rapports entre la France et l'Italie', *Atti del Congresso intern. di scienze storiche*, Rome 1903, 3.177-256

Veryard, Ellis: *An account of diverse choise remarks, as well geographical as historical, political, mathematical, physical and moral, taken on a journey through the Low Countries, France, Italy and parts of Spain*, London 1701

Villamont, Jacques de: *Les voyages de Seigneur de Villamont*, Arras 1598

Welsch, Hieronymus: *Wahrhaftige Reis-Beschreibung*, Stuttgart 1658

Wotton, Henry: *Life and letters of Henry Wotton*, London 1907

Zeiller, Martin: *Itinerarium Italiæ*, Frankfurt 1690

First published 2023 by
Pallas Athene (Publishers) Ltd.,
2 Birch Close,
London N19 5XD

Reprinted 2024

For further information on our books please visit
www.pallasathene.co.uk

pallasathenebooks PallasAtheneBooks

 Pallasathene0
issuu

ISBN 978 1 84368 067 3

Printed and bound in Great Britain by
TJ Books Limited, Padstow, Cornwall

MIX
Paper from
responsible sources
FSC
www.fsc.org FSC® C013056